Social History of Africa

"WE WOMEN WORKED SO HARD"

"WE WOMEN WORKED SO HARD"

GENDER, URBANIZATION, AND SOCIAL REPRODUCTION IN COLONIAL HARARE, ZIMBABWE, 1930–1956

Teresa A. Barnes

HEINEMANN
Portsmouth, NH

JAMES CURREY
Oxford

BAOBAB/ACADEMIC
Harare

DAVID PHILIP
Cape Town

Heinemann	James Currey Ltd.	David Philip Publishers (Pty) Ltd.	Baobab/Academic
A division of Reed Elsevier Inc.	*73 Botley Road*	*208 Werdmuller Centre*	*P.O. Box 1559*
361 Hanover Street	*Oxford OX2 0BS*	*Claremont 7708*	*Harare*
Portsmouth, NH 03801-3912	*United Kingdom*	*South Africa*	*Zimbabwe*
USA			
www.heinemann.com			
Offices and agents throughout the world			

ISBN 0–325–00173–1 (Heinemann cloth)
ISBN 0–325–00172–3 (Heinemann paper)
ISBN 0–85255–686–1 (James Currey cloth)
ISBN 0–85255–636–5 (James Currey paper)

British Library Cataloguing in Publication Data

Barnes, Teresa A.
 "We women worked so hard" : gender, urbanization, and social reproduction in colonial Harare, Zimbabwe, 1930–1956.— (Social history of Africa)
 1. Women—Zimbabwe—Harare—History—20th century 2. Women—Zimbabwe—Harare—Social conditions 3. Sex role—Zimbabwe—Harare
 I. Title
 305.4'096891

 ISBN 0–85255–686–1 (James Currey cloth)
 ISBN 0–85255–636–5 (James Currey paper)

Library of Congress Cataloging-in-Publication Data

Barnes, Terri.
 "We women worked so hard" : gender, urbanization, and social reproduction in colonial Harare, Zimbabwe, 1930–1956 / Teresa A. Barnes.
 p. cm.— (Social history of Africa, ISSN 1099–8098)
 Includes bibliographical references and index.
 ISBN 0–325–00173–1 (alk. paper).—ISBN 0–325–00172–3 (pbk. : alk. paper)
 1. Women—Zimbabwe—Harare—History—20th century. 2. Women—Zimbabwe—Harare—Social conditions. 3. Women—Zimbabwe—Harare—Economic conditions.
 4. Sex role—Zimbabwe—Harare. 5. Imperialism—Zimbabwe—Harare. 6. Nationalism—Zimbabwe—Harare. 7. Great Britain—Colonies—Africa—Administration. 8. Harare (Zimbabwe)—Social conditions. 9. Harare (Zimbabwe)—Race relations. 10. Harare (Zimbabwe)—Politics and government. I. Title. II. Series.
 HQ1801.Z9H372 1999
 305.4'096891—dc21 99–25010

Paperback cover photo: Woman with baggage and children, Harare, 1920s. Photo by David Gombera. Courtesy of Mrs. David Gombera.

Printed in the United States of America on acid-free paper.

03 02 01 00 99 SB 1 2 3 4 5 6 7 8 9

CONTENTS

ILLUSTRATIONS

PHOTOGRAPHS

TABLES

ACKNOWLEDGMENTS

I have benefited immensely from the intellectual generosity and moral support of many remarkable people. This book's shortcomings should not reflect on them! First is my partner, John Pape, early riser. Highly adept in labor history, teaching, project management, and the myriad chores of parenting, he has borne the brunt of all this. Lewis and Lonnie, our two children, have interrupted me a lot and have provided much joy. Laura Czerniewicz has been the best friend anyone could ask for. Rick de Satge, Margaret Waller, and Stephen Morrow have helped in many ways to keep the show on the road. The members of my Barnes-McConnell, McConnell, Barnes, Preston, Barnes-Josiah, Worthington, Williams, Lingham-Pritchard, and Jones clan in the United States have provided examples to try to live up to and warm kitchens to come home to. Of all these wonderful people, may I single out my mother, Pat Barnes-McConnell, who has exhibited prodigious energy, an unflagging sense of humor, and an iron determination to visit me bearing well-strapped Care packages wherever I have insisted on living. I would like to thank her for *everything*.

I "discovered" history as an expatriate high school teacher and then graduate student in Harare in the 1980s. Sandy Katz and Sharon Ladin first helped put my feet on that road. My second alma mater, the University of Zimbabwe, was the site of a real maturation in my thinking, and I thank Joseph Mtisi, Victor Machingaidze, and Alois Mlambo for their teaching, supervision, and support. My friend and erstwhile collaborator Everjoice Win has remained my closest link with Zimbabwe as I have moved ever farther south. In South Africa since 1991, I would like to thank everyone who helped with the permanent residence battle, and all the friends made in Johannesburg. I would like to thank staff members of

the Institute for Advanced Social Research and the history and political studies departments of the University of the Witwatersrand, members of the history department and of the Women of Colour Consciousness Raising group at the University of Cape Town, and my new colleagues at the University of the Western Cape for inspiration in finding paths through the maze of South Africa, old and new. Philip Warhurst provided a very helpful pointer to records held at the University of Natal. I would especially like to thank Gail Gerhart, from whom I learned a great deal about South African history and careful scholarship. Members of the Africanist community in the United States, especially those in feminist circles, were very welcoming when I ventured back to conferences as a real greenhorn. Jane Parpart has been especially supportive. For their originality, tenacious commitment to scholarly excellence, and deep insights, my greatest sources of intellectual inspiration are the works of Luise White and Ian Phimister. In addition I would like to pay this small tribute to Terence Ranger, a great historian of Africa. I am fortunate to have interviewed the insightful Lawrence Vambe, whose works are vastly quoted and should be made more widely available. I am also fortunate in being able to reflect on scholarship of the high caliber of that produced by Tsuneo Yoshikune, Michael West, Betsy Schmidt, Diana Jeater, and Tim Scarnecchia. The process of writing this book began with the help of Heinemann editor Jean Hay; her successor Jean Allman has been encouraging from the start, as has been Allen Isaacman since we first met way back when. I would also like to thank the anonymous readers of the manuscript for their very useful suggestions. Jim Lance at Heinemann patiently answered all my questions, and Lynn Zelem and the Greenwood production team have all been a pleasure to work with. Thanks to Everjoice and Leslie Humphrey in Harare for help with tracking down the cover photograph, and to Mrs. David Gombera for permission to use this excellent example of her late husband's work.

I would like to thank staff members of the National Archives of Zimbabwe for many years of kind assistance. Staff of the main library of Wits University, the Killie Campbell Africana Library of the University of Natal, and the African Studies Library at the University of Cape Town were also helpful. I gratefully acknowledge financial assistance for research from the Ford Foundation and the International Federation of University Women. Brown University was my first alma mater; a return for a postdoctoral year at its Pembroke Center for Teaching and Research on Women provided a needed opportunity to read, write, and reflect; thanks to all the 1996–1997 seminar organizers and participants for their ideas and friendship. I would also like to thank old friends Michael Harper,

Bob and Sarah Reichley, Eric Worby, Gul Rukh Selim, and Laura Worby for looking after me during my "exile" in Providence.

Finally, I am indebted to two sets of people: the ex-combatant students at Danhiko School in Harare, who in three years in the early 1980s taught me far more about political commitment and tenacity than I taught them about English and history, and the elderly people of Harare upon whose recollections this book is based. I hope that I have done some justice to the complexities of their lives.

INTRODUCTION:
TRUTHS OF THE PAST AND
TRUTHS OF THE PRESENT

> We women worked so hard. When I hear people saying, "We fought the war," I always say to the women, "We were the first ones to fight. Even if we didn't hold guns. But we did our best."[1]

This book is set in the period from 1930 to 1956, in a segregated slum in the capital city of a colony in British Central Africa. The colony was born from the imperialist visions of the Anglo–South African capitalist and politician Cecil Rhodes and was later branded with his name; by geographical and political circumstances it was demarcated from a sister territory on the far side of the Zambezi. This landlocked, dryish piece of central Africa was thus known in the colonial age as Southern Rhodesia. Its capital city was named Salisbury after an imperialist British prime minister.[2] The slum, at least, had an African name: after some years as the "municipal location" it became known as Harare, after a hill above the Mukuvisi River on Chief Seke's lands, where Rhodes' gold-seeking mercenaries settled in 1890.

By the time of the short quarter century discussed here, colonialism had passed from its initial stages of conquest into those of consolidation. Although the prospects for facilely profitable gold mining had collapsed, the military conquest of the Shona and Ndebele peoples had opened the way for speculation and the large-scale expropriation of indigenous assets. Strip mines, enormous concessionary farms, rambling towns, and the thin ribbons of railroads that ran between them were all permanently marked on the land by 1930. Colonial bureaucracies of commissioners, courts, and bizarre configurations of "customary law" had been institutionalized, as had the legality of racial discrimination in terms of mobility, employment, land ownership, and education. By midcentury, the white settlers, who comprised never more than 5 percent of the population, had developed an

enormous smugness about their "civilization" in the heart of Africa, which would last forever. Godfrey Huggins, the longest-serving of any British colonial prime minister, ruled. Local and transnational capital gradually rose from the depths of the Great Depression and finally discovered the combinations of labor, soil, water, coal, and sunshine that would produce profitable agriculture. This new strength came along just in time to help support Britain and its faltering empire through the economic and psychological travails of World War II.

In the 1930s, a diverse population of African people was still testing the shape of Rhodes' vision. It gradually became clear that they were to be permanently stabled in dust-bowl rural reserves or in slums on the outskirts of the towns. They were only to be allowed out to do manual labor in white households, and for farmers, mine owners, and urban businessmen. Such paltry training as was required for these jobs would be provided by missionaries as part of their "civilizing mission." Further, African men could expect to be assessed with a wide variety of monetary and labor taxes. These funds would ideally pay for their administration by the "native department," a kind of state within the colonial state.

By the mid-1950s, the dignified strategy adopted by African political leaders of petitioning for improvements in this regimen had run its course, sometimes imperceptibly, but sometimes with demonstrated finality. Under pressure, indigenous masculinity and femininity twisted in complicated steps with each other and with the implacable, but, it turned out, not unassailable adversary of settler society. In the quarter century under discussion here, patterns were setting, consensus was being reached, lines were being drawn. Settler society was slowly shaken awake from a deep, self-satisfied slumber. Jacarandas bloomed and African children drowned in open sewers. The central contention of this book is that decades before the advent of formal political nationalism, African people were unhappy with this situation and were unwilling to passively let it unfold. Therefore, I have taken the quotation from our interview with an extremely accomplished woman, Mrs. Agnes Kanogoiwa[3]—"We women worked so hard—we were the first ones to fight, even if we didn't hold guns," as emblematic of a deep mobilization of, inter alia, the forces of gender ideologies and practices. These efforts were undertaken in order to situate African social reproduction on a firm and sustainable footing.

HISTORIES OF COLONIALISM AND NATIONALISM IN ZIMBABWE

Practitioners of the discipline of history are living through challenging times. In southern African studies, just as the social historians swept up to a high water mark of production in the mid-1980s, it seemed as if a

crew of neohippie deconstructionists appeared and inexpertly whisked the tablecloth off the table of knowledge. Everything went flying and the diners grabbed frantically at whatever they could catch: a bit of class analysis here, pieces of narrative there. Faith in the conferred right of the professional historian to tease truth out of the past, like the bones out of fish, went straight out the window. Now, faithless remnants of the feast can be reassembled in history departments and conferences, but these are leaner times. The new "nuts and berries" history is light and travels well. It can be used to investigate the surfaces of all manner of interesting things.

Nationalism is a concept that survives all manner of preparation. Sometimes it comes as a fully satisfying, manly dish; at other times it is as insubstantial as a puff of icing sugar.[4] Nationalism is the main organizing historical principle, of course, behind contemporary Zimbabwe, as well as the rest of late twentieth-century Africa. This principle holds that the national spirit has been rescued, reinvented, revived, or refigured by successful antimetropolitan struggle. In the early 1980s in Zimbabwe, the canon of nationalism was both triumphant and triumphalist: one movement (and one movement only) had gradually and successfully gathered up the threads of discontent with and agitation against white settler society and its myriad injustices and fashioned them into a tow rope to freedom. The task of the historian, then, was simply to explain the genesis and composition of each individual thread and show how it had been woven up with the others. In 1980 and the early years of the decade, Zimbabwe was indisputably at a moment of freedom. Ian Smith was forgotten, if not gone, and the boys had come back from the bush. The sons of the soil raised their flag while Bob Marley ecstatically sang his redemption song.

The totalizing vision of this narrative gave it power but was also its main weakness. If any particular thread were to be either subsumed in or discarded from the weave, the notion of a unidirectional road to liberation was incrementally discredited.[5] Thus, for example, radical factions within ZANLA, the liberation army of the Zimbabwe African National Union (ZANU), were snuffed out in the 1970s. Similarly, the news of the so-called dissidence and the vicious repression meted out by government forces in Matabeleland against these critics and against defenseless rural villagers was officially suppressed in the country in the 1980s. It was imperative that the two wings of the liberation movement, ZANU and the Zimbabwe African People's Union (ZAPU), engage in a unification exercise. If some needs had not been met, and if some real anticolonial agitation had not been rewarded by "independence," then the legitimacy of the entire nationalist concept was in danger of unraveling.

Independent Zimbabwe can boast of many successes and achievements: majority rule, important pieces of "reversal" legislation, the consolidation of

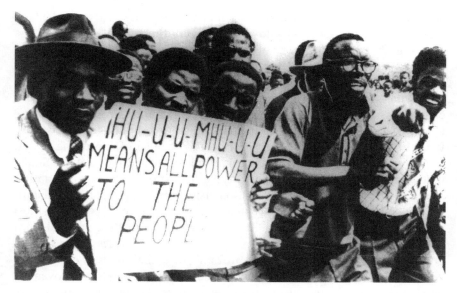

Photo I.1 The power of nationalism: ZAPU demonstration, 1976. Courtesy of
Associated Press.

an indigenous bourgeoisie, the transformation of educational curricula, and a
decade of expansion in much-needed social services. However, it also has
myriad failures. Women are not free. Workers are not free. The price of food
has (at least) quintupled. The land issue is far from being equitably settled.
Leaders settle into dynastic poses, reward each other for loyalty, and wriggle
down comfortably into the lap of globalization. These failures have already
led some, and may in the future lead others, to suggest a fundamental fraudu-
lence in the nationalist mission. But aside from the somewhat diversionary
issue of whether or not "things were better under Smith," there is more hold-
ing Zimbabwean society together than political nationalism. In its blazing
conceptual power, political nationalism has obscured other coherencies that
have more to do with basic constructions of culture than with the parapher-
nalia of electioneering.

Social reproduction is the term I have given to the aspects of cultural
construction that will be discussed in this book.[6] In this usage, social re-
production was a multilayered effort in the domains of gender and social
power. It had elements and initiatives in common with political national-
ism, but the two were not completely synonymous. Whereas nationalism
could consistently make choices for the sake of short-term political expe-

diency in advancing toward the goal of replacing one set of (at best) political principles and administrative structures or (at worst) personnel with others, social reproduction was a wider, deeper "campaign" (although with perhaps less deliberate coherency than this word suggests) waged by men and women of the postconquest generations to transmit something African into the future. It was a campaign that was simultaneously perfectly ordinary and spectacularly revolutionary: to enable African people to live together as families, to come and go freely, and to make choices according to their own priorities. In any particular political dispensation, therefore, social reproduction was secured to a greater or lesser extent.

Under settler colonial rule, the reproduction of African society was very insecurely maintained. It bears repeating that European settler society was, after all, content to wipe out the ability of African society to reproduce itself on any higher level than that of producing hewers of wood and drawers of water. African people found life on this level to be unacceptable. In the words of Miss Sophie Mazoe, a woman whom we interviewed in 1989, colonial society was quite happy to perpetually give African people "dogs' meat which they had bought for dogs." A settler was happy to "finish drinking his tea and then give the black man the left-over tea-leaves for him to pour water and drink as tea." Meals of dog food and weak tea are apt descriptions of African labor being exchanged for subsistence at levels that could not sustain social reproduction. In her interview, Miss Mazoe went on to sum up the colonial encounter.

> The *murungu* [white man] is the one who was bad. Because he could swear at his workers, "*Pfutseki, bob-jan* [get lost, baboon]. You African! Dirty! Shut up! You *kaffir!*" That was the problem. If you worked for a *murungu* you were a slave. They treated us like slaves—as if they captured us to come and work. . . . That was bad. If the *murungu* had not done that, we would never have fought.[7]

In what follows, I am not trying to reinvoke a simplistic populist narrative of "Africans versus Europeans" in which black and white men glare at each other across the color bar. That story has no analytical space for women or for gender. But narrative strategy is not abandoned here. Rather, the twenty-six-year period to be discussed was one in which gender was constructed in ways that helped African social reproduction gradually to draw the weights to the sustainable end of the scale. Here I differ somewhat from Nancy Hunt, who is of the opinion,

> colonialism can no longer be viewed as a process of imposition from a singular European metropole, but must be seen as "tangled layers of po-

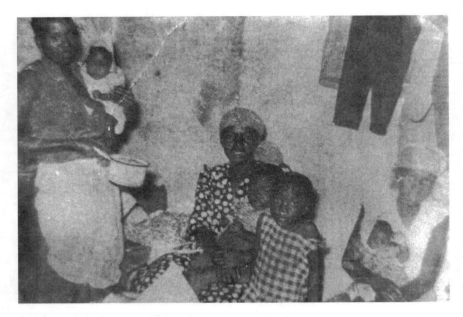

Photo I.2 Gender and social reproduction: interior of a room in Old Bricks, July 1959. Courtesy of *The African Parade.*

litical relations" and lines of conflicting projections and domestications that converged in specific local misunderstandings, struggles, and representations. . . . Social action in colonial and postcolonial Africa cannot be reduced to such polarities as metropole/colony or colonizer/colonized or to balanced narrative plots of imposition and response or hegemony and resistance. Such narratives, however refigured and nuanced in recent years, limit our appreciation of the enigmatic mutations and durations, facts and fictions, transgressions and secrecies that sustained research in fields and archives opens up.[8]

My research (which was as sustained as I could make it) has suggested that although a host of under-researched local misunderstandings and struggles certainly existed, a larger misunderstanding and struggle was also operative: "If you worked for a *murungu* you were a slave." Not all white settlers acted like racist overlords. But most did.[9] As much difficulty as historians have had with the concept of resistance, not all Africans resisted colonial rule.[10] In many ways, however, most did.[11] There was never a passive absorption of Western religious ideology,[12] nor of Western education.[13] Lilting along in deconstructionist mode, surely the creative examination of matters ever more

local can lead scholars to miss the forest for the trees. Historians may abandon complex narration out of postmodernist scruple, but if narration loses its critical edge, history becomes indistinguishable from soap opera.[14]

Beyond struggles against specific oppressions lie efforts to build or rebuild something. Such struggles and local representations were the means to an end or ends, not ends in themselves. Colonialism was a period of violent exploitation, destruction, and impoverishment, and it was also an era of reconsolidations of economic, political, and social identities and power. These latter processes add up to social reproduction; crucially, they were under way well before a political vision of a reclaimed Zimbabwean nation was articulated.

IMAGERIES OF TWENTIETH-CENTURY ZIMBABWE

There has been an explosion in the number of book-length histories of colonial Zimbabwe:[15] This is the harvest of the political economy of scholarship. International disapproval of the Rhodesian settlers' armed defense of white supremacy in the 1960s and 1970s stimulated both academic interest and political solidarity with the liberation movements and sent a generation of Zimbabwean scholars out into the world to earn doctoral degrees. Following the achievement of independence in 1980, these scholars returned home and in addition to pursuing their own work made hospitality a reality for waves of foreign researchers. Perhaps spurred by the fascination inherent in their subject matter, and certainly by the human and material treasuries of Central Africana at their home institutions, these students (and their mentors) have now in the late 1990s produced an impressive, varied body of work.

This means that today's students have a much wider variety of books to read. As graduate students at the University of Zimbabwe in the 1980s, my Zimbabwean colleagues and I had wonderful works on labor history to consult, but precious little else that could be considered progressive. Also, other than one encouraging section in Charles van Onselen's *Chibaro*,[16] there was literally nothing to read about African women in colonial Zimbabwe. I am thankful that this is no longer the case. The modern historiography of Zimbabwe, which decisively moved away from "settlers-only" apologia,[17] analyzed African workers and political figures, who, with two exceptions, were male.[18] These works have now been amplified with histories of African women as "peasants, traders and wives," and as independent urbanites confronting constant accusations of immorality in the early colonial years.[19] Most exciting have been the publication of studies that deal with the historical relations between African men and women—gender relations—encircled by the uneven authority of the colonial state.[20]

As a graduate student at the University of Zimbabwe in the 1980s, I
wanted to find out whether the archival record would support my hunch
that African women must have lived in Southern Rhodesia's towns prac-
tically from the earliest days of colonial urban settlement.[21] In fact I found
the files of the National Archives of Zimbabwe to be encouragingly stud-
ded, and occasionally deeply veined, with colonial representations of this
urban presence. All of the major Rhodesian government-sponsored com-
missions of inquiry into social and economic affairs, for example, included
African women to some extent in their terms of reference.[22] In two cases,
African women's economic and social roles were the primary objects of
investigation.[23] In the massive humdrum of colonial correspondence, the
situation of African women occasionally inspired volumes of contribu-
tions.[24] There were even fleeting references to manifestations of gender
and sexuality. For example, according to a notice of a 1908 urban segre-
gation campaign in Salisbury, the capital city,

> blacklisted were "a number of post office boys and native women on
> Dardagan's brickyard"; "several on Forbes' plot"; "strange boys" sleeping
> with brickyard workers; six women "in boys quarters at railway station";
> "two native women" at Ayshire station.[25]

Did the "fifty or sixty" children living on one of Salisbury's mission sta-
tions in that same year, I wondered, not have mothers? To whom were the 52
percent of African men who lived in the town's segregated "married quar-
ters" married?[26] Who were the "many native nurse girls" pushing prams
through Salisbury's avenues in April 1927?[27] Who laid an annual average of
fourteen charges of rape and rape-related assault in the Salisbury location
from 1928 to 1938?[28] Who served the tea at Salisbury's "tea parties," which,
according to a disapproving observer in 1949, had "almost exclusively a sexual
basis"?[29] Who joined the Harare Employed African Women's League in the
1950s, when there were estimated to be at least twenty thousand African
women living in Salisbury's townships?[30] Many, many other similar ques-
tions could easily be asked. After extensive research in the National Archives
it became clear to me that if Zimbabwean historiography had largely failed
to mention African women and issues of gender, it was partly because al-
though historians had pored over the documents, they had often simply dis-
counted pertinent information, perspectives, and debates about women.
Women were invisible because historians refused to see them, not because
they were not there. However, gender—the social construction of male/fe-
male dichotomies—was another issue. As Frederick Cooper has pointed out,
for colonial officials and in their correspondence, "The gendering of the
African worker was so profound it was barely discussed."[31]

[handwritten: to not focus on women is to miss the whole point.]

If gender and gender relations are used as a cornerstone of analysis of colonialism, it becomes clear that African women and the allocation of their labor were centerpieces of major struggles about social reproduction, which was in turn the very bone of contention between African and settler societies. Studies that did not consider African women's history also missed the history of gender relations and thus were largely unable to represent the anticolonial struggle in anything other than its political manifestations, and these, to some extent, inaccurately.[32] Perhaps the most important contribution to my thinking in this regard was made by one of Luise White's articles about colonial Kenya, which pointed out that unless the men who were MauMau combatants were considered not as generic people, but as *men* concerned with issues of masculinity (such as their abilities to be proper husbands and fathers), their motivations for engaging in political action could not hope to be properly understood.[33]

USING ORAL HISTORY

Writing gendered history was difficult, given the ideological limitations and material insufficiency of the archival correspondence and ephemera of colonial officials housed in the National Archives. Therefore, after completing an M.A. dissertation on urban African women's labor in the early decades of colonial rule,[34] I set out to extend the chronological period of study and to build on the archival foundation with oral history research. In 1988–1989, Ms. Everjoice Win and I interviewed fifty-eight elderly women and men in an oral history project in the townships of Harare. Armed with a list of questions and a tape recorder, we drove around Mbare, St. Mary's, Kambuzuma, and Highfield townships in an old green Peugeot looking for old people; once the ball got rolling we asked for referrals, which generally came quite readily. With a very few exceptions, we were received graciously and generously. Our interviews tended to last an hour, and each concluded with a photograph of the interviewee. We made return visits to distribute these photographs along with copies of a book intended for a local, popular audience, which was compiled from some of the interview material.[35]

The strength of our research approach was that of the largely unstructured interview; after basic biographical details, we tried to let our interviewees speak about their experiences of urban life as they wished. At the time I only wanted to "prove" that women had lived in Harare for a long time and had a substantial history there. In hindsight, one of the main weaknesses of this research was that although a range of women from a variety of backgrounds were interviewed, we may in some cases have been drawn too firmly into networks of old friends, whose religious and economic backgrounds and situ-

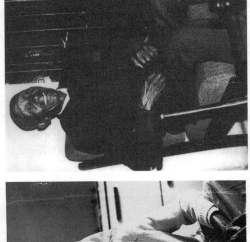

Photo I.3 Some of the people interviewed for this book in 1989: clockwise from top left, Joanna Scott-Mwelase, Elsie Magwenzi, Mativenga Beattie Ngarande, Bertha Charlie (left) and Maria Chagaresango. Photographs by author.

ations were quite similar. In addition, at the time we were unconcerned with qualitative issues of womanhood such as experiences of childbirth and child rearing, leading to glaring omissions that I now greatly regret.

Certainty having flown out the window with the great deconstructionist shake-up, however, one also has to acknowledge that the whole idea of "proving" something about the past with oral history is entirely problematic. Neither documents nor memories can constitute "proof." On the other hand, the work of historians, even when shorn of certainty, has always been to sculpt something with words—words that come from a variety of sources and whose accuracy one tries to ascertain. In this delicate process, nothing, as David Henige once pointed out, can enable the historian to reconstitute the past "as it really happened."[36] Oral history, however, is invaluable both as ideological corrective to official documentation and as indicators of how at any one point in time the people whose history (or histories) one is endeavoring to construct understand and articulate the intricacies of their own pasts. Primary documentary evidence is always invaluable in harvesting facts and distilled perspectives, of course, but "rememberings" unevenly bestow meanings on these facts and perspectives and on the physical, material world itself.

Historians have been writing about African women for a relatively short time, and their use of oral history is of even shorter duration.[37] A number of different approaches to the use of oral material have emerged. At one extreme are the published works that list a number of interviews in the footnotes or make reference in the introduction to the author's having undertaken an oral history project. In these works, the text is made up of the authors' interpretations of the interview material, and the actual words of the interviewees rarely if ever appear.[38] At the opposite end of the spectrum are works that follow the tradition of a work coedited by the British activist and academic Sheila Rowbotham in which interview material is presented practically verbatim.[39] The "historiography of oral discourse"[40] has come a long way since Rowbotham's work of the late 1970s; in African history its use has been justified, theorized, and championed by such authors as Vansina, Curtin, Miller, and Henige.[41]

Luisa Passerini's studies of the Italian working class during the fascist era have outlined a methodology that challenges old methods of scholarship and forces the reformulation of questions about social reality.[42] She suggests that self-images, identity, myths, and memories have a complex and contradictory relationship to social reality: it could be, she writes, that "all autobiographical memory is true; it is up to the interpreter to discover in which sense, where, for which purpose."[43] Similarly, Belinda Bozzoli and Mmantho Nkotsoe's study of elderly women in a South African homeland town foregrounds major themes of "life strategy" and personal consciousness, as the

women of Phokeng built up personal institutions and interacted with a range of social institutions. Bozzoli concludes,

> We are often told that the "great men and great events" theory of history is inadequate, but we are not often allowed to see what the alternatives are. Here the women give us their version of how things look from below, how history is constructed in their eyes. [44]

Such insights on the use of oral sources are making an impact on the historiography of colonial Zimbabwe.[45] Tsuneo Yoshikuni and Diana Jeater's interviews focus on the earliest periods of development of the towns of Salisbury and Gweru; Timothy Scarnecchia's study of urban space, gender, and politics in colonial Harare also relies heavily on oral interviews. [46] Writers tackling the liberation war in Zimbabwe have demonstrated the many advantages of using oral histories of "ordinary" participants in historic process.[47] Terence Ranger and Norma Kriger's works on peasant mobilization in the liberation war also draw on oral interviews.[48] These works can all be contrasted, however, with an exclusivist study of the struggle for independence for which interviews were conducted only with famous male political and military leaders.[49]

This study uses substantial excerpts from oral interviews. This reflects my understanding of Susan Geiger's point that crucial issues of authority, power, and knowledge must be confronted before the practice of a woman's interviewing a woman (and the uses to which the interviewee's words are put) can be categorized as feminist.[50] I have envisioned the literary result of an author's power and authority as the harvest of an irrigated field. The water that irrigates and makes any production possible is historical knowledge; it does not belong to the farmer and it comes from a source that she influences but does not control. I have kept in mind Bozzoli's cautionary view of an approach to the use of oral sources that glorifies "the voices of the oppressed" and in which "all interpretation is sacrificed."[51] It seems to me, however, that what she fears is less common than the reverse: that the voices and opinions of authors and editors combine in a mighty tidal wave of expertise and drown out everything else. It may be necessary to be wary of historiographical anecdotalism, romanticism, and populism in the use of oral sources;[52] but surely it is equally necessary to explore and experiment with these relatively new interfaces between theory, memory, and words.

One of my goals in writing this book is to demonstrate the salience of gendered history to an improved understanding of the urban past of Zimbabwe. I make this statement fully aware that some readers in North America may sigh sadly at its old-fashioned naiveté; gender is big academic business in the North and has been so roughly since the mid-1980s.

Feminist historians certainly fight many battles in the northern academy, but they generally do not need to justify their existence. Gender is fully embattled, however, in the southern academy. African historiography produced on the continent often resolutely fails even to give lip service to the scholarship of women and gender and the insights that these have produced.[53] I make this statement fully aware that some readers in southern Africa may sigh irritably at its feminist arrogance! For me, these antagonistic understandings about gender run parallel to the uncertainties caused by the deconstructionist shake-up. However, as Henrietta Moore and Megan Vaughan have elegantly mused, "There is no escape from the unease" produced by the necessity of considering information both as representation and as data.[54] Similarly, there is no escape from the face-off between historians who consider gender an irrelevant sideshow and those for whom it is a fundamental necessity. In trying to reconcile these four interrelated tensions long enough to write a book, I have chosen to produce a smoother narrative that relies heavily on excerpts of oral history transcripts, rather than a featureless book solely in my own "voice," bristling with multiplicities. This has been a strategic choice.

Despite many shortcomings, the set of 1989 interviews contributed enormously to my understanding of what I have called coherencies in colonial Zimbabwean history. The main themes of this book—conflicts and compromises in urban gender relations and the participating interference of the settler state—have been drawn from the articulated concerns and preoccupations of the women and men we interviewed. In all this I am guided by an aphorism of the great musician Salif Keita: "The truths of the past," mused the maestro, "are not necessarily the truths of the present."[55]

THE HISTORIOGRAPHY OF URBANIZATION AND AFRICAN WOMEN IN SOUTHERN RHODESIA

From the first expressions of academic scholarship focused on African women in the early 1970s,[56] there is now a burgeoning literature on women and gender in African societies, and in many historical periods.[57] An ambitious survey of the modern history of African women has recently been published.[58] These works generally heed Bozzoli's 1983 warning that rather than paint women onto the pages and into the conceptualizations of previously written history where the only available spaces are the margins, perspectives gained from studying gender relations can be used to review and rewrite "history" itself.[59] The development of a widely disparate, differentiated, and dedicated conglomeration of feminist scholars pursuing the "truths" of women's lives harkens forward to a time when what has been called "the

devastating conceptual error" of androcentric thought will have been sur-
passed by a "more fully human conception of social reality."[60]

In Zimbabwean historiography, studies that seek to overturn historical
androcentrism exist in a state of creative tension with the works of Giovanni
Arrighi, Ian Phimister, Terence Ranger, and Charles van Onselen,[61] to which
a student of class and society, industrialization, and the construction of capi-
talist relations in colonial Zimbabwe cannot fail to return. With some excep-
tions, the earlier works of these writers do not discuss African women in any
systematic way or gender relations at all; this is not completely true of later
works, although the center of historical gravity remains firmly with men.
This legacy can be creatively developed,[62] or it can be unreflectively trans-
mitted, as in a recent article.

> Labour costs [in urban areas] were subsidised by rural subsistence produc-
> tion, which bore all the costs of the reproduction of labour and the main-
> tenance of workers when they were unemployed. Housing conditions as-
> sociated with circular migration were also criticised, particularly for the
> tens of thousands housed in single-sex hostels. For the individual migrant
> the system generated a permanent climate of social, economic and politi-
> cal insecurity. Township raids, harassment, and racial discrimination all
> contributed to African urban residents (including permanently urbanised
> families) feeling that they were "living on sufferance."[63]

Of course, African urban residents experienced enormous amounts of ra-
cial discrimination. But the silences and omissions in this sort of account are
so vast that the entire conventional wisdom about labor migration in colonial
Zimbabwe is called into question. Who so bravely bore and paid the costs of
reproduction in the rural areas? Why did they agree to do so?[64] If there were
so few women in town, why the designation "single-sex" hostels? Was "the
individual migrant" invariably male? Again, if there were so few women in
town, how did so many "permanently urbanised families" come about? Ac-
knowledging the presence of urban women ("families," "single-sex") with-
out providing any details of their existence is common to many brief de-
scriptions of urbanization in colonial Zimbabwe.[65] Anthony O'Connor, for
example, although acknowledging that there were African women in colo-
nial Zimbabwe's towns, discusses them simply in negative terms: they mi-
grated less and had fewer employment opportunities; even those wives who
were urbanized by the 1970s commonly returned to the rural areas "for the
main farming season."[66] This amounts to a litany of reasons for ignoring urban
women. It is taken up by such writers as Susan Jacobs in a brief summary of
gender relations in Rhodesia before 1980: "Black men were forced or per-
suaded out of the reserved areas to engage in migrant labor in towns, mines

and commercial farms, leaving women, children, and elderly men behind to engage in subsistence agriculture."[67] My point here is not to belittle these studies, but to show that the language and concepts that they use foreclose the possibilities of considering and writing anything other than the experiences and histories of men—and as if these could be written without investigating women and the personal dimensions of men's lives that are bound up in gender relations.

The process of urbanization in colonial Zimbabwe was classically treated as a phenomenon that mainly concerned only the white population; tales of the growth of Rhodesia's "garden cities" routinely failed to mention either the servants' hovels at the back of suburban gardens or the squalid African townships of the far side of the railway tracks.[68] More recent scholarship has focused on the social aspects of urbanization and the African populations of Rhodesian cities,[69] and, in one case, the financial underpinnings of the growth of African townships.[70] Especially notable in this regard is Tsuneo Yoshikune's illuminating study of early "African Harare," which documents the continuities in community life in the municipal location and outer ring of suburbs that developed in the Salisbury area by the 1920s.[71] Also, coming from the best traditions of popular journalism and sidestepping many of the historiographical problems outlined previously, the perceptive contemporary accounts of urban life of Lawrence Vambe provide the all-too-rare views of an insider and participant in African urban life in the 1940s and 1950s.[72] Only one book-length study discusses the growth of Harare and its racial and gender groupings, putting most emphasis on the economic geography of the postcolonial period.[73]

African women were not completely left out of the historiography of urban Southern Rhodesia; earlier studies, however, largely did not examine the proposition that women's stories were secondary to those of men, and thus it was only as men's dependents that women occasionally entered history. A range of works demonstrates this approach. For example, Clive Kileff studied African suburbanites in Salisbury in the late 1960s. In his portrait of residents of two African suburbs, African women are discussed as appendages of men. That this to some extent reflected the cultural values of the people whom he interviewed is reflected in this passage:

> When I arrived at a home when both husband and wife were present, the wife would either excuse herself from the room or sit quietly. Both naturally assumed that I was only interested in talking to the husband. Only if I questioned the woman directly would she comment. Often when I asked the wife something, the husband would not let her finish; he moved to regain control of the conversation. Once when the wife continued to remain during the interview, the husband invited me to his private study.[74]

Boris Gussman's reflections on life in the townships of Bulawayo followed a similar pattern.[75] Richard Gray's important work breaks somewhat with this pattern, however, as he discusses the urban lives of African women in some detail.[76] This is also true in the works of A.K.H. Weinrich, especially in her studies of Mucheke township in colonial Fort Victoria and of African women and racial discrimination.[77] Kirkwood develops the idea of African women as wives and mothers by examining historical parallels with British women.[78] Similarly, Vassilatos briefly discusses another of women's relationships to men, prostitution, as does Tobaiwa in a brief review of contemporary prostitution in Harare.[79] The subservient position of women under the gender-discriminatory provisions of a manufactured and manipulated system of "customary" law is examined in the works of Cheater, Ncube, and Ranger.[80] The sociological surveys of African women in towns carried out by Olivia Muchena give background to the status of urban women in the 1970s; her approach is similar to that found in the journalistic accounts of Ruth Weiss.[81] Michael West surveys the documentary record for evidence of the cultural and political development of an African urban middle class and includes detailed sections on prostitution and women's organizations, urban families, marriage, homes, and houses.[82] Although each of these works is useful in addressing a historical marginalization of African women, as a whole they do not challenge the fundamental assumptions about the secondary importance of women in the urban areas.

Two writers have examined the economic roles and contributions of urbanized African women in colonial Zimbabwe from a materialist perspective. Focusing on Rhodesia's second city, Bulawayo, Lynette Jackson emphasized the importance of women's labor in urbanization and industrialization and asserted that this importance was not lost on either the administration of the colony or industrial capital.[83] Using Christine Obbo's phrase and insights about "uncontrollable women,"[84] Jackson documents the informal economic activities that put women at odds with male relatives and colonial administrators. Similarly, Tim Scarnecchia carefully delineates the dynamics of the building of urban communities in which African women played an important part, especially in the construction of cultural neighborhoods and prenationalist political movements.[85]

Frederick Cooper's conception of the existence and development of illegal space in urban colonial Africa, although an important source of inspiration for Jackson and Scarnecchia, has been less important for other recent works on African women in colonial Zimbabwe. Nancy Folbre's starting point, for example, is to assert that patriarchy was a significant force in precolonial and colonial Zimbabwe, and it continues to characterize independent Zimbabwe. Although Folbre's was one of the first works that broached the subject of the historical suppression of women in Zimbabwean culture, she is not

always able to make a convincing argument about the nature of the Rhodesian state or the character of the relationship between African men and the state. For example, she suggests that the main reason for the survival of the Native Reserves system was that it was a kind of gift from colonial administrators to rural patriarchs, because women's rural labor was "not insignificant padding against the burden of colonialism" for older men.[86] The reserve system, in her view, sheltered African men from wage labor "until at least the 1940s" and therefore "did not always work to the immediate benefit of white Rhodesians."[87] Although other writers (see later) have argued that several laws passed before the 1940s were designed to restrict women's mobility in order to gain the support of rural men and even to cement a kind of "unholy alliance" with them,[88] it seems inaccurate to interpret the segregationist and white supremacist logic of Rhodesian society and rural African class relations in this way.

Nonetheless, the existence of African patriarchy as a potent force in the Southern Rhodesian political economy cannot be denied. Its contours are carefully sketched in the works of Elizabeth Schmidt and Diana Jeater. Schmidt's work has focused on women in the Goromonzi district of what is now called Mashonaland Central, about thirty kilometers east of Harare. From this vantage point she has been able to examine women both as rural producers and, to a lesser extent, as urban migrants.[89] Probably the most important theme of her early work was the loss of women's social status and their economic marginalization in the early decades of colonial rule. Her subsequent work has emphasized the collaboration between rural patriarchs and the Southern Rhodesian state in devising "customs" and legislation that reasserted male control over women after an early official flirtation with female emancipation. Schmidt also discusses women's struggles in this process, and their various methods of resistance to restrictive measures imposed by an alliance between African patriarchs and the colonial state.

Charting the many paths taken by rural women—specifically those from Goromonzi district—is the greatest strength of Schmidt's work, and it undermines the popular myths that generations of rural women uniformly, silently, and passively shouldered the burdens of reproduction of a low-paid male labor force, that intrahousehold gender relations in the Reserves were serene and trouble-free, or that "traditions" and customary laws regulating gender relations were outside the purview of colonial self-interest or free of substantial colonial interference.[90] Linking the patterns of rural women's labor in precolonial and colonial times and outlining the early dynamics of women's urban employment as domestic servants are other valuable features of her work.[91]

Some sections of Schmidt's analysis are problematic, however. Despite the fact that she carefully discusses the rural male furor over mobile

women and the increasing commodification of bridewealth payments, she asserts that the social and economic status of women and their work was declining.[92] But why would rural men flock to meetings, write angry letters to Rhodesian authorities, and generally cause such commotion over an issue of declining importance? It would seem more accurate to say that by the 1930s rural patriarchs were angry precisely because in difficult and shifting economic sands, women's labor was absolutely crucial to the survival of men's socioeconomic status. It was of prime importance to reimpose control over women. Therefore, although women may have lost the ability to perform certain important and significant roles that were theirs in precolonial days,[93] their socioeconomic importance did not decline in the early twentieth century; to the contrary, although it was unevenly transformed in a new economic dispensation, it was a crucial factor in both rural and urban areas.

Diana Jeater's work has examined the ways in which African women of Southern Rhodesia came to be defined as inherently "immoral" by the state and to trace the ways in which this definition came to be accepted by society at large. Grounding her analysis in the central Gweru district, and concerned mainly with the period when the colony was under the capitalist rule of the British South Africa Company (1890–1923), she posits that the company's "occupiers," in addition to extracting economic surplus from the colony, believed it to be their duty to restructure African society to suit their own conceptions of civilization and morality. One of the biggest challenges that they faced was their interface with African domestic and sexual mores. They imposed a vision of sexuality as an individual matter, rather than as one involving entire lineages. The foremost elements in this vision were the assertion of the perversity of African male sexuality, and as time went on, the immorality of African female sexuality. In part as a result of the imposition of these concepts, African gender identities were redefined. As Jeater writes:

> Whereas there had been no distinct "realm of the moral" in the African communities of the late nineteenth century, the early twentieth century had seen the construction of a definite "moral discourse" in Southern Rhodesia which was influenced by, but not a simple rejection of, the concept of morality brought into the region by the white Occupation. . . . The conceptualisation of sexual behaviour as something that took place between individuals did not detract from the idea that its "moral" significance was determined by the extent to which lineage interests were damaged. As control over daughters became more significant than control over sons for the rural patriarchs, moral condemnation was seen to refer to women rather than to men.[94]

Jeater makes many original points, which go a long way toward explaining several of the confusing features of Rhodesian colonialism. The idea, for example, that by the mid-1920s, control over daughters had become more significant than control over sons not only contradicts Schmidt's idea about the waning status of rural women, it but also provides a reason for some of the frequently commented-on aspects of African life in the 1920s and 1930s such as constantly escalating demands for bridewealth payments in cash and, of course, the patriarchal demands for state assistance in recovering women who had absconded from rural homesteads.

Another interesting feature of Jeater's argument is that the administration of the British South Africa Company favored a policy of proletarianization in industrial areas—a policy that she treats as synonymous with the encouragement of the presence of women and families in towns and mines.[95] She even makes the somewhat startling claim (especially in the light of the settler administration's efforts a decade and half later) that company policy even countenanced encouraging single women to migrate to towns.[96] She claims, however, that these policies were annulled by the post-1923 settler government's overwhelming concern with segregation, and the supposed benefits that would accrue to white residents from the restriction of African economic competition and urban residence.

Jeater's sustained discussion of the issue of proletarianization in the first two decades of colonial rule is intriguing; some writers still discuss it as a future goal for postindependence Zimbabwe![97] Her point is supported by other historians, although generally not to the extent that she proposes. Van Onselen, for example, notes that segments of mining capital in the 1910s supported the idea of male miners' bringing wives and families to the mine compounds; Phimister concurs, but notes that the lessons of the reconstruction period in the mining industry had been that the labor of the migration of "single" men (i.e., men who reported for work without wives or dependents in tow) was the cheapest available.[98] Arrighi dates the necessary participation of African male workers in the cash economy from the early 1920s; Duncan Clarke points out that proletarianization should be understood as a process, rather than an event.[99] Yoshikune points out that settled urban families and labor stabilization, to whatever extent it was pursued as a policy, should not be confused with any new degrees of freedom to be enjoyed by urban Africans. By the end of the company's rule in 1923, Jeater writes,

> the "maturing" of the location system was apparent. African free dwellers had been expelled from the town centre; the tenant communities on the commonage had disappeared; African churches and schools had been shifted to the location area; the law unequivocally defined where the African workers were to sleep; the top-down machinery of control headed by a full-time

European superintendent was built; and the beer monopoly system added a revenue-generating dimension to location administration.[100]

Jeater concurs with other authors that the passage of the Natives Adultery Punishment Ordinance (NAPO) in 1916 marked a shift in the company administration's policy toward African women.[101] The NAPO provided for state criminal sanctions to be applied to a woman who was found to be committing adultery; its most significant aspect was that adultery of African women was defined as a criminal, rather than civil, offense. Whereas Schmidt analyzes the NAPO as a state attempt to bolster the authority of rural husbands at a time of increasing marital disintegration, Jeater discusses the legislation as "the outcome of a long campaign by rural patriarchs, in which the 'moral' issue of adultery became the center of complex political maneuvers and compromises between and within the white and Africa communities."[102] It set the tone for all later discourses on African women. Indeed, she argues that by the early 1930s, "a distinct moral discourse had been constructed in Southern Rhodesia."[103] The state conversed in segregatory tones with African men, whom it branded alternately as latently sexually perverse and yet responsible enough to be entrusted with the fates of African women; and occasionally with African women, who were simply written off officially as a bad lot. In their own communities, African men benefited from this discourse as in its applications to daily life they were allowed greater personal freedom; women, on the other hand, were made the subjects of permanently mounting decibels of condemnation, which, however, some of them found ways to deflect, and others simply ignored.

OVERVIEW OF THE BOOK

This book has at least three aspects that may annoy some readers. The first is that because of the limitations of the study that we undertook, other than the occasional use of the town to illustrate specific points, little is said about Bulawayo, Zimbabwe's second city. This lack of information should only be taken as the author's reticence to claim universality for her findings, rather than a lack of interest in Bulawayo. Despite the narrow nature of this study as indicated in its title, this book may be taken as a generic history of all urban areas in colonial Zimbabwe. Such a use would be unwarranted. It is becoming increasingly clear, for example, that the differences between north and south in Zimbabwe, colonial and postcolonial, demand to be taken very seriously. I suspect, however, that some of the conclusions drawn for Harare may apply in various degrees to the colony's other towns. There may also be some observations and conclusions that apply to some of the other colonial towns of the region. Karen Hansen's recent work on Lusaka, for example,

suggests many parallels.[104] Another problematic aspect is the fact that little is said here on the issue of inter-African ethnicity. Zimbabwe has three main ethnic groups: Shona, Ndebele, and Tonga. This book is primarily concerned with the first of these, but even this is hardly one homogeneous group. In addition, there were thousands of foreign migrant workers and work seekers in the colony in the period under review. Third, this book does not say much about the complex issues of race and its representations; it is mainly a history of indigenous African men and women. In fact when the terms *men* and *women* are used in this book, they refer, therefore, exclusively to African men and women. White men and women are, in an interesting inversion of most of the documentary record, almost invisible here and are most often referred to under the blanket term *settler*.

In relation to this book, I would defend this series of lacunae, not as necessary, but as admissible—because my aim is to resist the current historiographical style of focusing my sights on increasingly smaller targets. I have tried to write a history of a certain conceptual forest, not of particular trees, no matter how fascinating each might be. Gender is the road I have taken through that forest; other authors will take other roads. These unelaborated silences do indicate that more all-encompassing histories of gender relations and urbanization in colonial Zimbabwe remain to be written.

In relation to the many relevant debates and perspectives, this book, therefore, is a socioeconomic history of gender relations and the shifting balances of power between African society and the colonial state in one small urban area. Like Schmidt and Jeater, I focus on women and on gender as a way of explicating a deep internal weave in Zimbabwean society. This book synthesizes some of the recent work on urban Zimbabwean history and seeks to draw a three-dimensional portrait of African urban society. It grapples with questions such as, what are the mechanisms that have operated in Zimbabwean society to differentiate men from women, and women from each other, while also binding them together in distinct ways? What have been the wellsprings of this society's conceptual coherence?

Chapter 1, which is largely quantitative and descriptive, sets the stage of Salisbury and Harare in the 1930s. It sketches the political and economic structures with which African women interacted and, through their interaction, had a hand in shaping. Although official records were not kept well enough to allow for completely accurate perceptions of exactly how many African women lived in greater Salisbury at any given time, it is clear from what records do exist that there were substantial numbers of women to account for. African women are discussed as formal and informal sector workers, as the providers of food and in their capacities of victims of a miserably inadequate health care system. In these roles, women had to traverse a complicated set of central and local governmental structures. Interestingly, state

structures and personnel on these two levels were in many cases hostile not only to urban women but to each other. Antagonisms between municipal and central government, a manifest weakness of the colonial state as a whole, opened up loopholes that women wasted no time in using to their own advantage.

Chapter 2 takes a closer look at the nuts and bolts of the presence of African women in urban areas. Following on the economic angles already introduced, women's employment options and choices are discussed in more detail. This information shows that the processes, stresses, and fault lines of urban society did not simply work with or produce a uniform set of female bodies. An important result of studying urban women is the realization that they were differentiated from each other. This was somewhat disguised from an outside view by the fact that racial legislation forced all Africans to live together, "cheek by jowl," as it was sometimes put. But although cold economic reality was one thing, the imperatives of social reproduction were another. In looking at the topic of differentiation it becomes clear that socially, urban African society was far more comfortable reproducing itself hierarchically, not haphazardly. In analyzing this hierarchical reproduction, the chapter takes a step into the categories of class analysis, but because these categories do not translate very well for urban Africans under colonialism, the concept of being "well-known" is used analytically to separate women who were members of a small urban protobourgeoisie from those who belonged to a larger group of "proletarian" women.

The basis of differentiation between these groups was access to land, the urban expression of which was housing. This was true for men as well as women, but because women had a more subordinate status in the colonial political economy, it was even more pronounced in their case. The ideologies that situated a "proper" place for women were also important markers of the structures of class; domesticity and dependence were developed into the cornerstones of acceptable female behavior. The fact that there were different groups of women in town had important ramifications in the lives of the individuals concerned, of course, but it was also crucially important in the shape, concerns, and capacities of the African urban community itself.

Chapter 3 blends documentary and oral evidence in order to paint portraits of the varied and shifting responses that greeted African women's urban presence and work. The first set of responses discussed are those that issued from a changing African patriarchy. As with urban women, the point is made that it is important to disaggregate these patriarchs from each other, because African men also were not a uniform set of bodies. These groups of men and strategies of African society and the colonial state have a historiography, especially in Schmidt's work, which generally argues that there was

more collaboration than conflict between them. I take issue with this approach and argue that the imperatives of social reproduction led a changing African patriarchy into largely adversarial (whether defensive or offensive) approaches to the colonial state, but not fundamentally into accommodation or alliance. This is demonstrated by the vexed nature of the problem of "the control of women."

Chapters 4 and 5 deal with the themes that were suggested most directly by an analysis of the themes that emerged from oral history research. In order to achieve the goal of transmitting a culture that was both recognizably African and viable into the future, African men and women had to manufacture, negotiate, and maneuver through a fairly contortionist set of social conventions. Together, they constructed a system that, for example, allowed a man to cook and clean for a white employer but forbade him to do so in his own home; that allowed a woman to live comfortably in an urban area only if she ceaselessly demonstrated a dual willingness to behave as if she were in a rural area, and physically to return to a rural "home." I suggest that these difficult ideological developments and compromises were worked out in the streets and rooms of Harare township through a series of arrangements and confrontations—always under the heavy shadow of the state—between African men and women and, on a political level, between African urban society as a whole and the colonial state.

NOTES

[1] Interview with Mrs. Agnes Kanogoiwa, Waterfalls, 24 April 1989.

[2] G. N. Uzoigwe, *Britain and the Conquest of Africa: The Age of Salisbury* (Ann Arbor: University of Michigan Press, 1974).

[3] Mrs. Kanogoiwa's work as a radio broadcaster is discussed in Chapter 2.

[4] See, for examples, the varied contributions to Geoff Eley and Ronald Suny, eds., *Becoming National: A Reader* (New York: Oxford University Press, 1996).

[5] Brian Raftopoulos's discussion of the trade union movement's justifiable conflicts with the nationalist movement in the early 1960s is thus a significant break with the past. See his "The Labour Movement in Zimbabwe: 1945–65," in Raftopoulos and Ian Phimister, eds., *Keep On Knocking: A History of the Labour Movement in Zimbabwe, 1900–1997* (Harare: Baobab Books, 1997), p. 78–87; and Brian Raftopoulos, "Nationalism and Labour in Salisbury, 1953–1965," *Journal of Southern African Studies* vol. 21 no. 1 (1995).

[6] I have been very influenced by A. F. Robertson, *Beyond the Family: The Social Organization of Reproduction* (Cambridge: Polity Press, 1991). I use the term in Robertson's sense of the involvement of social institutions in the reproductive process, rather than in Jean Comaroff's sense of the public, political acts of men outside the domestic domain: *Body of Power, Spirit of Resistance: The Culture and History of a South African People* (Chicago: University of Chicago Press, 1985), chapter 3, passim.

[7] Interview with Mrs. Johanna Scott (Mwelase), Highfield, 31 May 1989.

[8] Nancy Rose Hunt, "Introduction" to special issue, "Gendered Colonialisms in African History," *Gender & History* vol. 8 no. 3 (1996), p. 326.

[9] Even at a conservative estimate, one third of the white Rhodesian population were diehard white supremacists, and in the 1970s three quarters were supporters of the Rhodesian Front. Peter Godwin and Ian Hancock, *"Rhodesians Never Die": The Impact of War and Political Change on White Rhodesia, c1970–1980* (Oxford: Oxford University Press, 1993), p. 46.

[10] Underlying much scholarship about political and social articulations with colonialism is an unstated allegiance to a division of African society into dichotomized Mayerian categories of "red"/ "school" or tribesmen/townsmen, or rural/urban, or traditional/modern. But the image of "red" Africans and "school" Africans blinds us also to the fact that perhaps all in their own way sought to conserve what was held to be most important. Red and school were about strategies and priorities, not diametrically opposed discourses of assimilation or isolation. Philip Mayer, *Townsmen or Tribesmen? Conservatism and the Process of Urbanization in a South African City* (Cape Town: Oxford University Press, 1971).

[11] It is also true that in colonial Zimbabwe, there were few genuine political collaborators with settler rule; I have only come across one case: a member of the Southern Rhodesia Native Association (SRNA) who spied on meetings of the Industrial and Commercial Workers' Union in the late 1920s. The role of African police constables and court interpreters, and so on, in this regard is, however, a promising area of research. See Walter Chipwaya, general secretary of the SRNA to Minister for Native Affairs, 28 June 1928. S 2584/73 vol. 1. In this book, all file references, unless otherwise noted, refer to the collection held at the National Archives of Zimbabwe.

[12] Jean and John Comaroff, *Of Revelation and Revolution: Christianity, Colonialism and Consciousness in South Africa* (Chicago: University of Chicago Press, 1991), esp. chapter 6; Norman Etherington, "Recent Trends in the Historiography of Christianity in Southern Africa," *Journal of Southern African Studies* vol. 22 no. 2 (1996); Paul Landau, *The Realm of the Word: Language, Gender and Christianity in a Southern African Kingdom* (Portsmouth: Heinemann, 1995).

[13] See Terence Ranger, *Are We Not Also Men? The Samkange Family and African Politics in Colonial Zimbabwe 1920–64* (Portsmouth: Heinemann, 1995); Sybille Küster, *Neither Cultural Imperialism Nor Precious Gift of Civilization: African Education in Colonial Zimbabwe, 1890–1962* (Hamburg: Lit, 1994).

[14] As this book is being written, for example, a "saga of Winnie Mandela" is being created in South Africa partly through the work of the Truth and Reconciliation Commission. This Hollywoodish saga, which the commission insists on calling "truth," has little to do with the examination and weighing of evidence from diverse sources and much more with the writing of a kind of supposedly popular script. Will Whoopi Goldberg play Winnie Mandela? Stay tuned!

[15] Ian Phimister, *An Economic and Social History of Zimbabwe: Capital Accumulation and Class Struggle, 1890–1948* (London: Longman, 1988); Colin Stoneman, ed., *Zimbabwe's Prospects: Issues of Race, Class, State and Capital in Southern Africa* (London: Macmillan, 1988); Christine Sylvester, *Zimbabwe: Terrain of Contradictory Development* (Boulder, Colorado: Westview, 1991); Ruth Weiss, *Zimbabwe and the New Elite* (London: British Academic Press, 1994); Carol Summers, *From Civilization to Segregation: Social Ideals and Social Control in Southern Rhodesia, 1890–1934* (Athens: Ohio

University Press, 1994); Timothy Burke, *Lifebuoy Men, Lux Women: Commodification, Consumption and Cleanliness in Modern Zimbabwe* (Durham, North Carolina: Duke University Press, 1996); Patrick Bond, *Uneven Zimbabwe: A Study of Finance, Development and Underdevelopment* (Trenton, New Jersey: Africa World Press, 1996).

[16] Charles van Onselen, *Chibaro: African Mine Labour in Southern Rhodesia, 1900–1933* (London: Pluto Press, 1976).

[17] L. H. Gann, *A History of Southern Rhodesia* (London: Chatto and Windus, 1964); L. H. Gann and Michael Gelfand, *Huggins of Rhodesia* (London: George Allen & Unwin, 1964).

[18] The two female exceptions were Mbuya Nehanda, medium of the Nehanda spirit, who inspired the first anticolonial war of 1896–1897, and Martha Ngano of the Bantu Women's League in the 1920s and 1930s. See Terence Ranger's classic studies, *Revolt in Southern Rhodesia, 1896–97* (London: Heinemann, 1967) and *The African Voice in Southern Rhodesia* (London: Heinemann, 1970).

[19] Elizabeth Schmidt, *Peasants, Traders, and Wives: Shona Women in the History of Zimbabwe, 1870–1939* (Portsmouth: Heinemann, 1992); Diana Jeater, *Marriage, Perversion and Power: The Construction of Moral Discourse in Southern Rhodesia, 1894–1930* (Oxford: Clarendon Press, 1993).

[20]Elinor Batezat and Margaret Mwalo, *Women in Zimbabwe* (Harare: Sapes Books, 1989); Jean Davison, *Gender, Lineage and Ethnicity in Southern Africa* (Boulder, Colorado: Westview Press, 1997); Christine Sylvester, "'Women' in Rural Producer Groups and the Diverse Politics of Truth in Zimbabwe," in Marianne H. Marchand and Jane Parpart, eds., *Feminism/Postmodernism/Development* (London: Routledge, 1995); Timothy Scarnecchia, *The Politics of Gender and Class in the Creation of African Communities, Salisbury, Rhodesia, 1937–1957* (Ph.D. dissertation, University of Michigan, 1993); idem, "Poor Women and Nationalist Politics: Alliances and Fissures in the Formation of a Nationalist Political Movement in Salisbury, Rhodesia, 1950–6," *Journal of African History* vol. 37 (1996); Nancy Folbre, "Patriarchal Social Formations in Zimbabwe," in Sharon Stichter and Jane Parpart, eds., *Patriarchy and Class* (Boulder, Colorado: Westview Press, 1988).

[21] This point has recently been strongly asserted for all African cities in the introduction to Kathleen Sheldon, ed., *Courtyards, Markets, City Streets: Urban Women in Africa* (Boulder, Colorado: Westview Press, 1996), p. 3–9.

[22] An exception was the 1925 Land Commission, although it took evidence from African women. The 1911 Native Affairs Commission, the 1930 Commission of Enquiry into Native Affairs, the 1943 Ibbotson report, the 1944 Howman Commission, the 1946 Natives Production and Trade Commission, and the Plewman Commission of 1959 all reported the results of their findings on a few questions related to African women.

[23] *Report of the Committee into Native Female Domestic Service, 1932*; and *Report of the National Native Labour Board on Its Investigation of the Conditions of Employment of Native Women in Certain Industries. . . 1953.*

[24] Examples include the correspondence on the passage of the Natives Adultery Punishment Ordinance of 1916 (N 3/17/2); the Natives Marriages Act of 1901 and subsequent revisions (N 3/17/4/1-2 and S 138/47, among others); 1924 Native Department correspondence on "the emancipation of native women" (S 138/150); conferences of Native Department officials in 1927, 1931, and 1933 (S 235/493, S 235/376, S 235/486, and S 1564); the "social and moral development" of the African

population at the time of the passage of the 1936 Natives Registration Act (S 1542/A1/20 vols. 1 and 2); and intermittent discussions of the need to control venereal disease (for example, S 1173/220) and of the construction of hostels for urban women in the 1940s and 1950s.

[25] Quoted in Tsuneo Yoshikuni, *Black Migrants in a White City: A History of African Harare, 1890–1925* (Ph.D. thesis, University of Zimbabwe, 1990), p. 57. The mention of "strange boys" is especially intriguing, given independent Zimbabwe's uneasy relationship with the issues of same-sex sexual relations. See Marc Epprecht, "'Good God Almighty, What's This!': Homosexual 'Crime' in Early Colonial Zimbabwe," paper presented to the African Studies Association annual meeting, 1996; and Deborah P. Amory, "'Homosexuality in Africa: Issues and Debates," *Issue: A Journal of Opinion* vol. 25 no. 1 (1997).

[26] Yoshikuni, *Black Migrants*, p. 79, 97.

[27] Minister of Agriculture and Lands to Premier, Southern Rhodesia, 25 April 1927, S 482/117/40.

[28] Teresa Barnes, *African Female Labour and the Urban Economy of Colonial Zimbabwe, with Special Reference to Harare, 1920–39* (Master's thesis, University of Zimbabwe), 1987, p. 42.

[29] R. R. Willcox, *Report on a Venereal Diseases Survey of the African in Southern Rhodesia* (Salisbury: Government printer, 1949), p. 41.

[30] Phimister, *Social and Economic History*, p. 259.

[31] Frederick Cooper, *Decolonization and African Society: The Labor Question in French and British Africa* (Cambridge: Cambridge University Press, 1996), p. 266.

[32] See Teresa Barnes, "'So That a Labourer Could Live with His Family': Overlooked Factors in Social and Economic Strife in Urban Colonial Zimbabwe, 1945–1952," *Journal of Southern African Studies* vol. 21 no. 1 (1995); idem., "'Am I a Man?' Men, Women and the Pass Laws in Colonial Zimbabwe," *African Studies Review* vol. 40 no. 1 (1997).

[33] Luise White, "Separating the Men from the Boys: Constructions of Gender, Sexuality, and Terrorism in Central Kenya, 1939–1959," *International Journal of African Historical Studies* vol. 23 no. 1 (1990).

[34] Barnes, *African Female Labour.*

[35] Terri Barnes and Everjoice Win, *To Live a Better Life: An Oral History of Women in Harare, 1930–1970* (Harare: Baobab Books, 1992).

[36] David Henige, "African History and the Rule of Evidence: Is Declaring Victory Enough?" in Bogumil Jewsiewicki and David Newbury, eds., *African Historiographies: What History for Which Africa?* (Beverly Hills: Sage, 1986), p. 96–97.

[37] Nancy Rose Hunt, "Placing African Women's History and Locating Gender," *Social History* vol. 14 no. 3 (1989) p. 360–379, esp. 370.

[38] An example in South African studies is *Vukani Makosikazi* (Johannesburg: Ravan Press, 1984).

[39] Jean McCrindle and Sheila Rowbotham, eds., *Dutiful Daughters: Women Talk about Their Lives* (Harmondsworth: Penguin, 1979).

[40] This phrase is borrowed from Jewsiewicki and Newbury, *African Historiographies.*

[41] Jan Vansina, *Oral Tradition as History* (London: James Currey, 1985); Peter Curtin, "Field Techniques for Collecting and Processing Oral Data," *Journal of African History* vol. 9 no. 3 (1968); Joseph Miller, "Introduction: Listening for the African Past," in Joseph Miller, ed., *The African Past Speaks: Essays on Oral Tradition and History*

(Folkestone: Dawson, 1980); David Henige, *Oral Historiography* (London: Longman, 1982). It may be noted that Miller draws a distinction between oral traditions and what I have termed *oral history*, labeling the latter as "personal reminiscences," as opposed to the recitations of traditions. See Miller, "Listening," p. 9–10.

[42] Luisa Passerini, "Italian Working Class Culture Between the Wars: Consensus to Fascism and Work Ideology," *International Journal of Oral History* vol. 1 no. 1 (1980); idem, *Fascism in Popular Memory: The Cultural Experience of the Turin Working Class* (Cambridge: Cambridge University Press, 1987).

[43] Luisa Passerini, "Women's Personal Narratives: Myths, Experiences and Emotions," in The Personal Narratives Group, ed., *Interpreting Women's Lives: Feminist Theory and Personal Narratives* (Bloomington: Indiana University Press, 1989), p. 197.

[44] Belinda Bozzoli with Mmantho Nkotsoe, *Women of Phokeng: Consciousness, Life Strategy and Migrancy in South Africa, 1900–1983* (Portsmouth: Heinemann, 1991), p. 242.

[45] See Ian Phimister, *Wangi Kolia: Coal, Capital and Labour in Colonial Zimbabwe: 1894–1954* (Harare and Johannesburg: Baobab Books and Witwatersrand University Press, 1994), p. 92–142; Terri Barnes and Everjoice Win, *To Live a Better Life: An Oral History of Women in Harare, 1930–70* (Harare: Baobab Books, 1992), passim.

[46] Yoshikuni, "Black Migrants," and Jeater, "Marriage, Perversion and Power"; Scarnecchia, *Politics of Gender and Class*, and "Poor Women and Nationalist Politics."

[47] Julie Frederickse, *None But Ourselves: Masses vs. Media in the Struggle for Zimbabwe* (Harare: Zimbabwe Publishing House, 1981); Irene Staunton, ed., *Mothers of the Revolution* (Harare: Baobab Books, 1990).

[48] Terence Ranger, *Peasant Consciousness and Guerrilla War in Zimbabwe* (Harare: Zimbabwe Publishing House, 1985); Norma Kriger, "The Zimbabwean War of Liberation: Struggles Within the Struggle," *Journal of Southern African Studies* vol. 14 no. 2 (1988), and *Zimbabwe's Guerrilla War: Peasant Voices* (Cambridge: Cambridge University Press, 1992). See also Teresa Barnes, "The Heroes' Struggle: Life after the Liberation War for Four Ex-Combatants in Zimbabwe," in Ngwabi Bhebe and Terence Ranger, eds., *Soldiers in Zimbabwe's Liberation War* (London: James Currey, 1995).

[49] David Martin and Phyllis Johnson, *The Struggle for Zimbabwe: The Chimurenga War* (Harare: Zimbabwe Publishing House, 1981).

[50] Susan Geiger, "What's So Feminist About Women's Oral History?" *Journal of Women's History* vol. 2 no. 1 (1990).

[51] Bozzoli, *Women of Phokeng*, p. 245.

[52] Ibid., p. 274 n3.

[53] See, for example, the papers on African historiography presented at the conference "Problematising History and Agency: From Nationalism to Subalternity," held at the University of Cape Town under the auspices of the Center for African Studies, 22–24 October 1997, and Paul Tiyambe Zeleza, "Gender Biases in African Historiography," in his *Manufacturing African Studies and Crises* (Dakar: Codesria, 1997).

[54] Henrietta Moore and Megan Vaughan, *Cutting Down Trees: Gender, Nutrition and Agricultural Change in the Northern Province of Zambia, 1890–1990* (Portsmouth, New Hampshire: Heinemann, 1994), p. xxiv.

[55] Monsieur Keita was interviewed in a television documentary about his life and music that I am unfortunately unable to reference properly. However, a similar proverb,

identified as Akan, says, "The ancient resting place is not necessarily the resting place of today." Mercy Amba Oduyoye, *Daughters of Anowa: African Women and Patriarchy* (Maryknoll: Orbis Books, 1995), p. 73.

[56] See, for example, contributors to the first special issue of an academic journal devoted to studies of African women, *Canadian Journal of African Studies* vol. 6, no. 2, 1972; Kenneth Little, *African Women in Towns: An Aspect of Africa's Social Revolution* (New York: Cambridge University Press, 1973).

[57] This literature is now too vast to reference meaningfully in a note. Recent important publications include Luise White, *The Comforts of Home: Prostitution in Colonial Nairobi* (Chicago: University of Chicago Press, 1991); Iris Berger, *Threads of Solidarity: Women in South African Industry, 1900–1980* (Bloomington: Indiana University Press, 1992); Sheldon, *Courtyards, Markets, City Streets,* esp. "Introduction," p. 3–27; Karen Tranberg Hansen, *Keeping House in Lusaka* (New York: Columbia University Press, 1997); Unni Wikan, *Tomorrow, God Willing: Self-made Destinies in Cairo* (Chicago: University of Chicago, 1996); Bozzoli, with Nkotsoe, *Women of Phokeng;* Dorothy Hodgson and Sheryl McCurdy, "Wayward Wives, Misfit Mothers and Disobedient Daughters: 'Wicked' Women and the Reconfiguration of Gender in Africa," *Canadian Journal of African Studies* vol. 30 no. 1 (1996); Nancy Rose Hunt, ed., special issue of *Gender and History* (1996).

[58] Catherine Coquery-Vidrovitch, *African Women: A Modern History* (Boulder, Colorado: Westview, 1997).

[59] Belinda Bozzoli, "Feminism, Marxism and Southern African Studies," *Journal of Southern African Studies* vol. 9 no. 3 (1983), esp. p. 140–141.

[60] This is a phrase of Elizabeth Minnich, quoted in "Origins," Personal Narratives Group, "Interpreting Women's Lives," p. 3.

[61] Giovanni Arrighi, "Labor Supplies in Historical Perspective," and "The Political Economy of Rhodesia," in Giovanni Arrighi and John Saul, *Essays on the Political Economy of Africa* (New York: Monthly Review Press, 1973); Ian Phimister and Charles van Onselen, *Studies in the History of African Mine Labour in Colonial Zimbabwe* (Gwelo: Mambo Press, 1978); van Onselen, *Chibaro*; Phimister, *Class Struggle*; idem, *Wangi Kolia*; Terence Ranger, *Revolt in Southern Rhodesia,* idem, *Peasant Consciousness,* idem, *Are We Not Also Men?*

[62] Scarnecchia, *Politics of Gender and Class.*

[63] Deborah Potts and Chris Mutambirwa, "Rural-Urban Linkages in Contemporary Harare: Why Migrants Need Their Land," *Journal of Southern African Studies* vol. 16 no. 4 (1990), p. 678.

[64] Token sentences about women performing subsidizing labor in the rural areas are, however, fairly common. The following unelaborated sentence is practically the only mention of African women in an entire volume dedicated to Zimbabwe's political economy: "This use of unpaid, largely female labor [in the reserves] was to become, as in the case of other third world countries, a permanent feature of the process of capital accumulation," Lee Cokorinos, "The Political Economy of State and Party Formation in Zimbabwe," in Michael Schatzberg, ed., *The Political Economy of Zimbabwe* (New York: Praeger, 1984), p. 18.

[65] See, for example, the contributors to Andrea Rother, ed., *Preliminary Discussions of Problems of Urbanization in Southern Africa* (East Lansing: Center for Urban Affairs, Michigan State University, 1989).

[66] Anthony O'Connor, *The African City* (London: Hutchinson, 1983), p. 86–88. His point about wives' migrating is an important one, however, that will be discussed in Chapter 4.

[67] Susan Jacobs, " Zimbabwe: State, Class and Gendered Models of Resettlement," in Jane Parpart and Katherine Staudt, eds., *Women and the State in Africa* (Boulder, Colorado: Lynne Rienner, 1989).

[68] See *Salisbury: A City Comes of Age* (Salisbury: Rhodesia Graphic, 1956); G. Tanser, *A Sequence of Time: The Story of Salisbury, Rhodesia, 1900–1914* (Salisbury: Pioneer Head, 1974), and *A Scantling of Time* (Salisbury: Pioneer Head, 1975); George Kay, *Rhodesia: A Human Geography* (New York: Africana Publishing Corporation, 1970); George Kay and Michael Smout, *Salisbury: A Geographical Survey of the Capital of Rhodesia* (Kent: Hodder & Stoughton, 1977).

[69] Eric Gargett, *The Administration of Transition: African Urban Settlement in Rhodesia* (Gweru: Mambo Press, 1977); Osmond Wesley Stuart, *"Good Boys," Footballers and Strikers: African Social Change in Bulawayo, 1933–1953* (Ph.D. dissertation, University of London, 1989); David van Wyk, *The Political Economy of Urbanization in Colonial Zimbabwe, with Special Reference to Chitungwiza* (B.A. honors dissertation, University of Zimbabwe, 1987); Stephen Thornton, "Municipal Employment in Bulawayo, 1895–1935: An Assessment of Differing Forms of Proletarianisation," in *Southern African Research in Progress,* vol. 4 (Centre for Southern African Studies, University of York, 1979); idem, "The Struggle for Profit and Participation by an Emerging African Petty-Bourgeoisie in Bulawayo, 1893–1933," *Societies of Southern Africa,* vol. 9 (University of London, 1980); Paul Mosley, "The Development of Food Supplies to Salisbury (Harare)," in Jane Guyer, ed., *Feeding African Cities* (Bloomington: Indiana University Press, 1989). Politically conservative perspectives are manifested in works such as D. Hywell Davies, "Harare, Zimbabwe: Origins, Development and Post-Colonial Change," *African Urban Quarterly* vol. 1 no. 2 (1986); David Drakakis-Smith, "Urban and Regional Development in Zimbabwe," in Dean Forbes and Nigel Thrift, eds., *The Socialist Third World: Urban Development and Territorial Planning* (Oxford: Basil Blackwell, 1987); Neil Dewar, "Salisbury to Harare: Citizen Participation in Public Decision-Making Under Changing Ideological Circumstances in Zimbabwe," *African Urban Quarterly* vol. 2 no. 1 (1987).

[70] Patrick Bond, "Economic Origins of Black Townships in Zimbabwe: Contradictions of Industrial and Financial Capital in the 1950s and 1960s," *Economic Geography* vol. 69 no. 1 (1993).

[71] Yoshikune, *Black Migrants.*

[72] Lawrence Vambe, *An Ill-Fated People: Zimbabwe before and after Rhodes* (London: Heinemann, 1972), and *From Rhodesia to Zimbabwe* (London: Heinemann, 1976).

[73] Carole Rakodi, *Harare: Inheriting a Settler-Colonial City: Change or Continuity?* (Chichester: John Wiley & Sons, 1995).

[74] Clive Kileff, "Black Suburbanites: An African Elite in Salisbury, Rhodesia," in Clive Kileff and William Pendleton, eds., *Urban Man in Southern Africa* (Gwelo: Mambo Press, 1975), p. 95–96.

[75] Boris Gussman, *Out in the Midday Sun* (London: George Allen & Unwin, 1962).

[76] Richard Gray, *The Two Nations: Aspects of Race Relations in the Rhodesias and Nyasaland* (London: Oxford University Press, 1960).

[77] A.K.H. Weinrich, *African Marriage in Rhodesia and the Impact of Christianity* (Gwelo: Mambo Press, 1982; A.K.H. Weinrich, *Mucheke: Race, Status and Politics in a Rhodesian Community* (Paris: UNESCO, 1976), and *Women and Racial Discrimination in Rhodesia* (Paris: UNESCO, 1979).

[78] Deborah Kirkwood, "The Suitable Wife: Preparation for Marriage in London and Rhodesia/Zimbabwe," and "Settler Wives in Southern Rhodesia: A Case Study," in Hilary Callan and Shirley Ardener, eds., *The Incorporated Wife* (London: Croom Helm, 1984).

[79] E. Vassilatos, *Race and Class: The Development of White Images of Blacks in Southern Rhodesia, 1890–1939* (Ph.D. dissertation, University of Rhodesia, 1974), p. 239–243; Donald Tobaiwa, *The Impact of Urbanisation on Rhodesian African Prostitution* (B.S. honors dissertation, University of Zimbabwe, 1977).

[80] Angela Cheater, "The Role and Position of Women in Pre-Colonial and Colonial Zimbabwe," *Zambezia* vol. 13 no. 2 (1986); Welshman Ncube, "Released from Legal Minority: The Legal Age of Majority Act in Zimbabwe," in Alice Armstrong, ed., *Women and Law in Southern Africa* (Harare: Zimbabwe Publishing House, 1987); Terence Ranger, "The Invention of Tradition in Zimbabwe," in T. O. Ranger and Eric Hobsbawm, eds., *The Invention of Tradition* (Cambridge: Cambridge University Press, 1983). See also Emmet Mittlebeeler, *African Custom and Western Law: The Development of a Rhodesian Criminal Law for Africans* (New York: Africana, 1976).

[81] Olivia Muchena, *Women in Town: A Socio-Economic Survey of African Women in Highfield Township, Salisbury* (Harare: Centre for Applied Social Studies, University of Zimbabwe, 1980); idem, *Women's Organisations in Zimbabwe: Assessment of Their Needs, Achievement and Potential* (Harare: Centre for Applied Social Studies, University of Zimbabwe, 1980); Ruth Weiss, *The Women of Zimbabwe* (Harare: Nehanda Publishers, 1986).

[82] Michael West, *African Middle-Class Formation in Colonial Zimbabwe, 1890–1965* (Ph.D. dissertation, Harvard University, 1990).

[83] Lynette Jackson, *"Uncontrollable Women" in a Colonial African Town: Bulawayo Location, 1893–1953* (M.A. thesis, Columbia University, 1987).

[84] Christine Obbo, *African Women: Their Struggle for Economic Independence* (London, 1980).

[85] Scarnecchia, "Politics of Gender and Class"; idem, "Poor Women and Nationalist Politics."

[86] Folbre, "Patriarchal Social Formations," p. 70.

[87] Ibid., p. 67.

[88] Elizabeth Schmidt, "Negotiated Spaces and Contested Terrain: Men, Women and the Law in Colonial Zimbabwe, 1890–1939," *Journal of Southern African Studies* vol. 16 no. 4 (1990); Teresa Barnes, "The Fight to Control African Women's Mobility in Colonial Zimbabwe, 1900–1939," *Signs: Journal of Women in Culture and Society* vol. 17 no. 2 (1992).

[89] Elizabeth Schmidt, *Ideology, Economics and the Role of Shona Women in Southern Rhodesia, 1850–1939* (Ph.D. dissertation, University of Wisconsin-Madison, 1987); idem, "Farmers, Hunters and Gold-Washers: A Reevaluation of Women's Roles in Precolonial and Colonial Zimbabwe," *African Economic History* no. 17 (1988); idem, "Negotiated Spaces and Contested Terrain"; idem, "Patriarchy, Capitalism and the Colonial State in Colonial Zimbabwe," *Signs: Journal of Women in Culture and Society* vol. 16, no. 4 (1991); idem, *Peasants, Traders and Wives*.

[90] All these assertions can be found, for example, in Ngwabi Bhebe, *Benjamin Burombo: African Politics in Colonial Zimbabwe, 1945–1958* (Harare: College Press, 1989).

[91] Elizabeth Schmidt, "Race, Sex and Domestic Labor: The Question of African Female Servants in Southern Rhodesia, 1900–1939," in Karen Tranberg Hansen, ed., *African Encounters with Domesticity* (New Brunswick, New Jersey: Rutgers University Press, 1992).

[92] Schmidt, *Peasants, Traders and Wives,* p. 86–92.

[93] Reading her work on this topic, one gets the feeling that Schmidt is referring to a loss of dignity, or approval, or stature that women had in precolonial times. "Patriarchy," p.734; *Peasants, Traders and Wives,* p. 86, 97.

[94] Jeater, *Marriage, Perversion and Power,* p. 227–228.

[95] Ibid., p. 51, 167–168, 206.

[96] Ibid., p. 171.

[97] The policy of stabilizing male labor by accommodating whole families on the mines is generally held to have been an innovation in colonial Zaire of the Union Miniere du Haut Katanga, and of the Broken Hill mines in colonial Zambia before the opening of the Copperbelt mines in 1926. See Jane Parpart, "Class and Gender on the Copperbelt," in Claire Robertson and Iris Berger, eds., *Women and Class in Africa* (New York: Holmes & Meier, 1986), p. 142: "Workers and peasants cannot yet be regarded as distinct classes. How these different social forces coalesce and pursue their interests, and in turn grapple or side with each other, remains to be worked out." Colin Stoneman and Lionel Cliffe, *Zimbabwe: Politics, Economics and Society* (London: Pinter Publishers, 1989), p. 194. This division of Zimbabwean society into not-quite-yet-proletarians and somehow-still-peasants is one of the trends in southern African historiography challenged in James Ferguson, "Mobile Workers, Modernist Narratives: A Critique of the Historiography of Transition on the Zambian Copperbelt [Parts One and Two]," *Journal of Southern African Studies* vol. 16 nos. 3 & 4 (1990), esp. p. 620.

[98] Van Onselen, *Chibaro,* p. 76–77; Phimister, *Economic and Social History,* p. 67.

[99] Arrighi, "Labor Supplies in Historical Perspective"; Duncan Clarke, "Discrimination and Underdevelopment," p. 50–52.

[100] Yoshikune, *Black Migrants,* p. 107.

[101] Schmidt, "Patriarchy," p. 739–741; idem, "Negotiated Spaces," p. 623–634; Barnes, "African Women's Mobility;" Mittlebeeler, *African Custom.*

[102] Schmidt, "Patriarchy," p. 743; Jeater, *Marriage, Perversion and Power,* p. 263.

[103] Jeater, *Marriage, Perversion and Power,* p. 265.

[104] Hansen, *Keeping House in Lusaka,* esp. chapter 1.

1

ECONOMICS AND SOCIETY
IN COLONIAL HARARE

> When I was still very young I came here to Harare with my
> mother. . . . She was coming to work. What else did people come to
> do in town? She came to work. My father had died.[1]

Southern Rhodesia had an urban past long before 1890. In previous centuries
the southeast had boasted one of Africa's most impressive urban centers,
whose stone walls had encircled a town with a population later estimated to
have been in the tens of thousands.[2] With a typically late Victorian combina-
tion of a mania for categorization and racism, white explorers and settlers
arriving some four centuries later decided that such an "advanced" place could
not possibly have been built and populated by the ancestors of "their Afri-
cans"—it must have been a far-flung offshoot of a "white" civilization such
as that of the Phoenicians. This far-fetched explanation was rejected, and the
walls and the ruins they sheltered were later logically reclaimed as indig-
enous productions and were to give the African nationalist movement a fo-
cus, a rallying cry, and a name: Zimbabwe.

But as the abandonment of Great Zimbabwe and of other ruined walled
structures dotted over the landscape mutely testified, and as the Victorian era
explorers and settlers were also gradually to discover, the land between the
Zambezi and the Limpopo did not easily support urban conglomerations. Gold
was relatively abundant, but it was scattered, the seams were difficult to
extract, and the best sites had been well worked for centuries. When the co-
lonial capitalist eye turned to large-scale commercial agriculture the difficul-
ties in turning a profit also proved enormous. Inexperienced and often inept
settler farmers hampered by heavy debt, a lack of scientific and technical
support, a supremacist attitude toward African workers, and the government's
inexperience in domestic and international crop marketing led by the early
1930s to successive near-catastrophic failures of cotton, tobacco, cattle, maize,

and dairy production.[3] Thus, the volume of trade that would support flourishing towns was largely not forthcoming in the first fifty years of settlement, and Bulawayo, Salisbury, Umtali, Gwelo, and Fort Victoria remained fairly forlorn outposts of administrative function until secondary industrialization started to take off in the 1940s. In that era, Salisbury was also something of a frontier town, as described so memorably by a character in one of Doris Lessing's early novels:

> Half a mile away, at the end of the street, a glint of waving burnished grass showed the vlei. The urban scene, solid and compact in the main streets, tended to dissolve the moment one moved into the side streets. The small colonial town was at a crossroads in its growth: half a modern city, half a pioneers' achievement; a large block of flats might stand next to a shanty of wood and corrugated iron, and most streets petered out suddenly in a waste of scrub and grass.[4]

Salisbury had been chosen by Rhodes as the colony's capital. Renamed Harare in 1982, it is fairly young, as major cities go: September 1990 marked its one-hundredth anniversary. Despite this youth, it partook of the traditions and style of a long line of British colonial cities.[5] Salisbury functioned as a spearhead of economic, political, and cultural penetration, facilitating the structural reorganization of indigenous society and serving as a focal point for whatever international capital found its way to the colony.[6] It was from the very beginning distinctly divided: into the Kopje area of earliest commercial development; the Causeway area, where commerce and government activities eventually met; the "Avenues" of white residence; and after 1893, the "location" to the south for African residence.[7] The leafy, garden city–like comfort envisioned for the settlers contrasted with the planned confinement of all Africans in the town to the cheerless location, which lay both downstream and downwind of the town center and various odoriferous enterprises such as the oil and bacon factory, a large commercial stable, the railway yards, the cemetery, and, perhaps inevitably, the sewage works.[8]

Despite these unsavory features, African people from the newly defined rural areas came to the town. As in the case of Mrs. Sondayi's widowed mother, described in the interview excerpt that opens this chapter, they "came to work." They were greeted by a variety of discriminatory legislation (sometimes enforced and sometimes not). These laws, for example, forbade them to walk on the pavements (until the 1930s Africans had to share the streets with horse-drawn and motorized transport); required black men to be constantly at the ready to show their identity documents to policemen; barred them from owning land or legally living in the so-called white suburbs to the north of town, where they performed the manual labor required to keep the settlers in the lap of whatever luxury the latter could afford. Feats of strenu-

Table 1.1 Official Estimates of the Adult African Population of Greater Salisbury, 1934–1956

	Men	Women	Total
1934	16,475	2,594	19,069
1946	36,358	2,700	39,058
1953	72,338	7,510	79,848
1956	59,272	6,312	65,584

Source: 1934 figure from Medical Officer of Health and Native Location Superintendent Report, Salisbury Mayor's Minutes, 1934; other figures from "List F. Statistical Data," evidence of the Salisbury municipality to the Urban African Affairs (Plewman) commission, 1958. S 51/5.

Table 1.2 Official Estimates of the Adult African Residents of the Salisbury Municipal Location, 1925–1956

	Men	Women	Total
1925	1,065	352	1,417
1930	2,352	679	3,031
1934	2,578	806	3,384
1936	2,900	800	3,700
1943	6,000	1,500	7,500
1945	7,571	2,276	9,847
1947	8,392	2,535	10,927
1949	11,290	2,233	13,523
1952	18,914	3,935	22,849
1956	31,636	5,169	36,805

Source: 1934 figure from Medical Officer of Health and Native Location Superintendent Report, Salisbury Mayor's Minutes, 1934; Yoshikuni, *Black Migrants,* p. 113; Salisbury Mayor's Minutes, 1948–49.

Table 1.3 White Population of Salisbury, 1931–1956

1931	9,619
1936	11,392
1941	18,179
1946	21,294
1951	40,433
1956	61,930

Source: Reports of the 1936, 1941, 1946, 1951, 1956 Censuses (Salisbury: Government Printer).

ous mental gymnastics were simultaneously performed by settlers, who maintained that the town was a "white" space even though it was constantly traversed by and populated by black workers. As Tsuneo Yoshikuni's work has convincingly demonstrated, African residents did not meekly comply with white fantasies that they simply disappear at dusk. Nor did they allow themselves to be shepherded en masse southward into the location. African people persisted, legally and illegally, in living in places such as Epworth Mission (a Methodist community about twelve kilometers southeast of town), and in the so-called white suburbs themselves. In 1941, fully three quarters of the employed male population lived on their employers' premises in the white suburbs.[9] In 1962, when the first complete census of the African population since 1911 was taken, 35 percent of Salisbury's African population lived in the white suburbs. In 1969 only 53 percent of the African population lived in the townships, while 42 percent of the people who lived in the "white areas" of the town were actually African.[10] The development of this pattern is due in large measure to an unrelenting "struggle for the city" waged by Salisbury's African people, aspects of which are discussed in Chapters 2 and 5.[11]

Tables 1.1, 1.2, and 1.3 display the official estimates of the African population of greater Salisbury, that of the location (later Harare township, and renamed Mbare in 1982), and the official census results on the white population of Salisbury. Except for the 1934 figures (marked with an asterisk), the numbers in the first two tables should be regarded as official "guesstimates" only. Often official figures were arrived at by assuming that the number of identity documents issued to adult men was equal to the male population; each of these men was considered to have a wife and three children. Thus the official submission of the city of Salisbury to the 1957–1958 Plewman Commission actually listed a figure of 1,222 men, 1,222 women, and 3,666 children in Mabvuku township! It was admitted, however, that even these suspiciously precise figures reflected "authorised" populations only and excluded "the floating portion of the population which is always to be found in the City seeking work or changing employment."[12] It is probably safe to say, therefore, that in the period under review, neither municipal nor central government had any accurate idea of the size of the African population of Salisbury, and that published statistics were gross underestimates.

LABOR TRENDS IN SALISBURY

The main priority of both the British South Africa Company and, after 1923, the settler administration was to develop Southern Rhodesia on a dual basis of mining and farming. Government funds that were tied up in schemes to support white miners and farmers—such as the duty-free importation of implements, plants, and materials; differential railway rates; provision of a

few technical services; and recruitment of cheap labor—could not be used to encourage urban industrial growth. Salisbury and Bulawayo therefore developed mainly into service centers for the first fifty colonial years. By 1923 the majority of the colony's two thousand civil servants were employed in Salisbury.[13] Bulawayo developed into the colony's mining capital and the headquarters of the crucial railway network. Until the 1950s, consumers depended on imported manufactured goods, although import substitution was boosted for the duration of both world wars.[14]

Despite its lack of significant contribution to the national income, economic life in Salisbury grew quickly, if unevenly. In the early years of the twentieth century, extensive government buildings began to dominate the Causeway area, providing "the administrative heart of the country."[15] The city's first industries processed local agricultural products into beer, flour, oil, soap, and exportable tobacco. By the end of World War I a foundry, printing works, a fertilizer factory, and small furniture workshops had also been set up.[16] These ventures were located in the southern parts of town, close to the railway and ostensibly to the supply of laborers from the location.

According to the 1926 census,[17] the work force of these early enterprises was overwhelmingly male: 3,852 men and 47 women (in the commercial stables, the railway location, and a number of the brick-making enterprises) were employed in the industrial areas, with a further 28 women in other employment in the southern parts of town.[18] Overall, there were 139 African women and 11,962 African men employed in greater Salisbury in 1926. The other 64 women worked as domestic servants in the northern suburbs.[19]

A measure of the character of these industries was the accommodation provided for their workers. In 1926, workers at the fertilizer factories lived with women and children in a compound with no latrines, and consequently the "clump of bushes just off the Beatrice Road . . . [was] covered with Excreta."[20] Two years later, it was noted that the oil and bacon factory workers were living in "hovels made of paraffin tins" on the commonage (public area surrounding the suburbs). Eight of fifty-six of these unfortunates were married, and the town ranger recommended to the police that the place be raided as he suspected the presence of prostitution.[21]

There was little industrial development in Salisbury by the time of the 1936 census. Despite a substantial increase in African employment since the early days of the Great Depression, most of the new jobs were in the nonindustrial areas of domestic service, railways, and warehousing.[22] However, gender differences in employment were clearly apparent: half of the male labor force came from Malawi, and 80 percent of the employed African women were Southern Rhodesians.[23]

The tenor of economic life in Southern Rhodesia during the 1930s was marked by the determination of the state to support the settler population at

the expense of any section of the African population that would serve. The firm entrenchment of a color bar had a number of practical consequences for urban Africans. In addition to their obvious exclusion from better-paid employment, they paid proportionately more for their housing, as the Salisbury town council only accepted tenders from contractors who employed exclusively white laborers. In 1943 the cost of a location "house" was consequently an astronomical £500.[24] A proposed "experiment" in using African labor to build houses in the location was scrapped in 1939 because of white opposition.[25] Similarly, in times of high unemployment, municipal schemes were devised only to help white job seekers. The paving of roads on the commonage, fencing of the airport, town maintenance work, and the laying of pipes to provide water-borne sewage systems to the northern suburbs were all undertaken exclusively by white workers.[26]

FOOD AND NUTRITION

From its early days, Salisbury became a marketing focal point. It consumed the surplus of rural food producers and also played an important role in the distribution of wider surpluses in the context of the world economy. In its own food consumption, Salisbury drew on a wide catchment area of producers.[27] Before the turn of the century, African peasants successfully marketed crops such as maize, eggs, chickens, beef, tomatoes, and potatoes in the new urban market.[28] After the introduction of restrictive pricing and marketing policies designed to support white farming, however, the task of supplying Salisbury with some perishable foodstuffs was undertaken by rural African women who lived within walking distance of white consumers.[29] Before food purchases were centralized by the development of shopping centers (the first of which was built in 1930, followed by others after 1950), there was a large market for perishables in the white suburbs.[30] Some vegetables were grown by African workers in "market garden" plots on the commonage rented indirectly from the town council.[31] A larger source of produce were the nearby rural areas, however. In 1927 a disapproving NC (native commissioner) noted the ease with which African women from the surrounding rural areas could sell grain and chickens in greater Salisbury, and in 1930 a commission of inquiry into the Salisbury location heard of "young girls from nearby kraals" selling produce in town.[32] According to Mrs. Maggie Masamba, who was born about 1912 and a lifelong resident of Epworth Mission:

> Selling vegetables? Things like peas, I think started in the 1920s, going to the '30s. . . . We the children and our mothers [took vegetables to town to sell]. And our grandmothers. We carried them on the head, yes. There were

no buses . . . and bicycles came later. It was a way of getting money so that they could educate their children. Our mothers [said] long back, when they were still young girls, they would burn firewood, this firewood, they burnt it to make charcoal. Do you know charcoal? . . . and [they] went to sell, in Harare. We don't really know where they went to sell. We just heard them saying that. They went to sell to the whites. [By 1912] they had stopped. They were now growing peas and beans and sold them. And maize.[33]

Mrs. Sarah Bakasa, a teacher who participated in the trade when she lived in Epworth from 1929 to 1931, linked vegetable selling to a system of rural-urban trade.

Yes, I remember, those from Chiremba [a village settlement on Epworth Mission land] used to sell maize and peas. That's what they grew mostly. They would walk on foot from Chiremba, carrying the things on their heads. There were no buses then; bicycles were few. It was the men who rode on them coming to work in town. But the women set out very early in the morning, before sunrise, to come [to town] and sell—peas, maize and other vegetables. They usually sold to the whites. . . . They carried peas—that's how they made a living. After the peas have been bought they go back carrying meat and sugar, going back home.[34]

Mrs. Gertrude Shope, who lived in Epworth in the 1930s, remembered that her mother had grown flowers for sale but had not sold them herself in town, rather sending them in with a man who had a bicycle.[35]

In an era of widespread male dissatisfaction with women's exercise of mobility,[36] the Epworth women enjoyed a number of advantages. The social control exercised in the mission community was seemingly so strong[37] that it was assumed that women would behave properly, and the vegetable journeys seemed to be profitable. According to Mrs. Sarah Ndhlela, vegetable trading was a legitimate activity for Epworth women, who walked twice a week to town and back, unsupervised. When asked whether men complained about these journeys, she replied:

[The men] really liked it, [saying], "We are being helped." Yes. The one [woman] who wasn't doing it would be encouraged by others saying, "Look at what other women are doing. You just spend the day seated! They are growing beans, they are growing peas, they are growing maize to sell—green mealies—you just spend the day seated!" . . . The men really liked it. Nobody complained because it was done with nothing else behind it. They just went to sell. At about this time [noon] they have finished, they are returning.[38]

Although one woman remembered that there were also men involved in the vegetable trade, it seems to have been a women's preserve.[39]

The involvement of African vendors in the food trade to white consumers was not uncontroversial. In 1936, the long-serving Southern Rhodesian prime minister, Godfrey Huggins, felt that although Africans should be able to sell trinkets and baskets in town, "White people should be prepared to buy [chickens, eggs, butter] from other white people living on the white standard, and be prepared to pay for them on that standard."[40] As late as 1944, however, some African producers were still competing successfully with house-to-house sales of perishable produce: "In most towns, there are regular vendors of vegetables who have been going round for the past 20 years."[41]

Inside the city an extremely uneven distribution of food flowed from enormous racial gaps in spending power and food distribution arrangements. A 1930 study reported that the average European artisan could expect to earn about £420, a farm owner about £300 per year, and a farm manager around £180. The average yearly wage for the most highly paid African domestic worker in 1930, by comparison, was about £36, and unskilled workers had a yearly income of about £9.[42] Those who earned the least had the least access to produce markets and ate least. There were no shops at all in the location in the early 1920s; the closest were three to four kilometers away. In 1930 there was one shop on the outskirts of the location.[43] In 1938, no meat, vegetables, or fruit could be bought inside the location.[44] By 1944, however, and perhaps as early as 1939, the location superintendent had started a market that was supplied by African traders from nearby reserves (and some as far away as Murewa and Mutoko).[45] A few services such as shoe repair and tailoring were provided illegally in residents' rooms, but most were only available outside the location. Even through the 1950s, the general dealers in the townships—although their numbers had grown impressively—still carried only the cheapest brands of tea, sugar, bread, and soap.[46] Until the 1940s location residents had to travel to town to buy meat. The author Lawrence Vambe recalled that in 1946, "about eight tiny African-owned grocery, butchery and general stalls" constituted the location's vegetable, fruit, and firewood market.[47]

From these restrictions flowed the inevitable consequence of African urban malnutrition. Widely cited reports of the mid-1940s called attention to the "totally inadequate diet" of families and the "unsatisfactory" diet of bachelors, which consisted mainly of bread and tea.[48] It was reported that bachelors (defined as "men who have no wives to prepare [their] food") were the greatest sufferers from malnutrition.[49] According to the assistant police commissioner in Bulawayo in 1943:

*Report on a Survey of Urban African Conditions in Southern Rhodesia (1943)

We ration the boys outside but in town we give them an allowance. . . .
They are allowed to have their wives living in the camp. The wives cook
their food for them, but the position of the bachelors is very unsatisfac-
tory. . . . It is futile to suggest that a Native should feed himself. Very few
have decent cooking places, and in the wet season there is seldom even a
roof over them.[50]

Overall, the Howman Committee, appointed to study urban conditions in
1943, reported,

Malnutrition and deficiency disease are particularly evident amongst the
industrialised bachelor labourers, who are the worst sufferers. They have
never been taught to cook, they tend to skimp the preparation of properly
cooked food and after the day's work lack the time and energy necessary
in the preparation of all those extras with which a wife makes her meals
appetizing and nutritive.[51]

Malnutrition was also widespread in the general urban population. African
children often suffered acutely. Mrs. Katie Chitumba, who started teaching in a
government primary school in Harare township in 1946, remembered,

life was very, very low; very, very poor, and most of the children would
faint here at school without having anything to eat. I do remember many
children used to faint during prayer time and you would run to the domes-
tic science to give them either a cup of tea. Their life was very low.[52]

In this situation of enforced deprivation, African women were very im-
portant in the provisioning and feeding of Salisbury. Some brought food in
from the rural areas. Others made the difference between workers' health
and illness as they provided cooked meals for men who otherwise would
have been trying to subsist on the cheap, empty calories of convenience food.
As late as 1953 it was noted that the most popular meal for many men con-
sisted of a bottle of Coca-Cola and white bread.[53]

THE "ECONOMICS OF DEATH"[54]

Perhaps the most significant area of urban administrative neglect of the
African population was in health matters, as the town authorities only heeded
calls to protect the health of the white population. Both Bulawayo and
Salisbury had general hospitals funded by the central government for Afri-
cans, but these were overcrowded, unsanitary, and understaffed.[55] A small
municipal dispensary, attending to outpatient cases and maternity work, was
opened in the location in 1934. A venereal disease treatment center was opened

in 1939 (see later) and a larger maternity clinic was opened in 1950. The Bulawayo municipal authorities refused to build a new clinic in the location in the mid-1940s, declaring the "the spirit of [African] self-help" would have to rule in the matter.[56]

Diseases caused by poor sanitation, inadequate housing, and malnutrition caused the most damage. In 1930, for example, some 60 percent of the 204 deaths reported among the African residents of Salisbury were caused by pneumonia, meningitis, tuberculosis, and typhoid fever; eight people died of cirrhosis of the liver. Seven infants died of "congenital causes and malnutrition."[57] Hookworm, bilharzia, and scurvy were also common urban scourges.[58] Of the fourteen African women who died in Salisbury in 1932, six succumbed to pneumonia, two to dysentery; two women died in childbirth of the twenty-one maternity cases attended to; typhoid, tuberculosis, and endocarditis each killed one woman; and one woman hanged herself. Ten of the sixteen children who died in that year succumbed to bronchial pneumonia.[59] At least one child died in 1935 by drowning in one of the location's open cesspools.[60]

The main focus of medical work in urban African populations was to try to control venereal disease, as this was thought to have the most serious impact on the white public health. Characteristically authoritarian, the approach was to try to ferret out diseased Africans and bar them from any contact with white people. As early as 1917 state officials discussed a proposal to require Africans entering a town to submit to a medical examination before being issued pass documents.[61] The pass law that was amended to include this provision was one of the few that also applied to women.[62]

In 1922 the Salisbury municipal physician began treating Africans who had venereal disease at the small municipal lazaretto (venereal disease facility). Some patients were forcibly detained after examination and others came in for voluntary treatment.[63] Interestingly, this system satisfied no one. The exams were medically insufficient, and severely inconvenient and undignified for the patient. West refers to men in Bulawayo in 1936 objecting to mass communal medical examinations, calling instead for individual exams in doctor's offices.[64] The system completely broke down, however, when it came to the examination of African women. Administrative difficulties and outright objections forced the abandonment of the practice. Urban African communities objected to the whole idea of examining women. Compulsory examination suggested that a woman might have venereal disease, thus implying that she might well be a prostitute. This insult angered men living in town "properly" with their wives: the reputations of these women (and by extension, of the husbands) should not be besmirched, even by implication. Second, who would examine the

genitals of African women? Both white and black female medical personnel were rare. And objections—that the state had to agree were reasonable—were raised when either a white male doctor or an African male orderly conducted examinations:

> It is rather hard lines on a respectable girl if she has got to parade at the town pass office and ask for a monthly contract. She is sent over to the medical man and she has to strip off and be examined to see if she is suffering from venereal or other disease. . . . As it happens we had a man of a certain age as the doctor, but at the same time we do have young fellows as doctors, and it is most unpleasant for these girls.

This official concluded, "The law is now a dead letter as regards these native women."[65] By 1931 the Bulawayo municipality had also dropped medical examinations of working women.[66] The unpleasantness of the procedure may have been a large part of the reason why, in 1931, for around seventy African women employed in Salisbury, only six "contracts of service" were issued monthly.[67]

When the Salisbury municipality finally opened a new health facility in late 1939, it was an infectious disease hospital, targeting venereal disease. People found to be suffering from syphilis or gonorrhea were forcibly detained and were subjected to a course of injections for an average period of forty days in 1933, thirty in 1938, and twenty in 1939.[68] This procedure logically led to the disease being driven underground as people suffering from infection were "only too eager for treatment, but naturally object[ed] to being detained in what, in their view, [was] a species of prison."[69]

THE STRUCTURES OF URBAN STATE AUTHORITY

The urban presence of central government for Africans was mainly manifested through the urban native commissioner. These employees of the Native Department had wide powers; among their duties were registering marriages and divorces; hearing civil disputes; collecting taxes; issuing passes, identity documents, and residence certificates; and maintaining links with structures in rural areas. The office of the NC in Salisbury was in Market Square in the southern part of the town proper.

The most central imposition of the NC in the lives of African men was the pass system: a constant physical reminder that black people were meant only to be visitors in white space. Pass laws requiring the carrying of an identity certificate on which would be endorsed important employment details (and, in later years, the date of last examination for venereal disease) were intro-

duced to Southern Rhodesia in 1896 and repeatedly elaborated. Men (defined as males over the age of fourteen, and then sixteen) were required to carry an identity document (known popularly as a *chitupa*), and, by the late 1950s, as many as thirteen other documents.[70] Under such draconian conditions, it is not surprising that, annually, the largest number of prosecutions of African men occurred under these laws. By 1942 there were eighteen thousand pass law convictions nationwide.[71] These convictions, moreover, came from a wider pool of men; according to an estimate in 1943, although three thousand men were physically rounded up by the police every month, most were merely harassed and warned; less than half were actually charged and (almost automatically) convicted.[72] Men combated the pass laws in many ways: in thousands of recorded instances they used other men's documents, mutilated certificates, refused to produce them, or simply traveled without them.[73]

Pass laws were only in a few specific areas applied to African women in the period under review. Most importantly, women were never required to register for identification certificates. African women were included in the provisions of Ordinance 16 of 1901, which stated that employed Africans were to be in possession of a certificate of employment; later amendments stated that applicants had to be examined for venereal disease. In later years, some of the provisions of the Natives Registration Act of 1936 applied to women, such as the stipulation that new migrants to towns be issued with a "town pass"—a pass to seek work—and people entering locations were to be issued with visiting passes. Both the 1901 ordinance and the 1936 act exempted married women from these regulations, however. But, in the twisted logic of the pass system, a married woman needed a pass to show that she did not need a pass; she was technically required to have either a marriage document or a certificate stating that she was the "approved wife" of an employed man.[74]

The 1958 Urban African Affairs Commission reported that many of the pass laws were outmoded, and could be abolished; Edgar Whitehead's government accordingly reduced the number and severity of the laws in 1961, although retaining the institution of the *chitupa*.[75]

Municipal Government

The authority of the Salisbury municipality was represented in the location in the person of the location superintendent, appointed periodically by the town council. His immediate superiors were the members of a council committee; in Salisbury until 1938 this was the ill-named "Commonage and Gardens Committee." Its membership changed every year, and committee members in turn ceremonially visited the location once a year. Little or no

long-term planning was achieved under a system of such institutionalized administrative neglect.

The authority of local urban government touched the lives of African residents in many other ways. Services such as housing, water supplies, electricity, sewerage, promotion of health, fire protection, streets, drainage and lighting, transport, and recreational facilities were all considered to be responsibilities of municipal government.[76] The provision of services was, of course, markedly inferior in African areas. Perhaps one example will suffice: white residents of Salisbury lived in pleasant, leafy suburbs on half-acre plots, and families enjoyed the use of private "water closets," which in the late 1920s were being converted from the bucket/latrine system to the more hygienic and convenient water-borne system. Location residents, however, were provided with a block of communal toilets in which the stalls did not have doors and that were meant to be used by both men and women. There was one such location "wash-house" for all; residents themselves divided the day into hours for men and hours for women.[77] According to one woman resident,

> it was one room with no doors. Everyone can see. If you bring a child, he can see you, how you were bathing. You see it was terrible. It was terrible.[78]

Even the authorities admitted,

recognition of inequality

> the latrines are, of course, far too few in number. . . . The latrines were all roofed with iron. As an experiment, the iron of one was removed, leaving the place exposed to the rays of the sun; the experiment was found to be so successful that all roofs have since been taken down. Before this was done the stench was often noticeable at 20 yards distance.[79]

In addition, workmanship in the ablution blocks was extremely shoddy.[80] Despite urgent calls by the location superintendent through the 1930s,[81] a modern sewerage system was not installed for another twenty years.

The long arm of the municipality also intruded into African urban life in the form of the enforcement of petty municipal bylaws, ranging from riding an unlicensed bicycle or cycling on a sidewalk, to "loitering" in the white areas of town, "creating disturbances," or trespassing in the location. In 1938–1939 nearly five hundred such infringements were reported for Africans in Salisbury.[82]

Central versus Municipal Government

Southern Rhodesian towns exhibited, almost from the beginning, the manifestations of a tension at times no less than acrimonious between local au-

thorities and central government. Decade after decade, when the need for better services and accommodation for African residents was mooted, officials at both levels of government clutched purse strings tightly and declared that the other party should pay for change. In the provision of medical services, for example, Salisbury's officials continually grumbled about central government's "slight" contribution to venereal disease care.[83] According to Gargett's survey of urban policy in the 1930s and 1940s, while the Native Department of the central government pointed an accusing finger at local authorities, these in turn "spoke with alarm at the deteriorating conditions and the impossible financial burden threatening the European taxpayer in the absence of any constructive government policy."[84]

In addition to financial tensions there arose a fundamental confusion over the administrative structures of segregated urban residential areas. In 1938 a former superintendent of the Salisbury location charged:

> Laws are passed by the Government without reference to the needs of the city, and very often are not carried into effect; and, of course, the Council provides a location which is only sufficient for the needs of a quarter of the native population. A native hospital is provided by the Government, which lacks ventilation or air space, and in which the sick and dying are packed like sardines. Disease is rife, and the officer entrusted with this branch of duties is utterly unable to cope with it, owing to the lack of facilities or assistance afforded him; and, of course, the Government has built a new gaol at a cost of nearly £100,000. All that can be said in its favour is that it is so uncomfortable that it may deter the criminal classes from carrying on their unlawful avocations in this vicinity.[85]

Similarly, because of the overlapping and uncoordinated administrative structures of central and local government, the 1958 Plewman Commission report described a bewildering array of African residential areas in greater Salisbury: "Harari, a Native Urban Area within the limits of the municipal commonage; Mabvuku, a Native Urban Area outside the limits of the municipality but within the area of its jurisdiction; St. Mary's, a Native Urban Location established outside the area of jurisdiction of the municipality and administered by the Government; Highfield, a Native Village Settlement established on land adjacent to the municipal boundary; Seki Township, a Native Township within the Seki Native Reserve; Rugare, a Rhodesia Railway Native Area on land owned by the Railways outside the area of jurisdiction of the municipality."[86] To this list can be added the nearby mission stations such as Epworth. The absence of a unified and local administrative system in these areas had an important impact on urban African residents. Laws designed to control the conduct of women, for example, could be evaded merely

by crossing over a line on a map; efforts to restrict the numbers of women entering towns were hopelessly snarled. Municipal governments could not insist that rural women have passes to enter towns—passes that logically would have been issued in rural areas—if central government did not first instruct or enable its rural officials to issue such passes. A 1931 survey in the town of Que Que listed the problems encountered in prosecuting urban women under existing legislation: the local magistrate found the vagrancy laws too vague to use, "illegal activities" such as prostitution that took place outside municipal boundaries were not subject to the provisions of town ordinances, and women often had a stock of adroit answers with which they could successfully outmaneuver attempts to send them away to rural areas under the Native Affairs Act.[87]

The lack of unified administration also contributed to the fact that occasional initiatives to improve aspects of African urban life generally remained localized and underfunded in character. In addition, the unwillingness of either branch of government to become substantially involved in "welfare" work accounts for the rise of the settler-run Native Welfare Societies in the towns which, with some government support, provided a few occasions for Africans to play soccer, watch morally uplifting films, and enter beauty, boxing, and dancing contests.[88] These paltry activities exemplified the official disinterest in African urban life through the mid-1940s.

CONCLUSION

As in the rest of twentieth-century southern Africa, the theme of "coming to town" resonates through the histories of African people in Southern Rhodesia. In the case of Salisbury, however, "town" was not a friendly, welcoming place. Instead, people came squarely up against the construction of humiliating systems of racial inequality that were designed to ensure white supremacy and black subservience, systems that were symbolized and institutionalized in the language of "*baas*/boy" and "madam/girl."[89] Inequality was exhibited everywhere in town. There were many examples. The settlers lived in comfortable houses that were tended by servants whose own accommodation consisted at best of crowded, squalid, airless cement rooms and at worst of "hovels made of paraffin tins." Pitifully small wages and rations were released in return for the labor that was the sinew of colonial production. Whites bought goods inside shops from which blacks were barred; whites were always served first in public places such as post offices. Domestically, private water closets and bathing rooms for white families contrasted starkly with the filthy public latrines to which some Africans had access, and the complete lack of facilities that many were forced to bear. The benefits of developments in medicine were denied to undernourished people.

Central and municipal governmental officials generally agreed that all these disparities were unobjectionable, although they often disagreed sharply on whose responsibility it should be to administer them. These disagreements opened up small but exploitable spaces where African people found a few jealously guarded and unequal opportunities. They planted seeds in those rocky fields; African women's labors therein form the subject of the next chapter.

NOTES

[1] Interview with Mrs. Stella Mae Sondayi, Highfield, 11 April 1989.

[2] See David Beach, *The Shona and Zimbabwe, 900–1850* (Gweru: Mambo Press, 1980); and idem, *Zimbabwe before 1900* (Gweru: Mambo Press, 1984); P. S. Garlake, *Great Zimbabwe* (London: Thames and Hudson, 1973).

[3] Ian Phimister, *An Economic and Social History of Zimbabwe: Capital Accumulation and Class Struggle, 1890–1948* (London: Longman, 1988) p. 171–174.

[4] Doris Lessing, *A Proper Marriage* (London: Hart-Davis MacGibbon, 1965), p. 304.

[5] King, Anthony, *Urbanism, Colonialism and the World Economy: Cultural and Spatial Foundations of the World Urban System* (London: Routledge, 1990), p. 13–26; A. J. Christopher, *The British Empire at Its Zenith* (London: Croom Helm, 1988), p. 114–122.

[6] The giant Anglo-American corporation moved its headquarters to Salisbury from Broken Hill in Northern Rhodesia in the 1950s, for example. See Greg Lanning with Marti Mueller, *Africa Undermined: A History of the Mining Companies and the Underdevelopment of Africa* (Harmondsworth: Penguin, 1979), p. 168–195.

[7] Kay, George and Michael Smout, eds., *Salisbury: A Geographical Survey of the Capital of Rhodesia* (Kent: Hodder & Stoughton, 1977); Tsuneo Yoshikuni, *Black Migrants in a White City: A History of African Harare, 1890–1925* (Ph.D. Thesis, University of Zimbabwe, 1990), chapter 1.The settler's desire to be insulated from African inhabitants thus predates the 1896 Chimurenga war. The unswerving segregationist logic of the Rhodesians gave the town a spatial fix that overrides Drakakis-Smith's contention that there was no urban planning "worthy of the name" in Rhodesia before the 1980s. David Drakakis-Smith, "Urban and Regional Development in Zimbabwe," in Dean Forbes and Nigel Thrift, eds., *The Socialist Third World: Urban Development and Territorial Planning* (Oxford: Basil Blackwell, 1987), p. 203.

[8] Completely different standards were invariably applied by the municipal government in these different residential suburbs when planning for orderly development, traffic flows, the healthiness of the environment, layout, desired population densities, and zoning regulations. See Yoshikuni, *Black Migrants*, p. 75; Kay and Smout, *Salisbury*, p. 15.

[9] Yoshikuni, *Black Migrants*, p. 168.

[10] 1962 Figure calculated from *Final Report of the April/May 1962 Census of Africans in Southern Rhodesia* (Salisbury: Government Printer, 1964), p. 60–61; 1969 figure from Kay and Smout, *Salisbury*, p. 46–47.

[11] This is, of course, Frederick Cooper's phrase: see his "Urban Space, Industrial Time and Wage Labor," in F. Cooper, ed., *Struggle for the City* (Beverly Hills: Sage, 1983). See also C. W. Pape, *A Century of "Servants": Domestic Workers in Zimbabwe, 1890–1990* (Ph.D. dissertation, Deakin University, 1995), chapter 7, passim.

[12] "List F. Statistical Data," evidence of the Salisbury municipality to the Urban African Affairs (Plewman) commission, 1958. S 51/5.

[13] Jeffrey Herbst, *State Politics in Zimbabwe* (Harare: University of Zimbabwe Publications, 1990), p. 18.

[14] J. Trinder, "The Industrial Areas," in Kay and Smout, *Salisbury*, p. 88.

[15] Michael Smout, "The City Centre," in George Kay and Michael Smout, *eds., Salisbury: A Geographical Survey of the Capital of Rhodesia* (Kent: Hodder and Stoughton, 1977), p. 67.

[16] Smout, "City Centre," p. 67; Phimister, *Economic and Social History*, p. 240–241.

[17] Although no complete African population censuses were attempted in these years, the quinquennial Southern Rhodesian censuses did keep careful track of the number of Africans employed in towns and rural areas.

[18] 1926 Census, Native Employment Schedules, Salisbury Urban Area, C 7/6/41/1–5; esp. C 7/6/41/5 vol. 1 and 2. The figures for women would be slightly higher if fifty-two women who were originally enumerated (fifteen at a brickyard and thirty-seven at the railway location) but were later crossed off the enumeration forms were included. Perhaps these women were counted as present but it was later decided that they were "merely" wives or dependents.

[19] Teresa Barnes, *African Female Labour and the Urban Economy of Colonial Zimbabwe, with Special Reference to Harare, 1920–39* (M.A. thesis, University of Zimbabwe, 1987), p. 27.

[20] Town Ranger to Town Clerk, 13 November 1926, LG 51/1.

[21] Town Ranger to Town Clerk, 31 December 1928, LG 51/1.

[22] *Report of the Director of the 1936 Census*, p. 101.

[23] *Report of the Director of the 1936 Census*, p. 107–108; Gray, *The Two Nations*, p. 92.

[24] Salisbury Mayor's Minute, 1937–38, p. 46; Gray, *The Two Nations: Aspects of Race Relations in the Rhodesias and Nyasaland* (London: Oxford University Press, 1960), p. 99, 252. According to the 1943 Ibbotson report, African labor was only used to build location housing in Bulawayo, Umtali, Gatooma, and Selukwe. Percy Ibbotson, *Report on a Survey of Urban African Conditions in Southern Rhodesia* (Bulawayo: Federation of Native Welfare Societies, 1943), p. 24.

[25] Percy Ibbotson, *Report on a Survey of Urban African Conditions in Southern Rhodesia* (Bulawayo: Federation of Native Welfare Societies, 1943), p. 24.

[26] G. H. Tanser, "The Birth and Growth of Salisbury, Rhodesia," in H. L. Watts, ed., *Focus on Cities* (Durban: University of Natal, 1970), p. 157.

[27] Paul Mosley, "The Development of Food Supplies in Salisbury (Harare)," in Jane Guyer, ed., *Feeding African Cities* (Bloomington: Indiana University Press, 1989), p. 209.

[28] Mosley, "Food Supplies," p. 207; Annual Report of the NC Goromonzi, 1921, N 9/1/24.

[29] See Barnes, *African Female Labor*, p. 32–33; Elizabeth Schmidt, *Peasants, Traders and Wives: Shona Women in the History of Zimbabwe, 1870–1939* (Portsmouth: Heinemann, 1992), p. 56–61; Nancy Horn, *Cultivating Customers: Market Women in Harare, Zimbabwe* (Boulder, Colorado: Lynne Rienner Publishers, 1994), p. 22–24.

[30] Smout, "The Suburban Shopping Centres," in Kay and Smout, *Salisbury*, p. 72–73.

[31] It was council policy only to rent such plots to Indians, not to Africans. Yoshikuni, *Black Migrants*, p. 137.

[32] Teresa Barnes, "The Fight to Control African Women's Mobility in Colonial Zimbabwe, 1900–1979," *Signs: Journal of Women in Culture and Society* vol. 17 no. 2 (1992), p. 595.

[33] Interview with Mrs. Maggie Masamba, Epworth, 20 April 1989.

[34] Interview with Mrs. Sarah Bakasa, Kambuzuma, 17 March 1989.

[35] Interview with Mrs. Gertrude Shope, Johannesburg, 22 March 1996.

[36] See Barnes, "African Women's Mobility," passim.

[37] According to Mrs.Tabitha Munda, if the daughter of an Epworth family who went to town fell from grace, her entire family would be forced to leave the mission. Interview with Mrs. Tabitha Munda, Epworth, 20 April 1989.

[38] Interview with Mrs. Sarah Ndhlela, Highfield, 13 March 1989.

[39] Interview with Mrs. Katie Chitumba, Mbare, 29 March 1989.

[40] Southern Rhodesia Legislative Assembly Debates, 1936 vol. 1, columns 604–622. See also memo by C. Bullard, "Native Registration Act 1936: Proposals not Recommended," 6 March 1936. S 1542/A1 vol. 1.

[41] Mr. Ferreira, Native Department, Salisbury, oral evidence to the Howman Commission, 1943, p. 154. ZBI 2/1/1.

[42] Gray, *The Two Nations*, p. 97–98, 108.

[43] Salisbury Town Clerk to CNC, 29 December 1924, S 235/383; Native Affairs Conference, 1933.

[44] E. G. Howman, *The Urbanized Native in Southern Rhodesia* (Salisbury: Institute of Municipal Accountants, 1938), p. 7.

[45] W. S. Stodart, oral evidence to the Native Production and Trade Commission, 1944, p. 2935, ZBJ 1/1/4; Volker Wild, "Black Competition or White Resentment? African Retailers in Salisbury, 1935–1953," *Journal of Southern African Studies*, vol. 17 no. 3 (1991), p. 186.

[46] Wild, "Black Competition," p. 190.

[47] Lawrence Vambe, *From Rhodesia to Zimbabwe* (London: Heninemann, 1976), p. 183.

[48] Percy Ibbotson, *Report on a Survey of Urban African Conditions in Southern Rhodesia* (Bulawayo: Federation of Native Welfare Societies, 1943), p. 13; R. Howman, "Report on Urban Conditions in Southern Rhodesia" (Howman Committee Report), *African Studies* vol. 4 (1945), p. 127.

[49] Howman Committee Report, paragraph 51; Oliver Pollak, "The Impact of the Second World War on African Labour Organization in Rhodesia," *Rhodesian Journal of Economics* vol. 7 no. 3, 1973, p. 127.

[50] Major Bugler, BSA Police, oral evidence to the Howman Committee, 1943, ZBI 2/1/1, p. 31.

[51] Howman Committee Report, paragraph 32.

[52] Interview with Mrs. Katie Chitumba, Mbare, 29 March 1989.

[53] Report of the Labour Officer for Salisbury East, March 1953, p. 2. S 2104/2.

[54] Charles Van Onselen, *Chibaro: African Mine Labour in Southern Rhodesia, 1900–1933* (London: Pluto Press, 1976), pp. 50–60.

[55] Phimister, *Economic and Social History*, p. 261; Howman, *Urbanized Native*, p. 4.

[56] Salisbury Mayor's Minute, 1934–35, p. 28; *African Weekly*, 29 March 1950; Phimister, *Economic and Social History*, p. 261.

[57] Report of the Medical Officer of Health, Salisbury Mayor's Minute, 1929–30.

[58] Phimister, *Economic and Social History*, p. 261; Medical Officer of Health report, Salisbury Mayor's Minute, 1931–32.

[59] Medical Officer of Health report, Salisbury Mayor's Minute, 1931–32.

[60] This incident seems to have been a catalyst for the replacement of open drains with underground pipes. Minutes of the meeting of the Commonage and Gardens Committee, 17 September 1935, LG 93/35; Location Superintendent's Report, Salisbury Mayor's Minute, 1935–36, p. 52.

[61] CNC to the Secretary, Department of the Administrator, 8 July 1917, H 2/9/2.

[62] Natives Registration Ordinance of 1901, Amendment Ordinance of 1918, or Ordinance No. 15 of 1918. H 2/9/2.

[63] Salisbury Mayor's Minute, 1922-23.

[64] Michael West, *African Middle-Class Formation in Colonial Zimbabwe, 1890–1965* (Ph.D. dissertation, Harvard University, 1990), p. 151.

[65] NC Howman, Native Affairs Advisory Conference, August 1931, Verbatim Report of the Proceedings, p. 101. S 235/486.

[66] NC Bulawayo, Native Affairs Advisory Conference, August 1931, Verbatim Report of the Proceedings, p. 108. S 235/486.

[67] According to the 1931 census report, there were sixty-nine African women employed in Salisbury; *Southern Rhodesia Statistical Yearbook, 1938*, p. 25; Acting NC Salisbury to CNC, 20 May 1931. S 138/5.

[68] Salisbury Mayor's Minute, 1939–40; Medical Officer of Health reports, Salisbury Mayor's Minute, 1932–33; Salisbury Mayor's Minute, 1938–39.

[69] Howman, *Urbanized Native*, p. 12.

[70] Boris Gussman, *Out in the Midday Sun* (London: George Allen & Unwin, 1962), p. 76. See also Teresa Barnes, " 'Am I a Man?': Gender, Identity and the Pass Laws in Colonial Zimbabwe," *African Studies Review* vol. 40 no. 1 (1997).

[71] "Summary of Offenses for Which Most Prosecutions Occur, 1932." S482/366/39; Gray, *The Two Nations,* p. 270.

[72] Captain Surgey, British South Africa (BSA) Police, oral evidence to the Howman Committee, 1943, ZBI 2/1/1, p. 165. Salisbury was the context of his remarks. See also S 1542/A1/20 vol. 2; and Annual Reports of the Commissioner, BSA Police, 1950, p. 67, and 1951, p. 53.

[73] "Summary of Offenses for Which Most Prosecutions Occur," S 482/366/39.

[74] See Barnes, "Am I a Man?"

[75] Report of the Urban African Affairs (Plewman) Commission, 1958, p. 110–114. Sylvester has identified this move as the "repeal of Rhodesia's mild pass laws." Sylvester, *Zimbabwe*, p. 43.

[76] This list comes from the Report of the Urban African Affairs Commission, 1958, chapter 4, p. 30.

[77] Interview with Mrs. Stella Mae Sondayi, Highfields, 11 April 1989.

[78] Interview with Miss Sophie Mazoe, Mount Pleasant, 16 February 1989.

[79] Report of the location superintendent, Salisbury Mayor's Minutes, 1935–1936, p. 52; interestingly the report notes that water-borne sewage had been installed in the Bulawayo location by this date.

[80] G. Storrar, *City of Salisbury: Report on Sanitation Scheme at the Native Location and Investigations into the Organisation of the City Engineer's Department* (Pretoria: mimeo, 1945).

[81] Salisbury Mayor's Minutes, 1938–1939, p. 40.

[82] Ibid.

[83] See Location Superintendent's Report, Salisbury Mayor's Minute, 1935–1936; Salisbury Mayor's Minute, 1938–1989, p. 39.

[84] Eric Gargett, *The Administration of Transition: African Urban Settlement in Rhodesia* (Gweru: Mambo Press, 1977), p. 18.

[85] Howman, *Urbanized Native*, p. 4.

[86] Report of the Urban African Affairs (Plewman) Commission (Salisbury: Government Printer, 1958), p. 33.

[87] Detective Sergeant Seengrass (?), in charge of Criminal Investigation Department (CID) Que Que, to Chief Superintendent, CID Bulawayo, 25 October 1931. S 1222.

[88] Gray, *The Two Nations,* chapter 1.

[89] *Baas* is from the Afrikaans word for boss; adult African men were referred to as boys. White women employers were referred to as madams and their black women workers as girls.

2

AFRICAN WOMEN'S WORK AND ECONOMIC DIFFERENTIATION BEFORE THE 1950s

What I saw was that in town there was the advantage that as a woman you could do something to help yourself and help in the home. . . . [In the rural areas] I would have just sat and waited for [my husband's] money. So the money he got would not have been enough to uplift the big family I had, for them to get enough education and getting enough things.[1]

The previous chapter has suggested that although the urban environment was inhospitable, African people entered it in order to achieve their own ends. This line of analysis is somewhat differently focused than the familiar themes of regional migration studies, which usually stress the factors that pulled or pushed migrants from their rural bases. Similarly, this chapter discusses urban initiatives of African women in Salisbury rather than, simply, their reaction to colonial structures and legislation. It is important to see these women as initiators—even as pioneers—because there were no blueprints for them in Salisbury. Important information was brought to them in the early colonial years, especially by black women from South Africa; nonetheless, there were no local precedents for the tasks indigenous women were about to undertake, and there were no preexisting clues about the nature of the developing urban environment. In making a way for themselves, they drew on previous experience and constructed the rest.

This chapter attempts to sketch out a complicated relationship between women's urban activities and their aspirations. As mentioned previously,

African people in Southern Rhodesian towns were not content merely to exist, nor were they content to survive randomly. They sought to survive in an acceptable manner: to live *properly*. Here again, the concept of social reproduction returns: to live properly was to live according to one's own, African, priorities. This formulation is not meant to suggest an attempted return to a frozen, primordial African identity, but rather one that seized available components and tried to mold them into something recognizable and satisfying. This is the sense in which I have taken the excerpt from Mrs. Selina Sitambuli's interview. Her interest in town life was not merely to survive, it was to uplift her family, to give her children "better education" and "enough things." Pointing out the innate materialism in this statement is not meant to denigrate Mrs. Sitambuli, but to suggest that ideologies of materialism and uplift from the plight of the masses played important roles in urban life.

One important aspect of this proper society was held to be hierarchy, and thus a certain kind of differentiation was a social goal. Differentiation was and is, of course, a defining feature of capitalism for those who are molded into its work force. But urban African people defiantly sought to define and acknowledge differentiation in ways that were not merely imposed by a capitalist system for whom they were all at best merely "boys" and "girls." Rather, what are called here differentiating pressures from above combined with attempts from below, to form urban communities that were very distinctly and consciously stratified. Differentiation was not pursued solely as an individualistic goal in itself. Although it certainly had individualistic elements, it was a means to the construction of a reproducible, proper community. Gender ideologies played crucial roles in these constructions.

ELEMENTS CONTRIBUTING TO DIFFERENTIATION

Now that postmodernism has largely swept the academic landscape of neo-Marxism in southern African studies, one rarely finds attempts to solve an old, complex problem: do women occupy the same, or different, class positions as their male relatives? The Marxist divide between productive and reproductive labor relegated this to the status of a minor issue, but with the rise of women's studies, it became a much more pressing problem,[2] which still confronts writers of women's economic history. Valuable studies of the 1980s revealed a great deal about relations between the African working class and the state, but not as much about the relationships between men and women of the working class(es); proletarianization and class formation were viewed as processes that affected women but not as processes in which they played a determining role.[3] Difficulties (unfashionability, the lack of accurate categories and terminology) now abound in the attempt to correlate class and gender. Still, if economic differentiation was at work, then its effects must be

accounted for. Generally speaking, substantial gender-based inequality within households means that women occupy class positions that are not identical to those of their male relatives. This is because men may, and often do, restrict women's access to the "family income" that determines class position; "family" property may not be jointly owned; and a man is more likely to have access to whatever benefits are proffered by state structures.

Urban African communities were economically and socially heterogeneous in class, gender, ethnic, and national categories. Recent historiography has stressed how each of these categories was socially constructed and thus changed over time. In terms of class distinctions, although an entire schematic diagram of urban African classes cannot be drawn here, I would like to use some of the language of Marxist analysis to discuss one dividing principle. In urban African communities there were men and women who, using various methods, differentiated themselves both materially and conceptually from the majority of severely underpaid workers.[4] It is inaccurate to say that these people inhabited the upper ranks of a working class because they hired and exploited the labor of other people. It is, however, also inaccurate to say that they were members of a bourgeoisie because in the context of the entire political economy they commanded minute amounts of capital.

Instead of leaning to one of these poles or the other, this chapter uses a gendered concept to which I was introduced by women interviewees to try to come to grips with urban social and economic differentiation. These interviewees said that some urban women were "well-known."[5] The way in which they used this term connoted more than mere fame. It was also separated conceptually from the realms of the "notorious": a well-known woman, first and foremost, lived properly. She had material assets that others lacked: a husband, a house, perhaps education. She certainly had elevated social status, community esteem, and maybe even a bit of money. She supposedly also enjoyed relative safety from the predations of the colonial state.

Pressures in the Early Colonial Period

Before the 1940s the state's main concern with African women was to define their positions, rights, and duties inside the evolving institutions of marriage in order to move African family relationships into line with the new capitalist economy. After an initial flirtation with some emancipatory statutes,[6] the legal codification of permanent minority status for women was meant to place them securely under the control of their male relatives. In Southern Rhodesia, as elsewhere in the region and Africa as a whole, however, legal codes were insufficient to halt the migration of women, and under pressure from disgruntled patriarchs the state began to try to take a more

active role in the control of women's mobility and their sexuality. Gradually, women's sexual activity outside the control of their male relatives became defined as immoral, and women so categorized became the objects of social condemnation.[7]

Morality for African women was defined narrowly in Southern Rhodesia: a moral woman was a hardworking, faithful wife. The scholarly understanding of this process in the early years of colonialism has been given a tremendous boost by Ranger's study of Mrs. Grace Samkange, matriarch of the extremely influential Samkange family.[8] Mrs. Samkange personified the upright, cleanly, and godly Methodist wife and mother, and Ranger has portrayed her as a mighty rock on which Southern Rhodesian Methodism was built. Like Mrs. Albert Luthuli in South Africa,[9] Mrs. Samkange was the quintessential "well-known" woman. She lived a life of labor and was concerned with the proper raising of children, the transmission of a sense of Christian mission to the next generation, and the organization of African Christian women into a powerful force for godliness. Perhaps she would have agreed with the state official who was in charge of the "the instruction of native women and girls" throughout the colony, who wrote,

> I like to think that this work is symbolised by the letter H. Humanity, Homes, Husbands, Housewives, Hygiene, Happiness and lastly Heaven. May I say that these things will be achieved by women. It is they who must guide the men! . . . the qualities of character required by the government can be better cultivated in the home than elsewhere.[10]

Encouraging the development of a core of loyal, thrifty, and obedient African wives in the mold of Mrs. Samkange fit in well with the state's overall orientation toward the African population before the 1940s: the manipulation of custom and tradition ("to bolster up tribal ways, to try to maintain the past"[11]) in order to develop manageable flows of labor to the colony's capitalist enterprises. Thus, women who were hungry for education found themselves in schools for wives in which domestic training was paramount.[12]

Many ideological pressures that encouraged obedient domesticity were brought to bear on school-trained girls. Some contributions were made by organizations such as segregated versions of the Girl Guides movement started in Southern Rhodesia in the 1920s.[13] School-age members were "Sunbeams"; older girls and women were "Wayfarers." Among other things, a Wayfarer did "her duty to God," was "a friend to animals," and was "clean in thought, word and deed." Wayfaring could change behavior; European women missionaries approvingly noted that after a few years, members often showed a "noticeable improvement" in personal appearance and "a greater understanding of the team spirit," and many had "spotlessly clean houses."[14]

The significance of these developments to the process of differentiation was expressed by a woman who became very prominent in women's organizations in Harare township in the 1950s. She had joined Wayfaring in 1929 and recalled that of the members of her generation, all had "assumed proper wifely characteristics in their homes and *are well-known even now*."[15] That the materialistic content of these messages had been well received was indicated in a description of "leading" urban African women in the 1970s:

These women are determined not to be left behind in the rat race of catching up with the rising living standards. They lead in introducing modern techniques in their homes and develop the community around them. They dress fashionably and often buy their clothes from leading stores and boutiques in town. They aspire to holidays abroad if they can afford it. They buy their food from supermarkets in town because the stores in their townships do not carry the type of choice of items they wish to purchase. Many of them drive cars of their own ... the desires and aspirations of these women are not different from any other race.[16]

Thus the early ideological pressures on African women from above focused on a small group of educated, Christian girls who were meant to be precipitated out from the mass of rural African women in order to provide proper wives for Christian boys. The seven H's (noted earlier) reigned supreme and were joined by what might be called the three P's: possession, property, and prestige.

Marriage and Class

Marriage has been a problematic subject in African studies. For example, a recent study of the construction of gender in Africa described the institution of African marriage as "a historically constructed, constantly negotiated mechanism of social control."[17] This describes a continent populated by calculatingly efficient and practically emotionless people. Did African people not marry for attraction, or love? Was this not especially possible in an urban environment, where the social ties of the rural areas (one manifestation of which was the arrangement of marriages) were looser? Unfortunately until histories of romantic love in southern Africa are written, historians will continue to portray intimate relationships as governed by essentially the same dynamics as corporations and grocery stores.[18] Marital attachment is, of course, a prime site of economic strategizing. Still, one of the epistemological techniques that continue to dog African people is the discussion of aspects of their daily lives as if they were never lost in thought, never angered, never enraptured. Texts that do delve into emotional matters, though, can just as

easily be off the mark: "African women respect their husbands but love their children," declares one such study.[19]

Marriage was a crucial element of being well-known in urban colonial Zimbabwe, but marital status was an extremely complicated issue.[20] African men and women in Southern Rhodesia could be properly married in either or both of two ways. First, they could be married "traditionally"—the marker of which was that *lobola* (bridewealth) had been agreed on or paid partially or fully by the man to the woman's family and the woman had passed into the new husband's sphere of influence. A second alternative was to be married by "Christian rites." Finally, a couple could chose to be married according to both systems—to enter into an agreement about *lobola* payment and to have a Christian ceremony. A fundamental dividing line between these options was whether or not the union was monogamous; polygamy was welcomed in "traditional" unions, but the colony's Christian denominations all consistently refused to allow it. Either type of marriage could be registered with the colonial authorities, at which point the individuals concerned would gain yet another kind of identity document: the marriage certificate.

What made a marriage proper was its discursive and conceptual distinction from a conjugal condition that was widely recognized and practiced but was roundly officially condemned by practically every segment of Southern Rhodesian society: *mapoto*,[21] or temporary marriage. In a *mapoto* relationship, no Christian or "traditional" ceremonies were undertaken. The families of the two parties were not consulted, and consequently no *lobola* payments were arranged to flow from the man to the woman's family. Both man and women involved in a *mapoto* relationship acknowledged that the relationship could be terminated at any time. A *mapoto* marriage thus eluded the authority of clan, lineage, and family, as well as that of the colonial state.

By the 1970s, according to Weinrich, the paths of urban women had developed in ways which intertwined marital status, education, and financial position. Women married in traditional, non-Christian ceremonies often were uneducated or had only a little schooling; women in *mapoto* relationships were never professionals but had perhaps primary schooling and had perhaps seen a failure of their hopes of coming to town to find a job. Finally, she noted, "Wives married in church have generally received a primary education, often a secondary education, and many of them are engaged in the professions." [22] These paths were some of the patterns that were in the process of setting in the period under review in this book.

In this period, there were a variety of obstacles in the way of achieving a "proper marriage," and consequently, properly married women were in a minority in the township. Official obstructionism, the difficulty in finding a suitable partner and in saving up enough money for *lobola* payments, the various requirements of Christian ceremony and marriage, and the practice

Table 2.1 Women in the Salisbury and Bulawayo Locations, 1930

	Salisbury	Bulawayo
Wives ("properly married")	150	200
"Concubines" (women in *mapoto* relationships)	300	725
Prostitutes	150	300

Source: The terms *properly married* and *concubines* were used in the original documents: NC Salisbury to CNC, 31 August 1936; Acting Superintendent of Natives Bulawayo to CNC, 15 September 1936. S 1542/S12, 1936–39.

of men leaving their properly married wives in the rural areas made marriage difficult both to achieve and to sustain in urban areas. Table 2.1 displays official estimates of the marital status of women in Salisbury and Bulawayo in 1930. Even allowing for a large degree of inaccuracy, it shows that proper marriage was a condition achieved by few.

A proper marriage, marked by a certificate, was the sine qua non of social respectability and, as Weinrich noted, of professional status. In the 1950s, the marriage certificate was also a woman's passport to the few urban perks that existed: enrolling one's children in a public school, being exempt from some police harassment, becoming legally self-employed, giving birth in a maternity hospital, or applying for slightly more spacious housing, for example.

But marriage in itself was not the most important marker of a woman's proximity to the state of being "well-known." Economically, marriage was a key attribute of urban economic survival but this was because women's access to land was mediated through men. The basal determinant of her social and economic position was her access to land, the urban expression of which was housing. Women who were able to accumulate some amount of capital had access to housing, which, dating roughly from the mid-1940s, they secured primarily on the basis of the formal relationships that they maintained with working men. Housing and marriage were linked because one of the main thrusts of urban segregationist legislation was to tie the provision of housing to male employment. After the implementation of the 1946 Natives (Urban Areas) Registration and Accommodation Act (NUARA), a man who lost his job in town lost the right to rent accommodation as well. But the municipalities never provided enough accommodation for the working African men of their cities. For women, gaining access to secure, legal housing was the only way to carry on some kind of entrepreneurial activity and/or to reproduce labor consistently. Owning land or a house, or to a lesser degree having the security of ten-

ure represented by being an approved tenant, meant that a person could at least potentially engage in a variety of accumulatory activities. Rooms or space to build shacks could be rented out to lodgers, vegetables could be grown for sale, bricks could be made, a minibrothel could be operated, or a small gambling operation could be run, or beer could be brewed, concealed, and sold. Significantly, all these activities could involve the hiring and exploitation of the workers who brewed and sold beer under supervision, worked as prostitutes for small-time madams, weeded vegetables, rented or sublet rooms from stand owners or house tenants. This group may also have included any domestic workers who cleaned the houses and clothes and took care of the children of these invariably Christian families.

The legal, or relatively secure, housing required for these activities was, however, extremely scarce. In the mid-1950s, for example, there was a backlog of at least twelve thousand housing applications in Harare township.[23] Therefore, an urban woman's primary motive and responsibility were to find space for herself, her belongings, and her children (if any) in a house; or a room; or space in a room. With very few exceptions, maintaining a relationship with a man was the most enduring way to achieve this, and the ideologically preferred way was through "proper" marriage. In 1943 it was already cynically observed by one official, "The marriage certificate, instead of being an imposition requiring legal penalties to enforce it, has become such an attraction that the urban Native Commissioner spends his time withholding it." He added, "And in spite of this, married quarters are being built at a rate far behind demand."[24]

Access to Housing

Urban women who had an eye to saving money from legal activities had few options. Until the 1950s, legal self-employment was restricted to men,[25] and there were few formal employment opportunities open to women (see later). They could, therefore, try to accumulate only through illegal activities. Two were what are now thought of as "traditional" for urban women— prostitution (see Chapter 3) and beer brewing (discussed later). All of these options were predicated, however, on control of or access to housing.

The authorities of Southern Rhodesia's towns followed different policies in allocating housing to African residents. The more liberal policies followed in Bulawayo are instructive. After 1895 the Bulawayo Sanitary Board (forerunner of the town council) allowed Africans to own dwellings in the location, while, however, retaining ownership of the land under the houses. This arrangement gave rise to a distinctive pattern of urban housing. In 1914, 92 percent, and as late as 1930, 68 percent of the

stands in the Bulawayo location were rented by women: a situation strikingly similar to that in both early Nairobi and some areas of Johannesburg in the 1920s.[26] Miss Theresa Cele, who was born in 1925, remembered the story of her grandmother's buying a stand in "Ma-BMC," the Bulawayo municipal compound, later known as Makokoba township:

> My granny was married by a European. She had four children . . . and then her husband died. That's the time when she bought the stand [where] we stayed. And her children were supporting her . . . the story, they say, when my grandfather died, she was given the money, then bought the stand.[27]

In addition to the obvious advantage of having housing for one's self, stand rental was a potentially excellent source of capital accumulation. Rental cost five shillings, but up to six huts could be built on a stand and rented out for five shillings apiece. There was no rent control in the location. By 1929, one woman had been able through a variety of activities to accumulate an estate that one government official estimated was worth hundreds of pounds.[28]

A diverse female population owned huts in the Bulawayo location. In 1915, for example, one group of location residents complained about women who were keeping brothels; in court, the accused madams all pleaded guilty. By 1930, allegations that prostitutes owned houses and also sublet them from male stand renters greatly vexed the municipal authorities.[29] On the other hand, a group of respectable married women in the location organized themselves to defend their economic interests in the 1920s; in testimony to the 1925 Land Commission, the president of the Bantu Women's League said,

> [Women] used to get a stand and they would build rooms on them which they used to let to other natives and now they are not allowed to do that. It is very hard on them as the men cannot get sufficient money to support their wives.[30]

African women also owned location houses in the midlands town of Gweru; Jeater notes cases of women's investing in property in the location and building up a "considerable" housing stock.[31]

African residents of the Salisbury location, however, were never allowed to build or own their own houses. But until the mid-1930s some Salisbury women managed to emulate the efforts of women in other towns despite legal restrictions. Decades later, prominent African men who had lived in the location recalled that it had once been possible for women to bribe the location police to allow them to rent houses for themselves. The practice of a

woman using a man to register for a house as her proxy also seems to have
been widespread in the 1920s.[32] According to Johanna Scott, who moved to
the location in the 1920s:

> If you [a woman] went to the location you could get a house. If you were
> a girl doing [prostitution], if you wanted a house you could get it. Rent
> was eight bob. If you had a house it was yours personally—as long as you
> could pay eight bob for it. . . . Then they said, "The houses are now for
> men," and those men who had no houses were given where the women
> had been removed. That's when they did away with giving women houses.[33]

Emma Magumede was such a person. Originally from Bulawayo, by the
1930s she had achieved notoriety in the location for her enormous physical
size, her "modern" life-style, and the wealth she accumulated from brewing
beer and running a brothel.[34] Even allowing for retrospective exaggeration
from fellow residents many decades later, Magumede must have been an
extraordinary person: tales were told of how she had not one, but two loca-
tion houses registered in her name; how she not only owned a car but em-
ployed a man to drive it. The "grocery store," which may have technically
been rented from municipal authorities in the name of her son-in-law, Jim
David, was widely remembered by residents of the time to have been man-
aged and controlled either by her or by her daughter, Winnie.[35] Despite her
disrepute, her son-in-law became a prominent township figure in his own
right, especially in the Reformed Industrial and Commercial Workers' Union
(RICU) of Charles Mzingeli, where ironically in 1951 he made a speech
welcoming women into the RICU as long as they met "the proper social
standard."[36] At his death in 1954, the respectability gained by the second
generation of this family was underscored by a report in the African press of
a statement from Winnie that thanked the "Daughters of Africa Burial Soci-
ety," numerous location residents, and church ministers for their support and
urged location women to belong to "church organizations and other benevo-
lent organizations such as clubs for members of such organizations are bound
by common ties."[37]
 The link between proper marriage and access to housing and economic
opportunities was displayed in 1953 when the Salisbury municipality decided
to accept applications for the lease of a "native eating house" in the location.
The twenty-eight applicants included nineteen men, seven women, a burial
society, and a musical group. Six of the women applied on the basis of being
married to men who were prepared to advance varying amounts of cash as
security. These amounts ranged from four hundred pounds to one thousand
pounds. The seventh woman was in business for herself as a wood vendor,
but her application was withdrawn. Interestingly, one of the married women

applicants was Winnie Magumede, of whom it was noted, "runs [her husband's] general dealer's store."[38]

The career of the first woman general dealer in Harare township displayed a similar relationship between marriage and housing and economic success. Born in 1913, Bertha Charlie had only minimal education and came to Harare township in 1931. On the basis of having been one of the local married women trained by the local volunteer Red Cross group, she started working in the late 1940s as a ward maid at the hospital for Africans in Salisbury, for which she received the "coloured" wage of eight pounds. She was then asked to become one of the first African women members of the Salisbury Municipal Police, where she and colleagues were charged with keeping order among the township's female population. Three years later she was given a license to sell cooked food to workers from premises that the municipality rented to her. Finally in 1957, she was "chosen" to operate a general dealer's store in the location, using as a foundation the money she had saved from her police wages and as a food vendor. In 1989 she was still running her business, employing at least three workers in the shop. In reflecting on her experiences as a businesswoman, she said:

> [In 1957] the whites . . . said, "We want to see what a black woman can do." Many people were put forward and I was chosen. . . . Many people fought for this shop. But Mr. Briggs [director of "native administration" for the city] said, "This is municipal property, this country doesn't belong to anybody [i.e., not only to men]." Many fought for it. But I persevered, my child. We can't tell you some of the things. . . . You would find horns [attempted witchcraft] across the doorstep. But I persevered . . . I was as good as the men, we were equal. I was even better than some.[39]

At every step up the ladder, Mrs. Charlie took advantage of the few, meager opportunities that the state held out to African women. From the first crucial step of being properly married, she went as high as a relatively uneducated woman in the township could. She learned first-aid skills, worked in the hospital, enforced municipal laws on other women, sold food to men who were not allowed to bring their families to town to cook for them, and sold small groceries to her neighbors. These were remarkable achievements for one woman in a time of severe restrictions.

Another method of accumulation by women was through the manufacture and sale of handicrafts, the most prominent of which was crochet work. This was historically entirely a women's occupation. In the towns of Zimbabwe today it is common to see unemployed and uneducated women hawking crocheted doilies, bedspreads, and clothing. But the prac-

tice of making and selling these items originated with more educated women, who probably learned the craft in mission schools and then taught it to each other. For example, one woman from a prominent family who came to live in the township in the 1950s was initially taught the craft by, and worked for, her sister. She branched out on her own and later also contracted orders out to other women. She claimed that in the 1950s she made enough money from her crocheting business to lend money to a brother who owned several buses![40] Another woman who "lived on doilies" remembered:

> [in the 1950s] many people hadn't known about [crocheting]. I taught my niece how to hold a crochet [hook]. She is now in South Africa, selling doilies. I told her, "Use a crochet, there is life in it." People were not yet aware that crocheting has got money, has got life, so that you won't bother your husband [i.e., need to ask him for money].[41]

DOMESTICATION PRESSURES FROM ABOVE, 1940s–1950s

As urban women consolidated their presence in town, they began to come to the attention of the colonial state. From the virtual neglect of the problems engendered by the presence of African women in cities, from the mid-1930s, increasing in pace after World War II and moving to consolidation in the 1950s, the colonial state and its associated institutions began to address the issue of the roles urban African women should play. Internationally, this realization was in line with developments in the rest of colonial Africa.[42] Internally, it was a spin-off from the struggle waged by male workers to force the colonial state to recognize their status as members of family units rather simply as unattached migrant workers. Consequently, Prime Minister Godfrey Huggins grudgingly acknowledged in a famous statement following the 1948 general strike, "We shall never do much with these people until we have established a native middle class."[43]

The large-scale presence of women as wives was the primary differentiating factor between a male migrant labor force and a settled, "stabilized" work force. Wives could be economically useful, as the 1944 Howman Commission discovered. "Bachelor" workers were the worst sufferers from malnutrition, and their living quarters were described as being in a state of "unhygienic filth." Married male workers, on the other hand, benefited from having properly cooked meals and from living in clean rooms staffed by wives who demonstrated what the commission felt was a remarkable level of "house pride."[44]

Given that the state eventually saw the value of having women in urban areas, what messages did it aim at them? Evidence for earlier periods is scanty

but suggests that the ideal of a properly domesticated wife was appropriated from rural ideology as the model of the ideal urban woman as well. "Cookery, laundry work, housewifery and other domestic science subjects" were the only subjects taught in classes for location women in 1936.[45] The following year a municipally funded "African women's club" was formed in the location, and sewing and knitting were among the new activities its membership took up. Significantly for the matter of differentiation between urban women, membership in the club was restricted to married women.[46] As influential as these messages were, however, it should be noted that according to a study carried out in 1957, 80 percent of urban African women had no affiliation with any club, association, or society.[47]

Timothy Burke's recent study of commodity marketing and consumption in colonial Zimbabwe has provided another dimension to an understanding of the imposition of domesticating ideology. As the state provided money for the classes, and the wives of government officials made it their business to help African women find the paths to proper domestication, local outposts of giant multinational firms like Lever Brothers dangled endless pills, cremes, and ointments in front of urban women.[48]

DIFFERENTIATING IDEOLOGIES FROM BELOW

All these pressures from above may have been persuasive and powerful, but alone they would not have made much impact. In fact, African urban communities themselves embraced a related differentiating ideology. This was the idea that there were "good" women and "bad" women and it was in the interests of all concerned to put conceptual, if not physical distance between them. Good women were ideologically separated from bad primarily according to their marital status. It has already been noted that the first club for African women in Harare township refused to accept unmarried women as members. This club was led by Mai Musodzi, a.k.a. Mrs. Franks, who was perhaps the best-known woman in the early history of the Salisbury location. Yoshikuni has traced her early life, from orphanhood during the first Chimurenga of 1896–1897, to married prosperity on a farming plot near Salisbury, through a move to the location in the mid-1930s.[49] There she quickly became the leader of respectable location women. Noted for her willingness to take on municipal officials in English on behalf of the township's women,[50] she served in many aspects of volunteer work until her death in 1952. Mai Musodzi almost had it all: relative prosperity gained in her farming years, a proper marriage, a township house, standing as a Catholic churchwoman, and relative safety from colonial harassment. What she did not have, interestingly, was formal education. This did not block her progress through the history of the township as an influential and powerful figure. The categories

that she personified endured: to become a member of the popular and powerful women's organization of the Methodist church, the *Ruwadzano rweMadzimai,* for example, one not only had to be married, but had to have had a church ceremony. Uneducated women were welcomed as long as they met this qualification.[51]

The minority of educated and properly married women were urged not only to learn, but to display the skills that would visibly differentiate their life-styles. Popular magazines in the 1950s sang the praises of women who learned such crafts as flower arranging: "We say, this is progress!"[52] Women's organizations within the churches played similar roles. According to *Ruwadzano* rules, members did not brew beer "or send others to do so"; they should not smoke, quarrel, or fight; a member "must keep her home clean, and her children clean, look after her husband's clothes, keep them clean and the buttons sewed on, and give him warm water with which to bathe."[53]

Clubs for urban women had become quite well established by the late 1950s, although only a minority of township women were members. Some boasted the leadership of European ladies; others were run by African ladies, but aims were similar: teaching or improving domestic skills. According to one group of Europeans who ran a club, "We are trying to give them the advantages that we have had from civilization . . . the male cannot advance on his own."[54] To this end, annual meetings of the Federation of African Women's Clubs featured demonstrations of how to make scones and lay a table for dinner. Mrs. Helen Mangwende, the wife of a politically active rural chief, was instrumental in setting up women's clubs in rural Mashonaland and served as an inspiration to women elsewhere. Mrs. Mangwende summed up the mission of the clubs in 1954: African women had "a great contribution to make . . . by building up happy and ideal homes," in which there would grow "healthy families, prepared and educated to face the future under the British flag."[55]

Sometimes ideologies from below, and literally from above, merged; an example is the extremely popular "Radio Homecraft Club" (RHC), broadcast on government radio after 1954. RHC was started by an African woman, Agnes Kanogoiwa, as an effort to "get women together because of some things we didn't like."[56] In a 1989 interview, Mrs. Kanogoiwa emphasized that one of RHC's functions was to air women's problems, these being mainly the difficulties faced by women who were not conversant with domesticity on the European model. RHC, which expanded from thirty to sixty minutes of weekly broadcasting by 1959, pumped out heavy doses of domesticity over the air. Early programs were in play form. Installments focused on two initially helpless, "primitive and ignorant" housewives who through diligent attention and practice eventually reached a standard of domesticity high

Table 2.2 African Women Formally Employed in Salisbury, from Official Sources, 1936–1969

	Employed Women	*Women in greater Salisbury*	*Percentage employed*
1936	167	2,700	6
1954	1,641	8,330	19
1956	1,527	6,312	24
1962	n/a	36,060	n/a
1969	10,190	100,320	10

Source: Teresa Barnes, *African Female Labour and the Urban Economy of Colonial Zimbabwe, with Special Reference to Harare, 1920–39* (M.A. Thesis, University of Zimbabwe, 1987), p. 43–44; City of Salisbury Department of Native Administration Annual Report, 1954, 1956; Report of the 1969 Census; population figures from Table 2.1. It should be noted that the numbers of employees in the 1950s are underestimates, reflecting only the people whose employment contracts were registered with the city's Registrar of Natives by their employers. After 1946 employers who could not prove that they had provided housing for their workers (a provision of the Natives Urban Areas Act) could not register them; thus, "a considerable proportion of African females in employment . . . are not in possession of registered contracts of service for the simple reason that there is no proper accommodation for them." Any such workers, male or female, were left out of the official tabulations. Report of the National Native Labour Board on . . . the Conditions of Employment of Native Women in Certain Industries, 1952, p. 11.

enough to allow them to compete in needlework competitions. RHC ran an annual sewing competition that brought in hundreds of entries. Winners received "a [sewing] machine or a radio set or something and that encouraged women to learn."[57]

FORMAL EMPLOYMENT OPTIONS FOR AFRICAN WOMEN IN THE TOWNS

Mission-educated women were mostly a rural phenomenon in the pre–World War II period, as they generally married men who then stayed within the sphere of the rural missions. Women who lived in the colony's towns represented a separate strand in African society. On the whole, the first women who came to towns were disaffected elements of rural society who sought new opportunities in the urban environment, girls running away from arranged marriages, wives leaving their husbands, and women of various marital status who fled rural communities in the wake of natural disasters and war.[58] Economic data on these urban women are sketchy and unreliable,[59] but as Table 2.2 shows, only a minority were formally employed.

Although wage labor for women grew steadily, then, it never employed more than a fraction of the African women in the city. This distinction becomes even more stark if unofficial population estimates are used. Phimister estimates that there were perhaps twenty thousand African women in the Salisbury townships by the early 1950s;[60] in which case, the number of formally employed women was minuscule.

However, although they were a tiny minority in regards to both other urban women and employed African men, by the early 1940s the increasing number of African women in industrial employment was noted throughout the colony. In 1940 the colony's prime minister believed that urban-born African women would soon begin to play a greater role in urban employment. By the end of the war the colony's employers had found themselves in a serious labor bottleneck: the chief native commissioner (CNC) reiterated in 1947 that the replacement of men by women as domestic workers was "obviously necessary;"[61] and in 1948 the NC Salisbury wrote disapprovingly of "the unseemly scramble for labour" among local employers.[62] Sure enough, two years later the municipality recommended that "more use be made of native female labour."[63] At the same time the colony's major employers urged that more urban housing be built, especially for women workers.[64] Women's wages were generally lower than men's: although those at the very bottom of the wage scales were paid virtually the same pittances, at higher grades the ratio of men's wages to women's was three to two, and in teaching it was six to five.[65] With this incentive, some employers in the postwar era gambled on the newest fashion in labor relations: "native females."

This growth in formal employment occurred in a confusing legal situation. As African women had the status of legal minors, employers could not legally enter into contracts with individual women, regardless of their age. Only their male guardians had the power to sign a contract with employers, who were left to decide for themselves how to negotiate questions such as which man in a woman's family could legitimately claim to be her guardian, to whom wages should be paid, and what should happen if a woman changed jobs.[66] Despite these difficulties, employment for African women in Salisbury grew steadily in the postwar period, tied to the boom in the tobacco industry and a large increase in the number of white households, which stimulated the demand for female domestic workers.

The Leaf of Gold

Tobacco became Southern Rhodesia's premier crop after World War II; as a result of the continuing demands of British smokers and a dire shortage of dollars to pay for American leaf, the giant British tobacco firms began to import Southern Rhodesia's crop, for which they could pay in sterling. The

output of the colony's previously faltering tobacco planters grew 200 percent in the 1940s.[67] This massive expansion necessitated new labor strategies: desperate to maintain the labor-intensive boom, the new tobacco barons began to pay higher wages than their main competitors for agricultural workers,[68] and many also began to employ more women. There had only been 4, 10, and 94 African women employed colonywide in the entire food, drink, and tobacco manufacturing sectors in 1936, 1941, and 1946, respectively.[69] But by 1952, there were more than 200 women working in tobacco grading and leaf tying in Salisbury alone.[70] Although employing some women as casual, part-time workers had been the norm in agriculture for many years, postwar tobacco planters and companies found this style of women's employment inadequate in the new era. By the mid-1950s tobacco growing and grading concerns were making increasing use of women workers.[71] Men continued to make up the bulk of the work force, however; the United Tobacco Company did not even propose to experiment with including women in its 900 strong work force until 1956, when it sought advice from the government on "the type of African female who would probably be most suitable."[72] In 1960 the Tobacco Export Corporation employed 117 women and 453 men.[73]

In addition to increasing the number of women workers, employers also began to try to bring them under more stringent labor discipline and even to shape a new kind of female worker. Thus an association of tobacco growers in the eastern district of Makoni recommended,

> that in view of the acute shortage of labour and the probability of further deterioration, every effort be made to enquire into the feasibility of employing unmarried girls under the same conditions appertaining to men but with the strict control within their own hostels and with evening classes including such items as homecraft, mothercraft, cooking, correct feeding, cleanliness, etc., each girl to be under contract, attested before a Native Commissioner and in the presence and with the consent of the father or guardian.

In this ambitious (but mercifully probably unimplemented) attempt at social engineering, the growers disingenuously claimed,

> It is felt that this scheme would be of direct benefit to the native girl, would be welcomed by her and her father; would have the support of religious bodies and would ultimately benefit the native race.[74]

Recurring themes in the correspondence about women working in the tobacco industry were their suitability for and reliability in certain jobs. Em-

ployers seemingly made such judgments according to gender stereotypes, not individual cases: women worked for lower wages and they had that mythical manual dexterity: "Certain jobs such as stripping is [sic] done well by female labour."[75] Stereotypically,

> while [women] were working, they were better than the African male adults at handling the leaves, but as soon as they drew their pay, they absented themselves for periods of six weeks or so and were completely unreliable as far as attendance was concerned.[76]

Similarly, farmers often complained that potential women employees would frequently "refuse to work for no apparent reason." Women could be "difficult to reason with." Another employer complained of the "monotonous regularity with which these women fall pregnant."[77]

Payment schemes for women in the tobacco factories varied. Some worked on a piecework basis. According to a woman who worked for a tobacco firm in the 1950s,

> you earned money according to your strength. One day you could not prune [stripping the leaves from the stem] enough to fill a "pocket" which was like a pillow case. Then when you go to the scales, if you had done little you could get 75 cents [7/6d.].[78]

Other firms paid a basic wage and bonuses for extra production. One company, which employed one hundred women, noted a case of a woman who earned bonuses of one, two, and four shillings, respectively, in her first three days of employment on a daily wage of only three and a half shillings.[79]

Tobacco grading remained an important source of employment for African women in Salisbury through the 1950s. Although there is little documentary evidence with which to judge women's levels of labor organization in the industry, there are indications that they successfully made demands of their employers on issues that specifically concerned them as women. Thus in 1960, the Tobacco Export Corporation converted two prefabricated huts, previously used as male dormitories, to child care centers for its women employees; it would be difficult to believe that this occurred through the company's unsolicited benevolence.[80]

Pushing Prams to the Park

Women's employment in private domestic service was the other, numerically more significant field of opportunity for urban African women in the

1950s, as a result of the high levels of white immigration into Southern Rhodesia's towns after World War II. From 1946 to 1951, 64,000 new white immigrants flooded in, and 9,000 came yearly through the 1950s.[81] The white population of Salisbury mushroomed from 11,392 in 1936 to 61,850 in 1956.[82] These new Rhodesians enthusiastically agreed that white should be served by black, and postwar Rhodesia employed ever more "nurse-girls," "garden boys," and "cook boys."

In this era, factory work was generally lower paid and less prestigious than domestic employment.[83] Mrs. Cecilia Rusike, for example, who worked briefly at a uniform factory in the 1950s, recalled the ups and downs of learning to get to work on time:

> You didn't sleep! You had to find somebody to wake you up and say, "Hey, is dawn!" If you try to sleep too much—"Oh! I am late!" and sometimes you run, like that [unbathed] and go and wash your face at the tap, and run! But when you got used to it, you would ask, "Who has a watch, what is the time?" "Ha, it's not time yet," and you go walking nicely.

Industrial work called for fewer communication skills and paid lower wages. Mrs. Rusike recalled:

> If you had a relative who was working they would advise, "You can do this [factory job] but not this [domestic service] where you always have to speak English, [and] you may be fired." That's why they looked for jobs for us which they thought we could do, and we worked just seated, not speaking. [In the factory] the inspectors would come and say, "Ah! She has done well," but you didn't talk much. That's what made us not to go to high jobs here if you were asked a question you [could only] say, "Ah. Yes. What? This?" So does that help? So they looked for [jobs] where we didn't have to speak.[84]

Mrs. Rusike must have learned these lessons with alacrity, for she left the uniform factory, where she earned ten pounds per month, and found a job looking after children in the northern suburb of Avondale for fifteen pounds per month. Similarly, Miss Keresiya Savanhu, who started working in 1952 on a production line packing biscuits, recalled that her industrial wages were less than those that she earned at her next three jobs as a domestic worker, where her monthly wages of four, five and nine pounds, respectively.[85] Her sister, Miss Matombi Savanhu, recalled the history of her domestic employment:

1954 Looked after one child and did housework in an apartment in Eastlea for four pounds per month

1955–57 Made morning tea and did light cleaning, laundry, and ironing for
 a family in Mount Pleasant for ten pounds per month; was given
 all the leftover food as well as a ration of mealie-meal

1958–80 Worked as a washerwoman for a series of employers; would col-
 lect laundry, take it home to wash and iron and return it the next
 day; paid seven or eight pounds per month; a person "with strength
 could get forty pounds per month"[86]

These wages can be contrasted with those paid by two Salisbury facto-
ries in 1953. At. B. L. Odes (Pvt.) Ltd., twelve women were engaged at a
monthly salary of £4 in the manufacture of cotton wool products; twenty-
one women were employed to wrap biscuits at the much lower monthly
wage of 12/6d at Wheat Products (Pvt.) Ltd. Although "liberal supplies
of broken biscuits to eat" were also given to the Wheat Products workers,
the observing government labor officer reported that it was "no wonder"
that the manager of the factory was reporting trouble with "absenteeism
and lack of interest" from his female workers.[87] Indeed, a few months
later, the officer wryly commented:

> Messrs. Wheat Products Ltd., manufacturers of biscuits, have decided
> to dispense with all female labour and to engage African junior [boy]
> employees instead. I am informed that the reason for this changeover
> is because of the absenteeism and the instability of the female workers.
> On the other hand, the manager of B. L. Odes Ltd., reports he is com-
> pletely satisfied with his female staff and he has no trouble dealing
> with absenteeism.[88]

Women like the Savanhu sisters, who worked as "free-lance" domes-
tics, earned a monthly average of £9.10.0 in 1957–1958 and £13.7.0 in
1959–1960.[89] These wages compared quite favorably with the average
wage of African men in Salisbury at that time: in November 1957 the
average income of so-called single men was £7.5.7d, rising to £8.1.10d.
in March 1958.[90]

The comparatively high wages that urban female domestic workers
could command had been a matter of comment for some time. In 1932 a
committee set up to investigate the question of African women in domes-
tic service noted that many European parents sought African women to
look after their children; presumably this would have translated into rela-
tively decent wages at a time when waged women were less common
than they were to become after the war.[91] In 1942 the NC Salisbury noted
that because of the scarcity of women child minders, even a woman in
her first such position could successfully demand wages equal to or greater

than those of "a good cook-boy, the head man of the domestic staff."[92] In 1946 a writer for the *African Weekly* sketched out the local laws of supply and demand in the domestic work sector:

> There are some who wonder why women get higher wages than men. This is because there are a lot of men who want to work, yet there are a few women and they are hard to get, so the whites increase their wages so that they won't leave. But men are paid less because the whites know that if the man leaves, they will quickly get another.[93]

In 1952 similar comments were to be found in the national census report, and a disgruntled official of the Salisbury municipality wrote:

> It is surprising to note the very substantial concessions which employers will allow to girls which they will seldom allow to male servants. The great majority of female servants are employed as nursemaids to children and as such their duties consist of pushing a perambulator [baby carriage] to the Park and sitting and watching children at play. For such duties many of these demand wages in excess of the cook employed in the same household, uniform and in addition, insist upon food from the employer's table.[94]

But the shortage of female domestic workers continued. As late as 1957, the municipal employment bureau in Salisbury received 369 referral requests from potential employers but was only able to place 170 women as domestic workers; in the last six months of 1958 there were 225 requests, only 165 of which were filled.[95]

In this context, however, colonial officials complained bitterly about African women domestic workers; in 1943 one complained:

> [Female domestic workers are] most unsatisfactory. They are entirely devoid of morals, utterly unreliable and on the slightest rebuke, leave their employment. Loyalty to their employers, conscientiousness and industry are things entirely foreign to their nature . . . they will become more depraved as time passes and their ambitions grow.[96]

Another moaned, "They are dishonest and lack a sense of responsibility . . . these girls appear to take a fiendish delight in teaching these young [European] children bad language, etc."[97]

Keresiya Savanhu would have truly annoyed these men. Remembering her many employers in 1989, she coolly observed:

> The whites . . . were hard. They were stingy with money. The amount he wanted to give you is what he gave you. If he wanted to increase [your

wages] he would increase by only one pound. Then you found the job painful and you stop. You just quit.[98]

Such insouciance must have been widespread; one woman was reported to have said at a meeting in Harare township in 1951, "First we want good wages and second we should be supplied with scrubbing brushes with long handles so that we do not hurt our knees."[99]

The Savanhu sisters were probably in another minority group as well; living with their mother in a small house in Harare township, both worked independently as "free-lance" cleaners. They were among the tiny minority of the township's female population who were able to take advantage of one other formal employment option—to be issued with a municipal permit to be self-employed. After 1953 these permits were only granted to women who could prove that they were wives or daughters of an approved male tenant in the township. As noted, the women who were free-lance cleaners, known as charwomen, often earned higher wages than the average male worker. Further, some women were able to accumulate savings from their labors. After working as a child minder and then as a firewood vendor, for example, Jane Maruta made a sizable deposit on a new truck with which to start a transport business.[100] Another woman, a Mrs. Chauma, was described in 1956 as,

> the first African woman in Salisbury to run a taxi. Previously she worked as a chair-woman *[sic]* and from her hard work she managed to serve *[sic]* enough money to buy a taxi cab. She employs a driver to run the car for her.[101]

WOMEN AT THE BOTTOM OF THE URBAN ECONOMY

As not all women were able or willing to achieve what became known as "approved wife" status, the majority of urban women maintained a more tenuous access to urban housing through other relationships with men. The most common of these, *mapoto,* was so popular that the state was forced to tolerate it even in periods when it was under pressure to remove women from urban areas. For women, the advantages of *mapoto* were the access to shelter and food and sometimes, the accumulation of goods (see later), that it offered; its disadvantages lay in its fundamental insecurity. For men, *mapoto* had obvious advantages: "Life needs a woman. So you find it's better to have somebody to kiss you. That's all."[102]

In Table 2.1 above, 50 percent of the women in the Salisbury location were estimated to be *mapoto* wives; in one Salisbury compound in 1943, 34 percent of the men were involved in *mapoto* relationships.[103] State policy maintained an uneasy relationship with *mapoto,* sometimes denigrating fe-

male partners as "concubines," and discussing them with some distaste.[104] Nonetheless, for the state, there was the advantage that *mapoto* women took care of their temporary husbands without the regulation and bureaucracy that were the cornerstones of the "approved wife" system.

Miss Caroline Renhas described *mapoto* in the 1940s:

> We did *mapoto*, there in Mbare. Yes. You were told [by a man], "You! Can you leave this place swept?" You want *mapoto*. So you sweep and sweep. You go and fetch water. Then he says, "I have left you some money. Go to the butchery and buy meat." Then you go and buy that meat. Then you come and cook your sadza. You make your tea. You drink. Then you sit there at that door. He comes back from work, he finds you there. And he says, "This is my wife."[105]

Mapoto women worked for men in a kind of barter deal. In return for her domestic and sexual work the man provided accommodation, food, and, intriguingly, domestic goods. A *mapoto* woman was not paid daily or nightly for her services; instead, it was tacitly acknowledged that when she left the relationship she was entitled to take away with her some or even all of the household goods that she fancied: "She took them . . . even clothes, when she knew she wanted to go. Who would he go and report to? [She would say,] 'He was living with me, refusing to give me money. That's why I have taken the things.'"[106] A reader wrote to the *African Weekly* in June 1945 complaining that a woman moved into a *mapoto* relationship with "her tables, chairs and beds"; her possessions were of better quality than the man's so he disposed of his own, but when she left, "the woman takes everything, including the bicycle, and other things that she bought with the man's money. The house is left empty." The writer even concluded by noting that men were getting into difficulties with their proper wives because of this practice![107] An interviewee described the rationalizations of both partners at the end of a *mapoto* relationship:

> [She would reason,] "He has rejected me, of course. He rejected me when I still loved him and it's better to take utensils, of course, pots and pans, they are a woman's. . . . Yes, they are mine. I cooked and I washed for you, and slept with you. So what I have taken is mine." . . . [A] man could use force [to get his possessions back]; but some would say, "I still have my strength, I can work and buy some more. Let her go."[108]

This arrangement may have signified an ingenious solution to the problems engendered by the low wages earned by male workers, an unwillingness of men to give cash to temporary partners, or women's awareness that

Table 2.3 Monthly Urban African Wage and Poverty Datum Line (PDL) Estimates and Calculations, 1929–1960

1.	Average wage of unskilled male workers in Bulawayo, 1929	£1.2.6
2.	Minimum budget, husband, wife, one child, Salisbury location, 1938	£1.17.0
3.	Minimum budget, husband, wife, two children, Bulawayo, 1939	£2.16.6
	Average cash only wage of married men, Salisbury location, 1939 Percentage deficit = 27%	£2.1.2
4.	Average male wage (including food and value of accommodation), Salisbury, 1939–1940	£0.19.8
5.	Average male wage (including food and value of accommodation), Salisbury, 1942–1943	£1.3.1
6.	PDL for man, woman, two children, 1943 Average male wage in cash Percentage deficit = 35%	£4.15 £3.2.1
7.	Minimum wage required by husband, wife, two children, 1943–1944	£7.7.4
8.	PDL for man, woman, two children, 1944	£10.0
9.	Estimate of minimum needs for a family, 1945 Average male wage, 1945 Percentage deficit = 40%	£5.0 £3.0
10.	Estimate of needs for husband, wife, three children, 1948	£10.0
11.	Estimated household income, husband, wife, three children, 1950s	£3.0
12.	Estimated budget of an African teacher, spouse, four children, 1957[*] Monthly wage for teacher with lowest qualifications Percentage deficit = 53%	£17.16.8 £9.10.0
13.	PDL for man, wife, two children, Salisbury, 1958 Minimum male wage after 18 months of work Percentage deficit = 55%	£15.13.11 £7.5.2
14.	PDL for man, woman, two children, 1960	£15.0.1
15.	Personal calculation of needs for man, woman, three children, 1961 Wage Percentage deficit = 54%	£21.9 £10

Source: 1929 Figures from average wages schedule attached to Superintendent of Natives, Bulawayo to CNC, 26 July 1929, S 2584/73, vol. 1. 1938 Figures calculated by E. Cordell, Native Welfare Officer, Salisbury location, included in report to Medical Officer of Health, Salisbury, 4 February 1938, Salisbury Municipality file 12/1/1 jacket 1. 1939 Budget figure from report of the Matabeleland Native Welfare Society and Salisbury wage figure cited in E. Cordell, "Some Economic and Social Aspects of African Family Life in the Salisbury Municipal Native Location" (Report of the Medical Officer of Health to Salisbury Mayor and Town Councilors), 14 December 1939, Salisbury Municipality file 12/7 jacket 9. 1939–1940 and 1942–1943 Figures from oral evidence of Mr. Ferreira, Native Department pass officer in Salisbury to Howman Committee, 1943, p. 155, ZBI 2.1.1. 1943 Figures from Ibbotson, *Urban African Conditions.* 1943–1944 Fig-

ure from Phimister, *Economic and Social History*, p. 262. 1944 Figures from Edward Batson, *The Poverty Line in Salisbury* (Cape Town: University of Cape Town, 1944). 1945 figure from G. Ballenden, "Report on Salisbury's Native Administration" in *Bantu Mirror*, 22 December 1945. The 1948 figure was an estimate given by Grey Bango to the National Native Labour Board Commission of Enquiry, 1948, S 1561/57. Estimates of 1950s wage for a family of five come from Vambe, *Rhodesia to Zimbabwe*, p. 192. 1957 figures for a teacher's family from African Teachers' Association, "Memorandum to the Urban African Affairs Economic Commission on Living Conditions of African Teachers in Urban Areas," 23 November 1957, S 51/7. 1958 Figures from Urban African Affairs (Plewman) Commission report, 1958, p. 78. 1960 figures from David Bettison, "The Poverty Datum Line." 1961 Figures from Nathan Shamuyarira, *Crisis in Rhodesia* (London: Andre Deutsche, 1965), p. 102.

* These figures referred only to food, fuel, and lighting costs and did not include clothing and shoe replacement and repair, school fees, entertainment, books, traveling, stationery and stamps, and upkeep of house and furniture. Had these been included, the association estimated that the monthly budget would have been about £27. The Association claimed, "no professional man can subsist on a scale below £20.0.0 *per mensem* and even this figure is the barest minimum and not economic." The 1961 figures were an individual resident's assessment of an urban family's needs and included school fees, medical expenses, light, and entertainment (all of which added up to about £1.5). These two sets of estimates are unique in that they were calculated by urban Africans themselves rather than by outside researchers and thus may represent more realistic assessments of the financial pressures faced by urban families.

given one or both of these, money was not the only thing that one could get from a man.[109]

Halfway between proper marriage and outright prostitution, *mapoto* was a way of making ends meet. The threat of complete impoverishment, which women who entered into *mapoto* relationships were trying to stave off, was, in fact, all too real.

URBAN SURVIVAL STRATEGIES

At the beginning of World War II, Southern Rhodesia was precariously poised on the doorstep of economic modernization. In a swiftly changing and tumultuous world, old segregationist attitudes were challenged by new responses. For example, in 1941, while the Minister of Justice could still question the very need to pay wages to African workers at all, he could also be taken to task in verse by the missionary Arthur Shearly Cripps:

> Sir, Africans homes, wives and offspring need:
> Many dependents, old and young they feed.
> For selves, sires, kindred far away
> One pound a head they in taxation pay:
> Their Dipping Fees their Dog Tax, Crown Lands Rent,
> Church Rates, School Charges press for settlement:

Table 2.4 Sources of Average Legal Income to African Households in Salisbury, 1957–1958 and 1963–1964

	1957–58	1963–64
Husband's earnings or wages	£12.4.8	£13.9.5
Other income	£1.1.7	£2.10.4

Source: "1963–64 Budget Survey" (Harare: Central Statistical Office, 1964), p. 24.

Pass Laws and colour Bans and Maize Control
Batten like ticks on body and on soul.
No, Sir, 'tis neither just nor meet nor right
To fine the Black far heavier than the White.[110]

The passage of World War II and the postwar currents surging through the colonial world catalyzed change on a number of levels in Southern Rhodesia. As in the rest of Africa, under the twin pressures of booming urban populations and unprecedented levels of inflation[111] the terrible living conditions of urban Africans in the colony came under investigation in a series of more or less scientific studies. Percy Ibbotson (1943), E. G. Howman and his committee (1944), Edward Batson (1944),[112] the Central African Statistical Office (1957–68 and 1963–64), and David Bettison (1960) all tried to discover the qualitative and quantitative outlines of urban African survival. Although hampered by methodological shortcomings,[113] these reports demonstrated that even when so-called luxuries (like school fees, medical expenses, and taxes) were excluded from their calculations, urban African households were receiving monthly incomes far too low to cover their costs. As the Howman Report mused worriedly in 1944, "Very large numbers of [urban] families must be perilously near starvation point." The degrees to which wages were not meeting minimum requirements in urban communities are starkly illustrated in Table 2.3.

Measuring for a stereotypically European family model of a waged husband, an unwaged wife, and their children,[114] researchers were divided about whether or not African women played any appreciable role in household finances. Most concluded that they did, but dissenters included Ibbotson, who held a thorough prejudice against women's working outside the home, and Bettison, for whom women were only important insofar as they exacerbated previously existing levels of urban poverty.[115] Other studies, however, acknowledged that women were often the ones who did the spending; they also made important contributions to narrowing the gap between male wages and

family needs and should therefore be included in urban budget research. The 1938–39 report on married life in the Salisbury location acknowledged that women played a role in urban family survival and enumerated several strategies in which they participated, including

> the taking in of lodgers who, between them, pay more or all of the room rent; other ways in which the deficit is made good are by prostitution on the part of the women-folk, often with the husband's connivance, petty crime, gambling and the illicit brewing of liquor. Of these, my investigations lead me to believe that casual prostitution is the most frequent method adopted in balancing the family budget.[116]

Later surveys sought to quantify women's economic contributions. Thus government urban "budget surveys" in 1957 and 1963 showed that sources of income other than men's wages were, although still small, increasingly important (Table 2.4).

The survey also alluded to the likelihood that families were increasing their income slightly by means that "respondents were unwilling to disclose" to researchers, implying that wives were engaged in prostitution. The only method of income augmentation actually suggested in the report was the sale of "illicit beer."[117]

Urban Prostitution

Prostitution played a curious role in the political economy of urban colonial Zimbabwe. State and local authorities complained incessantly about African urban prostitution, but it was never outlawed. However, it was indirectly regulated in such a way that prostitutes were at the bottom of the urban economy. Women's independent access to housing was closed off in the 1930s (see earlier discussion), and their work could not then lead to any kind of accumulation. This tactic was also used by the colonial state in Kenya, although at a later date.[118] However, the forms of prostitution in Southern Rhodesian towns do not exactly conform to the models described in Luise White's study of prostitution in colonial Nairobi.[119] Because of the imposed lack of independent housing in urban Southern Rhodesia, after the 1930s prostitutes could not wait for men to come to their lodgings (although seemingly some did wait for men to knock on the doors of their husband's rooms while the latter were away at work). No evidence has come to light suggesting the noisy, aggressive solicitation of clients on White's *wazi-wazi* model. Instead of house owners or brothel keepers, by the 1950s, African prostitutes in Salisbury advertised sex and men paid for and performed it in bushes, behind buildings, at outdoor dances; perhaps in the man's room but not in a

woman's. In addition, evidence suggests that at least in the late 1940s and through the 1950s, many urban prostitutes were forced to have pimps because men would not allow streetwalkers to operate independently.[120] The structural insecurity of prostitutes' lives and the crucial role in their differentiation from other urban women[121] played by the lack of housing are illustrated in the following statements. According to one interviewee:

> [In prostitution] today you sleep here and wake up, tomorrow you sleep [there] and wake up. If you do that you have invited being beaten up by your colleagues, you have invited being called "useless." Because you are doing wrong. You have invited trouble. But if you stay in one place, that man will give you that shilling. You buy relish, you cook, you eat and you are satisfied. Going here and there was a problem.[122]

Her statement was corroborated by a somewhat puritanical social study in 1949:

> Of 177 females questioned in 20 Native clinics [around the country] . . . no less than 51 owned to being harlots. [They] have no regular homes and usually rely on the last client of the day. Although some . . . will accept all comers, the majority have one or two exposures a day sufficient to obtain food and lodging for the night and money for necessities. The standard charge is 2s 6d. [for] "short time," five shillings for the night, and relatively much cheaper rates for longer periods.[123]

In comparison to the varied patterns that obtained in Kenya, then, in Southern Rhodesia prostitutes were literally streetwalkers. Thus in urban culture prostitution was firmly linked with a woman's physical mobility, implying that once she was moving around there was absolutely no doubt about what she was looking for. When the subject of prostitution came up in all the 1989 interviews, it was referred to through a variety of ingenious euphemisms. But all of these were premised on the idea of motion, of mobility, as the following selection shows: "If a man said, 'I [love] you,' then you would go with him"; "Some just went around hoping to get proposed to"; "Most of them just went about, not having one man"; "They would drink beer and go with people's husbands, when dancing was still there"; "In those days, a woman who rode a bicycle was a prostitute. Honestly!" "Because you would see one on her own, sometimes you saw two together—like how people move around"; "[I would go] home to my husband. They remain[ed] moving around"; "Those who ran away from home and did that job of theirs."[124]

Thus, in popular estimation, if a woman walked away from the simultaneous restriction and protection of patriarchal authority, she could only be

doing one thing: going about looking for other women's husbands. This was the very essence of impropriety.

Far from being well known, by the 1950s, individual prostitutes were so disreputable that they had lost the individuality of their own names; according to one interviewee, prostitutes used the names of so-called "champions" who had been famous prostitutes of the 1920s and 1930s (years when urban women still had some economic independence).[125]

White's models of prostitution in Nairobi are concerned with describing not only the labor process of prostitutes, but the destination of the proceeds of their labor.[126] Some Nairobi prostitutes represented yet another battalion of migrant laborers struggling to maintain the economic integrity of rural households. These daughters of the soil engaged in less capital-intensive methods of earning money (i.e., streetwalking) so that they could regularly remit funds to rural households. *Malaya* prostitutes, on the other hand, who accumulated property and engaged in more stable, long-term arrangements, were most disengaged from the processes of rural reproduction and strove to earn, save, and invest for themselves and found their own new urban lineages. Although these categories cannot be transplanted wholesale to the Southern Rhodesian situation, they do suggest that further research may be able to trace the uses to which women's sexual earnings were put. It is not possible at this point to quantify these two strategies, but it is possible to demonstrate that both existed in the towns of Southern Rhodesia. Early urban entrepreneurs like Emma Magumede were surely planning to pass their skills and assets on to their daughters. Yet, as we have seen, the colonial state closed down the access to housing that made these accumulatory strategies possible. But what about the reviled streetwalkers? What relationships did they maintain with the rural homes from which they had come? Unfortunately at this point it is only possible to set a bit of documentary and anecdotal evidence against the widespread popular assumption that urban prostitutes worked only for themselves. An Ndebele woman named Tambeleki arrested by the Bulawayo police in 1920 gave a detailed account of her work as an unmarried, childless prostitute in the location.

> I charge 10/- for sexual intercourse. If a man stays with me all night and has sexual intercourse I charge him 20/-. It is very easy to earn money this way. I can easily make £10 per month. I once made £10 in a month at Wankie. I make most money out of white men. They pay me 10/- for having sexual intercourse with me once. Natives sometimes have sexual intercourse with me and I charge some 10/- and others 5/-. It just depends on how much money they have.

She also gave detailed descriptions of what she did with the money that she earned.

I give my money to my uncle. His name is Majiyana who lives at Clarks farm, Khami. He buys food with it. He buys food for his family. I have no parents. I have a brother who is always being arrested for theft. His name is Macacata. He is now in the Location. My uncle is my guardian. He knows how I make my money. He is always telling me he does not want me to be a prostitute but he is always pleased when I give him the money. I gave him £2 just after christmas *[sic]*. I gave him £4 about four months ago. This was when I returned after having a trip to the Wankie Colliery. It was part of the money I had earned by prostitution. I gave him £2 about a month ago. I take the money to him. I walk home. I stay at home a few days and then return to town.[127]

A dividing line between the rural and urban strategies may have correlated with the women's places of origin. Women like Emma Magumede who came to Salisbury from other areas may have found that their rural relatives were too far away to communicate with them. Perhaps, on the other hand, the very fact that they were so far away from their relatives was evidence that they had indeed severed ties. But Tambeleki was an Ndebele woman who lived within walking distance of her extended family's homestead. Similarly, in her childhood, Miss Caroline Renhas, who was born in 1919, lived with her family in rural Shamva in Mashonaland; her unmarried sister frequently took a four-shilling train ride to visit their parents from her home in Salisbury. The sister always brought gifts—money (two or three pounds) or a small packet of goods like bread, sugar, tea leaves, and milk. Her parents never asked how she had obtained the money to travel and pay for these gifts; Miss Renhas remembered that her father would simply proclaim happily, "See the money I was given by my child!"[128]

Detailed research is needed to answer why, if they contributed to the survival of rural households, homeless urban prostitutes were so reviled. Perhaps their denigration does indicate that as time went on, their ability to do more than simply survive on their earnings was drastically eroded.

Home Brew

Struggles over urban liquor brewing had a long history in Southern Rhodesia. As a useful rural tradition was transformed into a debilitating yet pleasurable and profitable recreational activity, the drinking habits of African people quickly became matters of great concern to industry and the state.[129] A traditional activity of rural women, in the capitalist order, the brewing of beer and liquor became one of the few skills that a woman could barter for cash. The clash between the views of alcohol as some-

thing to be strictly controlled versus a commodity that African women could easily produce and sell in the towns was a protracted and messy one. Using the South African "Durban system" as a model,[130] by the 1940s the Southern Rhodesian state had painfully developed a rather creaky system that awarded urban monopolies in beer brewing to agents of its choice (in this case, the Salisbury municipality) and provided stiff penalties for anyone else caught buying or brewing within "prescribed areas." In order to force African drinkers in Salisbury to quaff official brew and none other, by 1920 the area in which private brewing of alcoholic beverages was prohibited was extended from a two- to a five-mile radius beyond the area of the commonage surrounding the town: about fifteen miles from the city center.[131] Slaking the thirst of the community was much too valuable an enterprise for urban women to give up, however, and they turned to brewing alternative concoctions. So-called hop beer was at first a "harmless household refreshment" gradually made stronger by the addition of other ingredients such as potatoes and sugar.[132] According to Mrs. Enniah Mutuma, who came to live in the Salisbury location in 1936:

> At first [hop beer] wasn't intoxicating. Later they put yeast in it and it changed, almost like *chikokiyaan*. . . . At first they were not arrested. It was only when they started to put yeast. . . . [It] was even drunk in the hotels, like the one near the brewery. You would go there and buy it for five cents. But when they put yeast, [the police] saw people getting drunk, and it was now brewed in big drums like this, foaming like beer, and then they realized, "Ah, it's not [hop beer] any more," and they started arresting people.[133]

By the mid-1930s the authorities were taking action against hop-beer brewers; Emma Magumede (mentioned earlier), for example, was arrested for having "strong hop beer" in 1936, and the authorities put out the word "Don't Brew Hop Beer. . . . All those who sell hop beer will be sent away from the location."[134]

The next brew to fall into official disfavor was known under the generic name *skokiaan* (spelling variations were Mrs. Mutuma's *chikokiyaan*, and *iskokiyana*). As opposed to traditional sorghum (opaque) beer, skokiaan could be made from a variety of harmless-looking ingredients—butter, yeast, mealie-meal, bread, and sugar. It took less time to ferment and carried a stronger "kick." Some brewers made it stronger, if not practically lethal, by including additives such as methylated spirits.[135] In the mid-1940s, officials noted that although Salisbury and Bulawayo were ringed by prohibited areas almost thirty miles in diameter where the only legal sources of opaque beer were the

municipal beer halls, "the illicit liquor racket and its attendant evils are very evident."[136] A large part of urban police work consisted of finding and "spilling" caches of illicit brew. In one week in 1943, for example, one site on the brick fields outside Salisbury yielded up 120 gallons.[137] The Bulawayo police reported that hundreds of gallons of home brew could be discovered in a single raid on uninhabited areas surrounding the town.[138] In 1948 the police discovered and destroyed no less than 560 gallons of home-brewed beer and 62,600 gallons of *skokiaan* in and around Salisbury; in Bulawayo the situation was little better, as 15,000 gallons of home-brewed beer and fifty thousand gallons of *skokiaan* were destroyed.[139] These encounters were not risk-free for the police; in 1946 the Bulawayo police were reporting assemblies in the veldt outside town that attracted hundreds of African drinkers, who on more than one occasion resorted to stone throwing when the police arrived to destroy beer stocks. "To continue on the present lines," warned the police commissioner, "cannot but lead to a clash between the Police and natives attending the assemblies." As the situation worsened, the police experimented with spotting the drinking assemblies with aircraft.[140]

By this time, "*skokiaan* culture" was alive and well in the major towns of the colony. An *African Weekly* reporter wrote horrified articles in 1949 about what he saw as the "wholesale corruption of [the African] race" displayed in weekend *skokiaan* assemblies in the Brickfields area of Salisbury:

> Night gains and it is hard to see except by torch, and you see that buckets and drums are here, there, in the open and cup after cup is deeped *[sic]* again and again, while the seller changes and clings the silver faster than the bank clerk. Indeed it is quick money; no wonder the culprits can afford to pay their fines, no matter how heavy. The cold and vicissitudes of the weather mar nothing. There is laughter, and song. Mashonas, Ndebeles, Bembas, Nyanjas and all, sing their equivalents of "For He's a Jolly Good-Fellow" wounded *[sic]* off by "Hip Hip Hurrah" and laughter again. Further on there an artist is picking tune on an old rusty guitar—"Chivura matamba," of course, and how zestilly *[sic]* the men and women dance to it. At the end a barrage of "encore" rushes out of the hundred and one mouths and the artist strums his instrument again, more diffidently and louder, at which the crowd dives again into unrestrained shaking of hips and shuffling of feet.[141]

In 1949, the state tried to ban urban illegal beer and the "*skokiaan* culture" by the passage of the Harmful Liquids Act, which forbade the manufacture, use and sale of home brew.[142] In addition, new municipal beer halls were built for African drinkers—by 1955 there were sixteen in Bulawayo and fourteen in Salisbury.[143] Under this two-pronged attack, the number of convictions under the Act in Salisbury decreased, and by 1952 a decrease in

Table 2.5 Men and Women Convicted of Selling Illicit Beer and *Skokiaan*, Southern Rhodesia, 1951–1952

	African Men	*African Women*	*Africans, Total*	*Other*
1951				
Beer possession	921	420	1341	0
Beer sale	169	165	334	4
Skokiaan possession	1187	410	1597	0
Skokiaan sale	n/a	n/a	699	0
1952				
Beer possession	1218	301	1519	0
Beer sale	181	146	327	0
Skokiaan possession	n/a	n/a	1831	0
Skokiaan sale	n/a	n/a	439	0

Source: Annual Reports of the Commissioner, BSA Police, 1950–1952.

the *skokiaan* trade was reported countrywide.[144] These reports could also have reflected a diminished police zeal for chasing inebriated people through the veldt, however, since, as West points out, in Salisbury after 1942 more people drank *skokiaan* as the beer hall admission rules became more restrictive.[145] Overall, therefore, it seems that the measures with which the state tried to curb "*skokiaan* culture" were insufficient to destroy several factors in urban life: the need for supplemental cash, easy access to fermentable ingredients, and the close proximity of brewers to township drinkers. Brewing certainly remained a good source of cash: in 1957 it was reported that a township resident who hosted a euphemistically named "tea party" where the guests drank "heavy coca-cola" could clear as much as fifteen pounds—roughly twice the minimum monthly wage—in a day.[146] While, as noted, the number of *skokiaan*-related offenses in Salisbury gradually decreased, the number of people convicted of possession of illegal beer still averaged almost fourteen hundred and the number of convicted beer sellers averaged forty-four per year in the 1951–55 period.[147]

Although beer brewing was traditionally a female skill, slaking the thirst of urban residents was too lucrative a trade for men to pass up completely. As one might suspect, given the urban preponderance of men and of male wage earners, most of those convicted of possession of illegal liquor were men, but so were many of the brewers (Table 2.5).

Similarly, five men and six women were evicted from municipal housing in Harare township for a repeat conviction of supplying or possessing liquor in 1953–54; in 1954–55 all sixteen evictees were men.[148]

In popular estimation, however, the beer and liquor trade was women's work. In the postwar era, for example, the *skokiaan* brewing scene in the Brickfields area as described earlier was dominated by "very tough women."[149] According to a report in *African Weekly*,

> The rock pillar of the industry is the skokiaan queen, a type of African woman peculiar only to the location and compounds, and she is the model of industriousness and devotion to duty.[150]

According to a woman who lived in a private location outside Salisbury in the early 1950s:

> The life there was one of brewing beer and selling. Beer was the only thing sold. . . . From those drums like this [indicated a large size] if we got £5, we would think we had got a lot. Because we sold those [drinks in] jam tins for five cents. Two were what we called a shilling. . . . If you were given beer for a shilling, haa, you would drink and be satisfied. So per drum . . . if you got £5 and a little bit more, ah, you would say, "I got a lot."[151]

CONCLUSION

Culled from a number of sources, the grim statistics on African economic status displayed here show just how difficult it was to play the game of urban survival in the period under review. In this situation, urban African female society was awash with cross-currents of privilege and privation by the mid-1950s. In an attempt to correlate class and gender, this chapter has discussed the general categories of African women's economic activities in Salisbury and has tried to show how these activities were intertwined with women's personal relationships with men in the general colonial context of imposed impoverishment. In fact it seems clear that urban gender cannot be discussed without reference to class, however the latter is defined. Whether discussed in terms of a proletarian/bourgeois, lower/middle, or nameless/well-known divide, class divisions were based on the bedrock of whether or not a woman had access to housing. The way the question of housing access was resolved had a determining impact on each individual urban woman and her socioeconomic options and decisions. But these class divisions between women were not simply generated by capital and the state and transmitted intact from above; gender ideologies from below were energetically developed to define and elaborate acceptable hierarchical structures in urban Afri-

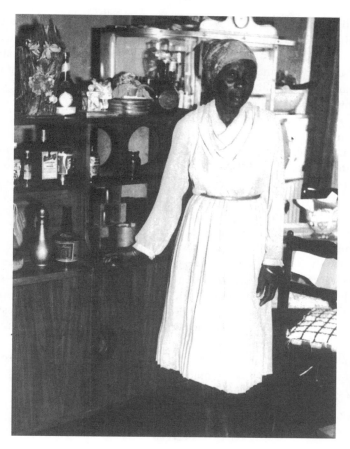

Photo 2.1 Playing the class game: Mrs. Mary Ruswa and her display case, 1989. Photograph by the author.

can society. This work was done by African women themselves through their membership in churches and women's clubs; by their participation in marriage ceremonies, however, wherever and by whomever performed; and by their willingness to engage in domestic labor. In a complicated interaction with settler society's evolving definition of morality and immorality,[152] African women helped define the parameters of what was considered to be proper. The resulting hybrid of "righteousness" became, in turn, a concept of great importance in the reproduction of African society. This idea will be developed further in Chapter 4.

In tandem with their ideological work, urban women undertook a wide variety of formal and informal employment, with the latter heavily predomi-

nating. It should be noted, however, that any one kind of employment was most unlikely to be constant over a woman's period of urban residence. Most women would have—or could have—engaged in both legal, formal activities and illegal, informal work according to the waxing and waning of their marital and economic fortunes. This makes it extremely difficult to generalize about a woman's class position over time.

It may seem that this discussion of energetic efforts towards differentiation contradicts earlier assertions that the most important aspect of urban communities was the reproduction of a unitary, recognizably African society. Although there are certainly contradictory elements at work here, one concept that can only be strengthened by further research is that a recognizably African society was one in which economic diversity was welcomed.

The gendered class analysis in this chapter, although somewhat rudimentary, is quite different from a quantitatively based class analysis of male employment patterns that is content simply to note that few women were formally employed. Rather, it is suggested here that the heavy preponderance of men in the urban population has prevented historians from seeing that women undertook ideological and material work that was as influential in the shaping of the urban community in class terms as the labor of men, which is one way of saying that class was refracted through the lens of gender.

Women's varied urban labors did not occur in a vacuum, of course. It is to the surrounding responses of male relatives and of the colonial state to women's hard work that we turn in the next chapter.

NOTES

[1] Interview with Mrs. Selina Sitambuli, Mbare, 24 April 1989.

[2] See Claire Robertson and Iris Berger, eds., *Women and Class in Africa* (New York: Holmes and Meier, 1986); Sharon Stichter and Jane Parpart, eds., *Patriarchy and Class: African Women in the Home and the Workforce* (Boulder, Colorado: Westview, 1988).

[3] Ian Phimister, *An Economic and Social History of Zimbabwe: Capital Accumulation and Class Struggle, 1890–1948* (London: Longman, 1988), p. 205–206.

[4] For an extended analysis of the development of the "middle class" in African urban communities, see Michael West, *African Middle Class Formation in Colonial Zimbabwe, 1890–1963* (Ph.D. dissertation, Harvard University, 1990).

[5] For an interesting parallel in Uganda, see Jessica A. Ogden, " 'Producing' Respect: The 'Proper Woman' in Post-Colonial Kampala," in Richard Werbner and Terence Ranger, eds., *Postcolonial Identities in Africa* (London: Zed Press, 1996) pp. 186–187.

[6] Diana Jeater, *Marriage, Perversion and Power: The Construction of Moral Discourse in Southern Rhodesia, 1894–1930* (Oxford: Clarendon Press, 1993), chapter 3, passim.

[7] This is one of the main subjects of Jeater's study, *Marriage, Perversion and Power.*

[8] Terence Ranger, *Are We Not Also Men? The Samkange Family and African Politics in Colonial Zimbabwe 1920–64* (Portsmouth: Heinemann, 1995), p. 32–62.

[9] Peter Rule, *Nokukhanya, Mother of Light* (Johannesburg: The Grail, 1994).

[10] Mary Waters, Organizing Instructress for Native Education Department of Southern Rhodesia, "Address on Work amongst Native Women and Girls in Southern Rhodesia," March 13, 1929. S2239/36/19.

[11] Richard Gray, *The Two Nations: Aspects of Race Relations in the Rhodesias and Nyasaland* (London: Oxford University Press, 1960), p. 129.

[12] West, *African Middle-Class Formation;* Elizabeth Schmidt, *Peasants, Traders, and Wives: Shona Women in the History of Zimbabwe, 1870–1939* (Portsmouth: Heinemann, 1992); Jeater, *Marriage, Perversion and Power;* Sita Ranchod-Nilsson, " 'Educating Eve': The Women's Club Movement and Political Consciousness among Rural African Women in Southern Rhodesia, 1950–1980," in Karen Tranberg Hansen, ed., *African Encounters with Domesticity* (New Brunswick, New Jersey: Rutgers University Press, 1992).

[13] Gray, *The Two Nations,* p. 321.

[14] Mrs. C. Carbutt, representing the Territorial Council of Girl Wayfarers Association, in evidence to Commission of Enquiry into Native Female Domestic Service, 1932. S94. Mrs. Carbutt was the wife of the chief native commissioner (CNC).

[15] Emphasis added. Mrs. Lillian Nhari, interviewed and quoted by Elizabeth Schmidt, *Ideology, Economics and the Role of Shona Women in Southern Rhodesia, 1850–1939* (Ph.D. dissertation, University of Wisconsin-Madison, 1987), p. 322.

[16] Mrs. E. M. Chirwa, *The Role of Women in the Economy: Address to the Rhodesian Institute of Public Relations Seminar* (Salisbury: Rhodesian Institute of Public Relations, 1976).

[17] Dorothy Hodgson and Sheryl McCurdy, "Wayward Wives, Misfit Mothers and Disobedient Daughters: 'Wicked' Women and the Reconfiguration of Gender in Africa," *Canadian Journal of African Studies* vol. 30 no. 1 (1996), p. 6.

[18] The one exception of which I am aware is Richard Werbner's chapter, "Justification, Rivalry and Romance," in his *Tears of the Dead: The Social Biography of an African Family* (Washington, D.C.: Smithsonian Institution Press, 1991).

[19] Mary Lou Cummings, *Surviving without Romance: African Women Tell Their Stories* (Scottsdale, Pennsylvania: Herald Press, 1991), p. 9.

[20] See Jeater, *Marriage, Perversion and Power,* passim.

[21] This term refers to the practice of an unmarried woman's using a man's pots to cook his food: thus the plural prefix *ma* added to *pot* ("pot") plus *o* signifying the state or process of.

[22] A.K.H. Weinrich, *Mucheke: Race, Status and Politics in a Rhodesian Community* (Paris: UNESCO, 1976), p. 45–46. According to a small survey of elite African men carried out in the early 1960s, the quality most desired in a wife was "same education." Gussman, *Midday Sun,* p. 146.

[23] This figure does not include the shortage of housing for temporary male workers or for unwaged women. Evidence submitted by the city of Salisbury to the Urban African Affairs Commission, 1958. S 51/5. See also Ian Phimister, *An Economic and Social History of Zimbabwe: Capital Accumulation and Class Struggle, 1890–1948* (London: Longman, 1988), p. 259–261.

[24] Roger Howman, Assistant NC Bulawayo, oral evidence to the (E. G.) Howman Committee Report, 1943, p. 59. ZBI 2/1/1.

²⁵ The only African women who were self-employed in Salisbury in 1936 were three midwives who were South African nationals. African men, on the other hand, worked as retailers, builders, shoemakers, painters, carpenters, tailors, herbalists, cycle repairers, brickmakers, and eating-house keepers. Annual reports of the NC Salisbury (District) and NC Salisbury, 1936. S 1563. Nonetheless, the state closed down the entrepreneurial activity of African men in the mid-1930s. See Stephen Thornton, "The Struggle for Profit and Participation by an Emerging African Petty-Bourgeoisie in Bulawayo, 1893–1933," in *Societies of Southern Africa,* vol. 9 (London: University of London, 1980); Volker Wild, "Black Competition or White Resentment? African Retailers in Salisbury, 1935–1953," *Journal of Southern African Studies,* vol. 17 no. 3 (1991). Margo Lovett, "Gender Relations, Class Formation and the Colonial State in Africa," in Jane Parpart and Kathleen Staudt, eds., *Women and the State in Africa* (Boulder, Colorado: Lynne Rienner, 1989), p. 32. The restrictions on African men were so severe that in the construction industry in the towns by the mid-1940s, "All that Africans were allowed to do was to puddle the cement and to hand the bricks . . . or . . . the planks to the builders." Mr. Reuben Jamela interview, NAZ African Oral History no. 63, p. 8.

²⁶ Thornton, "Struggle for Profit," p. 6; Janet Bujra, "Women Entrepreneurs of Early Nairobi," in C. Sumner, ed., *Crime, Justice and Underdevelopment* (London: Heinemann, 1982); Philip Bonner, "Division and Unity in the Struggle: African Politics on the Witwatersrand in the 1920s," Seminar Paper no. 307, African Studies Institute, University of the Witwatersrand, 1992.

²⁷ Miss T. Cele interview, Nyatsime College, Seke, 20 February 1989.

²⁸ Chief Superintendent, Criminal Investigation Department (CID) Bulawayo to Staff Officer CID Salisbury, 21 September and 2 October, 1929; typewritten memo, n.d., probably 1930. S 235/440.

²⁹ Ngwabi Bhebe, *Benjamin Burombo: African Politics in Colonial Zimbabwe, 1943–1958* (Harare: College Press, 1987), p. 10; Lynette Jackson, *"Uncontrollable Women" in a Colonial African Town: Bulawayo Location, 1893–1953* (M.A. Thesis, Columbia University, 1987), p. 33; typewritten memo, unsigned, n.d., probably 1930. S 235/440.

³⁰ Mrs. Martha Ngano, quoted in Thornton, "Struggle for Profit," p. 13.

³¹ Diana Jeater, *Marriage, Perversion and Power: The Construction of Moral Discourse in Southern Rhodesia, 1894–1930* (Oxford: Clarendon Press, 1993), p. 178.

³² Mr. Patrick Pazarangu, NAZ African Oral History collection, no. 56; Lawrence Vambe, *From Rhodesia to Zimbabwe* (London: Heinemann, 1976) p. 185; oral evidence of John Moeketsi to the Commission of Enquiry into the Salisbury Municipal Location, 1930, p. 22. S 85.

³³ Mrs. Johanna Scott, interviewed in Highfield, 31 May 1989.

³⁴ See notice of her arrest for brewing strong hop beer, *Bantu Mirror,* 7 March 1936.

³⁵ Interviews with Mr. Laxon Gutsa, Masasa, 5 November 1988; Mrs. J. Mwelase, Highfield, 31 May 1989; Mrs. Ruth Murhombe, Mbare, 5 April 1989; Miss Ennia Gasa, Mbare, 1 March 1989; Mrs. Bertha Charlie, Mbare, 21 February 1989; Mr. Munamo Rubaba, Tafara, 21 November 1988; Mrs. Enniah Mutuma, Mbare, 20 March 1989; Mrs. Sarah Bakasa, Kambuzuma, 17 March 1989; Mrs. Sarah Tsiga, Mbare, 14 April 1989; Mr. Lawrence Vambe, Belgravia, 17 February 1989.

³⁶ Timothy Scarnecchia, "Poor Women and Nationalist Politics: Alliances and Fissures in the Formation of a Nationalist Political Movement in Salisbury, Rhodesia,

1950–6," *Journal of African History* vol. 37 (1996), p. 293.

[37] *African Weekly*, 22 December 1954.

[38] A man was eventually granted the license; he was a township hawker with declared assets of £827. City of Salisbury Director of Native Administration to Town Council subcommittee, 14 April 1953. NAZ Record Center, file 12/7/3/1, location C25-14-6, box 109975.

[39] Mrs. Bertha Charlie, interviewed in Mbare, 21 February 1989.

[40] Mrs. Esther Chideya, interviewed in Mbare, 6 April 1989.

[41] Mrs. Cecilia Rusike, interviewed in Mbare, 28 April 1989.

[42] See Frederick Cooper, *Decolonization and African Society: The Labor Question in French and British Africa* (Cambridge: Cambridge University Press, 1996), esp. chapter 8.

[43] Teresa Barnes, "'So That a Labourer Could Live with His Family': Overlooked Factors in Social and Economic Strife in Urban Colonial Zimbabwe, 1945–1952," *Journal of Southern African Studies* vol. 21 no. 1 (1995); Gray, *The Two Nations*, p. 314.

[44] Howman Committee Report, 1944, p. 8. S 482/30/44.

[45] Salisbury Mayor's Minute, 1936–1937, p. 9.

[46] Salisbury Mayor's Minute, 1938–1939, p. 2; interviews with Mrs. Makoni, Mbare, 5 April 1989; Mrs. Stella Mae Sondayi, Highfield, 11 April 1989. Olivia Muchena noted that marriage was still a requirement for membership in women's clubs in the 1970s. Olivia Muchena, *Women's Organisations in Zimbabwe: Assessment of Their Needs, Achievement and Potential* (Harare: Centre for Applied Studies, University of Zimbabwe, 1980), p. 1.

[47] Second report on urban African Budget Survey in Salisbury, 1957–1958, p. 6. For a study of African women's clubs in a rural context, see Sita Ranchod-Nilsson, "'Educating Eve': The Women's Club Movement and Political Consciousness among Rural African Women of Southern Rhodesia, 1950–1980" in Karen Tranberg Hansen, ed., *African Encounters with Domesticity* (New Brunswick, New Jersey: Rutgers University Press, 1992).

[48] Timothy Burke, *Lifebuoy Men, Lux Women: Commodification, Consumption and Cleanliness in Modern Zimbabwe* (Durham, North Carolina: Duke University Press, 1996).

[49] Tsuneo Yoshikuni, *Black Migrants in a White City: A History of African Harare, 1890–1925* (Ph.D. thesis, University of Zimbabwe, 1990), p. 154–56; see her obituary, "Mrs. Maria Elizabeth Frank," *African Weekly*, 6 August 1952.

[50] Terri Barnes and Everjoice Win, *To Live a Better Life: An Oral History of Women in Harare, 1930–1970* (Harare: Baobab Books, 1992) p. 174.

[51] Farai David Muzorewa, "Through Prayer to Action: The Rukwadzano Women of Rhodesia," in Terence Ranger and J. Weller, eds., *Themes in the Christian History of Central Africa* (London: Heinemann, 1975), p. 260–263.

[52] "Women are catching up with the times," *The African Parade*, January 1960, p. 76.

[53] Farai David Muzorewa, "Through Prayer to Action: The Rukwadzano Women of Rhodesia," in Terence Ranger and J. Weller, eds., *Themes in the Christian History of Central Africa* (London: Heinemann, 1975), p. 263.

[54] Representatives of the Federation of Women's Institutes, verbatim evidence to the Plewman Commission, 1957, p. 587. S 51/7.

[55] Mrs. Helen Mangwende, "Christmas greetings," *The African Parade*, December 1954. Mrs. Mangwende, perhaps more than any other midcentury figure, is respectfully remembered as pivotal in the construction of an ideology of respectability for African

women. See Barnes and Win, "Better Life," chapter 14; Ranchod-Nilson, "Educating Eve," p. 202.

[56] Mrs. Agnes Kanogoiwa, interviewed in Waterfalls, Harare, 24 April 1989.

[57] *Radio Post*, October 1959, p. 3. Issues of the monthly *Radio Post* magazine through the late 1950s were filled with reports of the ever-increasing volume of entries in the sewing competitions and of the "huge task" undertaken by the white women who were the competition judges. Quote from Mrs. Kanogoiwa, interviewed in Waterfalls, Harare, 24 April 1989.

[58] The literature for colonial Zimbabwe discusses the exodus of women from rural areas in the beginning of the 20th century in terms of their fleeing patriarchal control, not, as in the case of South Africa, searching for their absent migrant husbands. See Schmidt, *Peasants, Traders and Wives*, p. 92–97; Jeater, *Marriage, Perversion and Power*; contrast with Philip Bonner, "Desirable or Undesirable Basotho Women? Liquor, Prostitution and the Migration of Basotho Women to the Rand, 1920–1945," in Cheryl Walker, ed., *Women and Gender in Southern Africa to 1945* (Cape Town: David Philip, 1990) p. 234–241, and Sean Redding, "South African Women and Migration in Umtata, Transkei, 1880–1935," in Kathleen Sheldon, ed., *Courtyards, Markets, City Streets: Urban Women in Africa* (Boulder, Colorado: Westview Press, 1996).

[59] From 1921 to 1962 municipal authorities and the Central Statistical Office based their population figures on indirect evidence—pass statistics, housing applications, and tax records—rather than on direct census counts. In 1962 (for the first time since the 1911 census) the new government of the Rhodesian Front supported a census that counted urban Africans directly in order to illustrate certain dubious political conclusions. Census figures for practically the entire colonial period are therefore quite suspect. Report of the 1962 Census; David van Wyk, *The Economy of Urbanisation in Colonial Zimbabwe with Special Reference to Chitungwiza* (University of Zimbabwe, B.A. honors thesis, 1987), p. 17–20.

[60] Phimister, *Economic and Social History*, p. 259.

[61] Report of the Secretary for Native Affairs, CNC and Director of Native Development, 1947. The replacement of male domestic workers with African women had been proposed as early as the report of the 1910–11 Native Affairs Commission. Southern Rhodesia Native Affairs Committee Report, 1911, A3/3/18; see also Schmidt, "Race, Sex and Domestic Labor: The Question of African Female Servants in Southern Rhodesia, 1900–1939," in Karen Tranberg Hansen, ed., *African Encounters with Domesticity* (New Brunswick, New Jersey: Rutgers University Press, 1992).

[62] Annual Report of the NC Salisbury, 1948, p. 1. S1051.

[63] City of Salisbury, "Memorandum on the Shortage of Native Labour," 25 October 1950. Thirty-two other suggestions were made in the memo. NAZ Historical Manuscripts, RH 27/3/12.

[64] This was one of four recommendations in a letter dated 30 September 1949, reporting to the Acting Prime Minister from a meeting convened by the Rhodesian Chamber of Mines and attended by the Rhodesia National Farmers' Union, the Rhodesian Tobacco Association, the Rhodesia Federated Chambers of Commerce, the Federation of Rhodesian Industries, the Rhodesia Mining Federation, and the Salisbury Municipality. S 486/136/49.

[65] "Report of the National Native Labour Board (NNLB) on Its Investigation of the Conditions of Employment of Native Women in Certain Industries . . . 1952" (Salisbury, mimeo, 1952), p. 37.

[66] NNLB 1952 Report, p. 7–9.

[67] See F. Clements and E. Harben, *Leaf of Gold* (London: 1962); Victor Machingaidze, *The Development of Settler Capitalist Agriculture in Southern Rhodesia with Particular Reference to the Role of the State, 1908–1939* (Ph.D. thesis, University of London, 1980); Phimister, *Economic and Social History*, p. 226–227.

[68] Phimister, *Economic and Social History*, p. 232.

[69] Report of the 1946 Census, p. 20.

[70] NNLB 1952 report, p. 6.

[71] Native Labour Department monthly report, April 1954, p. 9. S 2104/2.

[72] Labour Department, Précis Report on African Labour Administration, June 1956. S 2104/2.

[73] Labour Department Monthly Report, April 1960. S 2104/2.

[74] "Memorandum on Native Labour from the Makoni District Sub-Association of the Eastern Districts Regional Development and Publicity Association," p. 10; n.d. but probably around 1948. See also "Memorandum: Employment of Native Girls in Industry," 8 March 1945. Both in NAZ Historical Manuscripts SO 11/1/8.

[75] Monthly Report of the Labour Officer, Native Labour Department, Salisbury East, February 1953. S 2104/2.

[76] Report on African Labour Administration, Native Labour Department, May 1956. S 2104/2.

[77] Labour Department Monthly Reports, November 1959 and October 1960, S 2239; Manager of the Hippo Valley Hotel, Shabani, quoted in Report on African Labour Administration, May 1956. S 2104/2.

[78] Interview with Mrs. Faina Chirisa, St. Mary's, 31 May 1989; she worked in Salisbury for a company she called "Export Tobacco."

[79] Labour Department Monthly Report, April 1959. S 2239.

[80] Labour Department Monthly Report, April 1960. S 2239. Such facilities were not a complete rarity, however, as one was provided along with a clinic, school, and recreational facilities at a large tobacco processing estate outside Salisbury in the 1970s. Such facilities were, however, atypical. Joan May, *African Women in Urban Employment* (Gwelo: Mambo Press, 1979), p. 34–35.

[81] Anthony Hawkins, "The Economy," in G. Leistner, ed., *Rhodesia: Economic Structure and Change* (Pretoria: Africa Institute, 1976).

[82] Plewman Commission Report, 1958, p. 162.

[83] The turning point may have come with the exclusion of domestic and farm workers from the changes made in the 1959 Industrial Conciliation Act, which for the first time included other African workers in the nation's industrial relations system and accorded them limited trade union rights.

[84] Mrs. Cecilia Rusike, interviewed in Mbare, 28 April 1989.

[85] Miss Keresiya Savanhu, interviewed in Mbare, 21 March 1989.

[86] Miss Matombi Savanhu, interviewed in Mbare, 29 March 1989.

[87] Labour Department Monthly Reports, Salisbury East, March 1953. S 2104/2.

[88] Labour Department Monthly Reports, Salisbury East, August 1953. S 2104/2.

[89] Salisbury Department of African Administration Annual Report, 2959–60, p. 32.

[90] Central African Statistical Office, *First Report on Urban African Budget Survey in Salisbury, 1957–58* (Salisbury: mimeo, 1958), p. 2. These men's cash wages were approximately one pound higher than those of their colleagues, from whose wages the cost of food rations was deducted.

[91] "Report on Employment of Native Female Domestic Labour in European Households in Southern Rhodesia, 1932." S 482/117/40.

[92] Annual report of the NC Salisbury, 1942, p. 6. S 1563.

[93] "Women Must Work in White Men's Houses," *African Weekly*, 10 July 1946.

[94] City of Salisbury, Department of Native Administration Annual Report, 1951–52, p. 49.

[95] City of Salisbury, Department of Native Administration Annual Reports, 1957–58, p. 134; 1958–59, p. 66.

[96] This person also believed that domestic workers in general were becoming "more inefficient, indolent, insolent and crafty and I would now like to add, utterly unreliable." Unsigned and unaddressed typed sheet, n.d., but with a handwritten note at the top, "Put in bg Mr. Huxtable." General Correspondence to the Howman Committee, 1943. ZBI 1/1/1. These comments can reliably be attributed to the NC Bulawayo, who was at this time named Huxtable and who made practically identical comments in his annual report for 1942, p. 9. S 1563. See also Annual Report of the NC Salisbury, 1940, p. 13. S 1563.

[97] Annual Report of the NC Selukwe, 1943, p. 9. S 1051.

[98] Interview with Keresiya Savanhu, Mbare, 21 March 1989.

[99] City of Salisbury, Department of Native Administration Annual Report, 1951–52, p. 49.

[100] *African Daily News*, 10 October 1956.

[101] She practically ascended to proper petty bourgeois status when she employed a driver; she was also described as "a staunch member of the Methodist church." *The African Businessman*, vol. 1, 1961.

[102] Mr. Levi Gono, interviewed at the National Archives of Zimbabwe, 20 September 1989.

[103] Gray, *The Two Nations*, p. 259. For analyses of *mapoto* in earlier decades see Teresa Barnes, "The Fight to Control African Women's Mobility in Colonial Zimbabwe, 1900–1939," *Signs: Journal of Women in Culture and Society* vol. 17 no. 2 (1992), p. 568, 605–6; and Jeater, *Marriage, Perversion and Power*, p. 178–81.

[104] See, for example, Secretary for Native Affairs to Town Clerks, n.d., S 482/535; and correspondence from 1936 at the time of the passage of the Native Registration Act in S 1542/S12.

[105] Miss Caroline Renhas, interviewed in Highfield, 27 February 1989.

[106] Mrs. Effie Maripakwenda, interviewed in Mbare, 15 March 1989.

[107] R. A. Mahwata, letter to *African Weekly* 20 June 1945, quoted in Barnes and Win, "Better Life," p. 130.

[108] Mrs. Mary Butao, interviewed in Highfield, 28 February 1989.

[109] It is said that some *mapoto* wives did eventually marry their partners, but it was probably more common for the practice to shade into prostitution, depending on just how temporary a series of relationships actually were.

[110] The minister was of the opinion that Africans didn't really need wages since they all lived on family earnings in the rural areas; wages were only "extra." Arthur Shearly Cripps, "Africans' Pocket Money," *The Link* vol. 1 no. 6 (1941), p. 11.

[111] The urban cost of living skyrocketed 140 percent between 1939 and 1947. Phimister, *Economic and Social History*, p. 260–261.

[112] Batson had also produced poverty datum line reports in South Africa and influenced investigations in Kenya, a colony that also suffered from "a veritable plague of sociologists" in the postwar period. Frederick Cooper, *On the African Waterfront: Urban*

Disorder and the Transformation of Work in Colonial Mombasa (New Haven: Yale University Press, 1987), p. 257, 260.

[113] The poverty datum line (PDL) concept was flawed by the constant exclusion of common budget items that various researchers deemed to be unnecessary. Particular exclusions and general conclusions were then challenged by other researchers. For example, one study calculated that the "effective minimum level" that an urban African family needed to "sustain itself in a minimum state of health and decency" was 150 percent of the PDL of another researcher. Batson, 1944, cited in David Bettison, "The Poverty Datum Line in Central Africa," *Rhodes-Livingston Institute Journal: Human Problems in British Central Africa* no. 27 (1960), p. 21; see also B. Thomson and G. Kay, "The Poverty Datum Line in Central Africa (A Note on the P.D.L. in Northern Rhodesia)"; D. G. Bettison, "Reply to Thomson and Kay," *Rhodes-Livingstone Institute Journal: Human Problems in British Central Africa* vol. 30 (1963). Harris notes that Bettison's PDL was "extremely harshly drawn, and was more remarkable for what it excluded than for what it included." Peter Harris, "Industrial Workers in Rhodesia: Working-Class Elites or Lumpenproletariat?" *Journal of Southern African Studies* vol. 1 no. 2 (1975), p. 148.

[114] For a discussion of the inadequacy of these concepts in the African colonial context see Jane Guyer, "Dynamic Approaches to Domestic Budgeting: Cases and Methods from Africa," in Daisy Dwyer and Judith Bruce, eds., *A Home Divided: Women and Income in the Third World* (Stanford: Stanford University Press, 1988), p. 156–161.

[115] Ibbotson must have believed that if he did not measure something, it did not exist: "It is considered that any system which necessitates a wife undertaking employment in order to supplement the income of her husband is unsound, especially where young children are involved." Ibbotson, *Report on a Survey of Urban African Conditions in Southern Rhodesia* (Bulawayo: Federation of Native Welfare Societies, 1943), p. 21. On the basis of the guesswork of the Salisbury Department of Native Administration, Bettison claimed, "the proportion of men with dependents in Salisbury is thought to be small." Because the minimum wage paid to so-called single male workers was above his PDL calculations, he mistakenly deduced that "the proportion of the total population which might be viewed as 'in poverty' would not be large." This report never examined the assumption that most men had no families to support; nor did it consider the manifest distress of family groups in Salisbury, which belied its conclusions. Bettison, "The Poverty Datum Line," p. 25.

[116] E. Cordell, "Some Economic and Social Aspects of African Family Life in the Salisbury Municipal Location," (Salisbury, unpublished paper), p. 2; idem, Native Welfare Officer, Salisbury location, to Medical Officer of Health, 4 February 1938, Salisbury Municipality file 12/1/1 jacket 1.

[117] Central Statistical Office, "Report . . . 1963/64," p. 13, 26. A 1973 study of Harare township found husbands and wives jointly running gambling dens and home bars (*shebeens*) and sharing the profits. Women also earned money through petty trade and by hawking of vegetables, handicrafts, and cooked food. Joan May, *African Women in Urban Employment*, p. 29.

[118] Luise White, "A Colonial State and an African Petty Bourgeoisie: Prostitution, Property, and Class Struggle in Nairobi, 1936–40," in Cooper, *Struggle for the City*, p. 181.

[119] Luise White, *The Comforts of Home: Prostitution in Colonial Nairobi* (Chicago: University of Chicago Press, 1991), chapter 6, esp. p. 132–136.

[120] Mr. Levi Gono, interviewed at the National Archives of Zimbabwe, 20 September 1989; R. R. Willcox, *Report on a Venereal Disease Survey of the African in Southern Rhodesia* (Salisbury: Government Printer, 1949); see also, "Life in Harare Township," in *African Weekly,* esp. "Shameful Practices at Industrial Sites," May 18, 1949. This evidence contradicts White's assertion that pimping existed nowhere in Africa outside Johannesburg; White, "Comforts of Home," p. 6.

[121] Jane Parpart classifies prostitutes as a separate class in the social formations of the Zambian Copperbelt, reasoning that they were independent of men. See her "Class and Gender on the Copperbelt," in Claire Robertson and Iris Berger, eds., *Women and Class in Africa* (New York: Holmes and Meier, 1986), p. 151. There is little evidence for Southern Rhodesian towns that prostitutes were able to marry and become respectable. In her 1977 study of an African township, Weinrich similarly assigned prostitutes to the lowest rung on her set of "social strata" although she emphasized their high incomes and freedom from male control. This might be accounted for by the fact that in the mid-1970s single women had access to housing because of the construction of a women's hostel. Weinrich, *Mucheke,* p. 137, 142.

[122] Miss Caroline Renhas, interviewed in Highfield, 27 February 1989.

[123] Willcox, *Venereal Diseases Survey,* p. 46.

[124] Interviews with Mrs. Elsie Magwenzi, St. Mary's, 6 March 1989; Mrs. Mary Butao, Highfield, 28 February 1989; Mrs. Sarah Bakasa, Kambuzuma, 17 March 1989; Mrs. Loice Muchineripi, Mbare, 8 March 1989; Mr. Lawrence Vambe, Belgravia, Harare, 17 February 1989 (it should be noted that he was decrying what he saw as the narrow definitions of moral behavior and the conservative nature of urban African society); Mrs. Mary Ruswa, Highfield, 9 March 1989; Mrs. J. Mwelase, Highfield, 31 May 1989; Mrs. Cecilia Rusike, Mbare, 28 April 1989.

[125] Mrs. Mary Ruswa, interviewed in Highfield, 20 April 1989.

[126] White, *Comforts of Home,* chapters 4–6.

[127] Statement from Tambeleki, marked "Bulawayo.20.7.20." S 1222.

[128] Miss Caroline Renhas, interviewed in Highfield, 27 February 1989.

[129] For an excellent discussion of this transformation see van Onselen, *Chibaro,* p. 166–171. See also Schmidt, *Peasants, Traders, Wives,* p. 25–26, 59–60, 78, 87; and Michael O. West, "Liquor and Libido: 'Joint Drinking' and the Politics of Sexual Control in Colonial Zimbabwe, 1920s–1950s," *Journal of Social History* vol. 30 no. 3 (1997). I am grateful to Dr. Ibrahim Abdullah for this reference.

[130] In 1908 municipal officials in Durban devised an extremely profitable system of municipal beer halls coupled with the total prohibition of private brewing. Huge beer hall profits became an important source of revenue for the city. Yoshikuni, *Black Migrants,* p. 88; Paul la Hausse, *Brewers, Beerhalls and Boycotts: A History of Liquor in South Africa* (Johannesburg: Ravan Press, 1988).

[131] Handwritten note, n.d., but probably early 1930s, "Areas in which possession of Kaffir Beer is prohibited," S 246/780; Yoshikuni, *Black Migrants,* p. 103.

[132] Yoshikuni, *Black Migrants,* p. 107.

[133] Mrs. Enniah Mutuma, interviewed in Mbare, 20 March 1989.

[134] *Bantu Mirror,* 7 March 1936, p. 7.

[135] "Evil Drink," *African Parade,* May 1955.

[136] Annual Report of the Commissioner of the BSA Police, 1947–48, p. 16.

[137] Oral evidence of Mr. F. Pascoe (owner of a brickfield site) to Howman Committee, 1943, p. 157. ZBI 2/1/1.

[138] Annual Report of the Commissioner of the BSA Police, 1946, p. 163.

[139] Annual Report of the Commissioner of the BSA Police, 1947–48, p. 18.

[140] Annual Report of the Commissioner of the BSA Police, 1946, p. 163; 1947–48, p. 18.

[141] I believe the author of these articles was Lawrence Vambe; see "Skokiaan King of African Alcoholic Beverages, a Typical Brickfields Sundowner [Cocktails] Scene," *African Weekly* 8 June 1949, p. 11; interview with Lawrence Vambe, Belgravia, Harare, 17 February 1989.

[142] The act banned "concoctions known as skokiaan, barberton, quilika, isityimiyana, hopana, qedividi or uhali." Harmful Liquids Act, 1949, section 3, *Statute Law of Rhodesia,* vol. 2 (Salisbury: Government Printer, 1974).

[143] Annual Report of the Commissioner of BSA Police, 1955, p. 41.

[144] City of Salisbury African Administration Department Annual Reports, 1951–1957; annual report of the Commissioner of BSA Police, 1952, p. 55.

[145] West, "Liquor and Libido," p. 657-659.

[146] *African Daily News,* 11 February 1957.

[147] City of Salisbury African Administration Department Annual Reports, 1951–1952 through 1955–1956.

[148] City of Salisbury African Administration Department Annual Reports, 1952–1953 through 1954–1955.

[149] Interview with Lawrence Vambe, Belgravia, Harare, 17 February 1989.

[150] *African Weekly,* 18 May 1949.

[151] Interview with Mrs. Jessie Marange, Mufakose, 26 June 1989.

[152] See Jeater, *Marriage, Perversion and Power.*

3

DIVISIONS IN BLACK AND WHITE MALE RANKS

I think I can say that [the word] prostitute in those days was a very loose definition. Largely influenced, quite honestly, by the conservative nature of our own society . . . African society was even more conservative [than settler society], absolutely. A woman who rode a bicycle was a prostitute. Honestly! Exactly! Today [riding a bicycle is] acceptable, but in those days Anybody who was not married, who was living in a hut somewhere with kids and so on, she was called a prostitute. Unfortunately. Yes.[1]

DISCORD SOWN BETWEEN AFRICAN MEN

How did African men respond to women's urban work? The preceding excerpt, from an ex-journalist and perceptive observer of Harare life, Mr. Lawrence Vambe, suggests that women trod a thin line before they incurred the displeasure and condemnation of African society. How widespread was this displeasure? Three documents provide clues. The first comes from 1928, when a missionary couple forwarded to the prime minister a resolution passed by a meeting of their mission's African teachers.

We, the teachers of the London Mission in the Bubi District, gathered together on the Shangani Reserve, are all agreed that certain things are taking place among our people which destroy the nation. Such things are Tea-meetings in which both old and young people take great pleasure. When they meet at such times young men and girls are called together to meet at night for eating and drinking and then sell their bodies for immoral purposes. Girls and women are sold by auction one by one *to the man who pays most*, and are taken out for the night. Young men leave the towns and farms every Saturday with their money and spend it in this way. Some even form themselves into what they call

"clubs," paying for membership and arrange the places of the meeting. The one who arranges the meeting takes all the proceeds of the sale which usually takes place in closed huts where they first drink and dance with the girls. In this way many give birth to children born in immorality and other bad women do likewise. Some leave their husbands and enter the locations and compounds for bad purposes, travelling [sic] to and fro. We ask the Government to help us. We are greatly troubled about these things and we hate them because they destroy our nation and are unknown to us. There is no more purity among both young and old. Because of these things our nation is becoming defiled. We ask the Government to help us with these things that they may prevent them in our nation because we feel that there is no other place to seek for help but from you who make our laws.[2] [emphasis added]

A second example comes from men who sent written statements to a commission of inquiry into the situation in the Salisbury location in 1930.

Harlots. Are they who have spoiled the country and are they also who have put this DEAD life in all men and young men. They have put many lives of young men to death to Prison and to Poverty. . . . It would be altogether a better Location if the Gov't would stop harlots to stay in the Location, because they are the ruiners of other women who have a fixed marriage, a great many people have lost their good and honesty [sic] wives through harlots. . . . We would like the Gov't to fix up a way which should lead them to the happy and new life. . . . The life we are in now is almost rotten.[3]

The third example is an excerpt from a letter written in 1944 to the CNC from a group calling itself the "Keep Alive Society" on a mine outside the town of Selukwe.

We are afraid to command our children . . . now if you decide to get a stick as to command her she at once stands up strongly and she cries that my father has killed me in the forcement of refusing my husband. . . . Then after all she is told to chose for another husband whom she thinkest is the best one, yet he is penniless having no even [a] penny in his pocket. Both they go and live in the Compounds, in the Towns and in the farms and jion [sic] in those people live in who are considered of bad manners.[4]

What can we make of these eloquent pieces of African male protest? Historians have read such statements as this, from 1934, to mean that African society and the vast majority of African men were angry with urban women:

"Bitter expressions were vented on the subject of local women in towns and absurdly drastic remedies were voiced."[5] The Selukwe, Harare, and Bubi letters certainly contain similar elements: complaints about bad, defiant, mobile women and their immorality, and portraits of horrified, helpless fathers and duped husbands. Importantly, however, they also contain another element: complaints about the African men who collaborated in destroying "the nation"—those "who could pay the most." These two excerpts thus record not only men's unhappiness with mobile women, but their complex conflicts with each other.

Recent historiography as based on archival sources[6] has recorded an overwhelming majority of African male voices raised in protest about the mobility of African women. But this chorus was not in fact unanimous. The responses of African men to mobile women were not uniform; there was no clear, single, simple condemnation by all men of the mobility of all women. Gender relations in midcentury colonial Zimbabwe were far too complex for this. Not only, therefore, were men unhappy about women's exercise of some degree of economic independence—that independence, or male perceptions of it, also sowed discontent within male ranks.

Thus, the presence of urban women who were willing to do domestic labor was clearly in the interest of the urban men who could pay, or house, them to do so. Therefore the flourishing presence of women in towns must have pitted rural and urban men, or rural and urban-based strategies of men, against each other to some extent, as fathers and husbands battled to maintain control over women living with boyfriends and strangers on the mines and in the towns. This would also have been a struggle between African men of different generations: the older men who had seen the advent of colonialism transform their lives and younger men whose new choices were some of the most important manifestations of that transformation.[7] As many of the men in mines and towns were migrant workers, there would also have been conflict between indigenous and foreign men.[8]

Men from Southern Rhodesia who were committed to a rural-based strategy of economic survival, who were increasingly strapped for cash in the wake of escalating demands by the state for taxes and fees, yet on the other hand increasingly hemmed in by agricultural and marketing restrictions,[9] seem to have realized by the 1920s that money earned and remitted home by female migrants was as valuable as money earned and sent home by male migrants. Presumably those men who were being helped to stay afloat by their daughters' contributions would not have complained—or at least would have complained less fervently—about female urban migration. Those who lost the labor of women in agriculture and their remitted earnings, on the other hand, could logically have

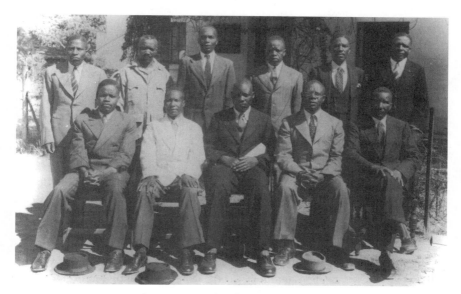

Photo 3.1 Urban patriarchy: the African advisory board of Highfield township, 1947. Photograph by Noel Wesson. Courtesy of the National Archives of Zimbabwe.

been expected to have been the most vociferous defenders of restrictions on the mobility of African women.

In May 1935 the Matabeland Home Society (MHS) hosted a public meeting in the Bulawayo location on the subject of immorality and focused on what the assembled men felt was the extremely unsatisfactory government enforcement of the Native Marriage Ordinance in the towns. This law, originally passed in 1901, is an excellent example of the "invention of tradition," as a measure that was initially passed to curb what the settlers saw as the "abuses" of the African marriage system.[10] Ironically it came to be used by African men thirty years later to try to rein in what they, in turn, decried as "nontraditional" and unacceptable behavior by African women. Further, they demanded that the government use the ordinance as a weapon against women's independence. The ordinance provided for the registration of marriages if certain prerequisites had been met and the issuing of marriage certificates. Commenting on what seems to have been a distinct lack of attention to the ordinance, the MHS members complained that the lack of marriage certificates in towns "let the gates open into the Town Locations and in Compounds as the Cave or a Shield of Natives males and females." African urban women,

the letter alleged, "see that they are free from being disturbed and [asked] for Marriage Certificates." Urban men, on the other hand (presumably not MHS members), made a bad situation worse by "taking a girl or women deserted from her parents or her husbands to Town . . . and simply stay together as wife and husband without consult her parents, either married her in proper Custom." The meeting "strongly" asked that "the gates into Towns" be shut to women migrants by way of renewed and vigorous inspection for marriage certificates. Interestingly, it was confirmed by a CID officer that proof of marriage was not demanded when an African man accompanied by a woman applied for accommodation in the Bulawayo location.[11]

The MHS members were examples of African patriarchs who distinguished between groups of migrating women. For some, in the decade of the 1920s, the problem had not so much been controlling women's mobility, for example, as controlling the *proceeds* of women's mobility.[12] Making two important distinctions within the African community, the MSH members first distinguished between themselves and African men who lived "illicitly" with other people's wives and daughters; second, they drew a distinction between married, dependent women and unmarried, independent women. Thus, it was not the presence of women as such that they objected to. Rather they were angered by the presence of women who did not have marriage certificates to prove that they were under full male control.

This distinction was also made by the groups of elders who were appointed to bodies called rural "native boards" in the 1920s and the Southern Rhodesian Native Association in 1932.[13] Interestingly, evidence suggests that the Native Association, an organization of elite, Christian men, strongly distinguished between groups of women who were, and were not, considered to be acceptable in urban areas. In 1928 the association sent a list of the topics that were on the agenda at their annual conference to the CNC: one was a declaration that respectable African women in town should not be vulnerable to continuous demands for pass documents from "rather overbearing" African policemen; on the other hand, married women who left the rural areas "to cohabit unlawfully with other men in the towns, mines or on farms as common prostitutes" should be "dealt with severely."[14] Ranger's study of the Samkange family mentions that the remarkable Reverend Thompson Samkange, who joined the association in 1925, supported the right of educated women to migrate to towns to look for employment.[15] Aaron Jacha, a progressive African farmer and secretary of the Salisbury branch of the association, protested against the Natives Registration Act in 1936 partly because he felt that it would not discriminate between "decent African women . . . walking to town" and mere prostitutes, who, he thought, should be strongly dealt with.[16] On a more inventive note, the South African immigrant Salomon Makeba, who chaired the association's executive

committee in the mid-1930s, wrote to the NC Salisbury in 1937, ascribing the Depression-era ills of African society to a "horrible disease" that was brought on and spread by African men's "having connection with loose women" during their menstrual periods.

> Men and women are too loose—it seems all are now loose living. Those who attend Church are better off than those who do not go to church; they at least try to keep themselves better—there are exceptions, some go to Church only for something to do. . . . There must be a Bill of Parliament to chase these girls and women from the Mines and the town location to stop the loose morals and the spreading of the disease. Then the country will be better; it is the only way to make the country better.[17]

Urban African men found themselves in a particularly contradictory position in regard to women. As many of them retained their ties to the land it was clearly not in their interest to support the removal of female labor from agriculture. It was also not in their interest to support women as competitors for domestic service jobs[18] and urban housing. As a man in Bulawayo said in 1930s, "In the location today prostitutes are permitted to hire cottages from the Municipality simply because they are able to pay rent and they have cottages in preference to working men, this should not be allowed."[19] But as urban residents, on the other hand, male workers needed both a companion and someone to perform domestic labor—to provide, as White has written, "the comforts of home."

The complexity of the African male response to the urban migration of African women should not, therefore, be underestimated. It is impossible to quantify the numbers of men who supported the mobility of respectable women as opposed to those who condemned the mobility and migration of all women. In 1932 the Umtali branch of the Native Association proposed a classification scheme that, many decades later, is instructive on this question. Writing to the CNC they said that they supported the idea of their own daughters' working in town as domestic servants. However, they claimed that "uneducated fathers" in the rural areas were afraid to let their daughters come to town because they would be "spoiled" there, and even if they found jobs, they would be paid wages too low to enable them to send any contributions home.[20] Here again, women's economic options were fundamentally woven into notions of social reproduction.

RESPONSES FROM THE COLONIAL STATE

An important historiographical development of the 1980s emphasized that African people were not passive victims of colonialism, and that

colonial society was shaped as much by actions from below as policies from above. This has introduced a welcome dimension of agency to the historiography of African women. But as writings of this genre generally trace a pattern of state action and African reaction and resistance,[21] some misconceptions are perpetuated. For example, Jeater argues that by the end of the 1920s,

> the stage had been set for the offensive against women which characterised the 1930s. The moment of freedom was over. . . . By 1936, the long-awaited pass system for women was instituted in the shape of the Natives Regis-tration Act. . . . By the close of the 1930s, the Pandora's Box of female resistance which the Occupation had opened up had been forced shut by the Occupiers themselves.[22]

But, as will be shown, although there was a legislative campaign against urban women in the 1930s, it remained largely unimplemented; the 1936 Natives Registration Act was in fact hardly more than an elaboration of the 1901 Registration Act in that it continued to exempt married women from controls and focused instead on a minority of young, unmarried female migrants.

Phimister's account of the relationship between African women and the colonial state in the 1930s and 1940s also contains some important miscon-ceptions. Focusing on issues of class struggle, he writes of women largely penned "within the confines of the reserves" who played no appreciable role in class formation because they earned no wages, and of women wage earn-ers in the towns whose proletarianization was only partial and was shaped by the joint operation of an alliance between "patriarchal concerns and capital's imperatives."[23] But if the class positions of women are not the same as those of their male relatives, it remains to be studied what the role of rural women in class formation might have been. Second, it has already been noted that the idea of an alliance between African patriarchy and the state is a troubling one, and to have that alliance dictating the terms of women's urban position without any consideration of women's agency is certainly misleading. Fi-nally, the urban working women to whom Phimister refers were a minority of the African female population of the towns; although he does suggest that "many" women in mine compounds and urban locations survived by becom-ing prostitutes,[24] their work is not linked in his study to any of the processes of class formation operative in other segments of the population. On the whole, therefore, entire facets of the experiences of the majority of African women under colonialism remain unexamined.

This study contends that in a more accurate rendering of cause and effect in state/African urban social relations, the state did what resisting it could—

to the urban actions of African people, especially women. Available documentary records, for example, indicate that the colonial state did not interfere with the physical presence of African women in the towns to a great extent in the 1930s (see later). How can this be explained? As White's studies of colonial Nairobi[25] powerfully argue, did urban women and African urban social reproduction present challenges to the Southern Rhodesian state with which it did not care to, or could not, cope?

A lengthy discussion, recorded verbatim, held by Native Department officials in August 1931[26] provides good ground on which to assess the state's relationship to urban African women in the first years of the Great Depression. It seems that the colony's native commissioners felt that patriarchs, not women, had rights that needed to be safeguarded; that there was a great deal of official frustration about how to stop the migration of women into the urban areas. The NCs discussed the difficulty in devising measures to control what women did in urban areas, finding that they could not work out the applicability or even the usefulness of legislation such as the 1889 Vagrancy Act or the Pass Consolidation Act of 1901 to urban women. They also faced a number of practical problems in day-to-day urban African culture that they could not solve. For example, a woman who came to town and proceeded to support herself on private land near town or even on common municipal land could not be prosecuted as a vagrant or trespasser, for three reasons. First, colonial legislation generally only applied to "natives," who by legal definition were only males (ironically women's minority status therefore protected them against some colonial abuses). Second, much of the legislation only applied within surveyed town boundaries. Third, women who were stopped in urban areas by African constables—the law enforcement agents most likely to deal with the urban African population—could easily be sexually harassed. Official fears about African policemen's harassing African women were regularly expressed in colonial correspondence:[27] thus, "If they [women] did carry a certificate, who is going to call upon them to produce it?" and "Can a cat be a policeman to a rat?"[28]

The commissioners also discussed the thorny problem of issuing passes that allowed women to stay temporarily in towns. This would be difficult when women arrived from the rural areas after hours, when government offices were closed (seemingly a common occurrence). Umtali was the only town where there was a hostel where such visitors could stay overnight and be easily issued with passes in the morning. Female visitors were thus forced to lodge with whoever would shelter them temporarily; often, the NCs thought, for lack of a twenty-four-hour pass service and cheap municipal accommodation they stayed with men who trapped them into prostitution. Also, women were legal minors and issuing them with

passes to stay in town required proof that they had their rural guardian's permission to be away from home; but the state was neatly and inescapably hoist with its own petard if, as was alleged (see later), guardians intentionally sent wives and daughters into towns to earn money. [29]

The main context of the discussion, though, was the chorus of male voices from the reserves pleading with the Native Department to control the flight of rural women to the urban areas. These discussions in fact showed evidence of considerable tension in what Schmidt has called the "unholy alliance" between rural patriarchs and state officials.[30] According to the NC Umtali:

> Whenever a guardian comes in [to town] and lays a complaint the women are at once issued with this order [to leave] and if they come in again they are prosecuted. But the difficulty is that these guardians will not come into town. I do not know for what particular reason unless it is that they find that although they get the woman she immediately runs back again. There are constant complaints that the women are there and yet the number of guardians who follow up their daughters is extremely small. If you do not get the guardian to complain under the present system it is almost impossible to discover these women.[31]

The NC Victoria agreed: "Why should we trouble? If they won't trouble themselves, why is it up to us to do it?"[32] The NC Gwelo voiced what seemed to be a strongly held opinion: guardians did not, in fact, come into towns to look for absent female charges because they wanted to share in the proceeds of any urban earnings, and it was thus in their interest not to have women returned to the rural areas. In 1935 the commissioner of police agreed, adding that in his opinion African parents often encouraged daughters to become urban prostitutes for the sake of their earnings;[33] the prime minister echoed these sentiments in 1936, alleging that he had been told that "it was no uncommon thing for the native to bring in a certain number of native girls . . . so that they can earn the money in town to pay the taxes."[34] The CNC suggested that the "evil" of immorality could be laid in large measure at the doorstep of African parents because they were, he said, apathetic in chasing absent womenfolk, demanded excessive *lobola,* and continued to pledge young girls in marriage to old men.[35] A Salisbury CID detective attempted to reconcile the loud complaints with the lack of interest in chasing women:

> It will be seen [from the figures provided with the letter] that, in view of the large native population in and around Salisbury, the number of young native women (apart from well-known prostitutes) whose presence in Town cannot be shown to be bona fide, is very small over the period dealt with.

If succeeding figures confirm this, it may be assumed that the evil has been exaggerated, owning to the surviving feeling among conservative natives out of touch with modern development, for the old close tribal and parental control of women.[36]

By the same token, the Bulawayo CID admitted that "the proportion of young native girls found in Town without the permission of their parents or guardians . . . was practically negligible."[37] As will be shown, figures in Salisbury and Bulawayo did indeed confirm that only a minority of urban women fell under suspicion of being runaways. All in all, this evidence from 1931 suggests that the state, in the personages of the officials of the Native Department, was casting about for new ways of dealing with the problems presented by urban women. As one NC put it in 1931, in regard to the urban migration and settlement of women, "We are rather stuck, we members of the Native Department . . . we [are] rather beaten over the thing and [do] not know what to do."[38]

The state eventually chose to delicately enter the fray, but not to interfere substantially—in the sense of implementing large-scale removals, for example—with the majority of the African women in urban areas. In 1931 the CNC noted that "measures" had recently been instituted to discourage rural women and girls from entering towns—but these "measures" were not being taken against women already resident in those areas.[39] A wide-ranging set of instructions was sent to all police stations in the country in August 1931,[40] stating, in part:

Requests from Native Boards throughout the Colony have been formu-
lated for assistance to prevent young girls going to towns and industrial
areas for immoral purposes. The Commissioner attended a conference of
senior N.C.'s on the 11th instant when this matter was discussed. It was
agreed that the laws dealing with vagrancy, &c. *[sic]* should be more strictly
enforced *against young women*. The Commissioner directs that steps be
taken to locate girls of the class referred to living in and around urban and
industrial areas. [41] [emphasis added]

There were further instructions that records should be kept of women in the urban locations who were approached by police in terms of the 1927 Native Affairs Act,[42] of those who were fined or arrested, and of those "un-married women and girls earning a livelihood by doubtful means in and sur-rounding" the towns (the circular warned that "native police" should not be allowed to carry out this work unless under white supervision; even these men should be "careful to avoid any accusations being brought against them"). The Southern Rhodesia police obediently recorded all this information; their surviving reports provide a fascinating glimpse into location life in the 1930s.

Table 3.1 "Quarterly Immorality Returns" on Location Women, Salisbury CID, 1931–1934

Quarter ending	"Warned"	"Prosecuted"	"Living on doubtful means, but not arrested"
September 1931	76	15	312
December 1931	35	5	300
March 1932	23	4	300
June 1932	18	5	300
September 1932	18	2	300
December 1932	22	8	300
March 1933	14	5	300
June 1933	17	8	300
October 1933	0	0	300
January 1934	46	23	300
April 1934	33	25	250–300
July 1934	34	13	250–300
Total	336	113	

Source: Quarterly returns collated from reports from Salisbury CID to Salisbury Staff Officer BSA Police headed "Immorality—native girls." S 1222. These figures only reflect raids carried out in the municipal location of Salisbury. It is not known what actions, if any, were taken in these years against women who lived outside the location.

It also reveals that the police targeted only a select few in the population of urban African women: the circular specifically mentioned only young women who were recent migrants. Therefore, older urban women who were (perhaps) evading direct patriarchal control or women who were living there by "doubtful means" were conceded to be beyond the regulatory scope of the colonial state or boundaries of its concern.

Prodded by a variety of circumstances, the police set out to look for women who matched the description of the 1931 instruction: young girls who seemingly had only been in the town for a short time. Those who fit the profile would be "warned out of town"; those who were identified as having previously been warned were prosecuted and if found guilty (and, seemingly, those who arrived at this point in the system invariably were) were given a choice between a prison sentence or a fine (Table 3.1). Every three months the sta-

Table 3.2 "Quarterly Immorality Returns" on Location Women, Bulawayo CID, 1931–1935

Quarter ending	"Warned"	"Prosecuted"	"Living on doubtful means, but not arrested"
Aug.–Sept. 1931	42	n/a	n/a
January 1932	91	7	600
April 1932	31	7	n/a
July 1932	n/a	1	600
October 1932	0	0	600
January 1933	17	0	600
April 1933	0	0	600
July 1933	0	0	600
October 1933	5	0	600
January 1934	0	0	600
April 1934	1	0	600
July 1934	3	0	600
October 1934	1	1	600
May–Oct. 1935	83	10	700
Total	374	26	

Source: Collated from quarterly returns from Bulawayo CID to Salisbury Staff Officer, BSA Police, headed "Immorality—native girls." S 1222.

tistics would be compiled and sent in to headquarters. This amounted, then, to a fairly constant but low-level harassment of urban women.

In 1930 it was estimated that there were 679 women living in the Salisbury municipal location; by 1934 this figure had grown to 806.[43] In each raid, therefore, only up to 6 percent of the female residents were "warned," and only up to 3 percent were prosecuted. Approximately 40 percent of the location women fell under suspicion as "living on doubtful means," but they were not harassed. Further, the remaining population of women, over half of the total, was *not* living on doubtful means and therefore led, by the estimation of the municipal authorities, lives that (even if perhaps not respectable) were beyond the scope of the enforcement of the "anti-immorality" policies.

In 1929 it was estimated that there were 750 women in the Bulawayo location, and at the end of December 1933 there were said to be 972 ("only

about 10 are lawfully married,") rising to 1,237 in 1936.[44] In the southern town, then, the situation was even more stark as the police warned and arrested even fewer women than did their counterparts in Salisbury (Table 3.2).

It should be noted, however, that the quarterly reports also, however, obscure an unquantified number of location raids. The file that contains this information also has marvelously detailed records of three individual raids in December 1931, February 1932, and October 1932 that the police seemingly carried out in order to compile lists of "native females alleged to be prostitutes in the Bulawayo location." Although this study is primarily concerned with Salisbury, this information from Bulawayo is presented because of the strength and interest of the data, and the lack of surviving returns from the Salisbury police.[45]

From the nine hundred or so women in the Bulawayo location, eighty-one, ranging in age from fourteen to twenty-two, were rounded up over the course of December 1931. Most had been in the location for less than six months, and the police ordered nearly 90 percent of them to leave Bulawayo by the end of the month.[46]

More lenience was shown to the thirty-one women who were rounded up in another raid on 22 February 1932. Although some 80 percent "admitted prostitution," only half were ordered to leave Bulawayo; these had been in the location for an average of sixteen days. The women who "admitted prostitution" but were not warned to leave Bulawayo either had lived in the location for a long time or had come from rural areas far from town.[47] By 1932, therefore, the authorities were differentiating quite carefully between the location women. Even if they believed that a woman was a prostitute, she was only ordered to leave town or face prosecution if she was a recent arrival whose home area was relatively nearby.

Sixty-nine women were rounded up by the Bulawayo CID in late October 1932 on the request of the location superintendent, who was spurred by a reported increase in the number of young women in the location; he also believed that "recent assaults" there had been connected with women.[48] On his request, the "detainees" were then sent to the NC Bulawayo, R. Lanning, who asked for the CID to ascertain a great deal of detail about the detained women. Most, it transpired, were unmarried, of no fixed abode; thirty-one of them "admitted prostitution."[49] On the basis of what he learned, Lanning ordered seventeen of the women, described as "young Matabele girls," to leave Bulawayo within the week.[50] No action was taken against the other fifty-two women, who were long-term visitors, formal and informal (*mapoto*) wives, known prostitutes, and women from Mashonaland and foreign countries. It had been noted by other officers that Lanning often refused to take action against women brought to him by the CID.[51]

The records of the 1931–1932 round-ups clearly suggest that the state had no intention of implementing a vigorous campaign against urban women at that time. Although the majority of location women conducted themselves so as not to attract the ire of the authorities, official suspicion of prostitution fell on a tiny minority. An obvious way for a woman to achieve this was to claim that she was, either formally or informally, married. Second, even of the suspected, mainly unmarried minority, the trend was to apply the only available sanction—an order to leave town— to a decreasing percentage, as 89 percent of the women rounded up in December 1931 were "warned out" but only 39 percent and 25 percent of the victims of the February and October 1932 round-ups, respectively, were so ordered. Last, the CID correspondence strongly conveys the impression that law enforcement officers increasingly saw their efforts as an exercise in futility. In the October 1932 raid, for example, a CID officer wrote that the location superintendent personally requested a round-up. It was duly carried out, but the same superintendent then told the CID that he was too busy to testify against the women in court and asked that they be sent instead to the native commissioner. This NC in turn prevaricated about sending the women away, saying that he would ask for some relatives be notified to come and pick them up. The NC said that he would warn a few of the youngest, newest arrivals to leave town; but he was, he said, in no position to take action against the rest.[52]

The Bulawayo CID continued to record its criticism of this system politely; two detectives wrote in 1935:

> When raids take place obvious confirmed prostitutes are left alone. Only young girls are interrogated and are taken before the [Assistant Native Commissioner] who interrogates them individually and decides which ones shall be ordered out of town. When girls are prosecuted for disobedience of [his] orders they never have money with which to pay their fines and are committed to gaol and it is suspected that male "friends" pay the fines. In the majority of cases fines are paid late in the afternoon or at week ends so that when the prisoner is released from gaol she cannot be taken direct from the Gaol to the Native Department for re-warning to leave town.[53]

Individuals in the urban police were in fact chafing at a system that may have pitted two branches of the colonial state against each other. Lanning in Bulawayo was not alone in his lack of zeal in "cleansing" the location; he would have found support from his highest superior in the Native Department, who had mused in 1933,

> I do not think you should try and stop prostitutes in the town because that would lead to grave discontent. You only want to control it.[54]

Civil servants had a number of reasons for their substantial noninterference with urban women, even those whom they described as prostitutes. They were wary of provoking urban resistance as had happened in South Africa when efforts had been made to require African women to carry passes in towns.[55] More strongly expressed, however, was the belief that urban women were "somewhat of a safeguard to native men's instincts."[56] According to the chief medical officer in Salisbury in 1935, these "instincts" were not to be taken lightly: "At the natives' present stage of civilisation his animal instincts, particularly if a little alcohol has been consumed, are uppermost."[57] The very idea of not having any African women available to bear the brunt of these "instincts" in turn summoned up the specter of white women set upon by hordes of sex-starved African men: "If the towns become extremely moral a valuable safeguard of the European woman is imperilled *[sic]*."[58] As has been well documented in recent scholarship, this "black peril" was one of the major phobias of the white Rhodesian political economy.[59] It seems that its officials would contemplate anything rather than lay themselves open to the charge of encouraging "the black peril" in the colony. As late as 1943 the NC Bulawayo was still maintaining that to take drastic action in removing urban prostitutes would "probably increase" the number of such cases.[60]

The passage and eventual pseudo-implementation of the 1936 Natives Registration Act did little to change this pattern. The number of convictions of urban women as runaways did not increase after 1936[61]; in Salisbury, a few women complied with a regulation that required them to apply for permission to be admitted to the location, but most did not.[62] Married women and long-term residents were officially exempted from regulation.[63]

THE PROVISION OF HOSTEL
ACCOMMODATION FOR AFRICAN WOMEN

As the state declined to clear the towns of urban women, it was logically presented with the problem of what to do with them instead. As noted in Chapter 2, housing policy ensured that by the time women came to be employed in their thousands in the towns after World War II the pattern of their enforced dependency on men for accommodation had been set. The state was, however, eventually forced into making a few paltry concessions toward providing independent accommodation for women. These efforts, however, met a mixed reaction from the urban African population itself.

By the 1950s, there had been a long history of calls for single-sex accommodation for women in the towns. Even before the 1920s government officials and missionaries linked the dearth of women domestic servants to the absence of urban accommodation for them. In later years a number of Euro-

pean organizations called attention to the housing shortage for African women in the towns. In responding to a call from the Anglican church in 1927 that African women be employed instead of African men as domestic workers in government institutions where they would come in contact with European women, officials mooted a scheme to erect small hostels for women in Salisbury or Bulawayo with the help of missionaries. Calling for what she called "a kind of casual ward" for women visiting towns, a representative of the Rhodesian Women's League noted in 1928:

[The location superintendent] has perfect control over the native men in his area, but is helpless where the women are concerned. . . . Outside the location there is absolutely no control over them, and they are forced either to put up with a so-called brother, or to squat on the commonage. Inside the location, the superintendent cannot cope with them, he has either to place them into the barracks with the single men, divided only by a partition and with no one in charge or less [sic] to quarter them with the married couples, whose accommodation is already very limited.[64]

A few years later, the report of the committee investigating the "employment of native female domestic labour" made the guarded recommendation that "in towns in which public opinion favours such a course," hostels be set up by government or voluntary organizations.[65] In 1943 an investigation by Percy Ibbotson for the Salisbury City Council strongly recommended the construction of a "Hostel and Clubroom for African females employed in Salisbury."[66] A number of witnesses to the Howman Committee were similarly of the opinion that the greatest obstacle to increasing the numbers of African women working in urban areas was the absence of decent accommodation for them. One of the committee's many recommendations, therefore, was that hostels for African women be erected in all urban areas.[67] The Federation of Women's Institutes passed resolutions at its annual congresses in 1941, 1947, and 1948 calling for hostels for African women, and the report of the National Native Labour Board of 1948 recommended, inter alia, that such hostels be constructed immediately.[68]

Yet central and local government did remarkably little to answer these requests. A small hostel for African women had been opened in the eastern town of Umtali in 1931, but it was operated under the private auspices of the Methodists at Old Umtali Mission.[69] In 1934 the NC Salisbury spoke confidently of a coming day, "when we have our hostels";[70] but these hopes were not to be realized for many years, as forces opposed to these ideas defended the exclusion of women from urban accommodation. For example, according to the Salisbury location superintendent in 1940,

regarding the letting of rooms to single women [there] is no doubt that
the setting aside of locations under the Native Urban Location Ordi-
nance of 1906 was accepted for the purpose of providing <u>male</u> natives,
employed in these areas with accommodation. To allow single native
females to occupy such accommodation to the exclusion of employed
male natives is undesirable.[71]

In this case it is easy to see that a superintendent with such views, who
was personally responsible for the allocation of location rooms (in this case,
until his retirement in 1952),[72] would block housing for independent African
women. The publication of the Howman Committee's recommendations in
1944 provoked an impeccably bureaucratic response from the secretary for
native affairs, who commented that although urban hostels for African women
were certainly needed, their construction and administration should not be
the responsibilities of central government; the employment of women who
were not living with their parents or husbands was very controversial; gov-
ernment, he thought, would be well served to wait until more evidence was
available on the effects of private hostels on urban women.[73] More direct
responses to the issue came from the Reverend Samkange and his son,
Stanlake, possibly in response to the welfare investigations of the day;
Samkange père wrote to the wife of the CNC in 1941 that it was impossible
to stop the migration of African women to towns: "How can you stop or
prevent a running stream?" he asked. He felt that hostels for women were a
necessity.[74] Stanlake concurred in letters to the *Bantu Mirror* newspaper in
1943.[75]

As one of the markers of developments in the colonial political economy
in the post-World War II era, municipal hostels were finally made avail-
able for African women in the 1940s. In 1945 the Bulawayo municipality
opened a hostel. Named after the mayor's wife, the Gertrude McIntyre
Native Girls Hostel was the result of a long campaign waged by the
Bulawayo Native Welfare Society and the "native advisory committee"
of the location.[76] Five more years were to pass before the city of Salisbury
opened its first hostel for African women, Carter House (named after a
prominent local Anglican clergyman), in Harare township.[77] McIntyre
Hostel and Carter House, representing the state's entire effort on behalf
of independent working women, could accommodate only a total of 298
women and can be contrasted with the huge building programs under-
taken by the state on behalf of white postwar immigrants. If Table 3.3 on
municipally provided women's accommodation in Salisbury is compared
to statistics in Chapter 1 on the numbers of African women resident in
greater Salisbury, it can be seen that state efforts represented only a drop
in the ocean.

Table 3.3 Numbers of African Women Legally Housed in Municipal Accommodation in Salisbury, 1951–1956

	"Single" women	*"Unattached" women*	*Total*
1951	0	13	13
1952	0	41	41
1953	0	47	47
1954	0	54	54
1955	65	30	85
1956	85	30	115

Source: "Overcrowding in Native Urban Areas; Aggregate of Housing Accommodation in Council's Native Residential Areas," memo submitted by Salisbury Municipality, Director of Native Administration, to Urban African Affairs Commission, 8 October 1957. S 51/5. It is not stated on what basis the municipality differentiated "single" from "unattached" women. See also National Native Labour Board (NNLB) report, 1952, p. 14.

In addition to official neglect, however, these numbers suggest the lack of straightforwardness of the urban housing situation for African women. Despite the fact that there was an urgent need for places for urban women to live, those few places that the state did eventually provide were initially chronically undersubscribed. The contradiction between the crying need for accommodation and the ready availability of a few decent rooms can be explained by the prevailing attitude of women toward the restrictions that the state placed on female hostel dwellers and the attitudes that the location community developed toward the women who, by choosing to live in the hostel, were flaunting their independence of men. For example, the fact that the McIntyre Hostel in Bulawayo was not full initially astonished the members of the 1952 National Native Labour Board.

This well conducted hostel has accommodation for 133 women and girls, yet on the 22nd May 1952, and for some time before that, when some 1,500 women were living in shocking conditions in the bachelor quarters of the location, it was only about half full.[78]

After hearing evidence from a number of African witnesses, the board concluded that the problem was the hostel's disciplinary regimen. Nightly curfews were enforced; visitors and weekend leave were strictly limited. Application had to be made to the matron for groups of three or more

Table 3.4 Occupations of Residents of Carter House, Harare Township, 1955–1959

	1955	1956	1957	1958	1959
Domestic worker	30	26	37	28	42
Charwoman	9	16	10	25	27
Child minder	–	–	–	7	3
Shop assistant	17	10	15	16	14
Factory worker	3	4	4	–	12
Hospital ward maid	4	27	21	29	49
Teacher	–	–	–	1	1
Religious worker	2	–	–	–	–
Hostel staff	–	2	2	2	9
Total	65	85	88	108	157

Source: Domestic workers worked in one house only; charwomen were free-lance cleaners. Salisbury Department of Native Administration, Annual Reports for the years noted. The 1958 Annual Report gives two different totals; the other is 163. 1957–1958 Annual Report, p. 33.

women to go to functions that would keep them out after 10:00 P.M. on weeknights and 11:00 P.M. on weekends. In addition, hostel dwellers had to undergo medical examinations when so ordered. The result of these and other regulations was that the hostel was the residence of last resort for the township's women. "I do not like to stay at the hostel because there is a rule which does not permit me to go where I like freely," one woman told the board. A male witness concurred: "I personally cannot encourage a person to go there, because it is only making one to be a prisoner."[79]

The other urban hostels for African women were run on similar lines. The first, in Umtali, was described in 1943 as

[not very] successful. It is successful up to a point but I think it is run on the wrong lines. There again you have a building with a 10 or 12 foot fence round it. It is more or less a gaol.[80]

Carter House in Harare township was also initially undersubscribed. There were beds for 165 women, but it held only 65, 85, 88, 108, and 157 residents in the years 1955–1959[81] (Table 3.4).

Miss Theresa Cele, who was a junior matron at Carter House from 1956 to 1964, recalls that the rent for each woman was about one pound per month.

It was a good place. It was helping [the residents] a lot, because some had nowhere to stay. . . . We had a special time. Nine o'clock we lock the gates. If they come late, unless they had permission to come late—because some of them were nurses, if they were due to come at a certain time we write it down, "so-and-so and so-and-so are on duties." Those who are working at the houses, they say, "We are on night duty looking after children, the madam is going out, we will come at such and such a time." They report— we open for them. But those who just go, we don't open. No. They must know the rules that at nine o'clock we close. Weekends we used to enlarge it a bit to half past ten.

But Miss Cele also described other factors that kept women away from Carter House.

[Outsiders] used to say, "Imba yemahure ivo [it's a house of whores]." It's what they used to call that place. And of course it was true. They [the residents] could do what they wanted. [They were] used to having so many boyfriends. Sometimes they will fight outside if the boyfriend comes and finds his girlfriend is standing with somebody. It was a job, that! That's why I moved [left the job in 1964]. You had to go [out] there and separate them. . . . Of course sometimes it was peaceful. But sometimes . . . especially weekends![82]

Whether real or imagined, the tarring of hostel residents with the prostitute brush must have led some women to choose other accommodation arrangements, as crowded and dependent as these may have been. Living independently in the "house of whores" would have been, to some extent, a public humiliation. The 1952 report of the National Native Labour Board described its understanding of the evidence presented by representatives of African organizations in Bulawayo about residents of the McIntyre Hostel:

Any woman or girl, who has been divorced or is a widow or who has once prostituted herself, neither wants nor deserves nor requires any consideration or protection. *She has lost her marriageable value and has "no future."*[83] [emphasis added]

The popular denigration of these women points to a number of factors operative on the urban housing front by the 1950s. First, the local disap-

probation of the Carter House women was to lead to serious consequences in 1956 (see Chapter 5). Second, and perhaps more fundamentally, it points to a rupture between the state's perspective on urban African women and the developing culture of the women themselves. Being branded with the scarlet letter of independence represented by residence at a hostel was a price less than two hundred of Salisbury's thousands of African women were willing to pay. The one-pound monthly room rental was a great deal more expensive than it seemed. By the 1950s one of the growing cleavages in the divided city of Salisbury was between African women who in the opinion of their community had "no future," and those women who, on the other hand, were determined to be people "with a future."[84]

CONCLUSION

For African men and the state, the issues of women's mobility and potential independence were for several decades more divisive than unifying. Rather than bringing about an alliance between African men and the state, or becoming a unifying force within African patriarchal ranks, women's initiatives brought African men into conflict with the state and with each other. For African society, an acceptable future was, simply, at stake. As for the colonial state, as a whole in the 1930s it was somewhat comatose on the issue of urban women. Organs of the state, such as the police force, in conjunction with local officials performed (presumably) enough surveillance to keep bureaucratic records such as "immorality returns." But overall the state largely did not actively answer the requests of some men to restrict women, nor did it make it any easier for others to live with urban women. Surviving records indicate that the police maintained low-level surveillance, harassment, and "repatriation" of young female migrants, but it did not subject the majority of women to this treatment. When changing postwar circumstances made it necessary for the state to make a gesture in the direction of dealing with the housing of urban women, its response was characteristically unsatisfactory. The more political moves that the state made in the late 1940s and early 1950s to try to come to grips with urban women are discussed in Chapter 5.

It has recently been suggested that one of the goals of the African nationalist movement was to heal the psychic wounds that African men caused each other as they clashed over one particular, controversial urban practice: men and women's drinking together in municipal beer halls.[85] The evidence reviewed in this chapter suggests that such a conclusion can perhaps be drawn on an even larger scale: conflicts between men over the entire issue of how to respond to women's urban initiatives became so divisive that a nationalist movement was called for, inter alia, to knit together the fractures that had

developed. As suggested in the Introduction, however, nationalism was only one of the coherencies that developed in midcentury colonial Zimbabwe. Another was the construction of an ideological system that can be called righteousness, to which the next chapter turns.

NOTES

[1] Interview with Mr. Lawrence Vambe, Belgravia, Harare, 17 February 1989.

[2] Quoted in letter from W. W. Anderson, London Mission, Shangani Reserve, to the Premier of Southern Rhodesia, 6 July 1928. S 482/802/39.

[3] Emphasis in the original. Written evidence of "Simon" and "Barton" to Native Affairs Commission of Enquiry into the Salisbury Municipal Location, 1930, p. 65–66. S 86.

[4] All errors in original document. Letter from "Keep Alive Society," Railway Block Mine, Selukwe, attached to Detective Inspector CID Gwelo to Assistant Commissioner CID Bulawayo, 20 June 1944. S 1222. When I began this research in 1988 I found two BSAP files dealing with "immorality" in the NAZ. The first, S 1222, was marked "Immorality: Personal, 1917–1930"; the side of the file was marked "files 1–30." The second was S 1227, "Immorality Policy Reports, 1916–1944," and its side was marked "files 61–105." These two files contained police reports and correspondence among the police, Native Department officials, and officials of municipal governments on a number of subjects including "immorality amongst native females," "black peril," and white men in sexual relationships with black women. Sometime in 1989 or 1990 the two files were combined into one by NAZ staff and renumbered S 1222. In late 1990 I was told that because it was a police file, S 1222 had been closed to researchers.

[5] Annual report of the NC Goromonzi, 1934, p. 12. S 1563.

[6] See, for examples, letters received in 1930 from "Rburamu Shirichena" about women "running" to towns. S 138/41.

[7] For example, in 1927 the members of the Southern Rhodesia Native Association asked that the government, inter alia, not hold fathers responsible for the taxes owed by their absent, migrant sons. "Notes of a Meeting on 1st June 1927 at Chief Native Commissioners' Office, with Delegation Representing Southern Rhodesia Native Association." S 2584/73.

[8] See Michael West's excellent dissection of this issue, "Liquor and Libido: 'Joint Drinking' and the Politics of Sexual Control in Colonial Zimbabwe, 1920s–1950s," *Journal of Social History* vol. 30 no. 3 (1997), p. 656–657.

[9] Teresa Barnes, *African Female Labour and the Urban Economy of Colonial Zimbabwe, with Special Reference to Harare, 1920–39* (M.A. thesis, University of Zimbabwe, 1987), chapter 2.

[10] Terence Ranger, "The Invention of Tradition in Zimbabwe," in T. O. Ranger and Eric Hobsbawm, eds., *The Invention of Tradition* (Cambridge: Cambridge University Press, 1983), regarding the 1901 Native Marriage Ordinance; see Diana Jeater's exhaustive treatment in *Marriage, Perversion and Power: The Construction of Moral Discourse in Southern Rhodesia, 1894–1930* (Oxford: Clarendon Press, 1993); and Elizabeth Schmidt, *Peasants, Traders, and Wives: Shona Women in the History of Zimbabwe, 1870–1939* (Portsmouth: Heinemann, 1992), p. 119.

[11] Handwritten note requesting information about the necessity of proving marriage to gain location accommodation, answered by Detective Sgt. Chubbock to Acting Superintendent, CID Bulawayo, 4 May 1935; Acting Chief Superintendent, CID Bulawayo, to Staff Officer, BSA Police, Salisbury, 6 May 1935. S 1222.

[12] Teresa Barnes, "The Fight to Control African Women's Mobility in Colonial Zimbabwe, 1900–1939," *Signs: Journal of Women in Culture and Society* vol. 17 no. 2, passim.

[13] Schmidt, *Peasants, Traders and Wives,* chapter 4. "We the Southern Rhodesia Native Association hereby express our deep appreciation and thanks to the Gov't:-…(4). For the prohibition of unmarried women wandering about in Towns and Mines," signed by A. S. Chirimuta, J. Zata, and Baminingo, Southern Rhodesia Native Association, to CNC, 23 May 1932. S 2584/73.

[14] Resolutions of the Southern Rhodesia Native Association for discussion at conference of 29 June 1928, as submitted to the CNC 23 June 1928. S 2584/73.

[15] Terence Ranger, *Are We Not Also Men? The Samkange Family and African Politics in Colonial Zimbabwe, 1920–64* (Portsmouth: Heinemann, 1995), p. 33.

[16] A. Jacha, letter to the editor, *Bantu Mirror,* 21 November 1936. There is a clipping of the letter in S 1542/AA1/20 vol. 1. See also members of the Southern Rhodesia Bantu Congress to CNC (n.d. but marked as received 4 May 1937). S 1542/A1/20 vol. 1.

[17] Makeba described himself as a South African who had come to Southern Rhodesia from the Cape in 1908. S. Makeba to NC Salisbury (n.d. but marked as received 6 March 1937). S 1542/A1/20 vol. 1; Ranger, *Are We Not Also Men,* p. 25.

[18] Elizabeth Schmidt, "Race, Sex and Domestic Labor: The Question of African Female Servants in Southern Rhodesia, 1900–1939," in Karen Tranberg Hansen, ed., *African Encounters with Domesticity* (New Brunswick, New Jersey: Rutgers University Press, 1992), p. 226–227; Terence Ranger, "Women in the Politics of Makoni District" (unpublished paper, University of Manchester, 1981) p. 12–13.

[19] "Salomon alias Jujuju," oral evidence to the Native Affairs Commission (inquiry into the Bulawayo Native Location), 1930, p. 29. ZAN 1/1/1.

[20] Oral evidence of six unnamed members of the Southern Rhodesia Native Association in Umtali, to Commission of Enquiry into Native Female Domestic Service, 1932. S 94.

[21] See Jeater, *Marriage, Perversion and Power,* chapter 9; Elizabeth Schmidt, "Patriarchy, Capitalism and the Colonial State in Colonial Zimbabwe," *Signs: Journal of Women in Culture and Society* vol. 16 no. 4 (1991).

[22] Diana Jeater, *Marriage, Perversion and Power,* p. 259.

[23] Ian Phimister, *An Economic and Social History of Zimbabwe: Capital Accumulation and Class Struggle, 1890–1948* (London: Longman, 1988), p. 205–206.

[24] Ibid., p. 204.

[25] White, *Comforts of Home,* chapter 9; idem, "Separating the Men from the Boys: Constructions of Gender, Sexuality, and Terrorism in Central Kenya, 1939–1959," *International Journal of African Historical Studies* vol. 23 no. 1 (1990); idem, "Bodily Fluids and Usufruct: Controlling Property in Nairobi, 1917–1939," *Canadian Journal of African Studies* vol. 24 no. 3 (1990).

[26] Verbatim report of the proceedings, Native Affairs Advisory Conference August 10–12, 1931. S 235/486.

[27] See correspondence around the time of the passage of the Natives Registration Act; Commissioner of the British South Africa (BSA) Police, Circular Instruction no. 26/37,

p. 2, S 1542/A1/20 vol. 1; verbatim report, Native Affairs Advisory Conference, 1931, passim., S 235/486; Commissioner of the BSA Police to CNC, 19 July 1935, S 235/383.

[28] Captain H. G. Seward, CID Bulawayo, oral evidence to the Howman Committee, 1943, p. 181. ZBI 2/1/1; *African Weekly*, 17 July 1946.

[29] W. Edwards, NC Gwelo, Native Affairs Advisory Conference, 1931, p. 98, S 235/486; Staff Officer of the Commissioner of Police, to Acting Chief Superintendent, CID Bulawayo, 9 May 1935, S 1222.

[30] Schmidt, "Patriarchy," p. 753–756.

[31] W. S. Bazeley, NC Umtali, Native Affairs Advisory Conference, 1931, p. 96. S 235/486.

[32] E. Howman, NC Victoria, Native Affairs Advisory Conference, 1931, p. 102. S 235/486.

[33] Staff Officer of the Commissioner of Police to Acting Chief Superintendent, CID Bulawayo, 9 May 1935. S 1222.

[34] This of course was the ultimate irony for the settlers: that their "civilizing mission" was in fact only encouraging "immorality." Prime Minister Godfrey Huggins, in debate in the Legislative Assembly on the proposed Natives Registration Act, Southern Rhodesia Legislative Debates, 1936, vol. 1, col. 588–589.

[35] CNC to Acting Commissioner, BSA Police, 2 November 1931. S 1222.

[36] Detective Sergeant for Assistant Superintendent CID Salisbury to Staff Officer BSA Police, 28 September 1931. S 1222.

[37] Chief Superintendent, CID Bulawayo to Staff Officer, BSA Police, Salisbury, 2 October 1931. S 1222.

[38] E. Howman, Native Affairs Advisory Conference, 1931, p. 101. S 235/486. See also resolutions made and withdrawn dealing with traveling passes for women, prohibition of sales of railway tickets to women without permission notes, and the requirement that foreign African women traveling into Southern Rhodesia must possess marriage certificates. Native Commissioners Conference, 1930, p. 12, 19. S 235/434.

[39] Annual Report of the CNC, 1931. S 138/1.

[40] The original circular instruction, letter no. 2498/1, was canceled in 1934 by Circular Letter No. 4567/3/34. According to a seemingly rather testy CID officer, this was because "no Police purpose is served by the work entailed in compiling reports dealing with native prostitutes and if information is required regarding the subject by the Native Department they are in a position to obtain it in other ways." Then, 4567/3/34 was in turn canceled by Circular Letter No. 1041/35 in February 1935, which provided that some of the provisions of No. 2498/31 should come back into operation. The major change was that although records of police action should be kept, they would no longer be submitted with other quarterly crime returns. This was in turn followed by yet another circular in 1935, urging police to continue to take "all steps possible to prevent young girls and women from visiting and remaining in areas other than where they reside with their parents." Chief Superintendent, CID, to Staff Officer, BSA Police, Salisbury, 10 November 1934; Lieutenant A. Hickman, Staff Officer of the Commissioner of Police, Salisbury, to all CID Superintendents (Circular Letter No. 4567/3/34), 21 November 1934, and his Circular Letter No. 1041/35, 28 February 1935; Staff Officer of the Commissioner of Police to all CID Superintendents, 6 September 1935; Circular Instruction No. 20/1935, 8 September 1935. S 1222.

[41] Circular Letter No. 2498/31, Staff Officer, BSA Police to CID Superintendents, 13 August 1931. S 1222.

[42] This act, probably heavily influenced by the South African 1923 Native Affairs Act, stated inter alia that if a woman in town refused to return to her rural area when so ordered by a Native Department official, she was disobeying her rural chief and as such was guilty of a criminal offense. Once the police alleged that a woman was a prostitute, she was given a certain number of warnings (she was "warned out of town"), and if these were not heeded, she was charged with contravening section 14 of the Act. Initial sentences ranged from fines of one to three pounds or one to three weeks imprisonment with hard labor, rising to ten pounds or four months in prison for second or subsequent offenses. See "Native Immorality Returns," from Salisbury, Bulawayo, and Umtali CID offices, 1931–34. S 1222.

[43] Evidence of the location superintendent to Native Affairs Committee of Enquiry into the Salisbury Municipal Location, p. 7, S 85; Native Location Superintendent's report, Salisbury Mayor's Minutes, 1933–1934.

[44] Lynette Jackson, *Uncontrollable Women in a Colonial African Town: Bulawayo Location, 1893–1953* (M.A. thesis, Columbia University, 1987), p. 14; Detective Sergeants Fitzgerald and Price, report to Bulawayo CID, May 1936. S 1222.

[45] "List of Native Females Alleged to Be Prostitutes in the Bulawayo Location," all lists compiled by Bulawayo CID, 9 December, 16 December, 17 December, 18 December, 21 December, 29 December, 30 December 1931; 22 February and 26 November 1932. S 1222. Because of the similarity in the pattern of "quarterly immorality returns" submitted by Salisbury and Bulawayo CID, it is probable that similar lists were also made by Salisbury CID; I did not find any such lists in the Archives, however. It may be noted that these records are not reliable sources of demographic data. It is not stated by whom the allegations of prostitution were made; there were very few African constables to do the work; women did not have passes so their answers to various questions could not be verified. Finally, the women would have been questioned in Sindebele or Chishona, but responses were recorded in English; one would give a great deal to know how the women's comments that the police translated as admissions of guilt or protestations of innocence were originally phrased.

[46] Typed and handwritten lists of women rounded up on 9, 16, 17, 18, 21, 29, and 30 December 1931; and Monthly Report for December 1931, Acting Chief Superintendent CID BSA Police Bulawayo to Staff Officer BSA Police Salisbury, 31 December 1931. S 1222. The lists are divided into columns, headed Name, Address, Tribe, Kraal, Chief, Date located (when picked up), and "Warned by" (including remarks such as "admits" or "denies," the time spent in the location, and occasionally any previous warnings or convictions). The lists were signed and dated by R. Lanning, NC Bulawayo, or Detective Simpson, Bulawayo CID.

[47] Handwritten note, T. Collier, Location Superintendent, to CID, 22 February 1932; typed list, "List of Native Females Alleged to Be Prostitutes in the Location," signed by R. Lanning, NC Bulawayo, 23 February 1932. S 1222. This list is divided into columns headed Name, Address, Tribe, Kraal, Chief, Date, Remarks.

[48] Detective Sergeant Butler, CID Bulawayo, to Chief Superintendent, CID Bulawayo, 27 November 1932. S 1222.

[49] Typed list, "List of Native Females Alleged to Be Prostitutes in the Bulawayo Location 26/10/32." S 1222. The list is divided into columns marked Name, Address, Tribe, Kraal, Chief, Married or single, Date, and Remarks. There are a few handwritten notes on the list, but it is not signed.

[50] Butler to Chief Superintendent CID Bulawayo, 27 November 1932. S 1222.

[51] Detective J. R. Beningfield, CID Bulawayo, to Chief Superintendent CID Bulawayo, 24 June 1932; Detective Sergeant Lanourman CID Bulawayo to Chief Superintendent CID Bulawayo, 29 August 1931. S 1222.

[52] Detective Sergeant Butler to Chief Superintendent CID Bulawayo, 27 November 1932. S 1222.

[53] "Immorality by Young Native Females," reports by Detective Sergeants Fitzgerald and Price, May 1935 to May 1936. S 1222.

[54] Native Affairs Advisory Board, 1933. S 235/487.

[55] See Teresa Barnes, "'Am I a Man?' Gender, Identity and the Pass Laws in Colonial Zimbabwe," *African Studies Review* vol. 40 no. 1 (1997).

[56] Chief Superintendent, CID Bulawayo, to Staff Officer, BSA Police, Salisbury, 2 October 1931. S 1222. Fears of venereal disease carried by Africans infecting the white population also played a role; see Barnes, *African Female Labour*, p. 31.

[57] "Extract from the report of the Medical Officer of Health, Doctor A.J.W. Wilkins, relative to the municipal location" (n.d. but probably October 1935); see reference in Detective Sgt. 3056, Salisbury CID, entry in "Salisbury file 2/363/1919, Native Prostitution, Venereal Disease," 18 October 1935. S 1222.

[58] NC Gokwe to Bulawayo Superintendent of Natives, 26 November 1934. S 1542/S12.

[59] John Pape, "The Perils of Sex in Colonial Zimbabwe," *Journal of Southern African Studies* vol. 16 no. 4 (1990); Schmidt, *Peasants, Traders, Wives*, p. 157–158, 169–178; Dane Kennedy, *Islands of White: Settler Society and Culture in Kenya and Southern Rhodesia* (Durham, North Carolina: Duke University Press, 1987), p. 137–138, 145–146. See also Lawrence Vambe, *From Rhodesia to Zimbabwe* (London: Heinemann, 1976), chapter 9, and Richard Gray, *The Two Nations: Aspects of Race Relations in the Rhodesias and Nyasaland* (London: Oxford University Press, 1960), p. 19.

[60] "Memorandum: Native Females Loafing in Town, interview with NC Bulawayo, 8/10/43." S 1222.

[61] Commissioner of the BSA Police to Secretary for Native Affairs, 17 March 1938, S 482/366/39; Secretary for Native Affairs to Secretary to the Prime Minister, 22 March 1938, S 138/5.

[62] Commissioner of Police to Secretary for Native Affairs, 15 November 1938, S 1222; see also Salisbury Native Location Superintendent, memo of 27 August 1938, S 1542/A1/20 vol. 2.

[63] The Natives Registration Act, 1936, sections 13 and 15. *Statute Law of Southern Rhodesia, 1939*, vol. 2; NC Salisbury to CNC, 31 August 1938. S 1542/A1/20 vol. 2.

[64] Mrs. Bloomhill, Rhodesian Women's League, "Report on Meeting on the Prevalence of Venereal Disease in Southern Rhodesia," October 1928, p. 41. S 1173/220.

[65] "Report of the Committee on Employment of Native Female Domestic Labour in European Households in Southern Rhodesia," p. 6. S 482/117/40.

[66] Annual Report of the Chairman of the Native Welfare Society, 1943. S 2584/85/2 vol. II.

[67] See oral evidence to the Howman Committee: Percy Ibbotson, p. 7–8; Mr. Huxtable, NC Bulawayo, p. 45; Mr. Hadfield, editor of the *Bantu Mirror*, p. 53; Mr. Lewis, NC Selukwe, p. 80; The Reverend Rushworth, Selukwe, p. 89; Mr. Farquar, Native Development Inspector, p. 119; Mr. Ferreira, Native Department pass officer, p. 155. ZBI 2/1/1. Howman Committee Report, recommendation number 27. *African Studies* vol. 4 (1945).

[68] "An African Policy: Federation of Women's Institutes of Southern Rhodesia, Resolutions to Congresses 1928–1950 on African Welfare," NAZ Historical Manuscripts WO 6/1/3; NNLB as reported in *African Weekly*, January 19, 1949. See also Secretary for Internal Affairs to Mrs. N. H. Wilson, 21 April 1948. S 482/539/39.

[69] Annual Report of the CNC, 1931, p. 19, S 138/1. See also Lady Stanley, "Hostels for African Girls: Home Life for Domestic Servants," *The Link* vol. 1 no. 2 (1941), p. 5.

[70] NC Salisbury to Acting CNC, 24 September 1934. S 235/363. The first hostels for male workers were built in 1946; Timothy Scarnecchia, *The Politics of Gender and Class in the Creation of African Communities, Salisbury, Rhodesia, 1937–1957* (Ph.D. dissertation, University of Michigan, 1993), p. 59.

[71] Emphasis in original. W. S. Stodart, Salisbury Location Superintendent, to Medical Officer of Health, 8 April 1940. Salisbury municipality file 12/7 jacket 11.

[72] *Rhodesia Herald*, 20 June 1952.

[73] Secretary for Native Affairs, Memorandum on the Howman Committee Report, 23 March 1944. S 482/30/44.

[74] Ranger, *Are We Not Also Men*, p. 47.

[75] Ibid., p. 52.

[76] *African Weekly*, "Opening of Girls' Hostel," 7 March 1945. See also "Report of the National Native Labour Board . . . 1952," p. 14.

[77] City of Salisbury, Native Administration Department annual report, 1954–55, p. 74. A 1941 meeting, attended by representatives of a number of organizations, had once again urged the construction of a hostel. As nothing was done through the 1940s, controversy brewed over the siting of such a hostel. Liberal Europeans urged that it be built in the white suburbs close to women's places of employment and removed from the "dangers" of location life, but residents of the proposed suburbs protested that such a course would lead to a disastrous depreciation of their property values. The hostel was eventually built in Harare township next to the bus terminus. See Lady Stanley, "Hostels for African Girls," and correspondence on "Housing of African Women in European Areas," in S 482/145/28/48/1.

[78] NNLB report, 1952, p. 12.

[79] Ibid.

[80] Mr. Ferreira, Native Department pass officer, Salisbury, oral evidence to the Howman Committee, 1943, p. 155. ZBI 2/1/1.

[81] Salisbury Department of Native Administration, Annual Reports for the years noted.

[82] Interview with Miss Theresa Cele, Nyatsime College, Seke, 20 February 1989.

[83] NNLB report, 1952, p. 13.

[84] This dichotomy was articulated by an African male witness in the NNLB report, 1952, p. 13.

[85] West, "Liquor and Libido," p. 657.

4

PARADIGMS OF
RIGHTEOUSNESS

You know men never used to tell us how much they were paid. I
don't want to lie. He hid it. He hid it. He would just give me money
to buy bread and food. That's all. I didn't know his pay. I don't want
to lie . . . I just waited for my husband to be paid and he [would give
me] a penny. It was hard for me. We were told by the elders that,
"You don't bother your husband. Whatever he gives you, thank God
for that. It's his money." So you don't say, "Give me money." You
don't say that.[1]

Mrs. Mary Butao was a quiet woman with a shy smile. We interviewed her
in the lounge of her house in Highfield, piling our gadgetry on a lovely old
dark wood table. The excerpt from her interview illustrates the tensions ex-
perienced by women identifying their needs but then having to make diffi-
cult choices between what were considered to be the right and wrong ways
of fulfilling these needs. Their new behavior was guided by old admonitions
and by new considerations. The topic of this chapter is the dichotomy drawn
between correct and incorrect behavior in interpersonal relations—women's
decisions about what to say, as Mrs. Butao put it.

Urban gender relations underwent a complex set of changes in the period
under review. The early stereotypes of women among African people were
that only those in rural areas had any hope of living virtuous and proper lives
and all town women were immoral and loose, undisciplined and wild. By the
end of the 1950s, however, there had evolved a new system, one that harked
back to and was rooted in previous rural traditions but was in fact largely
constructed from new elements. Women constructed this new paradigm of
righteousness themselves, struggling within various colonial structures to
demonstrate that they could attain and sustain respectable, proper, and moral
behavior. The evolution of this group matched the state's interest in the de-
velopment of a small African middle class, and righteousness came to be

defined in largely material terms. The paradox was that the colonial urban system, in its overwhelming concern for the maintenance of white privilege at the expense of African workers (both productive and reproductive), conceded relatively little material gain, and only to a minority of African townspeople. These people polished their domestic and social skills, while the majority—doing what they had to do in order to survive—neatly fulfilled racist prophecies of shiftlessness and immorality.

TURN OF THE CENTURY IMPROPRIETY

Perhaps nothing is as difficult to reconstruct as precolonial gender relations. Thanks to the work of Elizabeth Schmidt, we know a reasonable amount about women's labor in the decades preceding the invasion of 1890.[2] Jeater has provided an extraordinarily nuanced assessment of the precolonial stance toward sexuality.[3] Herbert's evocative book about ironmongering and the technologies of transformation, in which a number of the sites discussed are in Mashonaland, adds an extra element to our understanding of African gender construction and the ways in which the relationships between production and reproduction were conceptualized and manufactured.[4]

A synthesis of these three works might go as follows: gender in precolonial Zimbabwean society was less defined by physical, anatomical attributes, and more by participation in various social rituals of identity. The perpetuation of society was accomplished through constantly renewed and negotiated links between the dead and the living, and between the reproductive work of women and the productive work of men. But the boundaries between these different kinds of work were permeable. Women's work in the immediate precolonial decades was varied, including hoe-driven agriculture and other activities such as trading, gold panning, and pottery. The most important productive, technological transformations of natural resources were performed in ways that mimicked women's (birthing) labor; reproduction was thus a kind of model for material production. Circumstances associated with and evocations of abortion and infertility were, where humanly possible, strictly avoided. A woman who behaved with propriety, then, would be conscious of her vital role as the means of giving life; she would not shirk any number of duties that shored up the fortunes of her (natal or matrimonial) family.

So far this description of precolonial roles of African women coincides neatly with a stereotypical Western description of a downtrodden African female "beast of burden" in dire need of liberation.[5] But if gender definition did not function in the same way as in Western society, this view may not be substantially correct. The triumph over a hostile environment represented by women's successful reproductive work was the crowning achievement of any group of people. In addition, women—some women—exercised levels of

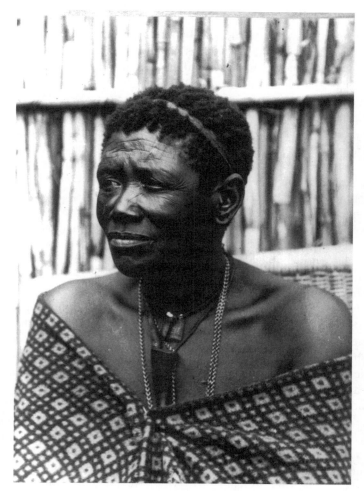

Photo 4.1 Precolonial respectability: Pitipita Gumede, one of the queens of Lobengula, the last Ndebele ruler. Courtesy of the Killie Campbell Africana Library.

power that had a distinctly masculine flavor. At a national level, a woman inspired and led parts of the first anticolonial struggle, and in mediating other relationships between the living and the dead, many other women often served as vessels of the spirits. In religious life, two nineteenth-century "prophetesses" seem to have wielded an enormous influence over rain, harvests, and health.[6] On a household level, mothers-in-law and the elder sisters of fathers wielded the kind of influence without which the extended family unit could

not function smoothly. It may be that such people, whom Westerners would consider to be obviously, unequivocally female, in fact became "situational," virtual males in these times. This does not, however, even add up to an easy, sexist equation of power with masculinity and powerlessness with femininity, because what would it mean to be a man if it were something that a woman could become?

Proper behavior by an African woman toward the end of the nineteenth-century might even have included elements that were unacceptable for Western women at the time, such as verbal assertiveness. One of the few indigenous descriptions of precolonial womanhood in Zimbabwean historiography comes from the indefatigable Lawrence Vambe's recollections of his grandmother, Madzidza. He was born in 1917, so she was probably born some time in the late 1870s. According to Vambe, Madzidza was not quiet or submissive; by character she was "impulsive, flighty, imaginative and . . . tough and outspoken." Only an unfortunate incident in which she was at fault and felt chastened enabled her husband to "assert his manly authority as head of the family."[7] Yet Madzidza was in no way an improper woman. She was a sincere devotee of what she saw as an African culture—a civilization, she probably would have said—in forcible decline after the military defeat of 1896–1897 and the imposition of colonial rule. Vambe says that she thought that being respectable and sane depended on having as little as possible to do with *chirungu*—European culture. Perhaps the best example that traditionalists like Madzidza could give of the corrupting influence of *chirungu* was what happened to the sons and daughters of Chishawasha who left the village and went to the towns. When in the early 1920s a Chishawasha woman became a prostitute, for example, the "otherwise innocent and puritanical" people of the community were "scandalized and angered." Village men and women alike, it would seem, "had visions of their hitherto clean-living settlement turning into a hotbed of immorality."[8] They first branded the woman as a traitor and then tried to banish her. Similarly, the community was aghast when it received word of a new social practice that was gaining popularity in town: African men in Salisbury, they were horrified to learn, were living with women to whom they were not married.

> This was greeted with a special horror because it was sordidly underhand. It lacked taste and propriety and anyway town women were little better than vermin. Polygamy was open, customary and clean and carried a permanent bond in which all the parties concerned accepted full responsibility. But this new-style instant concubinage had nothing to commend it.[9]

What was at the heart of this horror and condemnation? What did Misi and the *mapoto* women do in the locations of Salisbury that they were denounced

as little better than vermin? First of all, Misi, who was divorced from her husband, had sexual relations with men who were unknown to the community, possibly even with white men (it was not what she was doing, but whom she was doing it with). She accepted payment for these sexual relations and regarded the resulting income as her personal property (not as belonging to a male lineage into which she had married). She flaunted her new life-style in visits to the village that "contaminated" other women and soured village domestic relations. Finally, despite community objections she carried on with her activities, flouting the approval of the community and surviving without it (ignoring the displeasure of the ancestors). Similarly, *mapoto* relationships were abhorrent because they represented the negation of normal marriage. There was no *lobola*, and no bond or consent passed between families at the start of a *mapoto* relationship. It implied a temporary liaison, and the woman could not only accumulate her own property but take some of the man's as well; she was neither producing nor reproducing for the benefit of his lineage. Even if she sent money or presents back to the rural areas, it was most likely to her natal home, but in a patrilocal society, friction must have been generated between fathers and potential fathers-in-law (who were receiving neither *lobola* nor the fruits of the labor of young women). In all these ways, Misi and the other early urban women symbolized the destruction of African culture and a growing ascendance of European over African custom, which rural people were seemingly helpless to stop.

But in fact, were they so helpless? The theme of this book is the multivalent fight of African people to halt the destruction of their culture, to try to assure the reproduction of their society. Although matters may have looked bleak to Madzidza and the members of her generation, the next generation did not, in fact, "sell the farm," become indistinguishably assimilated, turn its back on its past, or lose its soul. That generation did what most generations do: tried to deal with new challenges with familiar tools, and with familiar challenges with new tools. And all, under circumstances not of their own making.

The most important interpersonal gender dynamic of the colonial era was the hostility of the African male—and the overall community—toward women who responded (or tried to respond) independently to the new political economy. Even the men surveyed in Chapter 3, who supported women's living in towns or traveling freely—generally drew the line at the urban presence and mobility of women whom they considered to be beyond the pale, for whatever reason. Structured independence, but not unstructured individuality, seemed to have been the most that the most liberal would allow. Yet the very structure of the colonial political economy made women into individuals—legally minor individuals, to be sure—but without whose participation such basic arrangements as marriages,

for example, could not be contracted. Male family members could no
longer unilaterally decide whom a daughter was to marry, or how she
would comport herself as an adult. This newly introduced impotence struck
at the very heart of the reproduction of African society; thus Vambe's tale
of Misi's misdeeds and the ascendance of the values that she symbolized
forms an eloquent and indispensable part of his saga of the degeneration
and decay of once-proud Chishawasha society itself.

It is possible to recreate some of the stories that would have caused such
dismay in Madzidza and her compatriots. One such tale is that of a woman
named Daisy, who was picked up on an unspecified charge in the Bulawayo
location in September 1920.[10] In the statement that she gave to the police,
Daisy described herself as an orphan from South Africa who had emigrated
to Southern Rhodesia around 1917. A male traveling companion had since
died. Daisy had gone first to Salisbury and after working briefly as a child
minder had found lodgings in the Salisbury location with a woman named
Mary Nyrenda. Mary lived with her man, Robert, on a stand that had two
huts. One they lived in, and she eventually persuaded Daisy to use the other
for prostitution. Daisy, who then proceeded to sleep "with plenty of natives"
for a charge of not less than five shillings each time, paid Mary ten shillings
per month for rent and occasionally also gave her small gifts of money. Ironi-
cally, Daisy's situation took a gradual turn for the worse when she ostensibly
decided to give up prostitution in order to start a *mapoto* relationship with a
man called Stephan.

> Then Stephan came along and wanted me to live with him as his wife.
> I agreed to do so. We continued to live in Mary's hut and he paid the
> rent to Mary for one month. He was alright *[sic]* and gave me money
> and food. This lasted about two months. I gave up prostitution, having
> got a man to keep me. The third month Stephan ill treated me. He gave
> me no food. I told him I was living with him as his wife and he ought
> to keep me. He told me he was not going to support me all the time and
> asked me why I did not do the same as Mary. He said Mary had some-
> one to keep her but she did prostituting as well. He asked me to do a
> bit with the boys. I had nothing to eat and commenced to prostitute
> myself again. . . . I prostituted myself for about three months for
> Stephan. The money I received for it went to buy food and sometimes
> Stephan took the cash. . . . He wanted the money I earned to gamble
> with and buy beer. If I did not bring him any money he used to beat
> me. Then he would tell me to go.

Daisy then fell pregnant, was summarily rejected by Stephan, went to
live in Bulawayo, and after her arrest in 1920, disappeared from the docu-

mentary record. Her story illustrates several dynamics of urban gender relations of the time: her ability to move from one town to another when conditions became difficult, her insecurity as an unmarried woman, and her dismay when Stephan was transformed from a lover into a pimp. Daisy's story is also notable in that her path crossed with that of Mary Nyrenda, who was exactly the kind of woman who might have appeared in the nightmares of Lawrence Vambe's grandmother. A Sotho woman who had also emigrated from South Africa,[11] Nyrenda by the 1920s had become "the leader of a syndicate of African *femmes libres* or 'prostitutes,' in Mashonaland."[12] The police believed that she indulged in all the criminal activities associated with African women: she was a prostitute who sold sex to black and white men; she brewed and sold beer; she not only lured young women into prostitution, but traveled with groups of them around the mines of Mashonaland. She, Robert, and her daughter, Annie, were evicted from the Salisbury location in 1920, probably not long after Daisy decamped for Bulawayo, and took up residence in a private location on a farm just outside the reach of municipal law enforcement. But Nyrenda did not just disappear; by the 1930s she had become something of a public figure, as she was "queen" of the Manyika Burial Society in the Salisbury location and dominated the local "underworld."[13] Nyrenda, probably the daughter of a more established pattern of Basotho rural impoverishment and migration,[14] exemplified women's self-loosening of the lineage ties that had bound them to their extended families and the development of new and independent gender identities under colonial rule.

As the only respectable African women who lived outside rural areas in the early decades of colonial rule were those who populated mission stations and schools, women in town were all held to be imitations of Mary Nyrenda. Towns were, in the words of one unhappy African husband whose marriage ended in Salisbury in 1918, the place of "all abomination and destruction."[15] At the end of the decade, the CNC believed that although rural African society tolerated its daughters' working for farmers, they had the lowest opinions of town women:

> Many of these female servants have been utterly demoralised by the vices and licence of Town life, they have become divorced from their homes and are looked upon by their people as outcasts.[16]

As outcasts and vermin, living in all "abomination and destruction," as Jeater writes of the period before World War II, "it is not surprising that the number of urbanised women remained low."[17] As a witness to the 1910 Native Affairs Committee said:

Natives of well-regulated ideas [will not] bring their wives into town to
settle in a location. They say that their wives are open to temptation and
they do not bring them in[to town].[18]

This fear of contamination contributed to the growth of what Yoshikuni
has called an "outer ring of suburbs" surrounding Salisbury, where wives
and families could be insulated from what were felt to be the irresistibly
corrupting influences of the location.[19] Even as late as 1929 members of the
Southern Rhodesia Native Association, many of whom lived in Epworth
Mission (where women's training and behavior were ringed with strict safe-
guards) outside Salisbury, described the location as "a cesspool of drunken-
ness and immorality."[20]

But although the charges of immorality and promiscuity would be-
come the "traditional" epithets hurled at urban women, respectable women
were not content to be barred from the towns. Instead, they developed
and defended a new respectability that was not confined to the reserves
and missions.

MANUFACTURING PROPRIETY: THE LONGEVITY OF *LOBOLA*

More enduring in defining propriety for African women than the lessons
of Western education was the institution of *lobola*. The longevity and trans-
formation of this remarkable tradition in colonial Zimbabwe have elicited
widespread scholarly comment, with observers generally concurring that the
transfer of assets from the potential bridegroom's family to that of the bride
was an important statement of the mores of precolonial social reproduction
that survived in the new colonial order. The change of the nature of the as-
sets, from a largely symbolic transfer of productive goods such as livestock
and agricultural implements, to straightforward cash payments (in steadily
increasing amounts over the course of the twentieth century), has also been
widely reported.[21]

Kuper notes, however, the poor documentation and research on the persis-
tence of the bridewealth custom in southern Africa; in addition, there have
been few attempts to explain why the tradition of *lobola* has survived.[22] West
suggests one reason for its survival in colonial Zimbabwe was "the largely
ephemeral and generational specific character of the forces opposing it" and
mentions the continuing importance of "the system of patrilineal descent,"
which expressed itself through the institution of *lobola*.[23] Schmidt suggests
more directly that *lobola* persisted because it could be turned into "a funda-
mentally commercial transaction" between generations of men in an increas-
ingly cash-starved economy; women themselves became the goods that were
bought and, by implication, sold.[24] But what did *lobola* represent in the new

social order of colonialism? Weinrich suggests that as late as the 1970s African patriarchs had other reasons besides the mere acquisition of cash for their ardent defense of *lobola*.[25] In fact, the essence of *lobola* as an evolving social institution was that it served to perpetuate lineages through the permanent assignment of the wife and of her children to the family of the husband. After paying *lobola*, the husband's line was assured of survival: even if a wife should prove to be barren, it was the duty of her family to send another woman, ideally fertile, as another wife. This process would have become increasingly important with the decline of polygyny; the mechanism of securing fertility through only one wife needed to be ever more securely safeguarded. It was this basic concern with the production of children, the reproduction of lineage, and, by extension, the reproduction of African society itself that explains the continued attraction of *lobola*. Thus, according to Chavunduka's exploration of the forms and functions of traditions in the greater Salisbury area in the 1970s,

> Bridewealth performs a number of important functions. Firstly it legalises the union . . . [it] also acts as a sort of insurance policy against the possible dissolution of marriage. . . . The third important function of bridewealth is to procure children . . . the children of any union belong to the woman's lineage until bridewealth has been paid. Thus bridewealth confers genetricial *[sic]* rights upon the husband's kin group, that is rights in the woman as a mother and refer particularly to the ownership of children.[26]

Because *lobola* remained a defining characteristic, not only of marriage but of a commitment to the perpetuation of the most crucial aspects of African life, it became a cultural centerpiece, a mark of honor, among urban women. This raises an interesting issue of what a "women's consciousness" might be considered to consist of in colonial Zimbabwe. Cheater suggests that African women did not develop a class consciousness because they did not realize that *lobola* was primarily a means of controlling their labor or that the economic interests of men and women were inherently opposed.[27] On the contrary, it seems to me that the longevity of *lobola* proved the opposite: that because *lobola* would not have survived without the support of women, they had a consciousness of themselves as women, but not in a direction that modern Western feminism would consider liberated. This, of course, is the crux of the disagreement between African and Western feminists, with the former arguing that the latter do not understand the dynamics of the women's investments in family and society, which can render their subordination by men a secondary issue.[28] It should be noted, however, that just as there were ideological divisions between African men over the issues of women's mobility, so

too there was a lack of unanimity on the issue of *lobola* between African women. Two women who were elected to the executive of the Native Missionary Conference in the 1930s argued long and hard against *lobola*, asserting that it was "a curse upon Africans" and that it reduced African women to "chattel."[29]

Dating from roughly the mid-1930s, however, these ideas were over-shadowed by an African women's counteroffensive. It was launched against the image of town women as notoriously and innately immoral and scandalous. This was a campaign to demonstrate that African women, too, were concerned with the survival of their society; they too, believed in *lobola*. This campaign was, of course, centered around the efforts and personality of Mai Musodzi (see Chapter 2), who initiated a movement *among married women*—women for whom *lobola* had been paid—to improve the quality of life for women in the Salisbury location.[30] By trying to find ways to make urban life materially more feasible for women for whom *lobola* had been paid, she was defending the institutions of *lobola*, of African marriage, and, by extension, the foundations of African society itself.

> She saw how people were living, because she used to move all over the location seeing how things were. You know long back a black person didn't bathe. A person could go somewhere and come back without bathing, a baby could [just] be dipped in water like this and taken out. So VaMusodzi wanted all that to end, because people didn't even sweep the yard.[31]

According to Mrs. Makoni, who came to live in the Salisbury location around 1926:

> It was hard for us in living [in the location]. . . . Some had difficulties, some were free, living with their husbands. Yes. So we had women who started organizations, the one you hear being called, "Musangano [meeting], musangano!" It was . . . for living, for life. There were women who wanted us to be helped; so we could help each other . . . about how we can live in the location.[32]

Mrs. Bertha Charlie recalled that Mai Musodzi was

> our mother who taught us. . . . She taught us according to what she was told by whites. She was called our leader.[33]

Learning to cook European-style food, to perform basic hygiene and first-aid, to sew and knit: these were pieces from which a new model of

respectability could be assembled. In finding these ways to uplift the situations of properly married women, Mai Musodzi defined the field as far as propriety was concerned. But in her emphasis on service to married women and their families, she made a statement, not so much about how unmarried women should be ignored (although they were, seemingly, firmly excluded from her milieu),[34] as about how it might be possible to rescue some women—those for whom *lobola* had been paid—from the sad fate of women like Daisy (see earlier). African society itself could also be defended against the even more dismal ramifications of the two gender relationships that were outside the boundaries of *lobola*: *mapoto* and prostitution. Mai Musodzi sought out the women who met the minimum requirements, wished to learn the basics, and could perhaps even, with the help of European ladies, be taught some of the finer points of respectability. It is a testament to the resilience of African culture that the minimum requirement of urban respectability for women was to meet what was in the process of being confirmed as the fundamental expectation of the patriarchal system. Thus, *lobola* continued to be a feature of African marriage, whether through a Christian ceremony or in what was known as a customary marriage. According to West, *lobola* survived quite well among the emerging Christian elite, who encouraged the commercialization of the custom.[35] In 1973 the physician and amateur anthropologist Michael Gelfand found that of seventy-six urban men interviewed (all of whom had been urbanites for at least ten years), all had paid some *lobola*; 64 percent had paid in full.[36] Married women, in both "customary" and Christian systems, participated in the institution, pledging themselves and promising their children to the families of their husbands.

The female conjugation of *lobola* and respectability is evidenced in the hostility between the township women who considered themselves to be properly married and those who were involved in *mapoto* relationships and prostitution. After all, in the colonial political economy these women were competing directly with each other for the attention, affection, and financial contributions of the same group of men. In the period under review there is little evidence of sisterly tolerance; rather, married and unmarried women left trails of mutual animosity through the historical record. A well-known woman (see Chapter 2) reflected:

> As a person who had a bit of knowledge, [the town authorities] took me as a person who could help. And the whites who taught found it easy to teach through me, because I understood their language. . . . But those who were [unmarried/divorced mothers]—they came to do their own "jobs" and we wouldn't aim to teach those. They had their jobs. I never had time for [them]. [37]

Photo 4.2 Colonial urban respectability: smiling woman, schoolchildren, man in suit with bicycle, house with curtains, garden with flowers; near Runyararo, Harare township, 1950s. Courtesy of the National Archives of Zimbabwe.

In the opinion of one married interviewee:

> Most of them just went about, not having one man. That's one of the things that helped them. Those who were not married and not educated, they just dressed well so that they could get men. Only some didn't even want to work. But they dressed so well. You would be surprised that they dressed better than you who were married [laughter]. Maybe that was their hobby. Ah. We can't really explain it.[38]

Similarly, another married woman remembered, seemingly with some satisfaction, the kind of punishment that could be meted out to unmarried women:

> If [a prostitute] was found in somebody's house, she was taken. . . . Some would be arrested. They would close the doors of the bar and open the water taps on those mahure [whores] and they would get wet. To fix them . . . just to fix them. They would feel cold and the water would still come down on them. Yes.[39]

On the other hand, one unmarried woman said,

We [unmarried women] would meet, sometimes in the bar. We were many and we would be friendly to one another. . . . We didn't have anything to do with them [married women].[40]

At the time of the struggles between the Reformed Industrial and Commercial Workers' Union (RICU) and the Salisbury municipality over police raids against unregistered women living in the township, these antagonisms flew into the open. In one case, at a public RICU meeting, an unmarried woman who spoke against restrictions of the 1946 Natives Urban Areas Accommodation and Registration Act was chastised by married women, "who asked her if she were not aware that married women were against the presence of unmarried women in the Township."[41]

In the rapidly changing social order of midcentury colonial Zimbabwe, many factors were conspiring to shift the gender balances of power. In the rural areas, patriarchs could no longer take for granted that women would perform any number of traditional functions. Women could attend mission schools, meet the need for cash by selling produce in rural and urban markets, engage in a bit of prostitution, wait for remittances from migrant relatives. They could make more of the agricultural decisions in the absence of these migrants and interact (and sometimes run off) with foreign migrant workers. In the urban areas, as we have seen, women undertook a number of economic and social initiatives: they grasped the opportunities presented by colonialism with both hands. They married teachers and preachers; they founded new religious organizations for Christian women and more secular versions in urban locations.[42] Sexual activity outside marriage had become something a man had to pay an individual woman (not her family) for.[43] Women who involved themselves in *mapoto* relationships did so out of economic need and also displayed a vision of gender relationships that was, in fact, dazzlingly original: who had ever heard of a woman leaving a man and taking not only the material possessions that were acknowledged her own (itself quite an innovation) but some of his as well?[44] As one woman described the rationale of a *mapoto* woman's leaving her man: "I cooked and I washed for you, I slept with you. So what I have taken is mine."[45] In all this social turmoil, it seems that patriarchs cut their losses, drew the line at *lobola,* and there made a successful defense of their rights over women.

Shifts in interpersonal gender relations, however, were encircled by the uneven authority of the colonial state, which exerted a powerful limit on the choices that urban men and women could make. *Lobola*, for example, was a practice that, after a short-lived flirtation with emancipatory statutes, the state was happy to live with. [46]

The tendency of state intervention was to transform what otherwise would have been the practice of ordinary rights and duties of men and women toward each other into extraordinary feats of endurance and resourcefulness. A male urban worker who wanted to live what he considered to be a proper life with his wife, for example, had to choose among a number of unattractive alternatives. He could leave her in the rural areas, where he might only be able to see her a few times a year; or earn sufficient wages and be of the right religion to settle her into a nearby mission station like Epworth and cycle back and forth twenty-five kilometers a day to live with her; or, if they had a marriage certificate, live with her in overcrowded squalor in the location, where few of the social norms of proper African culture could be sustained. If he wished to act in the capacities of a father toward his children, the worker faced a similar set of difficulties.

The continuing importance of *lobola* to urban people, the myriad absurdities imposed by the state on ordinary people, and the special insecurities suffered by urban African women are illustrated in a marriage case from Salisbury in 1944.[47] In February of that year, the municipal African police picked up a woman named Sarah in the municipal transport camp (where the city's transport workers and drivers lived) on a charge of trespassing. She was taken before the magistrate, fingerprinted, found guilty, and given the relatively light sentence of a fine of five shillings or seven days hard labor in jail. Her crime, for which trespassing was a euphemism, was being found in the camp without documents to prove that she was married. The police who arrested her must have been either new recruits or in a foul mood, because Sarah had lived at the camp, with one man, for the previous sixteen years. Described as "well advanced in years," she was as unlike the young women who were flocking to towns as it was possible to be. They were the supposed targets of such raids (see Chapter 3). Yet Sarah was caught in the state's dragnet.

Sarah's man was named Majoni. He had come from Malawi in 1920 and had never returned home. In 1928 he had met the orphaned Sarah in the Salisbury location and had "courted her" (as he put it). They proceeded to live together as husband and wife. As a mule driver in the transport camp he was relatively highly paid, earning a monthly salary of £2.15.0d; paying her fine of five shillings therefore would not have represented much of a financial sacrifice. The crucial part of their story was that because she was an orphan and could not trace her family, she had no known male relatives. From the couple's point of view this meant that although they had wished to marry, there was no one to whom Majoni could pay *lobola*. From the state's point of view there was no one from whom consent to a marriage could be obtained. For these reasons, and despite their decade and a half of cohabitation, no one—neither Majoni and Sarah themselves, nor the state—regarded

the couple as married. Nor could a marriage be performed without *lobola* payment and parental consent. There was no possibility of obtaining a Christian marriage certificate or an NC's marriage registration document, and the lack of such documents in turn rendered Sarah perpetually vulnerable to the kind of harassment she suffered in February 1944.

Sarah's case came to the attention of the NC Salisbury, however, and he initiated the legalities necessary for the couple to move through a loophole: the state of Southern Rhodesia itself would act in loco parentis for her, enabling them to marry officially. The NC wrote to the CNC, who wrote to the prime minister, who sent the following notice to the highest-ranking bureaucrat of the colony:

> Ministers have the honour to recommend that his Excellency the governor may be pleased, in terms of Section 6(2) of the Native Marriages Act (Chapter 79) to authorize the registration of the marriage between MAJONI, R.C. no. 18430 Mrewa, and SARAH. [emphasis in the original]

Although the documentary record ends at this point, presumably his excellency the governor proceeded to approve the registration of the marriage. The swiftness of the procedure, especially surprising in wartime, suggests that this was a fairly well-worn loophole. But the case of Sarah and Majoni also illustrates the conceptually extraordinary, contradictory, and cumbersome nature of state intervention in African domestic affairs, as well as the complex interactions between a traditionally based conception of gender relationships and the harsh realities of urban life. Finally, it shows the elements of physical risk in urban women's lives that all of these factors combined to engender.

THE 1948 GENERAL STRIKE

It may seem somewhat perverse to situate the 1948 General Strike, the premier episode of labor strife in midcentury colonial Zimbabwe, in a chapter devoted to changes in gender relations. But as the perspective on labor widens from an exclusive historiographical concern with wages and conditions of service it becomes clear that workers were not wooden, one-dimensional beings. The trade unions that they formed before the 1950s, like the Industrial and Commercial Workers Union (ICU) of South Africa, whose model they generally followed, battled the state on a broad range of fronts. Wages and working conditions were important to them, but so were the quantity and quality of food rations for families, housing, sanitation, and schools. What elevated these individual concerns to the level of national issues was

their intimate connection with changes in gender relations. Against the colonial vision of Africans as nameless, faceless minions whose personal relationships and comforts were of next to no consequence, Africans themselves carved out new definitions of decency and respectability. Not all urbanites were able or wanted to participate in these models to the same degree; many fell notably short. Differentiation along income, education, and international and perhaps intranational ethnic lines was a large part of daily life in places like the Salisbury and Bulawayo locations in the 1940s. Nonetheless, an event like the 1948 General Strike demonstrated that the mass of urban workers—with or without their erstwhile leaders—could with one voice demand a better deal for African men, women and children.

Progressive historians of colonial Zimbabwe are generally keen to associate their favorite characters with the 1948 strike, imbuing them with the heroic gloss of the event. I may be no different, but I can only wish that I had enough information to say with certainty whether African women—of whom there were tens of thousands in the colony's urban locations in 1948—participated in any significant way in the actual events of the strike. There are at least two ways to look at this question: First, even if every urban woman stayed indoors and heedlessly did her laundry and cooked *sadza* in mid-April 1948, gender relations were at the heart of the conflict. At issue was the image of "man as provider," which the colonial order was doing its best to make impossible. But if a man could not provide housing and food for his family, how could he command respect? And how could he live without respect? How could he fulfill his obligations to the ancestors to ensure the perpetuation of their lineage? How would his manhood and masculinity be assessed? Two decades later, how were the men of Africa answering the Reverend Thompson Samkange's 1925 challenge, "Are we not also men, born with the spirit of manhood within us?"[48] But an even stronger case for the relevance of gender relations to the strike can be made with the addition of a comment from Scarnecchia's work: during the strike in Salisbury, "Women remember men going around with megaphones *telling them to stay inside their homes*" [emphasis added].[49] How can we decipher this? Perhaps men wanted to protect women—and to be seen as protectors—from the threat of state violence (the soon-to-be prime minister, Garfield Todd, had, after all, flogged girls "on their bare buttocks" for boycotting meals at Dadaya Mission school the year before, proving that African females were not exempt from physical retaliation from the settlers).[50] But intriguingly, in April 1948, perhaps men did not want women to participate in the strike; if manhood and masculinity were among its central underpinnings, enthusiastic participation from women would certainly have muddied the conceptual waters.

For the purposes of this discussion, it does not really matter whether, in 1948, the predominant male perception of women had been that they were

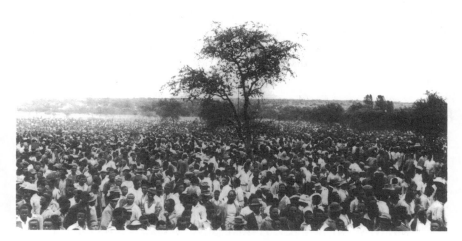

Photo 4.3 Part of the crowd gathered on the day of the General Strike in Bulawayo, 1948. Courtesy of the National Archives of Zimbabwe.

hungry, or frail, or even potentially overbearing; the important point is the recognition that the relations between men and women were a crucial feature of men's strike actions. Viewed from this perspective, the reproductive nature of the demands presented to the municipality of Bulawayo by the Federation of Bulawayo African Workers' Union and the Bulawayo Municipal Workers' Union in October 1947 make perfect sense. Certainly, and logically, the workers demanded higher wages, but they also wanted payment of the cash value of the inferior supplementary rations with which they were issued, recognition of their marriages, more married housing, and issuing of food rations by employers for wives as well as workers.[51] These were demands that urban African families be put on a more secure footing. Thus, giving evidence to the National Native Labour Board which was reconvened as a condition for the ending of the strike, workers stated that the wages paid to married workers should be higher than those paid to single men. Representatives of the work force at the Bata Shoe factory in the Midlands said that married men should be paid £8.10/- and their unmarried colleagues £2.0 less. The municipal employees of Gwelo asked for £7.10 for married men and £5 for single men. In Umtali, "most [African witnesses] claimed that

their rations were inadequate for their wives and families and that they could not live on their present salaries."[52]

Further, even these reproduction-related demands were eclipsed in Salisbury by the fact that the specific reason that many people embarked on a general strike was not wages, but the pending implementation of the Native Urban Areas Accommodation and Registration Act of 1946, which struck at the very heart of an evolving urban African settlement strategy. These conflicts are more fully discussed in the next chapter. As one informant recalled, however,

> the strike [in Salisbury] was because the people didn't want the government; the people were fighting about relatives visiting them and being arrested.[53]

The General Strike, then, was intimately connected with issues of gender and social reproduction.

MARITAL MIGRANCY: HARNESSING WOMEN'S MOBILITY

Migrant labor is another experience in colonial Zimbabwe that is uniformly discussed as only involving African men.[54] But as one author noted some years ago, "birds of passage are also women":

> It has become increasingly clear that migration of women, and migration in general, cannot be analyzed within the framework which focuses on young male adults responding to formal employment patterns.[55]

Even when women are included in migration studies, however, they are often dismissed analytically because of their marital status:

> Thus, it is young men who dominate most African migration streams, and when women do migrate it is usually to join husbands already working in towns.[56]

This paradigm implicitly assumes that married women perform only "unimportant" reproductive labor that is unworthy of further scholarly inquiry, and again relegates a large number of African women—especially urban women—to invisibility.

But an ingenious solution from below to many of the problems of colonialism in Zimbabwe was the evolution of a category of women who could be called "migrant wives." Migrant wives undertook a rotating combination of urban domestic and rural agricultural labor, a workable and sensible op-

Rewriting women into the historical narrative again.

tion for married women as long as rural reserves held out at least some promise of fruitful yield, urban male workers retained a significant degree of control over women's labor, and women themselves had a fairly high degree of potential mobility free of state interference. These exact conditions do not seem to have obtained in other parts of Africa, [57] colonial Zambia, or among women migrants in South Africa.[58] One study does, however, suggest a similar pattern may have developed in parts of colonial Botswana.[59]

The practice of marital migrancy[60] in colonial Zimbabwe provides an excellent opportunity to discuss the migration of women in general and of married women specifically, and to differentiate further between the ranks of married women. Phimister's injunction that the historical experiences of African women in colonial Zimbabwe were "anything but uniform"[61] is confirmed by the fact that although marital migrancy was common, it was not ubiquitous at any particular time. A migrant wife did not occupy a position high enough to insulate her from the need to work in one setting in order to support efforts in the other. On the other hand, as measured by the yardstick of social respectability, a migrant wife was far from occupying the lowest rung of the ladder of female society. She was properly married (*mapoto* wives did not do this kind of work); she was identified as attached to a man who had enough standing to provide both urban accommodation for her (as materially poor as it might have been) and rural agricultural land that she could plow, sow, and reap. In this social construction, migration in yearly cycles of reproductive and productive labor protected her from the corruption of the cultural dangers of town life. By returning regularly to rural areas, and by demonstrating her willingness to perform hard labor on her husband's rural fields, a migrant wife was "cleansed" of the taint of urban residence. Paradoxically, she was respectable partly because she dipped into the potentially dangerous pot of physical mobility, but the wedding of mobility and husband-benefiting labor ensured her respectability. This kind of travel was conceptually firmly distinguished from the mobility of *mapoto* women and prostitutes, who moved about for their own gain rather than migrating to work for husbands. *Mapoto* women and prostitutes were also more easily identified as women sadly lacking in virtue and moral rectitude. Thus another contribution was made to the definition of righteousness as the opposite of independence.

In the context of the 1920s, Yoshikuni discusses the development of periurban areas around Salisbury where elite employed men migrated between town jobs and their families.[62] I would suggest that by the 1940s, the additional pattern of wives' migrating between rural fields and urban husbands had emerged. The oral evidence to be reviewed later suggests that this was an intermediate development in the period under review. Before the 1930s, respectable wives stayed in the rural areas; after the 1950s increasing num-

bers of them came to live in towns permanently with their husbands.[63] In the two intervening decades marital migrancy was established as an acceptable option.

Although the phenomenon of marital migrancy does not rest on an extensive documentary foundation, there is some archival support. In 1932, for example, the superintendent of the Salisbury location reported that both men and women were constantly traveling in and out of the location; a few years later his successor identified some of the travelers as women who moved to a seasonal pattern. During the rainy season (when planting and weeding chores had to be performed in the reserves) and at harvest time "many" of the location women returned to work in the rural areas. In addition, a common feature of early objections to the 1936 Natives Registration Act centered on fears that it would interfere with the movements of "respectable" and "decent" African women, the group from which migrant wives would have sprung. Similarly, police were then issued with instructions (which violated both the spirit and letter of the act) to extend "reasonable latitude," when dealing with Africans visiting towns who were found with a pass to do so.[64] Four decades later, a survey conducted in 1963 gave some quantitative evidence of the tenacity of marital migrancy from a rural perspective. R.W.M. Johnson found significant percentages of married women in their twenties absent from Chiweshe reserve (which lies about forty-five miles northwest of the capital city) over the course of the year, with 15 percent absent in December, but 40 percent absent in August (the month of the fewest agricultural duties).[65]

But the main evidence for marital migrancy comes from a rich body of oral evidence. Many of the women interviewed in 1989 recalled a particular form of migrancy as a common strategy in the early years of marriage and young adulthood. They spoke of many wives who divided their time between town and country primarily according to an agricultural schedule. Their evidence suggests a phenomenon that was more structured than simple occasional visits from rural wives to their working urban husbands. Migrant wives, who at varying times seem to have included a significant proportion of urban women, represented the ultimate solution to the problem of the reproduction of African colonial society: they did everything. In yearly cycles, they ministered to the personal needs of urban husbands, raised children, and either managed or personally performed rural agricultural production. According to Mrs. Sarah Bakasa, who came to live in Harare in 1936:

> [Some women] stayed in the reserves. Their husbands are the ones who stayed in town. . . . But [some wives] . . . came after they had finished harvesting. As soon as the thunder went DR-R-R-R [signaling the start of

the rainy season] they go back to farm. Um. That's how some women and
their husbands lived. . . . These were things they planned with their hus-
bands, that, "You will often go home."[66]

Some migrant wives were agents of the dispersal of consumer goods to
the rural areas (always identified as "home" in these excerpts):

We took sugar . . . jam, margarine and milk. Long back we used con-
densed milk. That's what we carried, and soap. [When we came back
to town we brought] nothing. Could you bring maize from home? Haa.
If it was pumpkin time you could bring pumpkins. If it was time for
those vegetables grown at home, we would bring that, for us to eat . . .
we never sold anything [i.e., never brought back anything to sell in
town].[67]

Similarly, Mrs. Elsie Magwenzi recalled, even more explicitly, that women
lived in town in "the non-plowing season," and when they returned to the
rural areas, they carried, "groceries, everything you would buy . . . even if
the husband didn't come for a while, you would not run out. Sugar, tea-leaves,
bread, jam, everything."[68]

A number of variables fed this development. First it seems that after the
1930s it became clear to some rural women that the best way to arrest the
development of *mapoto* relationships was to live with their husbands as much
as possible: "That is when they saw it was better to live with your family, as
a family, yes. To avoid all that."[69] Also, by the time of World War II the
presence of married women in towns was not seen as quite so shocking. For
example, according to Mr. Beattie Ngarande:

Women started coming [to Harare] a lot from around 1941. That's how
women came. Before then, women didn't come here. She would even refuse.
The parents of the girl, the father would say, "I don't have a child who
goes to town." . . . What is she going to do in town as a woman? No! She
can stay [in the reserve] and tend her chickens, yes, and her things. But
going to town—to go and just sit?[70]

Third, location men began to accept, allow, or encourage extended visits
from their wives. This may have represented a diffusion of an ideal—sus-
taining of some permutation of family life under the colonial yoke—from
the elite pattern established in places like Epworth, Seke, and Domboshawa,
to the less rarefied town location neighborhoods.

When Mrs. Esther Chideya remembered twenty years of wifely travels
(she married in 1930 but only came to live in Harare permanently in 1951)
she outlined how the patterns of mobility and respectability intertwined:

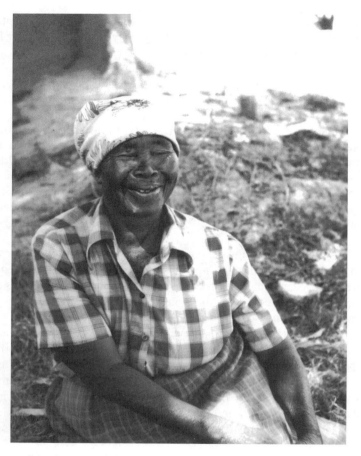

Photo 4.4 Mrs. Maggie Masamba on her farm in Epworth, 1989. Photograph by the author.

We would just come at *chirimo* [the hot part of the dry season]. We didn't come that often. Because long back it was said, "Is a person who lives in Harare mad?" It was said, "'Manyasaland' [people/women from colonial Malawi] live there." That's what they said long back. There were no Mazezuru [in town] . . . the Mazezuru would say, "No wife lives in Harare, is she a Brandaya [from Blantyre, in Malawi]?" It was so difficult and people would say, "Such a grown woman living in town? Ah, what's wrong?" Ah. They would consider such a person as useless. It was difficult to stay in town. We only came when people were now used to it. . . . [In the earlier period] the women who lived in town were prostitutes, those

were the women in prostitution, and *mapoto, who lived here and didn't go home.* [emphasis added].[71]

Mrs. Maria Chagaresango, who came to live in Harare in 1945 and married the following year, recalled her travels:

[After marriage I didn't stay in town]. I would just come and go back home [in the reserve]. I would come occasionally . . . I would come when there was no work at home. During the plowing season I would be at home. [One] couldn't come [to town] in December. That is the time for work. And many people spend Christmas at home. [During *chirimo*] I would come, then I go back when it's about time to work. . . . Many women did that. . . . Later on with the coming of schools the women would stay [in town] with their children who were going to school here. But when it was time for work [in the reserves] I would just leave the children with their father.[72]

Similarly, Mrs. Sarah Tsiga, who married and came to live in Harare in 1943, said:

Up to now I am still going [to the reserves to farm]. I do a lot of farming. [All along] when it rained we would go home to farm. [My husband and I] went together . . . he would stay for a few days and return quickly and I remain there the whole [Christmas] holiday with the children, finish cultivating and come back. When schools open. At harvest time we go back.[73]

Marital migrancy solved some problems but created others. According to Mrs. Bakasa,

We who lived with our husbands in town [permanently] saw it as something bad. We said, "Um, no, this is not good." That you went to farm there, leaving him here? It's like you are tempting him. There aren't many who can resist it: you know men—they get girlfriends![74]

Mrs. Ruth Murhombe was of the opinion that a "good" man who lived in town would come back from work, do his own washing and cooking, and shun *mapoto* relationships, but "good" men were few.[75]

Mrs. Magwenzi outlined some of the difficulties a migrant wife might encounter:

It went according to the rules. You could say, "I am going to my husband in Harare today." But if he wasn't aware of your coming, you could get there and you would be told to go back home. By the husband. And you

would go home. [Because] you would have come without his knowledge.
But if you planned and you had agreed that you would come and stay for
so many days, then you could stay.[76]

In contrast to those who portrayed the development of migrancy among
wives as a matter of personal choice, Mr. Lawrence Vambe discussed it in
terms of the colonial restrictions placed on women's urban residence:

> Some [women]—those who could—they would live in town part of the
> year. When the rainy season came they went back home. . . . If they came
> from nearby . . . they could live for a certain time in the urban areas with
> working relatives or husbands, but when the rains came then they went
> back to do the agricultural work to raise crops. Because that is how they
> could supplement the income of the family as a whole. Because the men
> were earning very little. . . . So they went back home, they did the plow-
> ing, weeding and harvesting and so on and so on. When all that was done
> they came back to town. [There were women who did this every year],
> absolutely. But I think from the point of view of the law, no black woman
> was supposed to be in the urban areas . . . even a married woman [had to]
> be in the municipal area with a permit. She had to be authorized to live
> with her husband.[77]

Being a migrant wife was not an option open to every urban woman.
Obviously, unmarried women were excluded; so, culturally, were *mapoto*
wives. But migrant wives also seem, perhaps paradoxically, to have belonged
to a higher stratum of urban women than the norm. Divorced women and
widows would not have had secure enough access to urban accommodation
or rural land to warrant cyclical migration. Also, since urban accommoda-
tion was based on constant tenancy, as observed by the location superinten-
dent or the location police, many wives of men of lesser standing would
have had to limit their rural visits. Thus marital migrancy was a manifesta-
tion of yet another interface of class, race, and gender in colonial Zimbabwe:
some African male workers were able, in one fell swoop, to keep the wolf of
full rural dispossession from the door and afford the relative luxury of hav-
ing wives in town to look after their needs. On the other hand, for women,
marital migrancy was an admittedly strenuous way to juggle a threefold strat-
egy: a nonconfrontational enforcement of marital fidelity, the maintenance
of respectability in their communities, and the supplementing of family fi-
nances.

Although it is not possible to date precisely the rise and fall of marital
migrancy, it seems that this pattern developed from the mid-1930s and
flourished from the 1950s onward. Despite the construction of new satel-
lite townships earmarked for permanent family residence such as

Mabvuku, Kambuzuma, and Mufakose, marital migrancy did not disappear. It continued to be a strategy used by some families to maximize socioeconomic returns.[78] For example, Mrs. Bakasa explained that even in the late 1980s, although fewer wives were migrating, the practice still existed:

> Some are still doing it today! [But the practice] decreased. It decreased. The men became aware now. It was caused by lack of knowledge. Ah. How can you leave your wife to go and live on their own there? You must stay with your wife and children. Even here some still do it. At that house I am looking at [across the street in Kambuzuma township], the wife is at home [in the rural areas]. She comes [to town] occasionally. She lives in Murewa. But she is now an old woman. With grandchildren. Some of her sons have got wives. But she goes home, and leaves the husband here. Yes, it's still there.[79]

As time went on, more women could live respectably—although, it should be noted, perhaps illegally (see Chapter 5)—in town without adding the rigors of rural labor. And in so doing, they stood an even better chance of preventing their husbands from becoming involved in *mapoto* relationships. However, as Mrs. Bakasa emphasized, perhaps the waning of wifely migrancy was also due to men's changing perceptions.

As will be discussed in the next chapter, the increasing number of urban family units was not an automatic development; nor was it due to an oversight of colonial officials. More women lived with their husbands in town because more families chose to disregard municipal regulations, and, significantly, to unite to fight municipal authority.

CONCLUSION

Why righteousness? I have chosen this term to describe new urban paradigms for African women rather than a word like *propriety*, which is too weighted on the side of the stiff and the starched. The term *righteousness*, on the other hand, while radiating whiffs of cleanliness, also sends echoes of heat and fervor, and of a proud refusal to fall. Righteousness also, crucially, implies at least a measure of condemnation of the fallen. Even muted by dust and the passage of years, I heard this fervor in the documentary record and in the voices of the women we interviewed. It really mattered to people how women behaved. They grew impassioned on the subject. It was a struggle of good against evil. It harkens back to Herbert's point about how infertility was a state that should be shunned if at all possible, but in town there were people, like *mapoto* women and prostitutes, who chose to remove themselves

from the social reproductive cycle. This was, ideally speaking, unacceptable behavior, but in practice it flourished nonetheless under the pressures of colonial urban life.

The categories under discussion here were anything but static in the period under review. We do not really know how "good" and "evil" female behavior were represented in the immediate precolonial period, but Vambe suggests that around the turn of the last century his grandmother was firmly wedded to ideals of clean behavior that included *lobola* and polygamy. Chishawasha was, however, also an early mission station, and the intertwining of Christian and indigenous ideals of righteousness is the subject of a book in itself.[80] By the middle of the colonial period, however, new definitions of *good* firmly included *lobola* but less often accommodated polygamy. Men struggled with the state, at least in part, to be able to live up to their fatherly and marital responsibilities. Female mobility was gradually appropriated by the forces of respectability and controlled to allow for wifely migrancy. The next chapter will discuss a development that was later to bedevil the feminist community of Zimbabwe: by midcentury, female independence had certainly come to be equated with *evil*.

These developments were not merely accidental by-products of a larger process of colonial economic development. The perspective articulated here would take issue with a historiographical assumption that whereas people engage consciously in political and economic struggles, personal dynamics simply unfold naturally over time. On the contrary, paradigms of social righteousness were actively constructed by, inter alia, the labor of women who worked hard to support the perpetuation of lineage and, by extension, of their changing society.

NOTES

[1] Interview with Mrs. Mary Butao, Highfield, Harare, 28 February 1989.

[2] Elizabeth Schmidt, *Peasants, Traders and Wives: Shona Women in the History of Zimbabwe, 1870–1939* (Portsmouth: Heinemann, 1992), esp. p. 44–53.

[3] Diana Jeater, *Marriage, Perversion and Power: The Construction of Moral Discourse in Southern Rhodesia, 1894–1930* (Oxford: Clarendon Press, 1993), esp. chapter 1.

[4] Eugenia Herbert, *Iron, Gender and Power: Rituals of Transformation in African Societies* (Bloomington: Indiana University Press, 1993), passim.

[5] The uses of this term in relation to women in Southern Africa are reviewed in Margaret Kinsman, "'Beasts of Burden': The Subordination of Southern Tswana Women, ca 1800–1840," *Journal of Southern African Studies* vol. 10 no. 1 (1983); for a critical analysis of this concept, see Iris Berger, "Interpretations of Women and Gender in Southern African Societies," in Robert W. Harms, Joseph Miller, David Newbury, and Michele Wagner, eds., *Paths toward the Past: Historical Essays in Honor of Jan Vansina* (Atlanta: African Studies Association Press, 1994), p. 123–141.

[6] Terence Ranger, *Are We Not Also Men? The Samkange Family and African Politics in Colonial Zimbabwe 1920–64* (Portsmouth: Heinemann, 1995), p. 39.

[7] Lawrence Vambe, *An Ill-Fated People: Zimbabwe before and after Rhodes* (London: Heinemann, 1972), p. 24.

[8] Ibid., p. 199.

[9] Ibid., p. 247.

[10] The charge may have been suspicion of prostitution with white clients, as the translated version of her statement was included in a set of statements from other women dealing with transgressions of the unwritten code that white men should not have sexual relations with black women. There was no legislation barring these actions, but the CID was tasked to keep track of and report on such liaisons in each district. S 1222.

[11] The African women of colonial Lesotho have a well-documented history of migration to the urban areas of South Africa, most notably Johannesburg; Philip Bonner dates their exodus from their impoverished mother country from the early twentieth century. Nyrenda's story suggests that there are further aspects of their international migration to be investigated. Philip Bonner, "Desirable or Undesirable Basotho Women?: Liquor, Prostitution and the Migration of Basotho Women to the Rand, 1920–1945," in Cheryl Walker, ed., *Women and Gender in Southern Africa to 1945* (Cape Town: David Philip, 1990).

[12] Tsuneo Yoshikuni, *Black Migrants in a White City: A History of African Harare, 1890–1925* (Ph.D. thesis, University of Zimbabwe, 1990), p. 139–140, 179 n25.

[13] Ibid., p. 179 n25.

[14] See Bonner, "Desirable or Undesirable Basotho Women."

[15] Walter Chipwaya, handwritten letter, 1918, NSM 2/1/1, quoted in Teresa Barnes, *African Female Labour and the Urban Economy of Colonial Zimbabwe, with Special Reference to Harare, 1920–39* (M.A. thesis, University of Zimbabwe, 1987), p. 18.

[16] CNC to Secretary to the Premier (Native Affairs), 21 February 1927. S 482/117/40.

[17] Jeater, *Marriage, Perversion and Power*, p. 183.

[18] Frederick Posselt, oral evidence to the Native Affairs Committee, 1910–11, p. 329. A 3/3/19/3.

[19] Yoshikuni, *Black Migrants*, chapter 4.

[20] Excerpt of Resolution A, adopted by the Southern Rhodesia Native Association annual conference, 4 June 1929. S 2584/73 vol. 1.

[21] For discussions of *lobola* in colonial Zimbabwe, see J. F. Holleman, *Shona Customary Law: With Reference to Kinship, Marriage, the Family and the Estate* (Manchester: Manchester University Press, 1952); Joan May, *Changing People, Changing Laws* (Gweru: Mambo Press, 1987), p. 39–41, 59–60; Michael West, *African Middle-Class Formation in Colonial Zimbabwe, 1890–1963* (Ph.D. dissertation, Harvard University, 1990), p. 111–112; Elizabeth Schmidt, "Negotiated Spaces and Contested Terrain: Men, Women and the Law in Colonial Zimbabwe, 1890–1939," *Journal of Southern African Studies* vol. 16 no. 4 (1990), p. 635–639; idem, *Peasants, Traders and Wives*, p. 114–116; Sylvester, *Zimbabwe: Terrain of Contradictory Development* (Boulder, Colorado: Westview, 1991), p. 145–146; Teresa Barnes, "The Fight to Control African Women's Mobility in Colonial Zimbabwe, 1900–1939," *Signs: Journal of Culture and Society* vol. 17 no.2, p. 594–596; Jeater, *Marriage, Perversion and Power*, chapters 1 and 4. For discussions of the bridewealth custom in southern Africa see Walker, "Women and Gender," passim; Adam Kuper, *Wives for Cattle: Bridewealth and Marriage in Southern Africa* (London: Routledge and Kegan Paul, 1982); A. R. Radcliffe-Brown and D. Forde, eds., *African Systems of Kinship and Marriage* (London: Oxford University Press, 1950);

E. J. Krige and J. L. Comaroff, eds., *Essays in African Marriage in Southern Africa* (Cape Town: Juta, 1981). For overviews of bridewealth customs in other African countries see Claire Robertson and Iris Berger, eds., *Women and Class in Africa* (New York: Holmes and Meier, 1986); Jane Parpart and Katherine Staudt, eds., *Women and the State in Africa* (Boulder, Colorado: Lynne Rienner, 1989); Sharon Stichter, *Migrant Labourers* (Cambridge: Cambridge University Press, 1985), esp. chapter 3.

[22] Adam Kuper, *Wives for Cattle*, p. 162.

[23] West, *African Middle-Class Formation*, p. 118, 120.

[24] Schmidt, "Negotiated Spaces," p. 635.

[25] A.K.H. Weinrich, *African Marriage in Rhodesia and the Impact of Christianity* (Gwelo: Mambo Press, 1982), p. 70–103.

[26] Gordon Chavunduka, *A Shona Urban Court* (Gwelo: Mambo Press, 1979), p. 58.

[27] Angela Cheater, *Idioms of Accumulation: Rural Development and Class Formation Among Freeholders in Zimbabwe* (Gweru: Mambo Press, 1984), cited in Norma Kriger, *Zimbabwe's Guerrilla War: Peasant Voices* (Cambridge: Cambridge University Press, 1992), p. 196.

[28] See discussion of this issue in the Introduction.

[29] Terence Ranger, *Are We Not Also Men? The Samkange Family and African Politics in Colonial Zimbabwe 1920–64* (Portsmouth: Heinemann, 1995), p. 46.

[30] Interviews with Mrs. Makoni, Mbare, 5 April 1989; Mrs. Stella Mae Sondayi, Highfield, 11 April 1989; Mrs. Bertha Charlie, Mbare, 21 February 1989.

[31] Interview with Mrs. Johanna Mwelase, Highfield, 31 May 1989. I think that by babies' being "dipped in water" she meant that before African women were shown the error of their ways, their babies were rather desultorily dampened, not thoroughly washed. This association of the pre-Mai Musodzi days with dirt is quite metaphorical; see also Timothy Burke, *Lifebuoy Men, Lux Women: Commodification, Consumption and Cleanliness in Modern Zimbabwe* (Durham, North Carolina: Duke University Press, 1996), passim.

[32] Interview with Mrs. Makoni, Mbare, 5 April 1989.

[33] Interview with Mrs. Bertha Charlie, 21 February 1989.

[34] Interviews with Mrs. Stella Mae Sondayi, Highfield, 11 April 1989; Mrs. Makoni, Mbare, 5 April 1989.

[35] West, *African Middle-Class Formation*, p. 119.

[36] Michael Gelfand, *The Genuine Shona: Survival Values of an African Culture* (Gweru: Mambo Press, 1973), p. 193.

[37] Mrs. Stella Mae Sondayi, interviewed in Highfield, 11 April 1989.

[38] Terri Barnes and Everjoice Win, *To Live a Better Life: An Oral History of Women in Harare, 1930–1970* (Harare: Baobab Books, 1992), p. 120.

[39] Mrs. Loice Muchineripi, interviewed in Mbare, 8 March 1989.

[40] Miss Keresiya Savanhu, interviewed in Mbare, 21 March 1989.

[41] Scarnecchia, *Poor Women*, p. 291; see also p. 293–294.

[42] See Ranger's portrait of the redoubtable Grace Samkange in *Are We Not Also Men*, p. 34–43; Barnes and Win, *Better Life*, chapter 13.

[43] Jeater, *Marriage, Perversion and Power*, p. 180–183.

[44] "When they separate the woman takes everything, including the bicycle, and other things that she bought with the man's money. The house is left empty." Letter in Chishona, translated by Everjoice Win, from *African Weekly*, 20 June 1945.

[45] Interview with Mrs. Mary Butao, Mbare, 13 April 1989.

[46] Jeater provides the best account of this process; see *Marriage, Perversion and Power*, chapters 1 and 3, passim.; see also the CNC's views on the "beneficial effects" of *lobola*, CNC to Chief Secretary, Salisbury, 26 March 1900, N 3/17/4/1.

[47] This story is taken from several documents: NC Salisbury to CNC, 18 February 1944; statements by Majoni made 14 February and by Sarah made 17 February and 3 March 1944; CNC to Secretary to the Prime Minister (Native Affairs), 17 March 1944; notice of Executive Council meeting, 29 March 1944; all in National Archives Record Center, location 32.17.2F, box 35635, file 2201, vol. 1.

[48] Ranger, *Are We Not Also Men*, frontispiece.

[49] Scarnecchia, *Politics of Gender and Class*, p. 134.

[50] CID Headquarters, Bulawayo, "Security Branch Memoranda on Native Affairs," Memo # 2, 30 July 1947; quote from Memo # 18, 25 February 1948. Held in the collection of the Killie Campbell Africana Library (hereafter KCAL), University of Natal, South Africa. See also Michael West, "Ndabaningi Sithole, Garfield Todd and the Dadaya School Strike of 1947," *Journal of Southern African Studies* vol. 18 no. 2 (1992).

[51] Teresa Barnes, "So That a Labourer Could Live with His Family: Overlooked Factors in Social and Economic Strife in Urban Colonial Zimbabwe, 1945–1952," *Journal of Southern African Studies* vol. 21 no. 1 (1995), p. 102.

[52] CID Headquarters, Bulawayo, "Security Branch Memoranda on Native Affairs," Memo # 21, 11 June 1948. Held in the collection of the KCAL, University of Natal, Durban, South Africa.

[53] Mr. Munamo Rubaba, quoted in Barnes, "So That a Labourer," p. 105.

[54] Typical is D. Drakakis-Smith's assertion that "there were few alternatives to population pressure in the communal districts other than migration to the towns. Traditionally in Zimbabwe this has been of single men, at least in the initial phases." D. W. Drakakis-Smith, "The Changing Economic Role of Women in the Urbanization Process: A Preliminary Report for Zimbabwe," *International Migration Review* vol. 18 no. 4 (1984). Although Schmidt is careful to write of "male labor migration," she does not investigate whether there were women labor migrants and what their roles in society may have been. This is surprising, as she does discuss in some detail the phenomenon of women's fleeing rural areas for the mines and towns. Schmidt, *Peasants, Traders and Wives*, p. 3–9, 82–89.

[55] Mirjana Morokvasic, "Birds of Passage Are Also Women," *International Migration Review* vol. 18 no. 4 (1984), p. 899.

[56] Clive Wilkinson, "Women, Migration and Work in Lesotho," in Janet Momsen and Janet Hutchinson, eds., *Geography of Gender in the Third World* (London: Hutchinson, 1987), p. 227.

[57] For a discussion of the main theoretical models of migration by women in the Third World, see Sarah A. Radcliffe, "The Role of Gender in Peasant Migration: Conceptual Issues from the Peruvian Andes," *Review of Radical Political Economics* vol. 23 nos. 3 & 4 (1991). Stichter thoroughly discusses the literature on female migration in Africa; the pattern of wifely migrancy as I have sketched it out here does not appear (Stichter, *Migrant Labourers*, esp. p. 150–158), nor does the section on female migration in Catherine Coquery-Vidrovitch, *African Women: A Modern History* (Boulder, Colorado: Westview, 1997), p. 74–78.

[58] Bonner discusses married women's migrancy as a monodirectional rather than cyclical phenomenon: seemingly once Basoto women got to the Rand they stayed there. Similarly, in Bozzoli's account of the life strategies of Phokeng women, women did not

undertake yearly rural-urban cycles under the direction of husbands; migration was, rather, more a matter of balancing women's own urban wage work with the maintenance of familial ties in rural Phokeng. Bonner, "Desirable or Undesirable Basotho Women," in Walker, *Women and Gender*, p. 230–241; Belinda Bozzoli with Mnantho Nkotsoe, *Women of Phokeng: Consciousness, Life Strategy and Migrancy in South Africa, 1900–1983* (Portsmouth: Heinemann, 1991), p. 103–109, 238; Gina Buijs, "Women Alone: Migrants from Transkei Employed in Rural Natal," in Gina Buijs, ed., *Migrant Women: Crossing Boundaries and Changing Identities* (Oxford: Berg, 1996); Sean Redding, "South African Women and Migration in Umtata, Transkei, 1880–1935," in Kathleen Sheldon, ed., *Courtyards, Markets, City Streets: Urban Women in Africa* (Boulder, Colorado: Westview, 1996). Neither Chauncey nor Hansen discusses wifely migrancy in colonial Zambia; Copperbelt wives seem to have arrived from the rural areas and stayed put, but this might be more related to historiographical concerns than to an absence of the phenomenon. George Chauncey, "The Locus of Reproduction: Women's Labour in the Zambian Copperbelt, 1927–1953," *Journal of Southern African Studies* vol. 7 no. 2 (1981); Karen Tranberg Hansen, "Negotiating Sex and Gender in Urban Zambia," *Journal of Southern African Studies* vol. 10 no. 2 (1984). Parpart, however, cites a 1943 study claiming that 33 percent of Copperbelt wives had lived in town for at least three years, and "many" had not visited home since their arrival. She notes, "This trend continued throughout the colonial period." Jane Parpart, "Class and Gender on the Copperbelt," in Claire Robertson and Iris Berger, eds., *Women and Class in Africa* (New York: Holmes and Meier, 1986), p. 143.

[59] Wendy Izzard, "Migrants and Mothers: Case Studies from Botswana," *Journal of Southern African Studies* vol. 11 no. 2 (1985).

[60] I use this term to describe the cyclical migration of wives with some reservation, as the migrant labor of men should probably also be seen as marital migrancy. However, migrant wives were by definition working within the bounds of marriage and household arrangements. The fields, the crops, the children, and their access to urban accommodation all either belonged to or depended on husbands. Male migrant workers were not equally hemmed in by these obligations.

[61] Phimister, *Economic and Social History*, p. 203.

[62] Yoshikuni, *Black Migrants*, p. 153–165.

[63] This is a difficult assertion to quantify. Peil implies, without elaboration, that marital migrancy was still common in the 1980s: "Many wives of migrants in Kenya and Zimbabwe spend part of the year farming at home." Margaret Peil with Pius O. Sada, *African Urban Society* (Chichester: John Wiley & Sons, 1984), p. 120.

[64] Superintendent of the Salisbury municipal location, oral evidence to the Commission of Enquiry into Native Female Domestic Service, S 94; Native Location Superintendent's Report, in Salisbury Mayor's Minute, 1935–36; letter of A. Jacha published in *Bantu Mirror*, 21 November 1936; Arthur Shearly Cripps to Governor of Southern Rhodesia, 10 December 1936; Staff Officer, BSA Police, to all stations, Circular Instruction no. 26/37, 20 May 1937, S 1542/A1/20 vol. 1.

[65] Women were enumerated as absent from the reserve if they were gone for more than fifteen days. R.W.M. Johnson, "An Economic Survey of Chiweshe Reserve," *Rhodes-Livingstone Institute Journal: Human Problems in Central Africa* vol. 36 (1963), p. 87–89.

[66] Interview with Mrs. Bakasa, Kambuzuma, 17 March 1989.

[67] Interview with Mrs. Maria Chagaresango, Mbare, 21 February 1989.

[68] Interview with Mrs. Elsie Magwenzi, St. Mary's township, 6 March 1989.

[69] Interview with Mrs. Katie Chitumba, Mbare, 29 March 1989. She was speaking at this point in the interview of the mid-1940s.

[70] Interview with Mr. Beattie Ngarande, Mbare, 27 April 1989.

[71] Interview with Mrs. Esther Chideya, Mbare, 6 April 1989.

[72] Interview with Mrs. Chagaresango, Mbare, 21 February 1989.

[73] Interview with Mrs. Tsiga, Mbare, 14 April 1989.

[74] Interview with Mrs. Bakasa, Kambuzuma, 17 March 1989.

[75] Interview with Mrs. Murhombe, Mbare, 5 April 1989.

[76] Interview with Mrs. Magwenzi, St. Mary's township, 21 February 1989.

[77] Interview with Mr. Vambe, Belgravia, 17 February 1989.

[78] O'Connor notes, for example that in the mid-1970s it was common for wives to return home for the main farming season. Anthony O'Connor, *The African City* (London: Hutchinson, 1983), p. 88.

[79] Interview with Mrs. Bakasa, Kambuzuma, 17 March 1989.

[80] See Paul Landau's recent work along these lines, *The Realm of the Word: Language, Gender and Christianity in a Southern African Kingdom* (Portsmouth: Heinemann, 1995).

5

CONFLICTS, COMPLEXITIES, AND COMPLICATIONS IN THE 1950S

So women have come a long way; [they] have got a long way to go.
[But] there is no doubt that in the context of our history they have
made tremendous progress . . . 90% is through their own efforts.
Because they have refused to be oppressed. They have applied them-
selves.[1]

In the 1989 series of interviews, all of the respondents were asked, "What
was the worst thing about living in town?" Many replied that the regi-
mens imposed on women by men were the greatest problem that women
faced. The following interview excerpts suggest that these women, who
generally were in the prime of their working lives in the 1950s and 1960s,
found a significant amount of frustration in the curbs that their husbands
and society at large tried to place upon them. There is a danger in reading
these statements too literally and in generalizing from them too broadly.
It would be easy but fundamentally inaccurate to suggest on this basis
that wives and husbands were at war with each other, that African wives
rebelled, or that African urban marriage was an endangered institution.
Rather, it would seem that urban married women consented to the ideal
of women's being reined in; at the same time, however, they individually
tried to find acceptable ways around such restrictions in order, as the
excerpts make clear, to help their families. Paradoxically, then, the goals
of social reproduction could only be met by bending if not cracking the
ribs of the values that that reproduction was supposed to protect. These
women's efforts, in my opinion, constitute the kind of refusal to be op-
pressed of which Lawrence Vambe speaks in the preceding excerpt. This

process was fraught with difficulties, however, and conflicts in urban gender relations characterized many aspects of the 1950s.

According to Mrs. Bertha Charlie, for example, the biggest problem that faced urban women was that

> women were bothered by their husbands. The husbands harassed their wives. Today it's better.[2]

Mrs. Ruth Murhombe identified the greatest problem as lying at the interface of husbands, wives, and wages:

> I would say [the worst problem in women's lives was] the money was little, the one our husbands gave us. So for us to educate the children we had problems, and you think of going home [to the rural areas]. When you go home, the husband doesn't bring money any more . . . the money doesn't come home. But you worked so hard, farming! It was bad. . . . At home he doesn't give you soap! Never! You had to use *ruredzo*! Ah. You don't get soap.[3]

Mrs. Sarah Bakasa said that she felt that women's most important problems were due to men's limited "understanding":

> We were helping [our families] by crocheting, and selling to the whites, but some [wives] were forbidden to go and sell. Yet she is trying to help [her] husband, but because of lack of understanding he forbids her. Even teaching! Some friends of mine were forbidden to teach. Honestly. Ah! My child [the problem was] just men's lack of understanding. Yes. Forbidding her from going to teach. Yet they had certificates in their houses and they would say, "Lucky you, who are teaching": those who were teaching were lucky to have good husbands. Yet these others just sat, waiting for what "Daddy" would bring.[4]

Mrs. Cecilia Rusike gave a very thoughtful answer to the question, "What was the biggest problem in women's lives?"

> In women's lives, [it was] the way we were oppressed by men. They are the ones who put rules which made us go down [lose ground] and not going to work. Not being allowed to work. Many [women] were left at home in the reserves. They didn't know Harare, they were not allowed to come here to Harare. Isn't it? We were not allowed to work, if you were so-and-so's wife. It was not allowed . . . some men thought women would reject their husbands if they saw what was there [in the outside world]. That's all I can see.

When asked how urban women were oppressed by their husbands, she answered:

> We say prostitutes were the ones doing bad things, and the men admired those who went around looking for money. Those who ran away from home and did that job of theirs. What made men do that was—they met these women in bars. Don't you know whores don't leave bars? So men would forget their homes.

But then she continued:

> I can't say whose fault it was. We thought those governments built bars. They were the ones who brewed beer, so when they did this business, they built places where people would come and buy beer. Nobody is forbidden from buying beer, if he had money. . . . Beer made men run away from us; to go to those others. Isn't it? Can a woman who lives here [an urban woman, a prostitute] and one from the rural area be the same?[5]

Mrs. Agnes Kanogoiwa's perspective on this issue included the additional pressures placed on wives by in-laws. A wife who was brave enough to work for wages was vulnerable to criticism from many quarters.

> If you go to the rural areas today, you will come across in-laws who say, "We don't want our daughter-in-law to work. For what? She is married, she must stay at home." . . . They prefer a daughter-in-law to go home to do fieldwork and help them in whatever they are doing, not work[ing in town]. And the other thing—the dirtiest thing—in-laws and husbands, some think that once a daughter-in-law works she will be sending money to her own parents. They don't like it. They pay lobola when they get married so they think, "Whatever my wife earns should come to me." . . . Then the worst thing—if [the husband] says, "I don't want my wife to work" [then] his wife will not look as clean, as smart as that one who works. So he— that same husband—will be going for that other woman. Then he will say, "You are dirty, you are not as clean, you don't look after yourself." Not [caring] she is not working. He can't pay for the children's education, food, new things in the house, dresses for the wife. Ah, its impossible.[6]

OPTING OUT

One consequence of these kinds of personal and social pressures on urban women was that some of them eventually opted out of the race for respectability, which required the satisfaction of too many conflicting demands. There were a few niches in the urban economy where a woman could survive eco-

nomically without a husband if she were willing to give up her chance to earn society's esteem. During our interviews in 1989, one elderly woman was described to us by her neighbors as a long-time prostitute.[7] In fact, when we went to interview her, she recalled that she had left two husbands after they each took up with other women. Describing the second marriage, she said:

> I married again. Then he again took another woman. So we started having problems. So I said to myself, "If I have failed, I have failed. But at least I have tried." How long can you keep on trying? . . . I realized I had had enough.

She then told us in a roundabout way that she had indeed become a prostitute for a while because of poverty.

> What used to happen was that if a man said, "I love you," then you go with him. Because you will be suffering. Isn't it? But if you are living well would you just want that man? You wouldn't because you would be living well.

She implied that when times improved for her, she took up another way of earning money and worked as a vegetable seller in the market. When asked whether it had been difficult overall to survive in town without a husband, she answered,

> To me it was lighter because I worked for myself. If I wasn't working for myself it would have been difficult.

Another woman, a domestic worker, revealed that although she had had a lover for twenty-two years, she had never married.

> He had his wife and nine children. But I stayed for a long time [with him]; twenty-two years. My boyfriend. But I didn't want also to get married. No. I didn't want. Men talk too much.[8]

A final example of the ways in which women's economic and personal options sometimes intertwined to support independence, but at a high price, is provided by the story of Miss Keresiya Savanhu. Born in the location in the early 1930s, she was able to exploit either a loophole in the location regulations or an unusual kindness by the location administrators: after being abandoned by her husband for another woman, Keresiya's mother was allowed to keep their house on condition that her children worked for wages.

According to regulation and custom, houses could only be leased from the municipality by African men, but Mrs. Savanhu had no sons. It was most unusual that her daughters, Keresiya and Matombi, were designated as workers to whom housing could be allocated, thus allowing Mrs. Savanhu to keep her accommodation (the normal procedure would have been to evict them all immediately). Perhaps it was their long-time residence in the location and the fact that both daughters had been born there (and thus had no rural home to go to) that swayed the authorities in their favor. Under these circumstances, however, Keresiya never married.

> I wanted to get married. But I . . . had a relationship with a certain boy for two years and I didn't have a child. Then I thought that if I got married . . . and I don't [then] have a child with him, he will divorce me. If he marries me he will take me away from my mother's house. Then I will go, and my mother's house will be closed [i.e., she will be evicted because] my mother will not have somebody to work for her and look after her house. Then when I . . . return [after a divorce] my mother will be suffering without a house. Where [would] I go and live? Then I decided to stay with my mother—looking after my mother.[9]

GENDERED CONFLICTS ARTICULATED

A number of acrimonious letters written to the "African press"[10] indicated the very real pressures that were being applied to African women by their society by the 1940s. What might be seen as a traditionalist backlash was developing against the behavior of urban women who were "refusing to be oppressed," as discussed earlier, and against a perceived consequent social impotence of African men. These traditionalists conceded that there had been female misbehavior in the precolonial days, but they believed that punishments had been so severe back then that further misdeeds had been emphatically deterred.[11] As one man wrote to the *African Weekly* in 1945 (in a fairly circular argument):

> I think most of our people have forgotten what causes prostitution. . . . Look at the fact that long ago those who engaged in prostitution (especially the Karanga of Gutu, Zimuto, Chivi and Chilimanzi) had their eyes gouged out. In those days prostitutes were few.[12]

Another writer concurred.

> Before the whites came, girls and women obeyed their parents or guardians. If they didn't they were beaten up. Then our girls had good characters and behaved well, and they got married in their homes.[13]

Such men decried what they saw as the defiling of traditional culture by women.

These days everybody knows that in towns and on mines there is a dance called the "Tsaba-tsaba." Like all dances it is a good dance if it is done properly. What spoils the dance are some women and girls who do degrading things. They fling up their dresses and move their behinds and fronts in a bad way, not befitting good girls and women. Please don't do things that degrade us; dance tsaba-tsaba properly.[14]

At least one male correspondent was of the opinion that women were so uncontrollable that "most [of them] want to be allowed to go around naked. They are only afraid of the government otherwise they want to go around naked."[15] According to a magazine columnist, town women did not know "the difference between human and animal behaviour"[16] and were generally a disgrace:

You see a woman wearing expensive clothes and shoes and their [sic] faces powdered. Lip-stick is used until the lips are as red as red pepper, and the hair is stretched like a white woman's.[17]

Idle hands were also thought to be doing the devil's work:

When I pass through the locations, especially in the mornings and evenings, I get surprised by some women who will be seated on their doorsteps doing nothing with hands folded. Please, girls and women, how can our race develop if we act that way?[18]

Judging by these letters and articles, *mapoto* marriage—the same arrangement that had so horrified the Chishawasha community in the 1920s (see Chapter 4)—was the practice most disliked by the despairing traditionalists.

Today with the coming of towns and compounds, we see that women do not obey and do what they want. They go to towns with the pretext of looking for jobs, but when they get there they start [to] "*kubika mapoto*," And that's the end of them! Because once a woman starts she will do it endlessly. Can't our leaders help to end this?[19]

Mapoto relationships cut at the very heart of the reproduction of social identity. Bypassing the traditional linking of lineages and disrupting the form of obligations between the genders meant that the mechanisms for passing on lineage membership and consciousness were breaking down.

I say *mapoto* must end here in Rhodesia, because I see many fatherless children. [They] are troubled because they are fatherless and totemless. When the child grows up, who will get an I.D. for him? . . . Secondly, if a girl is fatherless, who will give her away on her wedding day? . . . What is her totem? When the *mapoto* liaison ends the man must take the child and thus enable her to have a totem. Such a child will then know his or her ancestry.[20]

Not knowing one's ancestry was considered to be an unimaginable fate. Ancestry, philosophically, was the essence of identity.[21] Although Shona cosmology is a topic far too broad for this study, it should be noted that the entire system of social relations rested on knowing one's connection with a series of ancestral spirits, who determined in turn the lineage membership and position of any particular person. A man or woman who did not know such information would be excluded from the all-embracing systems of brotherhood, mutual assistance, and respect that ideally characterized social relationships among the living. He or she would also be excluded from the systems of care, protection, and well-being ensured by the correct acknowledgment of the momentous role of the spirits of the ancestors in mediation between the living and their fates.[22] No less crucial aspects of culture than these were threatened by the new gender relationships in the towns.

The social insecurity wrought by these upheavals accounts for the venom that eventually was articulated and aimed at a perceived source of the disruption: independent, urban women. They became the scapegoats for the disorienting shifts brought on by the increasing encroachment of Europeans on African culture. This explains why the consequence of becoming a *mapoto* woman was to become socially known as a "bad woman." Mrs. Katie Chitumba remembered what people used to say about a *mapoto* woman:

She was a bad woman. She is a loose girl—why did she agree [to live with the man who proposed *mapoto* to her]? If she wanted that man she must take that man to her parents so that they know, "My daughter is living with Mr. So-and-so."[23]

Similarly, African popular literature, paradoxically a manifestation of the encroachment of European culture that simultaneously articulated African social perceptions, was concerned from its early days in the mid-1950s[24] to give clear warnings about the dangers posed to African society by urban life. In Kahari's analysis of Shona novels, for example, urban life served as a literary symbol of African degeneration in the modern age:

In contrast to the rural areas which stand for all that is traditional in outlook, the urban areas are soul-destructive, destroying such things as hu-

man relationships and such values as hospitality. The urban areas are melting pots in which "things fall apart." . . . Because there is no social control in the city the African falls prey to prostitution, pickpocketing and organized crime, including murder.[25]

In this literature, unmarried, unattached, or "badly behaved" women were foremost among the specific dangers that waited to ensnare African men living in towns. Therefore, in novels written in both ChiShona and SiNdebele, the vast majority of urban female characters were portrayed negatively. Their iniquity made moral points and illustrated the dangers of transgressing social convention. Urban female characters uniformly came to bad ends.[26] An example is the character Jane in the novel *Rurimi Inyoka*, published in 1976.[27] Jane takes on a lover, who jilts her. She then finds a second man, Timothy, who on the advice of his respectable female neighbors eventually also refuses to marry her.

Timothy gets influenced against Jane by Mai Zipfende and Mai Mashumba. He had intended to marry Jane after discovering that Jane was pregnant but the things said by Mai Zipfende and Mai Mashumba about Jane set him thinking again. They tell him that it was a bad idea for a proper man like him to marry a woman who had been jilted by his friend. They liken Jane to vomit that had been thrown up by another man, a blanket that has been used by another man. They remind him that Jane has come to him only after she had been turned away by Simon in Harare and ask why Timothy is willing to accept a woman who has been found nauseous *[sic]* by another man.[28]

Subjected to this humiliation, Jane commits suicide, her brother kills Timothy in revenge, and then he himself dies from wounds suffered during their fight. The moral lesson of the book is that Jane's "whorish" behavior in pursuing Simon and Timothy was the cause of all the suffering and tragedy. According to Gaidzanwa, this story is typical in its portrayal of town women; to a woman they end up dead, mutilated, despised, and humiliated: fates befitting vermin.

Thus, a popular monthly magazine of the 1950s reviewed the cultural stereotypes of African women:

A typical African woman is often supposed to be a pathetic, wretched creature, who cannot say "booh" to a goose. Her natural habitat is a smokey *[sic]* kitchen and dirty surroundings, where flies and chickens and dogs often do the cleaning. Or in the urban area she is a skokiaan-addicted creature or some shy not-too-good damsel whose brains are full of nothing but boys.[29]

In the wider urban culture, then, women were the villains whose bad behavior was to blame for the upheavals in African society symbolized by prostitution, *mapoto*, and divorce. One irate husband, musing on ways to "stamp out the evils of divorce," advocated the confinement of women in houses as the only way to curb their destructive tendencies:

> My own view is that my wife is my property and I should not keep her far from my house. . . . I believe that the work of the wife is in the house and to improve the family's standard of living and not to work out where she is going to behave as if she is still a girl looking for a husband.[30]

These arguments were given a new twist by Mr. Willie Musarurwa in a letter to *The African Parade* magazine in 1955; he claimed that women were not ready to be given equal rights with men because they suffered from "conservatism, inertia and satisfaction with things as they are." Ironically, he fingered the prevalence of *lobola* as evidence of women's many weaknesses:

> The fact that they smile (instead of resisting) when being "sold" at a high price, because it signifies their worth on the scale of human value, completely damages their claim to equal rights with men.[31]

But urban women were not completely swayed by such misogyny; in the written realm (as well as others, one can assume) some were quite eloquent in their own defense. Musarurwa's letter, for example, appeared in tandem with those of two women who stoutly defended the extension of equal legal rights to women. It should be remembered that African women were, and remained until 1982, legal minors. One of the writers, Mrs. Victoria Chingattie, identified by the magazine as "a modern African woman," wrote:

> An Italian writer of the Mediaveal *[sic]* period said, "When woman usurps man's sphere, anarchy and all manner of wickedness will flourish." That might have been so in his time, but no one can believe such nonsense today. Barring biological and social inheritance, "Intelligence Tests" have proved that girls are more intelligent than boys up to the age of eleven when girls are constantly told that they are somehow inferior to boys until they believe it.[32]

Women had also defended themselves in print in earlier decades. In 1944, for example, one women had written in to the *African Weekly*:

> I hear a lot of men blaming us women for causing *mapoto*. This is not true! Men are the ones who cause this, because they are the ones who leave their wives at home, when they come to work in towns. . . . Because

of this they come to us, working women, lying that they want to marry us; and they don't tell us they have wives at home . . . this is what has destroyed the morality of girls who work in towns. It is the men who leave their wives at home who are wrong. They are the ones who lie to women so that they can engage in *mapoto* and [say] they will marry them when they have enough money. Even young boys from schools wear nice clothes and lie to us.[33]

Another woman expressed her idea of solidarity between urban women.

I, Julia, am surprised when I hear people saying that there are women called *vakadzi vemapoto* [*mapoto* women] in the locations. Listen to me, I say all of us women are *mapoto* women, those who had church weddings, NC [customary, civil ceremony] weddings. And also those like me who just live with a man without marriage, so that when the love is finished, they will quickly move on without spending time burning in the sun waiting for your marriage to be annulled [by a native commissioner]. We are all women of *mapoto* because we all use pots.[34]

Another woman defended herself and her compatriots vigorously in a letter published in 1942. Emelina Ncube was replying to a previous letter sent in by a man who apparently had written that town women were "lizards to be smashed." Miss Ncube fired back:

Yes, Bantu girls are foolish, but good because our sister gave birth to you and she kept you very nicely and today you blame us because of our misfortunes. You have said that you do see African girls now being at European tables with their lips and cheeks painted with red powder and who have forgotten that they are Africans. Who gives them that money for buying that powder? Are they not those "majoki" boys who give them that money? Yes, African girls have coloured children, but why is it that African uncle "John" and African brother "Shoniwa" have both coloured girls in their rooms? You have said, "Girls are like a farthing which buys nothing that people use." If it was not that a Bantu girl gave birth to you where would you have been today? Are you not more precious than a farthing?

She concluded:

Mr. Emman . . . [promised] some heavy blows to any Bantu girl who tried to reply him. Does this poor dictator of women know very well that this is not Germany where Hitler does not allow any person to reply to any question? No, this is democracy where rich, poor, cripples, and blind are free to oppose any question put in front of them. . . . We are ready for those

heavy blows which you have promised to smash us lizards—[signed] Bantu girls.[35]

But even these younger women, so confident and fluent, were not the first generation of town women to defend themselves against charges of endemic female iniquity. Perhaps the more lasting contributions on this front were made by women of an age to have been Emelina Ncube's mother. As discussed in Chapter 4, they waged silent campaigns to define and defend the possibility of respectability and rectitude for town women. They did not overtly challenge the patriarchal order in so doing, as did Miss Ncube ("We are ready for those heavy blows"). The lack of overt challenges to patriarchy may account for the longevity of this strategy.

THE RICU AND GENDER STRUGGLES IN HARARE

Chapter 4 examined the rise of "marital migrancy" among African women, noting that by the mid-1950s it had begun to shift in the original population of town families as more women gained a more permanent foothold with their husbands in town. But this new proficiency in uniting and reuniting families had not come automatically or easily. Rather, in the Salisbury area a large contributing factor was a campaign of approximately five years duration, waged under the banner of the Reformed Industrial and Commercial Workers' Union (RICU) on behalf of the marital rights of township men and for township residence rights for women. This campaign was led by Charles Mzingeli, a follower of the ICU in South Africa,[36] entrepreneur, musician, and man of political dedication and charisma. Mzingeli's political reputation has been largely shadowed by his nonradicalism during the early nationalist era.[37] However, the RICU campaign was the most sustained anticolonial struggle in Harare before the onset of the full-blown nationalist movement. It was unprecedented in its public challenge to the separation of African families under the migrant labor system, and in its explicit championing of the rights of urban women.

Keeping an eye on chronology: the 1945 railway strike was followed by a well-publicized committee of inquiry and subsequent wage increase and government promises to improve living conditions for the railway workers. In 1946 the Rhodesian legislature passed the Natives (Urban Areas) Accommodation and Registration Act (NUARA, discussed later), and in response, the RICU was formed early[38] that year. A full two years of organizational presence in Harare township thus preceded the April 1948 general strike.

The historiographical fortunes of the RICU are of late on the rise. This is mostly due to a gradually shifting focus of Zimbabwean historiography. The 1947–1952 campaign was the RICU's greatest success; historians who found

issues of women and gender uninteresting and unimportant paid it little mind. Historians explicitly looking for these issues, on the other hand, are seizing on the RICU as an overlooked chapter in prenationalist history.[39] As the pendulum swings it is important to remember that historiographical fashions may come and go, but accurate social history is difficult to achieve. Although the 1947–1952 campaign, and the 1956 bus boycott (see later) make excellent high-water marks for historical narratives, the contemporary meaning of these events for Salisbury's African population may be another question altogether. How large did these campaigns actually loom in the consciousness of Harare township residents? Even Mzingeli pointed out in 1952 that although the RICU claimed two thousand members, this was not particularly impressive when one realized that there were thirty-four thousand workers in Harare township.[40]

Also, the RICU campaign may suffer the same fate as the school boycott of the African female students at Dadaya Mission, which is languishing now, not as a narrative of defiant young women taking on the colonial education system, but as one of the early political correspondence of the then young teacher Ndabaningi Sithole with Garfield Todd, the man who meted out the punishment to the girls.[41] Mzingeli, with a kind of posthumous tenacity, may take his place in the pantheon of politically correct precursors of the nationalist movement, and the unmarried women of the township, like the Dadaya students, may simply become another eclipsed footnote in the life of yet another great, if periodically misunderstood, man.[42] On the other hand, the RICU campaign may come to be seen as the Zimbabwean equivalent of the heroic women's anti-pass campaigns in South Africa, which at least one historian also sees as a women's protest that was undermined by male nationalists.[43]

Like the ICU of South Africa,[44] from which it took its inspiration and the core of its name, the RICU was

> a sort of trade union, trade union cum political organization, cum civic organization, a bit of everything, we took in everything. And as a result, our membership was not even demarcated, we didn't have any boundaries.[45]

There is no consensus on the early strength and membership of the RICU; the general picture presented by all sources, however, is of a small organization with one experienced leader (Mzingeli) surrounded by budding trade unionists such as Reuben Jamela, Shato Nyakuaru, and Patrick Pazarangu. They caught the crest of a wave of popular discontent, and the RICU grew exponentially but disintegrated precipitously when the contradictions among the interests of its differing constituencies, tactics, and changing political winds became too great. In 1947 the organization was reputed to have only twelve

Table 5.1 Estimates of RICU Membership, 1947–1952

	1947	1948	1950	1951	1952
CID reports of RICU claims at meetings		125	400–600	1,157	2,000–4,000
Records of the Fabian Society, London		12	125	500	1,133
Oral evidence to NNLB, 1952		3,000	—	—	—
NNLB report, 1953		—	—	—	2,250
					(109 women)

Source: CID confidential memos no. 21, 11 June 1948; no. 45, 11 April 1950; no. 59, 31 October 1951; no. 64, 31 March 1952; no. 70, 30 September 1952, KCAL; Fabian records from West, *African Middle-Class Formation*, p. 368; Mzingeli's oral evidence to the National Native Labour Board, 1952, in Scarnecchia, "Poor Women and Nationalist Politics," p. 291; "Report of the National Native Labour Board . . . 1953," Appendix A.

paid-up members and enjoy regular attendance of about sixty people at its monthly meetings;[46] but according to other sources—Mzingeli's correspondence with the Fabian Bureau in London, which might have been inflated to impress foreign supporters—it held two protest meetings in 1947 that were each attended by more than six hundred people.[47] Scarnecchia estimates that the organization's membership in the late 1940s was confined to about one hundred stalwarts and draws a picture of the RICU's gaining significant popular support only after the 1948 general strike (Table 5.1).[48]

Lawrence Vambe's recollection is that Mzingeli "sounded the warning drums and rallied the people of Harare to the battle" over the NUARA as soon as it was passed; the main issues in the general strike in Harare township were housing-related, rather than wage-related (as in Bulawayo), and the fight against the NUARA raged on for three years.[49] Interestingly, as early as 1947 the educated and respectable African gentlemen who led the Southern Rhodesia Bantu Congress noted (in horror) that Mzingeli was "instigating people to cease work as a protest against the Act, which means he is instigating the people to revolt."[50] At least in Salisbury, Congress was, however, unable to fight off Mzingeli's popular appeal in the late 1940s, just as he in turn would be eclipsed by the young radicals of the mid-1950s. In this regard, it seems somewhat doubtful that the zenith of the RICU's membership was reached in 1954, with seven thousand members; other sources present an organization in its death throes by then, canceling monthly meet-

ings and struggling to get members to pay their dues.[51] It should be noted that the Southern Rhodesian government regarded the RICU in its heyday as subversive and more radical than other African organizations, opinions that could only have been confirmed when the African National Congress (ANC) of South Africa and the South African Communist Party sent "fraternal greetings" to the RICU's annual conference in 1950.[52]

It also seems likely that at the times of its highest membership figures, the RICU was led mainly by men, but followed by women. Scarnecchia cites Mzingeli as telling the members of the 1952 NNLB that the majority of the RICU's members were women.[53] Ironically for any androcentric history of political organization and protest in Southern Rhodesia,[54] the CID noted in early 1953, when RICU meetings were drawing one thousand people, that the vice-president, Patrick Pazarangu, suggested that "women should refuse to sleep with their husbands until they joined" the RICU. Reportedly the women present had rejected this idea, saying that it would encourage divorce![55]

There had been several intimations before the passage of the NUARA and the formation of the RICU that too much municipal interference in the issue of how many African women should be allowed to live in the location would be a troublesome issue. It is somewhat ironic, of course, that given the prevailing negative attitudes of African men toward the presence of young women in the towns, as discussed earlier, they would swing around and defend urban women against state efforts to remove them. Although it may be that the state overstepped its bounds by going after respectable women as well, it may also have been that African men and urban society in general were in the final analysis actually loath to throw their wives, daughters, and sisters to the state's wolves despite their "misbehavior." At any rate, as early as 1936 the location superintendent warned that the city council should be "most careful" about taking action to remove African women from the township. W. S. Stodart, location superintendent in 1940, similarly warned that any removals should be approached "with caution."[56] As high levels of postwar migration and the lack of accommodation in the location led thousands of women to seek shelter wherever they could find it, slum conditions deteriorated even further in areas like the periurban Brickfields. After an inspection tour in 1946 Salisbury's chief medical officer recommended that all African women and children and "other natives who are not actually in the employ of brickmakers" be removed from that area.[57] In response, the NC Salisbury warned:

> It is submitted that any such steps could, at most, relieve the position inconsiderably. Considerable resentment would ensue, if such steps were taken, which might result in serious unrest among the Native population

apart from introducing a social menace which might very well develop serious proportions and be very difficult to eradicate.[58]

The NUARA, modeled on the 1923 Natives (Urban Areas) Act in South Africa,[59] was meant to bring order out of the chaos in postwar towns. According to Gray, after 1944, the prime minister, Godfrey Huggins, was ready to concede that more African families would settle in the towns, but the legislation framed to cope with the situation made no substantive concessions to African aspirations for urban rights and facilitated closer control over men, women, and children in the townships.[60] The Act put the onus of providing workers' accommodation on the municipalities and the burden of paying rents for workers on their employers. It also provided for the establishment of several new features of location administration: advisory boards, a separate accounting system, location managers (rather than superintendents, a change of emphasis), health and labor controls, and strict nightly curfews.[61] With regard to women, the Act finally formally recognized that some African workers had wives with whom they should be entitled to live in town. But this recognition was a very mixed blessing: only a certain type of worker, married in a certain way, to an "approved" wife, living in a certain type of accommodation, could legally live with a woman. These categories were in fact so narrowly defined that most urban families were excluded and even those who managed to qualify in terms of employment and marriage faced a long wait for housing because of a huge backlog.

Salisbury established its own Native Administration Department and began to implement the Act in January 1947. The department's interpretation of the legislation was that only men who could prove continuous employment for two years and who were "properly" married (and could prove it with possession of a marriage certificate) qualified for married quarters in the location. This was the only kind of housing in which a woman could live; she, therefore, also had to be properly married. A man who could fulfill all these requirements could live with his family in a section of the township called New Location. In addition, a small provision was made for single working women: a few teachers and nurses could be allocated beds in shared rooms in a separate row of Old Bricks, an old, dilapidated section of one-room bachelor "houses." No other women were to be allowed in the township.

In this way, a number of previously irregular practices to which the authorities had turned a generally blind eye (see Chapter 3) became straightforwardly illegal. Men living with women who did not have marriage certificates, women lodgers, and women with or without marriage certificates living with men in sections of the township that were allocated to bachelors were now all rendered criminals. Many women had settled, for lack of alter-

native, in the Old Bricks section of the township, where the rooms were so crowded that it was common for a family's living space to consist of the curtained-off area around one bed. Children slept under the bed. Other bachelors and/or families occupied the other curtained-off corners of the tiny room.[62] But because after January 1947 Old Bricks was only designated officially for single men and a few professional women, the municipality took it upon itself to find, arrest, and try to evict any other women found living there, regardless of their marital status. Large-scale raids were initiated, usually at night, to "cleanse" the location of such women. One such raid was described in 1950:

> The biggest and most extensive raid ever was carried out by the Municipal police on Monday morning last week. Several women and some men were arrested. Some women had children on their backs . . . the Director of Native Administration stated that these quarters are for single men and those who come there without the permission of the Superintendent do so at their own risk.[63]

To avoid these raids, some women slept out in the open veldt, popularly known as "the bush," exposed to the elements; others slept at home but tried to outrun police patrols when they heard them coming.

> In the 1950s, that's when the inspection really started. We would go and sleep there, on the Mukuvisi [River], running away from inspection. We were not married. Ah . . . you couldn't guess [when the police would come]. The people in the area where they started would come running, saying, "You are sleeping! Trouble has come!" Then we come running outside now.[64]

The raids, popularly known as "inspection," illuminated differing concepts of morality: the colonial definition that any woman who broke the law was immoral clashed with the township community's view that married women should be exempt from harassment. If the raids had only targeted the young and unmarried women who had been targets of the low-level actions that the municipality had been fitfully mounting for at least a decade (see Chapter 3), it is unlikely that community opposition would have been aroused to such an extent. But respectable married women (for whom the code phrase was women "with babies on their backs")[65] were also being forced to submit to indignities such as sleeping outside, running through the township in fear, and enduring police harassment and arrest. When interviewed, Mrs. Enniah Mutuma scoffed when asked whether the police claim that their inspection was a good thing (because they said that they were arresting prostitutes) was true:

Ah. Which ones? Everybody knew, "These are [the] prostitutes," and they did whatever they were doing. But the [police] even took old women. They would be grouped at the office there.[66]

By persecuting respectable women—wives, widows and mothers—the Salisbury municipality "raised a hornet's nest."[67] As an unusually militant editorial voice in the *African Weekly* protested:

To us the present methods of arresting these women and prosecuting them for visiting their legal husbands is far from being a solution to the problem which demands immediate attention. . . . The Native Advisory Board stand for co-operation with the local authority but if such is to be the price the answer is "No! Never."[68]

The municipality's intransigence led to the RICU's championing the cause of all Harare township's homeless women. In fact, the issue gained so much momentum that temporarily the distinction between married, respectable women and unmarried women became blurred. At one point, Mzingeli, though denying allegations of facilitating immorality, was reportedly defending all women against the raids:

Mr. Charles Mzingeli [said] that a married woman should not be separated from her husband. He refuted the allegation that his organization, the RICU, claimed to champion the cause of unattached women by condoning any immoral act. "The membership of the Union is open to all persons irrespective of sex. . . . Many of these women have lived in Salisbury for many years and had been warned several times to go home, but just because this home does not exist they are arrested time and time again when raids take place."[69]

He was not the only one who, in the heat of the moment, developed a concern for all township women, both respectable and disreputable. Symptomatic of this unprecedented campaign, another man declared, "We do not want any form of raids or inspections because unmarried women do not only exist among the people of Harare, everywhere in the world they are found,"[70] implying not only that unmarried women should also have rights, but that African women were being unfairly hounded in comparison to women of other communities.

The fight between the RICU and the municipality was gathering steam at the dawning of the decade of the 1950s. In January, the Salisbury director of native administration (who Vambe notes was "loathed" by township residents)[71] called for imposition of stricter pass laws to control the movements of African men inside the municipal boundaries; in the esti-

mation of the CID, an "unusually large" group of three hundred people attended the February RICU meeting.[72] Meanwhile RICU candidates continued to sweep annual elections to the township's Advisory Board, an initially enticing but ultimately toothless provision of the NUARA. Speakers at RICU meetings spoke of "this rotten society" and "these heartless settlers."[73] If the CID is to be believed, however, at the 1950 RICU annual general meeting, attended by about one hundred people, Mzingeli reported that his attempts to deal with the NUARA had been unsuccessful: "He pointed out that if the RICU had more members he could then obtain results."[74] Matters do not seem to have been coming to a boil at this point, however; a hot issue in mid-June 1950 was whether or not the elderly and ultrarespectable Mai Musodzi (see Chapter 2) had actually signed a letter—the sort of act the authorities branded as disloyal and practically treasonous—asking for a wage increase and improvement in conditions for the African women Red Cross volunteers at the African hospital.[75]

Times had certainly changed by mid-1951, however. Perhaps under pressure from rumors of escalating night raids,[76] a huge crowd of about four thousand people attended the RICU meeting of 3 June 1951. The excitement and anger of the meeting come through even in the characteristically dismissive words of the CID:

> The unusually large audience is attributed to the main subject for discussion, "Women in the Location" which attracted bachelors and unattached females who stay around the beer hall. There was little of interest discussed until the main subject was reached, "rumours about removal of native females who are not in possession of Occupation Certificates for the native township." No official instructions have been issued in respect of such a course, but the African male is apprehensive about possible expulsion of prostitutes and unmarried women. A number of speakers spoke at length on the undesirable hardship which would be caused if unmarried women were ejected. When one native, Stanilas, advocated that single women return to the reserves and get married, as a preponderance of unmarried females tended to prostitution and immorality, a general uproar followed. It was finally agreed that Mzingeli should discuss the matter with the Director of Native Administration and the sum of £7.10/- was handed to him to assist in his work on behalf of the women of the location.[77]

Scarnecchia's account of the meeting contains wonderful notes of the subjects brought up by the speakers: the unjust treatment and isolation endured by unmarried women who had no recourse to any figures of authority, the hostility this engendered in some married women, and speeches from men who criticized the night raiding policy.[78]

On 15 June, Mzingeli escorted a group of ten women to the director of native administration, who made the concession of granting them certificates of occupation; a few other certificates followed. This was a truly unprecedented civic protest, even though the municipality deftly managed to limit the concession to only a few individual women. For the time being, no matter, however; the RICU's next monthly meeting was attended by three thousand people, whose "general view was that Mzingeli had done a very good job of work in this matter and it was recorded that this appreciation had been shown by the meeting."[79]

Incidentally, the issue of women's staying in urban locations was not confined to Salisbury. In a foray into the north, Benjamin Burombo[80] held a meeting of his Bulawayo-based British African National Voice Association in the location of the northern town of Rusape in August 1951: "One of the women present wanted to know why unmarried women were excluded from the location."[81] The tiny RICU branch that Mzingeli managed to establish in the Bulawayo location regularly took up similar issues; in addition to dirty lavatories and "vermin-infested quarters," in August 1952 the branch agreed to take "the fact that African wives were not allowed to visit their husbands in the township" to the location's advisory board.[82]

By October 1951 the RICU had raised enough money to send Mzingeli on a tour of Britain; he left in November and returned to the colony on 31 January 1952. In true showman's style, he made a triumphant political return to the township on 3 February, riding in an armchair carried on the back of a truck that was draped in black in respect for the recent deaths of the local unionist Abel Choto and the father of the South African ICU, Clements Kadalie. Above the chair hung a red banner that read, "Son of Africa we are Proud of You." Mzingeli brought greetings to the eight hundred–strong crowd from many British organizations, including women's organizations. The people of Britain were "kind," he reported, and there was no color bar.[83] At a later meeting he said that during a visit to a British zoo he had seen some black baboons as well as "others which were as white as Europeans"—a wonderfully subtle revision of a standard Rhodesian racial insult.[84]

In March 1952, the RICU meeting of six hundred people discussed the topic of arrests of location women "heatedly and at great length."[85] The township Advisory Board then passed a resolution asking the City Council to review its policy of not allowing properly married women to live with employed husbands in the single men's quarters while they were waiting to be allocated married housing.[86] The director of Native Administration replied to this resolution that it amounted to the encouragement of "immorality and anti-social conditions among the African people."[87] Press reports, probably hoping to smear Mzingeli, began to appear, claiming that he had formed a "protection society" for unmarried women; in April he was, as noted, forced

to defend himself against the allegation "the RICU was championing the cause of unmarried women of doubtful character."[88] Attendance at RICU meetings continued at healthy levels throughout 1952, however, with CID estimates ranging from five hundred to nine hundred (with twelve hundred people attending a special meeting in November called to discuss wages and the cost of living).[89] Signs of the changing times were the resignation of W. S. Stodart, the location superintendent for seventeen years, in June 1952, and the death of Mai Musodzi in August.[90]

The RICU campaign to force the municipality to end night raiding seems to have involved a number of tactics. In addition to the mass protest meetings, in April 1952 it was noted that a boycott of the permit system seemed to be in operation: "It cannot be denied that the proportion of women visitors who trouble to report to the Superintendent for visitor's permits has decreased, while the number seen frequenting the township has substantially increased."[91] In addition, according to Patrick Pazarangu, delegations were sent to and meetings were held with municipal officials. He recalled that Mzingeli had said to the officials:

"Most of these men in the Old Bricks have wives but when they visit their husbands they are arrested, how do you expect the men to survive? Do you want the men to be homosexuals?" This was a meeting held in the hall. Mzingeli said, "Well I know how we will rectify this."[92]

In March 1952, Mzingeli threatened officials with a South African–style civic disobedience campaign by the location women. The campaign did not materialize, however.[93] According to Shamuyarira, Mzingeli did organize a boycott against rent payments.[94] There is some other documentary evidence on the outcome of the RICU campaign to halt the raids; it was noted in July 1952 that the Town Council had been setting aside rooms for the use of legal male tenants and their wives for the duration of the wife's visitor's permit; raids, however, were to be continued. According to one source, this decision was met by a meeting of "well over 3,000" indignant residents in Harare.[95] That the pressure on the municipality was maintained until night raids were discontinued was, however, the recollection of contemporary observers such as Nathan Shamuyarira ("limited success"), Patrick Pazarangu ("from then on there were no raids"), and Reuben Jamela. According to the latter (although his recollection of the date of the policy change seems to be incorrect by about two years):

[The RICU] took [the issue of the raids] on until it was later allowed, a man was allowed to register his wife. Round about . . . when they started allowing registration, 1950. They started registering in Old Bricks. There

was already in New Location, that had women, families. That had fami-
lies. But in Old Bricks, which was the main section of the township, that
had no women registration until about '49–'50. That's when if you had, a
wife, properly married wife, you could be registered and given a room.
One room![96]

Just as important as any actual change in municipal policy was the fact
that people perceived it to be a result of their own actions. Another important
development during this struggle was a new-found, though fleeting (see later)
community tolerance for unmarried women.

RAPE AND NATIONALISM: THE 1956 BUS BOYCOTT

The 1950s was, of course, the decade in which previously local and re-
gional campaigns by African people for economic and political rights were
gradually transformed into a coherent national movement for independence.
As the radical approaches of one political era were condemned as the timid
platitudes of the next, elements as disparate as rural struggles against the
restrictive 1951 Native Land Husbandry Act;[97] the settler-led amalgamation
of Southern Rhodesia, Northern Rhodesia, and Nyasaland into the Central
African Federation;[98] the urban protests led by Benjamin Burombo and
Charles Mzingeli; the growing trade union movement (symbolized by rail-
way workers led by Joshua Nkomo); and the new radical leadership of the
South African–educated elite coalesced by the late 1950s into a movement
that sought to end settler domination of African political, social, and eco-
nomic life. Although at the time of this writing there is no single, compre-
hensive history of Zimbabwe's nationalist struggle, there are works on spe-
cific aspects of the development of nationalism and autobiographical accounts
of the nationalist explosion written by men who became powerful politicians
after the achievement of independence in 1980.[99] These narratives generally
stress the decline in popularity of groups such as the RICU in favor of in-
creasingly militant groupings that eschewed the politics of petition in favor
of direct, and eventually violent, confrontation with the forces of the Rhode-
sian government. The historiography of the nationalist struggle has also
emphasized the rural areas as the primary sites of military confrontation and
thus the rural character of the conflict.[100] The role of the urban populations
in Rhodesia in the nationalist struggle has yet to be systematically explored,
even though the first explicitly nationalist organizations were centered in the
townships of Salisbury and Bulawayo.[101]

The event that is often cited[102] as marking the formal start of the turn to a
much more confrontational style of politics was the Salisbury bus boycott of
1956. A month-long campaign of the radical City Youth League, the boycott

forestalled a planned increase in bus fares for Salisbury's economically be-
leaguered African population and served notice of its growing anger on mu-
nicipal and state authorities.[103] A central event in the boycott was the attack
and rape of women residents of Carter House, the new 156-bed hostel that
was situated directly opposite the township's main bus terminus. Carter House
residents were the only women who were raped during the boycott. The fo-
cus of male anger on these particular women illuminates some of the explo-
sive undercurrents of urban gender relations in this period, and the abandon-
ment of the spirit of tolerance that prevailed briefly in the early 1950s around
the RICU-led antiraid campaigns.

Regarding urban sexual violence, Jeater's observation that transformations
of sexual mores were as profound indicators of colonial change as the more
commonly mapped shifts in politics and economics has not yet been system-
atically followed up.[104] Women in Harare township were no strangers to the
exercise of violence by men: rape and wife beating were familiar afflictions.
No less well regarded a source than Lawrence Vambe told Schmidt in an
interview that traditionally men could beat their wives "without social sanc-
tion."[105] Male violence against women was not uncommon in the colony's
mining and railway worker compounds.[106] On average, at least one case of
rape was reported to the Salisbury native commissioner every month in the
1930s. In 1989, one interviewee shared a painful memory of being raped in
the early 1930s when she was a teenager. She simply recalled, "Men just did
that." [107] Violence against women had even previously surfaced in the con-
text of political protest: women in the Salisbury location had been gratu-
itously attacked during the 1948 general strike.[108]

It has already been noted in Chapter 3 how residence in an urban hostel
had been linked in the minds of the African public with social impropriety
and prostitution. Carter House residents—domestic workers, shop assistants,
and factory workers—earned their own keep. They were not beholden to
proper husbands, *mapoto* partners, or sex clients. Worst of all, their very vis-
ibility as residents of a hostel for working women flaunted their indepen-
dence. Hostility to hostel women by the community of township men sur-
faced violently under the conditions of September 1956.

It makes both geographical and economic sense that boycotts of monopo-
lized bus services were common to segregated societies in the 1950s. As
long as segregation and apartheid forced workers to live far from the only
places where they could look for or earn a wage, transportation costs were a
matter of survival. Transport costs for African workers in Salisbury ranged
from 18 to 30 percent of the average male wage, for example, making the
fare for the daily journey from the far-flung townships a painfully large ex-
traction.[109] Interestingly, although the 1956 boycott in Salisbury was unequivo-
cally run by the young radicals of the City Youth League, the genesis of the

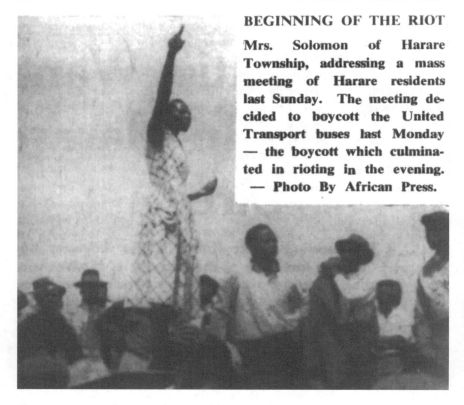

BEGINNING OF THE RIOT

Mrs. Solomon of Harare Township, addressing a mass meeting of Harare residents last Sunday. The meeting decided to boycott the United Transport buses last Monday — the boycott which culminated in rioting in the evening. — Photo By African Press.

Photo 5.1 Mrs. Eleanor Solomon of the RICU, 1956 Salisbury bus boycott. Courtesy of the National Archives of Zimbabwe.

idea in Salisbury may have been in the RICU era. In August 1952, still in the RICU's heyday, a CID report noted that Patrick Pazarangu, RICU vice president, had, at a monthly meeting attended by nine hundred people, "condemned the high cost of bus fares and suggested that if Africans boycotted the buses the fares would be lowered."[110] High bus fares were also discussed at RICU meetings in September 1952 and January 1953.[111] Also, a unique bit of historical evidence links the RICU to the boycott: a photographer from the *African Weekly* caught a former RICU official standing on a platform, arm raised defiantly, addressing a meeting in Harare township about the proposed boycott the day before it began. This was Mrs. Eleanor Solomon, an impulsive and militant former RICU leader.[112] One could also speculate on an intellectual linkage of the boycott with Gandhian struggles in India.[113] The most famous bus boycott in a segregated society in the 1950s was that conducted

in Montgomery, Alabama, from December 1955 to December 1956, but this, at the onset of the American civil rights struggle, received relatively little attention even in the United States at the time,[114] and it is thus unlikely that it would have been reported in the Southern Rhodesian press. A more plausible link could have been through RICU leaders' reading or being told, perhaps by returning migrant workers, about the many bus boycotts in urban South Africa and especially two of Johannesburg's townships: in 1940 and 1944 in Alexandra township; a series of boycotts in Evaton township in 1950 and 1954–1956, and the important boycott in Alexandra in early 1955.[115] After 1948, Mzingeli received and distributed weekly radical papers from South Africa, *The Guardian* and *Nkululeko*,[116] which would not have failed to report on these critical actions. Interestingly, women were prominent organizers of the Montgomery and at least of the earlier Alexandra boycotts.[117]

At any rate, the immediate catalyst of the boycott in Salisbury was a very reasonable rumor that the bus fares charged by the monopoly service, the Salisbury United Omnibus Company, were about to be raised. And it was the economics of gender relations that drove the boycott over the edge into violence. As noted in Chapter 2, many women workers in this era earned wages higher than the male average. Flaunting this advantage, on one of the first mornings of the boycott in September 1956, "some" women, identified as Carter House residents, took a bus to town and duly returned by bus after work. When challenged about their disregard of the boycott call,

> one girl was heard saying she had enough money to pay the extra threepence; *she would not obey the strike orders from poor men.* [emphasis added][118]

At this point rioting broke out among a crowd at the terminus; the bus in which the women were riding was stoned; the police fired tear gas. In the subsequent melee, food stalls were burned and bus shelters destroyed; barricades of corrugated iron were set up in the streets and shops were looted. Most importantly, Carter House was attacked. Sources give different numbers for the women—perhaps five or as many as sixteen—who were raped in the assault on the hostel, which lasted into the night.[119]

According to one newspaper account, a hostel resident testified against three men charged with her rape that

> her assailant slashed her with a knife on the thigh and slapped her in the face twice. The woman had been raped by two other accused and the third refused to have anything to do with her. Instead he demanded cash. The woman pleaded, cried and told him that she had no money, but the accused paid no heed to this.

Another woman testified:

The assailants broke into her room after all the lights had been put off and they asked her to either choose death or surrender herself to them. She refused to surrender and commenced to sing a hymn. The assailants left her. Later they followed her to another room where they tore her dresses and hit her. One of the rioters suggested that she should be carried somewhere but others said she should be carried to the common room. One of the assailants was about to attack her when the Municipal police arrived.[120]

Perhaps for the first time, African women were accorded the kind of saintly vocabulary usually reserved for white women in the national press. As was to become increasingly common as the nationalist struggle gathered steam, however, the male rioters were portrayed as bloodthirsty barbarians. Thus, in 1958 the CNC could condemn nationalists as exemplifying the "unstable, emotional, aggressive people who are a constant menace to established order—the lunatic fringe," who lurked in the townships.[121] At the time of the bus boycott, the press carried extensive and vivid accounts of the violence in Carter House. An alternate portrayal is Shamuyarira's dismissive mention of the rapes as an example of "ugly incidents which occur whenever there is a riot," for which "there is always some reason."[122]

But the rapists were taking their revenge, not only for a few women's immediate refusal to cooperate with the boycott call, but for the very existence in the township of independent female hostel residents. As noted in Chapter 3, it was a widely held opinion by the early 1950s that "any woman or girl, who has been divorced or is a widow or who has once prostituted herself, neither wants nor deserves nor requires any consideration or protection."[123] The background of the tense financial and social relations built up between township and hostel residents explains why Carter House was attacked and the rapes specifically visited on its residents, not this time on other township women, of whom there were at least many thousands at the time.[124] By being raped, the Carter House women were being punished for their perceived social and economic transgressions. In short, this particular episode of violence against women illustrated the community's distrust and dislike of independent African women as well as the antagonisms and tensions that had built up in gender relations in urban African society by the initial years of the nationalist struggle.

THE RISE OF AFRICAN WOMEN'S ORGANIZATIONS

This book deliberately ends in the watershed year of 1956, the year of the Salisbury bus boycott, the rape of the Carter House residents, and the ending

of an era of dignified Christian politics with the death, in August, of the indefatigable Reverend Thompson Samkange.[125] The last section of this study is therefore devoted to a development that immediately preceded these events: the rise of economic and political organizations for African women in urban areas. This development was not one-dimensional, as each category of organization manifested a number of strands running through urban life. These organizations can be divided into three main groups, however, according to their dominant preoccupations. Some were explicitly politically nationalist in character. Others eschewed politics and were primarily concerned with buttressing women's class-based social and domestic skills. Finally, others were explicitly concerned with pursuing the goals of social reproduction.

This scheme of categorization suggests that women's historical responses were quite complicated, and that no simple dichotomy should be drawn between women who were politically oblivious and those who were political activists. Models exist that do tend to support this dichotomization. The first claims that in nationalism as in everything else, African women "played no significant public role in the colonial society." The only exception in the entire history of colonialism in Zimbabwe, according to this view, was Martha Ngano, the immigrant from South Africa who led the Native Women's League of the Southern Rhodesia Native Association in the 1920s and 1930s.[126] The other model is diametrically opposed to the first: women were deeply involved in the anticolonial struggle, and nationalism drew much of its early fervor from poor urban women, whose interests were subsequently sidelined by a male leadership intent on achieving a masculinist victory over the colonial state.[127] By *masculinist* I mean a strategy that foregrounded the interests of men as "fathers, as political rulers or members of a political brotherhood, as owners and controllers in the economy, as sexual subjects, as producers of particular kinds of knowledges and rationality, and as relative nonparticipants in reproductive work and other activities widely designated as women's purview."[128] Perhaps the decision of a diverse group of male leaders such as Benjamin Burombo, George Nyandoro, Grey Bango, and John Ngazimbi to stop shaving and grow beards in early 1953 so that they would resemble the widely admired Kenyan nationalist Jomo Kenyatta can be seen, in some small way, as indicative of such a masculinist response![129]

I reject the first model outright: it can be taken for granted that if there was a political struggle in colonial Zimbabwe, African women were involved in it. Perhaps they were not involved in the same ways as their husbands, fathers, and sons, but they acted in ways that were important, that were public, private, or both. Women are also viscerally involved in the definition of a masculinist response to colonial oppression, one crucial ideological element of which was the male protection of women from colonial ravages (such as the pass laws),[130] from other men, even from themselves. The second model

is much more persuasive, yet it presents a narrative of the male leadership coming to power on the backs of poor women, who then are excluded, as respectable women, performing respectable tasks, take over that corner of the nationalist limelight that was allotted to women. But were these respectable women numerous enough to sustain a generalized female support of nationalism?

Was there, in fact, a generalized female support for nationalism? This is a topic that cries out for focused oral history research, and there are few specific data in the secondary literature with which to theorize on this question. Most studies of the 1980s, which focused on rural struggle, did not really investigate the consciousness of women and assumed that women supported the struggle.[131] Kriger's alternative argument, that the liberation war in Zimbabwe eventually succeeded in dislodging the colonial regime largely without genuine peasant support, insinuates a dominant dynamic of political illegitimacy of the guerrilla war, which I think is quite inaccurate.[132] However, her point, that it may often be the devil one knows (oppressive husbands, neighbors, chiefs) rather than the devil one doesn't (a distant colonial bureaucracy) that induces people to become involved in political action, is a compelling one. It is perhaps too simplistic to ascribe the involvement of African women in the early nationalist struggle to an extensive critique of white Rhodesia. Perhaps it is also too simplistic to see a transfer of women's communicative and management skills from, for example, the work of rural women's clubs to support of the guerrilla struggle.[133]

Urban Women's Clubs

African women were gaining a bit of the urban limelight in the 1950s. Some of the less reactionary sections of settler society were even grudgingly willing to grant that some "progress" was being made among them; according to Garfield Todd in 1957:

> There is a real rising of the spirit amongst the [African] women of Southern Rhodesia and although most of them are pretty primitive yet, in almost all communities there are leaders determined to work for the improvement of the communities. So on the women's side we have seen an enormous change over the last five years.[134]

African women's clubs were Todd's example of the progress that was being made by African women. The first congress of the Federation of African Women's Clubs (one of several such groups) in Harare township in 1954 hosted representatives from 52 clubs around the country; in 1956 there were 121.[135] Salisbury had, of course, a long history of club organizations for

African women, which were primarily concerned with spreading and improving the skills of domesticity and with upgrading the reputation of town women (specifically of married women). By the 1950s, the club movement in Salisbury was a site of some interesting ideological conflicts.

For example, the organs of settler society seized upon women's clubs as a way to promote political conservatism. In 1952, a new women's club was launched in Harare township. The militantly named "African Women's League" was in fact sponsored by the wife of the commissioner of police and endorsed by the city's director of African administration. Despite its fierce title, the league sought merely to "foster a spirit of self-help and to employ [women's] leisure time in useful occupations, such as knitting, reading and discussing matters that are of direct interest to the woman in the home."[136] The foundation of this club may have been a blatant attempt to co-opt the energies of township women from the RICU-led struggles over police raids; the club was launched at a high point in this agitation, April 1952. The fact that the new club's membership was said to be open to single women (as well as married women, of course) indicates that its founders were trying to distract women away from protest into supposedly absorbing activities like reading *National Geographic* and *Readers' Digest*. The list of the club's office bearers and members was studded with "well-known" names: Rakgajane, Chingattie, Vambe, Bakasa, and Samuriwo, among others.[137]

But this particular attempt to purify the African women of Harare township was probably short-lived. One of the members listed, Miss Mkandawire, did not recall this Women's League, stating to the contrary that the first club she belonged to was called Sunganai Club, started by Mrs. Isaac Samuriwo in about 1956. Her personal experience with and consciousness of the oppression of police raids before 1955, when she married, was certainly not muted by membership in any club.[138]

Another example of the cross-currents within the club movement is provided by Mrs. Emmah Chigomah, a prominent member of the township's Helping Hand Club. Started in 1953, Helping Hand provided accommodation for rural women visitors and a crèche for children of working mothers in accommodation let to it by the municipality. The club had an annual grant of one hundred pounds from municipal funds and employed two full-time workers.[139] Helping Hand was notable because it was also a creation of South African–born women of Harare township, many of whom were the wives of prominent men born in Southern Rhodesia.[140] It presented a powerful discourse of properly married women extending a helping hand to the embodiments of a broken society: "stranded" illegitimate children, children of working mothers and "visiting women who were often at the mercy of tsotsis [rascals, thieves]."[141] In 1955, Chigomah ran for a seat on the township's Advisory Board as a candidate from the Harare Civic Association, a group

that opposed the RICU. She won, polling the second highest number of votes and thereby beating out eleven men.[142] She represented the respectable, well-known women of the township. Her election, paradoxically was due to the increase in visibility afforded township women by the RICU but almost certainly simultaneously represented a backlash against RICU politics and the championing of the cause of homeless women.

Chigomah's conservatism was not universal. In Bulawayo, the public career of Jane Ngwenya (who became one of the few notable female nationalist politicians) started early, when she was expelled from a mission school for asking whether heaven was "for blacks only or for everybody." As an adult she moved on to involvement in a women's group in Mzilikazi township.

> I was Secretary of the Women's Association which questioned a number of issues that we did not like in schools, clubs, mortuaries and so on. . . . There were many of us women who agreed that all these bad practices must end. I was secretary of this organization. Then I joined politics.

Her entree into politics was typically bold.

> One day when I was coming from church, I found Mr. Burombo addressing a gathering of about 25 men. I just felt like joining them. I sat there, carrying my baby on my back. They were surprised to see a woman join in. The essence of what he was saying was exactly what I had been wanting to talk to someone about, but without success. In 1958, when the African National Congress was formed, I joined it. That is how I began. I was looking for a body which spoke that type of language that I found Mr. Burombo speaking on that day.[143]

The urban clubs for African women certainly facilitated displays of middle-class-like domestic splendor, but they were not isolated from the troubles of their times, and members also organized themselves to take up local issues and to reach out (again, a notion reinforcing hierarchy) to their less-privileged sisters. Emma Chigomah's political victory in 1955 and Jane Ngwenya's move, as she said, to "join" politics show the cross-fertilization of club life with political concerns. Similarly, in 1958, two prominent women (one the wife of Aidan Mwamuka, one of Harare township's most successful bus entrepreneurs) made an attempt to form a "Women's Voice Association." Regarding the latter, a magazine report rather paternalistically noted,

> regardless of whether such an organization in necessary or not, [it] is a spirit of political consciousness which should be encouraged to take the right direction.[144]

Organizations of Waged Women

By the early 1960s there was at least some dissatisfaction with the traditional activities of African women's clubs. A contributor to the popular magazine *African Parade* wrote in 1960:

> Have you ever noticed how almost all the women's clubs in the country run along the sale [sic] lines? We met either once a week or once a month and learn how to cook, sew, or clean houses from year to year. This is all very nice but is this all we should do at this stage of development in our country? . . . I feel it is time some of the clubs with an advanced type of membership started to add some of the subjects outside the house sphere. For instance how many of us know anything outside our own homes and towns?[145]

Perhaps reflecting this dissatisfaction, but certainly evincing the concerns of another segment of the urban female population, women's organizations with other concerns came into being in the 1950s. Specifically, groups of working women banded together. Official reports from 1953 noted the first of these, the Harari Employed African Women's League.[146] The documentary sources on the league portray it as a docile, well-meaning organization, made up mostly of domestic workers, nurses, and a few factory workers who sought an organized method of job listings and promotion of aspects of their welfare such as late night transportation from work.[147] The league was in fact presented somewhat mockingly in official reports because the president of the women's organization until 1955[148] was a man, Augustine Mukarakate. Thus, although the Salisbury native administration department assessed the league as seemingly "a species of trade union in embryo," it was quick to add, "It is of interest to note in this connection that the founders of this body are three men!"[149] Similarly, when two officers from the Native Labour Department attended a meeting of the league in May 1954, they made sure to note in their report that it was the fifteen men who had attended, not the fifty women, who asked most of the questions.[150]

Reuben Jamela, an important early trade unionist, remembered the Employed African Women's League quite differently, however.[151] He claimed that it was an RICU affiliate:

> And so from about 1950 we had quite a few independent unions such as the artisan's union which was mine, the transport union, and the catering, hotel, and the women. This is when we started organizing women and by 1952 they had formed an association which had later on changed its name to, it started as a women workers' association. Then we made it, called it as a union. And it became the [African] Women

Workers' Union of Southern Rhodesia. Led by Augustine Mukarakate. He, we employed him, we advised him to, we encouraged him to organize any woman who was interested in joining a workers' group. He did quite a good job of it, and by 1954 it was an established organization. . . . So this is when the women became properly, well, I wouldn't say properly organized union, but it was an established organization which was recognized by us, and even had contact of its own with government, with other bodies, such as international trade unions and so on. So this was in 1950, 1954, the beginning, the building up. [By] 1955 it was quite a union, with an office.

Jamela also discussed the reasons for the RICU's interest in such an organization.

We felt all sections of employment should be organized into single voices, or stronger voices than individuals. Because at that time we were shouting, should I say, it was a bit more than shouting, we had no channels of negotiation. So it was putting pressures and so on. So we felt if every section, sector of workers spoke about it, made noises about it, underpayments and poor working conditions and so on, it will help our organization to be recognized in terms of negotiations with government and employers' organizations. . . . All these other unions I've mentioned had no women. None. Not one woman. But we had a few women here, a few women there, who sometimes came to attend our meetings. There was no way how we could help them. So in order to help them, we advised them to come together, form an organization, then we can help them to push forward whatever complaints or dissatisfactions they had and so on.

Jamela explained that the league was run by men (Mukarakate, and a colleague in Harare, and Rolly Bango in Bulawayo) because of their prior experience in labor organization. The women's union was like the ICU and the RICU in that members belonged to different sectors of the work force. With badges bearing the insignia of an open hand, representatives of the women's union attended the 1954 inaugural congress of the Southern Rhodesia African Trade Union Congress (TUC), and Mukarakate was elected vice president of the Mashonaland region. [152]

Jamela's claim of a direct link between the women workers' union and the RICU is interesting in the light of Scarnecchia's presentation of Mukarakate's success with the new organization as symptomatic of the RICU's weakening hold on the collective imagination in Harare township. [153] It could be that Jamela's recollections of the Women's Union issue forth more from his identification with the budding TUC, which Mzingeli bitterly opposed, than from his role as an early RICU official.

It may be noted that Augustine Mukarakate was no run-of-the-mill township resident. For example, he was identified in 1956 as one of the first owners of a leasehold house in the newly opened section of New Highfield township. The African press admiringly reported his plans to enlarge the house, use the lodger's room provided for his own purposes (foregoing any rent), plant a hedge of fir trees, and hire workmen to do the floors of the house in "cement and oxide."[154] Moreover, identifying him as "the Professional Boxing Promoter and well known social figure of Highfield," a 1958 issue of *Radio Post* magazine carries an advertisement featuring Mukarakate endorsing Castle Beer. He is quoted to the effect that after a tennis game, "You can't beat a cold Castle," and he adds, "My wife has a busy and harassing time running the Highfields Creche, and she too finds there is nothing like a cold Castle to pull her together at the end of a tiring day."[155] Coming soon after the passage of legislation that decriminalized the use of clear (European) beers and wines by African drinkers,[156] this advertisement testifies to Mukarakate's star status in Harare township.

Documentary sources indicate that Mukarakate resigned as president of the women's union in October 1955; he died in a car crash sometime after 1958.[157] The women's union also lost ground at about this time, one indicator of which is that a "Rhodesian African Women's Union" appeared in a list of twenty-seven African trade unions in the colony in 1957 but, along with ten other organizations, had disappeared from a similar list in 1958.[158] As with the RICU itself, its mass organization strategy faded away as workers were organized in industry-specific unions in the TUC era. Jamela's overall assessment of the African Women's Union was that it flourished in the era, as he put it, "before the politics"—before the advent of explicitly nationalist organization.[159]

Women's grievances about their working conditions did arise in Southern Rhodesian trade union circles in the 1950s; the existence of a women's union, represented in either RICU or TUC circles or both, may have been a contributing factor. Many of these grievances were aired in the hearings of the 1952 National Native Labour Board (NNLB), which focused specifically on the conditions of women in employment. The board had been appointed partly because,

African Organizations are getting concerned over some of the existing conditions of employment of African women in industry in Bulawayo and Salisbury . . . quite a number of women are members of African organizations in Bulawayo and Salisbury, and . . . trouble may be anticipated fairly soon, unless steps are taken to put their working conditions on a better footing.[160]

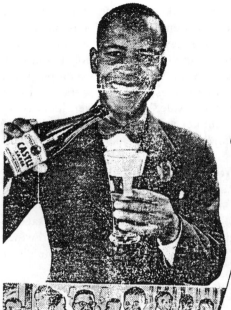

"Cold Castle is the drink for all occasions"

says **AUGUSTINE MUKARAKATE,**
the Professional Boxing Promoter and well
known social figure of Highfields.

"My boys may sometimes get beaten in the ring, but you can't beat a cold Castle when the occasion calls for a cool refreshing drink. After a game of tennis I'm always happy to serve Castle Beer to my friends, then I have an excuse to enjoy one myself.

My wife has a busy and harassing time running the Highfields Creche, and she too finds there is nothing like a cold Castle to pull her together at the end of a tiring day."

A. Mukarakate

There is no finer drink than Castle Beer. For friendly or formal occasions your friends and associates will really enjoy a sparkling and refreshing cold Castle.

COLD CASTLE

The finest Beer you can serve

Grant 193/571-

Photo 5.2 Augustine Mukarakate endorses Castle Beer, 1958. Courtesy of National Breweries, Zimbabwe.

During the 1953 annual congress of the Federation of Southern Rhodesia African Workers' Unions in Bulawayo, it was reported that

> a representative of the Womens [sic] Union deplored the way in which women were treated in the industries. They were treated like men and forced to work from sunrise to sunset even if they were not well. The Conference agreed to make representations on this question.

One of the seven resolutions passed was "That this conference recommends that women receive the same pay as men."[161] This was also in response to the recently released report of the NNLB, which had recommended a new wage for women of £3.9.0,[162] lower than that recommended for men.

The women workers' group was not the only labor-related women's association in the country at this time. In 1956, "a hesitant effort by [urban] factory girls to form their own union" was noted.[163] As previously noted, three hundred wives of railway workers in Salisbury formed a Women's League in 1958.[164] In the same year there was an African Trades Union Club for women in the town of Gwelo, led by a Miss Lizzie Ngole. Probably the same organization identified by the Labour Department as a "female branch" of the Commercial and General African Workers' Union, Ngole's group had a membership of fifty-five women in late 1958.[165] Ngole herself was a first cousin of Jane Ngwenya.[166] The African press in 1958 carried another intriguing example of women's interest in trade unionism:

> Prostitutes Meet. May form union . . . at Masasa, six miles outside Salisbury, eight prostitutes met there last week to discuss matters of common interest. They decided to build the nucleus of a trade union. The opinion of other centres will be tapped, and if possible, a Colony-wide trade union formed, which may affiliate to the T.U.C. of Southern Rhodesia. At last week's meeting it was decided to raise the fees by almost 100%, with effect from the first of March. It jumps from 2s. to 4s. A spokesman told our vernacular representative that this step had been taken in view of the high costs of all commodities—food, clothing, and furniture—in town, and the recent wage award to African workers.[167]

Despite this fairly startling example of women's interest in trade unionism and organizational involvement, it should be pointed out that such activity probably remained the exception rather than the rule. Why were more women not involved? One explanation is that simply attending meetings was a serious problem for them. When asked whether she knew anything about women in the trade union movement, Miss Katie Chitumba gave a sharp reply that immediately reinvoked the physical and ideological barriers placed in front of urban women:

I do not have any knowledge about that because we never went to any meetings. How could we go—most meetings were done late in the evenings and sometimes on week-ends. How could a woman be seen joining or traveling to those meetings? We would be asked, "Where are you going and what are you going to say at that meeting," [and] we had no answer and so it was improper. Some of us were not courageous so we never went anywhere near those meetings.[168]

The activism of women who did choose involvement in formal trade union activity did not happen in a vacuum. Mrs. Helen Gamanya, who became the first woman member of the executive of the Southern Rhodesia African Trade Union Congress, found that her indignation over inequality in the workplace led her into trade unionism, but that indignation itself had been fueled by the nationalist movement. Around 1959, she worked in a garment factory in Salisbury.

At the company a problem arose because my mother is a coloured, they were employing both coloured and black girls. They regarded me as a coloured because of my complexion. They took me on, but I was a nationalist and I did not like the way the other African girls were treated with me receiving better treatment because of the British divide and rule tactics.[169]

Explicitly Political Organizations

In the mid-1950s, African urban life was increasingly suffused with the excitement of mounting an overt African challenge to settler rule and to what Mrs. Gamanya described as "British divide and rule tactics." African women were publicly involved in the beginning of the nationalist movement. We have seen Mrs. Eleanor Solomon at the birth of the 1956 bus boycott. In 1958 it was noted that there were women's leagues of the African National Congress of Southern Rhodesia in Mabvuku and Highfield townships, with branches thought soon to follow in Harare township. Thus, auxiliary women's organizations were created and mobilized the respectable women of the urban townships into supportive roles for the nationalist struggle.[170] As Shamuyarira wrote:

The African nationalist movement in our country never really started making big strides until 1958–59, when the women had become convinced that the numerous grievances they had in their homes could only be set right by supporting a nationalist movement which would do something about their problems. On the public platform women are more powerful speakers than the men; more enthusiastic in branch organization; and certainly more influential with non-members. . . . In town . . . women have

spearheaded many organizations, and even the professionally qualified women, who are normally too busy or too removed from the people to do such work, have in Rhodesia been eager canvassers for the nationalist parties.[171]

Interestingly, these branches may have been following in the footsteps of the women's branches of the Nyasaland African National Congress (NANC) and Northern Rhodesian African National Congress (NRANC). In the aftermath of their unsuccessful campaign against the federation of the three territories, these groups, which could recruit easily from the thousands of foreign migrant workers in Southern Rhodesia, were both active and militant in the urban locations of Southern Rhodesia. As early as 1953, for example, the NANC was holding meetings in the Salisbury location; at the February 1955 meeting, which attracted four hundred men and women, members stood and chanted, "Africa! Africa! Africa!" when their chairperson entered the room.[172] Such a militant spirit could not have been lost on the local population. When Jasper Savanhu, newly chosen African member of the Federal Parliament, addressed a meeting of the Southern Rhodesia All Africa Convention in Harare township in 1954, he was reported to have said that he was "disappointed to see that there were no females present as the defiance campaign in Northern Rhodesia and the Mau Mau in Kenya were supported by women."[173] The NANC and the NRANC had flourishing women's branches; meetings that featured women speakers from the two territories seemed fairly regular occurrences. In fact, when Mrs. Chirwa, the wife of W. M. Chirwa, federal member of Parliament for Nyasaland, spoke to the Salisbury branch of the NANC in August 1955, reportedly attended by about one thousand people, she threw down the gauntlet to the African women of Southern Rhodesia:

> Mrs. Chirwa then spoke, criticising the lack of support by African women in Congress matters in Southern Rhodesia. She said that women in Nyasaland had a well run League of their own with women office bearers, and that men and women were working together in the fight for self-government. Mrs. Chirwa said that in the Northern Territories women held meetings with the District Commissioners and asked why women in Southern Rhodesia did not do the same.[174]

In 1958 wives of railway workers who were active in the railway workers' union put the blame for their lack of participation in union activities on their husbands, who "made them feel that the fight was for men only."[175] Much more historical research is needed on this question, but the available evidence supports an interpretation that the early African nationalist movement was happy to have urban women move into the role that Shamuyarira

described as "eager canvassers" but not as full-fledged and equal leaders. According to Jane Ngwenya, "In politics, I don't think anyone wanted women to be there."[176]

Women's obedience was highly valued in the nationalist movement, as demonstrated by nationalist leaders' virtual sanctioning of the rapes visited on the supposedly strike-breaking residents of Carter House in 1956. The degree to which the commitment of the liberation forces to women's equality in the later preindependence period was simply lip service can only really be assessed with detailed studies of women combatants in the armed liberation struggle. On this issue, Kriger's exegesis of the multiple Soviet-style contradictions in the rhetoric and reality of the treatment of women in the guerrilla armies is convincing.[177]

CONCLUSION

To use a medical analogy: the actions of African women reviewed in this chapter can be likened to someone cracking someone else's ribs in a resuscitation effort. African women in towns cracked some of African society's ribs in efforts to help it survive. This is historiographically a difficult concept to grasp and to portray. I think this degree of difficulty partially accounts for the problem Western observers often have when they condemn African women's organizations as not being radical or militant enough, and African women for failing to understand their own oppression; cracked ribs are externally invisible but internally quite painful. The task at hand for women was to save the patient, not to abandon it to some miserable, patriarchal fate.

I would suggest that this rib cracking can be equated with the rule breaking, the refusal to be oppressed, that is spoken of in the excerpt that opens this chapter. By Western standards, a rejection of oppression has to fit into the service of a greater personal liberation, and in the case of African women this would have to be liberation from the men and male standards that sought to restrain them. Anything less by African women is seen as misguided and incomplete, or simply quaint.[178] To fail to accept this criticism would be to be duped by some kind of cultural relativism, to have the wool pulled over one's analytical eyes by misguided apologism for "African culture." But the refusal of African women had a dual nature; it variously sought to evade both male control and colonial subjugation. Women's refusal to be oppressed, then, pointed them not in the direction of liberation from personal oppression but from oppression that was rooted in the colonial political economy. And who is to judge whether this effort was conceptually immature, misguided, or incomplete?

Married African women worked hard for their families, but, crucially, the African family was a social institution, not a closed, nuclear circle of indi-

viduals. The evidence reviewed here suggests that women did concede the upper hand in their family and social lives to men, but in such a way that men and African society were placed on a more secure footing. By refusing to be oppressed, urban women did two things. They worked very hard for social reproduction, but in so doing they could easily be judged as having eroded the standards of respectability and thereby earn occasionally dangerous amounts of male condemnation. The complexity of risking such male responses for the sake of securing the long-term fortunes of those very same men ideally gives an idea of the tightrope that urban women walked. Some sauntered across gracefully; others lurched dangerously at times but ultimately made it across. Others, the unmarried, the *mapoto* women, and the Carter House residents, fell into the abyss of social displeasure. In the period under review, at least, the social rehabilitation of such women seems only rarely, as in the RICU campaigns, to have been commonly considered. This may have been because these women's very lowliness buttressed the popular ideals of social hierarchy.

The last section of this chapter discussed the vibrant rise of organizations for urban women in the 1950s. The cross-currents in this development suggest another aspect of women's complicated responses to midcentury colonial conflicts. Women must have moved in and out of different organizations, and the preoccupations of these organizations also shifted in response to the tides of social circumstance. I have conceptualized the women's groups discussed according to their primary orientation: first, to support the transfer of formal political power from white male to black male hands; second, to support the improvement of working conditions and salaries for waged women; third, to improve the ability to display ever more finely honed domestic skills. Thus, women's involvement in political, economic, and social organizations reflected a multidimensional struggle. It is debatable whether these categories can be seen as adding up mechanically into a larger effort. Although the evidence does not suggest formal collaboration or coordination, it may be reasonable to see these three kinds of groups as sharing a concern for upliftment, and perhaps therefore—by extension ideally not too tenuous—with urban social reproduction. Certainly, however, there was great potential for the groups and their concerns to come into conflict with each other. This classification scheme contradicts the view that women played no public role in society, but it also differs from one that suggests that when women were not visibly nationalists they were socially quiescent. The extent to which these three aspects of women's public activity intertwined over time awaits further research.

It should also be noted that although a minority of urban African women were members of any of the organizations listed here,[179] most women worshipped in some denomination, whether Christian or Africanist. Church at-

tendance was an activity that women could generally pursue without danger of incurring male displeasure. The interplay of religious faith and spirituality with women's organizations is another topic that cries out for research.

NOTES

[1] Interview with Mr. Lawrence Vambe, Belgravia, Harare, 17 February 1989.

[2] Interview with Mrs. Bertha Charlie, Mbare, 21 February 1989.

[3] Interview with Mrs. Ruth Murhombe, Mbare, 5 April 1989. *Ruredzo* was a home-made soap, made with the lye from ashes.

[4] Interview with Mrs. Sarah Bakasa, Kambuzuma, 17 March 1989.

[5] Interview with Mrs. Cecilia Rusike, Mbare, 28 April 1989.

[6] In the context of the interview, Mrs. Kanogoiwa was discussing attitudes that she faced as a young married woman in the 1940s. Interview with Mrs. Agnes Kanogoiwa, Waterfalls, 24 April 1989.

[7] She is not named here because she discussed prostitution with us on the condition that this part of her interview, conducted in March 1989, would be used anonymously.

[8] See note 7. This interview was conducted in February 1989.

[9] Interview with Miss Keresiya Savanhu, Mbare, 21 March 1989.

[10] This appellation is something of a misnomer since the publications cited were white-owned ventures that tried to appeal to the African urban market.

[11] Such sentiments were apparently convincing to members of the Native Affairs Committee of Enquiry as early as 1911: "Under native law death or deprivation of a limb or of eyesight were common punishments for the offence [of adultery]." Southern Rhodesia Native Affairs Committee report, p. 3. A 3/3/18. See also Diana Jeater, *Marriage, Perversion and Power: The Construction of Moral Discourse in Southern Rhodesia, 1894–1930* (Oxford: Clarendon Press, 1993).

[12] Letter entitled, "The Causes of Prostitution," by P. Damiani, *African Weekly*, 25 July 1945. This letter was published in Chishona and was translated by Everjoice Win. See also Nancy Folbre, "Patriarchal Social Formations in Zimbabwe," in Sharon Stichter and Jane Parpart, eds., *Patriarchy and Class* (Boulder, Colorado: Westview, 1988), p. 65–66.

[13] Letter signed by "J. F. Asingadimapoto" (i.e., "one who is against *mapoto*"), *African Weekly*, 14 June 1944.

[14] Letter to the *African Weekly*, 19 April 1944. In the same era, new ways of dancing similarly scandalized Basotho men on the Rand when confronted with migrant Basotho women dancing, making "shaking and thrusting movements with their shoulders, hips and bosoms, while lifting their flared skirts." Quoted in Philip Bonner, "Desirable or Undesirable Basotho Women? Liquor, Prostitution and the Migration of Basotho Women to the Rand, 1920–1945," in Cherryl Walker, ed., *Women and Gender in Southern Africa to 1945* (Cape Town: David Philip), p. 248.

[15] Solomon Machowa, letter to the *African Weekly*, "Women and I.D. Cards," 27 December 1944.

[16] "Women's Education," *African Weekly*, 8 May 1946.

[17] "Women and Girls' Lives in Towns," by "Amai" [Mother], *African Weekly*, women's page, 28 June 1944.

[18] *African Weekly*, women's page, 19 September 1945.

[19] Letter from "J. F. Asingadimapoto" to *African Weekly*, 14 June 1944.

[20] Letter titled "Mapoto Child," from M. B. Beyah, Salisbury, to *African Weekly*, 13 December 1944.

[21] See Eugenia Herbert, *Iron, Gender and Power: Rituals of Transformation in African Societies* (Bloomington: Indiana University Press), p. 14–15; Chenjerai Shire, "Men Don't Go to the Moon: Language, Space and Masculinities in Zimbabwe," in Andrea Cornwall and Nancy Lindisfarne, eds., *Dislocating Masculinities: Comparative Ethnographies* (London: Routledge, 1994), p. 152–156; discussion of ethnophilosophy in Parker English and Kibujjo Kalumba, *African Philosophy: A Classical Approach* (Upper Saddle River, New Jersey: Prentice-Hall, 1996); Jean Davison, *Gender, Lineage and Ethnicity in Southern Africa* (Boulder, Colorado: Westview, 1997).

[22] According to Gelfand's understanding of Shona culture and the relationship between individuals and their vadzimu (ancestral spirits):

> Ultimately a person owes everything to his *mudzimu*; there is no doubt that a person owes his *unhu* (his personality) to his *vadzimu*. His behaviour, his consideration for others and his honesty are derived from his *mudzimu*. Equally, . . . a person owes his safety and protection entirely to his *vadzimu*. If their protection is removed for any reason he may suffer any kind of illness, accident, tragedy or even death. Any reversal in life may be due to a withdrawal of this protection.

Writing in the 1970s, Gelfand was of the opinion that,

> Shona townspeople who have lived an appreciable time in the urban environment of Salisbury still cling closely to their moral and spiritual values even though they have adopted very largely the material way of the West. We find evidence of this in each phase of their lives studied, in that basic or characteristic features which distinguish the Shona way of life from that of the West remain mainly inviolate.

Michael Gelfand, *The Genuine Shona: Survival Values of an African Culture* (Gweru: Mambo Press, 1973), p. 113–114, 120–121, 195; see also David Lan, *Guns and Rain: Guerrillas and Spirit Mediums in Zimbabwe* (Harare: Zimbabwe Publishing House, 1985), esp. p. 9–70. Gelfand's view is probably overstated; in one case, as Chavunduka writes in regard to marriage, "What is known to the formal courts . . . as customary marriage is not customary marriage at all. It has been modified by the legislators in a number of ways." Gordon Chavunduka, *A Shona Urban Court* (Gwelo: Mambo Press, 1979), p. 11.

[23] Interview with Mrs. Katie Chitumba, Mbare, 29 March 1989.

[24] The first book written by an African in Southern Rhodesia was published in 1954; it was followed in 1956 by a novel in SiNdebele by Ndabaningi Sithole and by S. W. Mutswairo's first novel in ChiShona in 1957. See Michael West, "Ndabaningi Sithole, Garfield Todd and the Dadaya School Strike of 1947," *Journal of Southern African Studies* vol. 18 no. 2 (1992), p. 301; George Kahari, *Aspects of the Shona Novel and Other Related Genres* (Gweru: Mambo Press, 1986, 1992), p. 100.

[25] Note how Kahari implicitly assumes that "the African" is male. Kahari, *Aspects*, p. 107–108.

[26] Rudo Gaidzanwa, *Images of Women in Zimbabwean Literature* (Harare: College Press, 1985), p. 74.

[27] Giles Kuimba, *Rurimi Inyoka* (Gwelo: Mambo Press in conjunction with the Rhodesia Literature Bureau, 1976), discussed in Gaidzanwa, *Images of Women*.

[28] Gaidzanwa, *Images of Women*, p. 54.

[29] *The African Parade*, February 1955, p. 18.

164

[30] Jefiyas Ndlovu, letter to the *African Daily News*, 6 March 1958.

[31] Musarurwa became one of the best-known African journalists in the country; at the time of his death in 1990 he was chief editor of the *Sunday Herald*, the main weekend newspaper in independent Zimbabwe. This letter was printed in *The African Parade*, April 1995, p. 31.

[32] Mrs. Chingattie was a staff nurse at the Harare Maternity Hospital and also started a singing group, the Gay Gaities, which was very popular in cultural circles in the mid-1950s. *The African Parade*, April 1955, p. 30; February 1955, p. 18.

[33] Letter from Miriam L. Chiota, *African Weekly*, 28 June 1944.

[34] Letter to the *African Weekly*, 4 April 1945.

[35] *Bantu Mirror*, 28 March 1942. Vambe defined *majoki* boys as those young urban men who the rural elders felt were slavish imitators of Western ways: "a reckless, confused and unreliable lot." Lawrence Vambe, *An Ill-Fated People: Zimbabwe before and after Rhodes* (London: Heinemann, 1972), p. 245.

[36] See Clements Kadalie, *My Life and the ICU: The Autobiography of a Black Trade Unionist in South Africa* (London: Cass, 1970); Helen Bradford, *A Taste of Freedom: The ICU in Rural South Africa, 1924–30* (New Haven: Yale University Press, 1987).

[37] Timothy Scarnecchia, *The Politics of Gender and Class in the Formation of African Communities, Salisbury, Rhodesia, 1937–1957* (Ph.D. dissertation, University of Michigan, 1993), p. 166; Lawrence Vambe, *From Rhodesia to Zimbabwe* (London: Heinemann, 1976), p. 96; it was Shamuyarira's scornful opinion that Mzingeli moved in the mid-1950s into a political style of multiracialism and tea drinking. Nathan Shamuyarira, *Crisis in Rhodesia* (London: Andre Deutsch, 1965), p. 34.

[38] Timothy Scarnecchia, "Poor Women and Nationalist Politics: Alliances and Fissures in the Formation of a Nationalist Political Movement in Salisbury, Rhodesia, 1950–6," *Journal of African History* vol. 37 (1996), p. 288, says the RICU was formed in February 1946; an early RICU official, Reuben Jamela, remembers that it was formed in March or April; interview with Mr. Reuben Jamela, Harare, 26 December 1990. Ranger gives a date of April. Terence Ranger, *Are We Not Also Men? The Samkange Family and African Politics in Colonial Zimbabwe, 1920–64* (Portsmouth: Heinemann, 1995), p. 110.

[39] Teresa Barnes, "So That a Labourer Could Live with His Family: Overlooked Factors in Social and Economic Strife in Urban Colonial Zimbabwe, 1945–1952," *Journal of Southern African Studies* vol. 21 no. 1 (1995); Scarnecchia, "Poor Women and Nationalist Politics."

[40] CID confidential memo no. 64, 31 March 1952. KCAL.

[41] West, "Ndabaningi Sithole."

[42] The subtlety of Scarnecchia's analysis, that male politicians used and subverted the energies of the gender issue in the township, may be paved over in the scholarly road making from 1940s civic protests to 1950s nationalism. See Scarnecchia, "Poor Women and Nationalist Politics," esp. p. 306–310.

[43] Julia C. Wells, *We Now Demand! The History of Women's Resistance to Pass Laws in South Africa* (Johannesburg: Witwatersrand University Press, 1994).

[44] See Bradford, *A Taste of Freedom*.

[45] Interview with Reuben Jamela, Harare, 26 December 1990.

[46] Ian Phimister, *An Economic and Social History of Zimbabwe: Capital Accumulation and Class Struggle, 1890–1948 (London: Longman, 1988)*, p. 267; the CID reports on meetings in July and October 1947 noted attendance of 60 and 30 people, respectively. CID confidential memos no. 2 and no. 9, 1947. KCAL.

[47] Michael West, *African Middle-Class Formation in Colonial Zimbabwe, 1890–1965* (Ph.D. dissertation, Harvard University, 1990), p. 367–368.

[48] Scarnecchia, "Poor Women and Nationalist Politics," p. 291.

[49] Vambe, *Rhodesia to Zimbabwe*, p. 237–238, 243–247.

[50] Aaron Jacha to Thompson Samkange, 7 August, 1947, quoted in Ranger, *Are We Not Also Men*, p. 121.

[51] Scarnecchia, "Poor Women and Nationalist Politics," p. 291. The eighth annual RICU conference in June 1954 was attended only by thirty-five to forty people: "Very little of importance was discussed owing to the small attendance which, incidentally, points to an RICU decline. . . . Mzingeli once again showed that he is not 'au courant' with Trade Unionism by saying that the RICU should organise as many branches of the Union as possible so that they would be able to form a TUC (Trade Union Congress) within the RICU." CID confidential memo no. 90, 22 June 1954. KCAL.

[52] Ranger, *Are We Not Also Men*, p. 112; the Southern Rhodesian CID mistakenly identified the signatories of these South African greetings as W. M. Sisula and Moses M. Motani. CID confidential memo no. 48, 29 June 1950. KCAL.

[53] Scarnecchia, "Poor Women and Nationalist Politics," p. 291.

[54] In the opinion of Michael West, for example, African women played "no significant public role in the colonial society." West, "Dadaya School Strike of 1947," p. 30.

[55] CID confidential memo no. 75, 6 March 1953.

[56] Salisbury Municipality file 12/7, jacket 11. W. S. Stodart to Medical Officer of Health, 8 April 1940.

[57] Report of the Salisbury Medical Officer of Health to subcommittee of the Salisbury Town Council, 23 December 1946. S 482/163/41.

[58] Annual report of the NC Salisbury, 1946, p. 2. S 1051.

[59] T.R.H. Davenport, "Rhodesian and South African Policies for Urban Africans: Some Historical Similarities and Contrasts," *Rhodesian History*, vol. 3 (1972).

[60] Richard Gray, *The Two Nations: Aspects of Race Relations in the Rhodesias and Nyasaland* (London: Oxford University Press, 1960), p. 279–283; Vambe, *Rhodesia to Zimbabwe*, p. 236.

[61] Eric Gargett, *The Administration of Transition: African Urban Settlement in Rhodesia* (Gweru: Mambo Press, 1977); T.R.H. Davenport, "Similarities and Contrasts," p. 9–10.

[62] Interviews with Mr. Laxon Gutsa, 5 November 1988; Mr. Munamo Rubaba, 21 November 1988; Mrs. Shumirai Rubaba, Tafara, 23 November 1988; Miss Sophie Mazoe, Mt. Pleasant, 16 February 1989; Mrs. Elsie Magwenzi, St. Mary's, 6 March 1989; Mrs. Ennia Mutuma, Mbare, 20 March 1989; Mrs. Ruth Murhombe, Mbare, 5 April 1989; Mrs. Faina Guchu, St. Mary's, 24 April 1989.

[63] *African Weekly*, 8 November 1950.

[64] Interview with Mrs. Faina Guchu, St. Mary's, 24 April 1989.

[65] The implication was that prostitutes would not have had children to carry. An explanation from 1936 was that prostitutes contracted venereal diseases that rendered them infertile; Salisbury Town Clerk to Secretary for Native Affairs, 11 September 1936, S 1542/S12. Also, given that prostitutes had even less access to housing than other urban women, perhaps they were forced to send any children back to the rural areas. The community's social ideal was that a respectable married woman would often fall pregnant, thus simultaneously proving her gynecological health, valuable fertility, and irreproachable moral status.

[66] Interview with Mrs. Faina Guchu, St. Mary's, 24 April 1989.

[67] See Teresa Barnes, "'Am I a Man?' Gender, Identity and the Pass Laws in Colonial Zimbabwe," *African Studies Review* vol. 40 no. 1 (1997).

[68] *African Weekly*, 9 April 1952.

[69] Ibid.

[70] Quoted in *African Weekly*, 30 July 1952.

[71] Vambe, *Rhodesia to Zimbabwe*, p. 239.

[72] A new pass system was proposed, wherein all African men in the town would have their registration certificates confiscated and would be issued with a special municipal identity book. The registration certificate would only be returned upon a man's departure from the municipal area. *African Weekly*, 4 January 1950, p. 1; CID confidential memo no. 44, 24 February 1950. KCAL.

[73] Vambe, *Rhodesia to Zimbabwe*, p. 241.

[74] CID confidential memo no. 48, 29 June 1950. KCAL.

[75] CID confidential memo no. 49, 21 July 1950. KCAL.

[76] Scarnecchia, "Poor Women and Nationalist Politics," p. 291. The May meeting had attracted only 170 people; CID confidential memo no. 54, 22 May 1951. KCAL.

[77] CID confidential memo no. 55, 29 June 1951. KCAL.

[78] Scarnecchia, "Poor Women and Nationalist Politics," p. 291–292.

[79] CID confidential memo no. 56, 26 July 1951. KCAL.

[80] See Ngwabi Bhebe, *Benjamin Burombo: African politics in Zimbabwe, 1946–58* (Harare: College Press, 1989).

[81] BANV (British African National Voice Association) meeting, Rusape location, 15 August 1951, reported in CID confidential memo no. 57, 27 August 1951. KCAL. Other grievances included land shortage, "the low level of *lobola* payments," destocking, restrictions of farming, patients in hospitals forced to work, prisoners being beaten in jail, increases in the cost of living and beer, "dirty beer mugs" (presumably at the beer hall), lack of accommodation in the location, and the poorly built character of the housing (no lights, doors, or floors) that was available.

[82] CID confidential memo no. 69, 28 August 1952. KCAL. Unsuccessful attempts to start a Bulawayo RICU branch are first mentioned in memo no. 59, October 1951. Perhaps spurred by Mzingeli's recent trip to Britain, 110 people attended an RICU meeting in the Bulawayo location in March 1952, however; memo no. 64, 31 March 1952. KCAL.

[83] CID confidential memo no. 63, 27 February 1952. KCAL.

[84] CID confidential memo no. 70, 30 September 1952. KCAL.

[85] CID confidential memo no. 64, 31 March 1952. KCAL.

[86] *African Weekly*, 2 April 1952.

[87] Ibid.

[88] CID confidential memo no. 65, 29 April 1952. KCAL.

[89] CID confidential memos, no. 69, 28 August 1952; no. 70, 30 September 1952; no. 72, 29 November 1952. KCAL.

[90] *Rhodesia Herald*, 20 June 1952; *African Weekly*, 6 August 1952.

[91] *African Weekly*, 2 April 1952.

[92] P. Pazarangu, NAZ African Oral History no. 56, p. 67.

[93] Scarnecchia, "Poor Women and Nationalist Politics," p. 293–294.

[94] Shamuyarira, *Crisis in Rhodesia*, p. 40.

[95] *African Weekly*, 30 July 1952. The CID memo for July 1952, no. 68, does not mention an RICU meeting. KCAL.

[96] Shamuyarira, *Crisis in Rhodesia*, p. 34; Patrick Pazarangu, NAZ African Oral History no. 56, p. 67; interview with Mr. Reuben Jamela, Harare, 26 December 1990.

[97] This was one of a series of similar measures implemented throughout English-speaking central and southern Africa that followed the Swynnerton Plan in Kenya, which were meant to reorganize peasant agriculture and society into small-scale capitalist production units. The laws were uniformly intensely unpopular in the African countryside and vigorously resisted where attempts were made to implement them. See Montague Yudelman, *Africans on the Land* (Cambridge: Harvard University Press, 1964); Henry V. Moyana, *The Political Economy of Land in Zimbabwe* (Gweru: Mambo Press, 1984); Ian Phimister, "Discourse and the Discipline of Historical Context: Conservationism and Ideas about Development in Southern Rhodesia, 1930–1950," *Journal of Southern African Studies* vol. 12 no. 2 (1986); Victor Machingaidze, "Agrarian Change from Above: The Southern Rhodesia Native Land Husbandry Act and African Response," *The International Journal of African Historical Studies* vol. 24 no. 3 (1991), p. 576–586.

[98] This pastiche fell apart in 1963.

[99] See Bhebe, *Burombo*; Terence Ranger, *Peasant Consciousness and Guerrilla War in Zimbabwe* (Harare: Zimbabwe Publishing House, 1985); Lan, *Guns and Rain*; J. Day, "The Creation of Political Myths: African Nationalism in Southern Rhodesia," *Journal of Southern African Studies* vol. 2 no. 1 (1975). Chapter-length studies of the development of nationalism include Ngwabi Bhebe, "The National Struggle, 1957–62," and Misheck Sibanda, "Early Foundations of African Nationalism," in Canaan Banana, *Turmoil and Tenacity: Zimbabwe 1890–1990* (Harare: College Press, 1989); David Martin and Phyllis Johnson, *The Struggle for Zimbabwe: The Chimurenga War* (Harare: Zimbabwe Publishing House, 1981), p. 51–72. Scarnecchia's "Poor Women and Nationalist Politics" is an important recent study. In addition, personal narratives are important sources; see Shamuyarira, *Crisis in Rhodesia*; Vambe, *Rhodesia to Zimbabwe*; Maurice Nyagumbo, *With the People: An Autobiography from the Zimbabwean Struggle* (London: Allison & Busby, 1980); Joshua Nkomo, *Nkomo: The Story of My Life* (London: Methuen, 1984).

[100] See Ranger, *Peasant Consciousness*; Norma Kriger, *Zimbabwe's Guerrilla War: Peasant Voices* (Cambridge: Cambridge University Press, 1992); K. D. Manungo, "The Peasantry in Zimbabwe: A Vehicle for Change," and Norma Kriger, "Popular Struggles in Zimbabwe's War of National Liberation," in Preben Kaarsholm, ed., *Cultural Struggle and Development in Southern Africa* (Harare: Baobab Books, 1991); Julie Frederikse, *None But Ourselves: Masses vs. Media in the Struggle for Zimbabwe* (Harare: Zimbabwe Publishing House, 1981); Martin and Johnson, *Struggle for Zimbabwe*.

[101] See John Pape, "Domestic Workers and the Liberation Struggle," unpublished paper presented to Conference on the Zimbabwean Liberation War, University of Zimbabwe, July 1991; Scarnecchia, "Poor Women and Nationalist Politics;" idem, *Politics of Gender and Class*, chapters 5 and 7; Ranger, *Are We Not Also Men*, esp. chapter 4.

[102] Examples include Christine Sylvester, *Zimbabwe: Terrain of Contradictory Development* (Boulder, Colorado: Westview, 1990), p. 42; Sibanda, "Early Foundations," p. 46; Martin and Johnson, *Struggle for Zimbabwe*, p. 66; J. Day, "The Creation of Political Myths," p. 53.

[103] The account that follows is largely based on Miriam Green, "The Salisbury Bus Boycott, 1956," *History of Zambia* no. 13 (1973).

[104] Jeater, *Marriage, Perversion and Power*, p. 196; see, however, Marc Epprecht, "Domestic Violence and Capitalism in the History of Sub-Saharan Africa," unpublished paper, 1995.

[105] Elizabeth Schmidt, *Peasants, Traders and Wives: Shona Women in the History of Zimbabwe, 1870–1939* (Portsmouth: Heinemann, 1992), p. 20, 220n181.

[106] Van Onselen, *Chibaro*, p. 175–176, cited in Jeater, *Marriage, Perversion and Power*, p. 194; J. R. Lunn, *Capital and Labour on the Rhodesian Railway System, 1890–1939* (Ph.D. dissertation, St. Anthony's College, Oxford University, 1986), p. 305.

[107] Teresa Barnes, *African Female Labour and the Urban Economy of Colonial Zimbabwe* (M.A. thesis, University of Zimbabwe, 1987), p. 42; interview, Mbare, 1 March 1989.

[108] Scarnecchia, "Poor Women and Nationalist Politics," p. 300.

[109] Green, "Boycott," p. 5.

[110] Notes on RICU monthly meeting held 3 August 1952; CID confidential memo no. 69, 28 August 1952. KCAL.

[111] CID confidential memos no. 70, 30 September 1952; no. 74, 31 January 1953. KCAL.

[112] Photo no. 21346, NAZ collection; Scarnecchia, "Poor Women and Nationalist Politics," p. 300–301.

[113] This could have been via the travels of the Reverend Thompson Samkange in the 1930s, or through Southern Rhodesian students observing the Indian community in South Africa (also inspired by Gandhi); Ranger, *Are We Not Also Men*, p. 63–86.

[114] J. Mills Thornton III, "First among Equals: The Montgomery Bus Boycott," in David J. Garrow, ed., *The Walking City: The Montgomery Bus Boycott, 1955–1956* (New York: Carlson Publishing, 1989), p. xviii–ix.

[115] Tom Lodge, *Black Politics in South Africa Since 1945* (London: Longman, 1983), p. 13–15, 156–80, 179–82.

[116] Scarnecchia, *Politics of Gender and Class*, p. 168–169.

[117] Garrow, *The Walking City*, passim; David Garrow, ed., *The Montgomery Bus Boycott and the Women Who Started It: The Memoirs of Jo Ann Gibson Robinson* (Knoxville: University of Tennessee Press, 1987); John Nauright, "'I Am with You as Never Before': Women in Urban Protest Movements, Alexandra Township, South Africa, 1912–1945," in Kathleen Sheldon, ed., *Courtyards, Markets, City Streets: Urban Women in Africa* (Boulder, Colorado: Westview, 1996).

[118] Shamuyarira, *Crisis in Rhodesia*, p. 43. According to Green, there were only two women on the returning bus. Green, "Boycott," p. 8.

[119] Green, "Boycott"; Scarnecchia, "Poor Women and Nationalist Politics," p. 305.

[120] *Central African Daily News*, 4 October 1956.

[121] Quoted in Alan Cousins, "State, Ideology and Power in Rhodesia, 1958–1972," *International Journal of African Historical Studies* vol. 24 no. 1 (1991), p. 42. After the beginning of the armed struggle, guerrillas were portrayed in even more lurid and bloody language. See Frederickse, *None But Ourselves*.

[122] Shamuyarira, *Crisis in Rhodesia*, p. 43.

[123] "Report of the National Native Labour Board . . . 1952," p. 13.

[124] City of Salisbury, Department of African Administration, Annual Reports, 1956–57, p. 130; 1957–58, p. 12.

[125] Ranger, *Are We Not Also Men*, p. 155; the term *watershed* is Ranger's, p. 159.

[126] West, "Dadaya School Strike," p. 302.

[127] Davison, *Gender, Lineage and Ethnicity in Southern Africa*, p. 150–151; Scarnecchia, "Poor Women and Nationalist Politics."

[128] Quoted from chapter 7, "Finding the Man in the State," in Wendy Brown, *States of Injury: Power and Freedom in Late Modernity* (Princeton, New Jersey: Princeton University Press, 1995), p. 178.

[129] If the CID reports can be believed, the Mau Mau struggle was seemingly being followed fairly closely by urban Southern Rhodesian leaders; it was reported in January 1953 that George Nyandoro, Isaac Samuriwo, and Aidan Mwamuka had each bought a copy of L.S.B. Leakey's book *Mau Mau and the Kikuyu*; CID confidential memo no. 74, 31 January 1953; the seeming trivia of the beard growing was reported in memos no. 73, 5 January 1953; no. 75, 6 March 1953. KCAL.

[130] See Barnes, "Am I a Man," passim; Scarnecchia, "Poor Women and Nationalist Politics," p. 301.

[131] Martin and Johnson, *Struggle for Zimbabwe*; Ranger, *Peasant Consciousness*; Lan, *Guns and Rain*.

[132] Kriger, *Zimbabwe's Guerrilla War*, chapter 5, passim.

[133] Sita Ranchod-Nilsson, "'Educating Eve': The Women's Club Movement and Political Consciousness among Rural African Women in Southern Rhodesia, 1950–1980," in Karen Tranberg Hansen, ed., *African Encounters with Domesticity* (New Brunswick, New Jersey: Rutgers University Press, 1992), p. 212–213.

[134] Verbatim evidence of Garfield Todd to the (Plewman) Commission of Enquiry into Urban African Conditions, 1957. S 51/2.

[135] Ministry of Internal Affairs, African Women's Clubs. Report on Congress of Federation of African Women's Clubs, 6–7 June 1956. NAZ record center, location 32.14.3F, box 35583, file 3407.

[136] *African Weekly*, 2 April 1952, p. 1.

[137] Ibid.

[138] Mkandawire was her maiden name; when married she became Mrs. Chitumba; interview in Mbare, 29 March 1989.

[139] Salisbury Native Administration Department, annual report, 1954–55, p. 54; *African Parade*, March 1960, p. 19, 75, 80.

[140] Sibongile Mhlaba, *South African Women in the Diaspora: The Case of Zimbabwe*, paper presented to Women's History Workshop, Biennial Conference of the South African Historical Society, Rhodes University, Grahamstown, South Africa, July 1995.

[141] *African Parade*, March 1960, p. 19.

[142] City of Salisbury Department of Native Administration Annual Report, 1955–56, p. 97.

[143] Interview with Jane Ngwenya, Zimbabwe Congress of Trade Unions (ZCTU) labor history interview project, 1995. NAZ.

[144] *African Parade*, November 1958, p. 61–62.

[145] *African Parade*, January 1960, p. 63.

[146] Monthly Report of the Salisbury East Labour Officer, September 1953. S 2104/2, p. 5.

[147] Monthly Reports of the Salisbury East Labour Officer, September 1953, p. 5, November 1953, p. 1, S 2104/2; Native Labour Department Monthly Report, November 1953, p. 7, S 2104/2; Native Labour Department Monthly Report, May 1954.

[148] City of Salisbury Department of Native Administration Annual Report, 1955–56, p. 61.

[149] City of Salisbury Department of Native Administration Annual Report, 1953–54, p. 45.

[150] Department of Native Labour Monthly Report, May 1954. S 2239.

[151] Jamela dissociated himself from the radical nationalists in the early 1960s; the movement's grievances against him are summed up in Jonathan Hyslop, "Trade Unionism in the Rise of African Nationalism: Bulawayo 1945–1963," *Africa Perspective* vol. 1 no. 1–2 (1986), p. 56–57, and in Nyagumbo, *With the People*, p. 158.

[152] Reuben Jamela, interviewed in Harare, 26 December 1990.

[153] Scarnecchia, *Politics of Gender and Class*, p. 293–295.

[154] *African Weekly,* 7 March 1956.

[155] *Radio Post*, June 1958, p. 28

[156] The Southern Rhodesia Liquor Amendment Act came into force in July 1957, stating that Africans would for the first time be able legally to purchase clear (as opposed to sorghum-based, "traditional") beer and wines of less than 50 proof. In addition, they could apply for an "exemption certificate" to purchase spirits on the same terms as "Asiatics and Coloureds." *Central African Examiner*, 22 June 1957; see also West, *Middle-Class Formation*, p. 187–195, and Ranger, *Are We Not Also Men*, p. 153–154.

[157] Salisbury Department of Native Administration annual report, 1955–56, p. 61; interviews with Reuben Jamela, 26 December 1990, and Mr. Beattie Ngarande, 25 April 1989.

[158] Ministry of Labour, Social Welfare and Housing, annual reports, 1957, p. 14; 1958, p. 23–24.

[159] Reuben Jamela, interviewed in Harare, 26 December 1990.

[160] "Minutes of the Meeting of the National Labour Advisory Board held on Wednesday 16 January 1952," NAZ Record Center, location 32.5.6F, box 36290, file 3318. The discourse of looming trouble used here is, I think, an indication that official memories of the 1948 General Strike were still fresh—even four years later.

[161] CID confidential memo no. 84, 4 December 1953. KCAL.

[162] A. W. Aust, labor officer for Bulawayo South, to Commissioner of Native Labour, Salisbury, 12 November 1953, reporting on opinions of African leaders in Bulawayo on the provisional regulations for African women in employment. NAZ Record Center, location 32.5.6F, box 35291, file 3320.

[163] J. F. Holleman, "The African Woman in Town and Tribe," *The Listener*, 4 October 1956.

[164] *African Weekly*, 2 April 1958.

[165] Department of Labour, Monthly Reports for November 1958, p. 10, and December 1958, p. 10. S 2239.

[166] ZCTU interview with Jane Ngwenya, 1995, NAZ. According to Ngwenya, Ngole eventually went into exile in Malawi with her children but died shortly after her return to Zimbabwe.

[167] *African Daily News*, 3 March 1958. I have often wondered whether this report was not a kind of April Fool's joke, as it is incomprehensible that except in the very first flush of trade union fever prostitutes, despised as they were in polite African society, would have thought that TUC leaders would take them seriously. Unable to verify this report, I offer it at face value.

[168] Mrs. Katie Chitumba, interviewed 5 December 1995 by Gift Chitumba, ZCTU labour history project, NAZ.

[169] Mrs. Helen Gamanya, interviewed by Gift Chabatwa, ZCTU labour history project, 1995, NAZ.

[170] Scarnecchia, "Poor Women and Nationalist Politics," passim.

[171] Shamuyarira, *Crisis in Rhodesia*, p. 113.

[172] CID confidential memos no. 78, 8 June 1953; no. 98, 9 March 1955. KCAL.

[173] CID confidential memo no. 88, 6 April 1954. KCAL.

[174] CID confidential memo no. 103, 4 August 1955. KCAL.

[175] *African Weekly*, 2 April 1958, p. 1.

[176] Quoted in Davison, *Gender, Lineage and Ethnicity*, p. 150.

[177] Kriger, *Zimbabwe's Guerrilla War*, p. 191–196.

[178] For a trenchant critique of these unfortunately prevalent responses to African women generally, see Ama Ata Aidoo, "Literature, Feminism and the African Woman Today," in Delia Jarett-Macauley, ed., *Reconstructing Womanhood, Reconstructing Feminism: Writings on Black Women* (London: Routledge, 1996). Similar issues are discussed in another controversial context involving African women in Joyce Russell-Robinson, "African Female Circumcision and the Missionary Mentality," *Issue: A Journal of Opinion* vol. 25 no. 1 (1997).

[179] According to a study carried out in 1957, 80 percent of urban African women had no affiliation with any club, association, or society. Second Report on Urban African Budget Survey in Salisbury, 1957–1958, p. 6.

6

CONCLUSION

In the paperback cover photograph (photo 6.1) of this book, a well-dressed woman crosses a busy street. In the background are the stanchions of a bus stop and an iron fence like the one that surrounds the main bus terminus in Mbare. The woman is in midstep, intent, lips pursed in concentration; she is frowning slightly. A bulging duffel bag is balanced on her head. The fingers of her right hand are tightly clasped by two little boys in suits and dark shoes, one of whom is old enough also to tote a plastic carrier bag. As one's eyes move around the photograph, her burdens multiply. A handbag hangs over her left shoulder. In the crook of her left elbow and with three fingers she grips a rolled bamboo sitting mat, a large umbrella, and a bulky parcel tied up in cloth; the hand of another neatly dressed child is scissored between two other fingers. I like to think that only the initiated will catch the final details of this photograph—the little shoe sticking out from under her right elbow and the cloth knotted tightly on her chest: she is carrying yet another child on her back, hidden from the photographer. The formal clothing and the bamboo mat suggest that she and the children are on their way to a solemn occasion like a funeral. Somehow, although she is practically a one-woman public transport system, the woman is graceful, in control, moving forward.

This photograph is a moment plucked from time; for me, it sums up the position of the urban African woman: her work—the bag, the bundles, the children—is hard, even extreme, but within the bounds of what women are normally considered able to do. It is the shifting balance between the normal and the excessive that fascinates me about this picture. But this is a contemporary photograph of a "private" moment of this woman's life, one might object; how can it possibly relate to wider issues of historiography, nationalism, and social reproduction?

This book has attempted to marshal forces from across the academic spectrum—historical, political and economic—to lay a foundation that is solid enough to explain why and how many of the contemporary legacies of colonial era social reproductive struggles are illustrated by the deter-

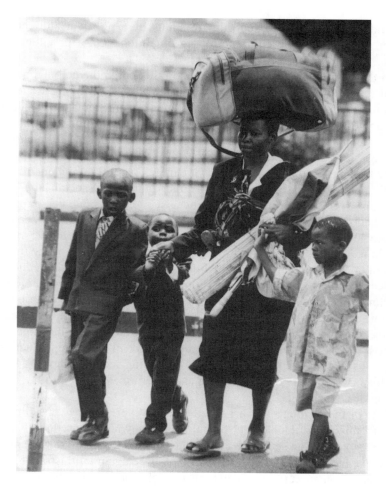

Photo 6.1 Woman with baggage and children, Harare, 1990s. Photograph by David Gombera. Courtesy of Mrs. David Gombera.

mined, overburdened woman in the paperback cover photograph. One of my main aims in writing this book has been to connect that present with a conceptually developed past. The way women took up the limited opportunities in town that they found to make reproductive and productive contributions to their own fortunes and those of their families and society suggests that the direction of women's work changed over time, and that it was crucially important when it took the trajectory of group survival. In colonial Zimbabwe, these opportunities were simultaneously made

available and limited to subordinate status by a political and economic order dedicated to the construction and maintenance of privilege for its white, capitalist masters and clients.

In the short quarter century reviewed in this book, the colonial order entered its middle age, clearly determined not to grant a living wage to the urban African work force. Therefore, women's work, female righteousness, and domestication became the foundation of a sustainable social mix. With these ideological weapons, women's work could be harnessed again, as in the ingenious category of migrant wives. But this program was also tenuously balanced and controversial, as it entailed painful reminders of African men's perceived lessened ability to direct family and social labor and of quarrels over women's "independence." Crucially, however painful the "cracked ribs" that resulted from women's hard work may have been, African society found the means to reorient itself successfully in the socioeconomic wilderness of colonialism. I have conceptualized this as the transmission of an African identity into the future, a struggle against the reduction of African people to labor units, to mindless, cultureless cogs in the colonial machine. I believe that this success was achieved mainly in the period under review, and that it justifies the conceptualization of a coherent (although, of course, far from conflict-free) urban community facing the challenges of the mid-1950s. This investigation of women's work in social reproduction destabilizes an equation of "womanness" with being socially ignored and without history; it restores overburdened and determined women to the national chronicles.

One of the challenges that I face here, however, is not to succumb to an all-encompassing, teleological functionalism in which everything happened for a reason, African society neatly made itself work, and there were no loose ends. Let me refer to the cover photograph once again to illustrate my problem. The woman certainly is getting the job done, and with style. Let us imagine that her hard work in balancing her burdens so neatly represents the social reproduction of society. However, her considerable achievement comes at a cost: I would bet my last Zimbabwe dollar that her back really hurts, that her shoulders are sore, and that she has a headache—and yet, miles to go before she sleeps, to paraphrase the poem. It is her willingness to lay her body on the line repeatedly, to use herself up, that makes the whole scenario possible. But her pain is a loose end. The decision made by Mrs. Butao (whose words open Chapter 4) to bite her tongue and choose silence in the face of a husband who did not want to be questioned about where the money went is a loose end. Once again eschewing a differentiation between private and public, I think that these uncompensated excesses dangle visibly in the public domain. Paradoxically, it is a measure of the success of women's efforts and choices that we can choose to ignore them.

This book has had five themes: gender, women's work, colonial urban development, social reproduction, and coherencies. Gender has been the primary analytical path taken because it is a category that can explicate both the internal weave and outer shape of a society. Historical accuracy cannot be achieved without it. Yet, gender as a concept is surprisingly slippery in a non-Western context.[1] It behooves the researcher of African gender systems to carefully interrogate every presupposition she has about how men and women are different from each other; on close inspection the categories and the constitutive elements themselves are sliding around in ways that may be quite familiar to the indigenous, but quite alarming to the foreign observer. For example, I suspect that the uncompensated excesses alluded to above are significant elements of that which has marked women as different from men in African social cosmology. Thus, "the" difference between men and women is not just defined by superficial physical features. It is also not simply that women are powerless, because, like the woman in the cover photograph, women are strong. It is, rather, the visible lack of social compensation to individual women for their decisions to go beyond the call of duty; their pain is a loose end.[2] My evidence suggests that if there is merit in this idea, it lies at least in the colonial era construction of gender identity. Therefore, this is not an ahistorical claim for a universal law of African gender identity, although there may have been parallels and equivalents at other historical periods. I have written elsewhere of another element in the construction of African gender identity in colonial Zimbabwe, the pass laws.[3]

Over roughly the past two decades, feminist scholarship has been in the process of defining and redefining the sex-gender distinction as the notion that gender is the way that culture makes sense of and constructs meaning from biological, sexual difference. In a recent book, Judith Butler interrogates the notion of social construction and asks the important question of why construction implies artificiality and dispensability whereas that which is "natural" is simply given.[4] I would like to ask a related question from a different angle: does construction imply permanence? For me the notion of construction is related less to that which is artificial and more to that which is built to last. A house made of bricks is a house made of bricks; it cannot metamorphose itself into a glass palace or an airport terminal. Even Butler's useful notion of gender as performative starts from a certain solid baseline of subjective identity; an actor is an actor before he or she assumes a role. But my material suggests to me that the idea of gender construction as permanent can be misleading, at least in the context of the time and place discussed in this book. Maybe the joins between the different elements of gender identity were not mortared together. Maybe they were stitched, or sewn; or lashed

and knotted together with conceptual ropes that could swell in the rain and stretch and give. If gendered identity were more a house of thatch than one of bricks, it could more easily be dismantled, moved, and reassembled. I am venturing into these fields of intellectual quicksand because my material suggests to me that gendered identities in colonial Zimbabwe were indeed made, but in a sort of ebb and flow between, for lack of better terms, masculinity and femininity.[5] This idea can, after Eugenia Herbert, be called a situationality of gender.[6] The material forces that propelled this movement were different in the nineteenth century than in the colonial era and are therefore of necessity different now in the postcolonial era. Amadiume's scenarios of situational gender in precolonial Nigeria include much greater elements of consensus than of the coercion and inequality so common to the contemporary scene, for example.[7] I have also argued elsewhere that participation in the power of collective, social ritual is another crucial element of African gender identity, which is therefore not simply a matter of individual choice or predilection.[8]

A certain possibility of gendered transposition explains aspects of social history in Southern Africa that, if they were to be taken seriously at all, might otherwise be ascribed to some kind of indigenous quaintness. In a recent essay, for example, Iris Berger quotes a Pondo gentleman who had been originally interviewed by the anthropologist Monica Hunter in the 1930s. He said, among other things,

> Times long ago were good. Everything is bad now. We pay taxes. Long ago men were not white men's women.[9]

I think that his becoming a "white man's woman" was not just a metaphor; it was a crucial part of his lived experience of colonialism. This gendered situationality was evident in many aspects of the history of colonial Zimbabwe. For example, the field of domestic employment in settler households was historically of enormous significance in the history of African male wage labor, as there were at times more male servants than mine workers.[10] What did these "servants" do for their "masters"? They washed, cleaned, cooked, carried, and fetched, all ideally without audible complaint. What better example of their learned—and through the phalanx of discriminatory colonial labor legislation, enforced—femininity, of situational gender?

Gendered identities were also fields on which political nationalism was fought, in colonial Zimbabwe as elsewhere. This is a notion that can help keep the conceptual power of nationalism itself in perspective. Recall the Reverend Samkange's asking, "Are we not also men?"—perhaps implying that if "we" were not also men like white men, then "we" were women

like black women. Long ago, Franz Fanon pointed out that Algerian colonialism built a dynamic of a French masculine conquest of an Algerian nation outwardly conceived as female, which "laid the groundwork for constant structural conflict between the Algerian man and the colonizing nation."[11] To be conquered, to have to approach on bended knee, to lack access to social recognition for one's achievements, and to have these rituals of subordination repeated on a daily basis—perhaps these are elements of "womanness" that were rejected by nationalist movements in which men sought to be men again.

At the beginning of this book, mention was made of the idea of "coherencies" in Zimbabwean culture that were independent of and obscured by political nationalism. This idea stems from my personal experience of eight and a half years of living in Harare in the 1980s and observing that African people were conscious of themselves as a distinctly heterogeneous group of people who had experienced more things that brought them together than things that seriously pulled them apart. On a daily level these things were as varied as eating a good hefty meal of *sadza nenyama*, having a rural home, clapping properly to say thank you, hearing the sound of an *mbira* on the wind. The historical coherencies discussed in this book have ranged from the separate, but interwoven categories, strands, and dimensions of women's organizational activities; to the public distaste for women's independence; to an abiding concern for material advancement and hierarchical social organization.

Perhaps, however, one of the most enduring of these coherencies is the sense of women's being defined and molded as the people who, in space and time, are inadequately compensated for extraordinary feats of endurance. But there is a wider dimension, beyond individual inequity, to women's endurance. For Benedict Anderson, nations are "imagined communities" because no one person can ever hope to personally know all the other members of the nation.[12] I would suggest that in a profoundly gendered sense, some people have more imagining to do than others. In colonial Harare, African social reproduction was achieved by coherently constituting masculinist spheres of overt, contemporary domestic and political power and female universes in which the future, imagined as embodied in posterity, became the rewarding principle for hard work. A "real," good, respectable woman accepted this hard bargain. And this is why, conceptually speaking, African women were always mothers or seen in relation to their proximity to motherhood: women were mainly not compensated in the present, but in an imagined time, a daydream time—the future—when the fullness, meaning and potential of children would be realized. These contemporaneously invisible developments were the most characteristically female of rewards. This line of reasoning does not

mean to suggest that children were conceptually delinked from fathers.[13] But children represented something different to mothers and fathers, to women and men. Unlike women, men were materially compensated for their feats of endurance in the present. As social beings, men were given the right to wield whatever political power they could, and, on a daily basis, inter alia, the first bowl of food, warm water with which to wash their hands, and cleaned clothes. They were rewarded with the labor and the deference of women. Women, on the other hand, would ideally become mothers of the nation. Sparks will fly between such asymmetrically charged points. In colonial Harare, African society learned to reproduce itself by harnessing the structured inequalities of present and future, male and female, the tangible and the imagined.

NOTES

[1] For discussions of this idea in a Western context, see Denise Riley, *"Am I That Name?" Feminism and the Category of "Women" in History* (Minneapolis: University of Minnesota Press, 1988), and Judith Butler, *Gender Trouble: Feminism and the Subversion of Identity* (New York: Routledge, 1990); idem., *Bodies That Matter: On the Discursive Limits of "Sex"* (New York: Routledge, 1993). For a recent grappling with this idea in Zimbabwean studies, see Christine Sylvester, "'Woman' in Rural Producer Groups and the Diverse Politics of Truth in Zimbabwe," in Marianne Marchand and Jane Parpart, eds., *Feminism/Postmodernism/Development* (London: Routledge, 1995).

[2] Skeptics may claim that I am hereby elevating lower back pain into a force in human history!

[3] Teresa Barnes, "'Am I a Man?' Gender, Identity and the Pass Laws in Colonial Zimbabwe," *African Studies Review* vol. 40 no. 1 (1997), passim.

[4] Butler, *Bodies That Matter,* introduction and chapter 1, esp. p. xi.

[5] The constricting and ultimately almost nonexplanatory nature of these terms is explored in Chenjerai Shire, "Men Don't Go to the Moon: Language, Space and Masculinities in Zimbabwe," in Andrea Cornwall and Nancy Lindisfarne, eds., *Dislocating Masculinities: Comparative Ethnographies* (London: Routledge, 1994), p. 149.

[6] Eugenia Herbert, *Iron, Gender, Power: Rituals of Transformation in African Societies* (Bloomington: Indiana University Press, 1993), p. 79.

[7] Ifi Amadiume, *Male Daughters, Female Husbands: Gender and Sex in an African Society* (London: Zed Press, 1987).

[8] Teresa Barnes, "The Bark Has Been Stripped from the Tree: Theorizing African Fatherhood and Patriarchy in Southern Africa, circa 1850–1990s," paper presented to the South African and Contemporary History Seminar, University of the Western Cape, October 1997.

[9] Iris Berger, "Interpretations of Women and Gender in Southern African Society," in Robert W. Harms, Joseph Miller, David Newbury, and Michele Wagner, eds., *Paths towards the Past: Historical Essays in Honor of Jan Vansina* (Atlanta: African Studies Association Press, 1994), p. 123.

[10] C. W. (John) Pape, *A Century of Servants: Domestic Workers in Zimbabwe, 1890–1990* (Ph.D. dissertation, Deakin University, 1995); and idem., "Still Serving the Tea:

Domestic Workers in Zimbabwe, 1980–90," *Journal of Southern African Studies* vol. 19 no. 3 (1993).

[11] Lewis Gordon, "The Black and the Body Politic: Fanon's Existential Phenomenological Critique of Psychoanalysis," in Lewis Gordon and T. D. Sharpley, eds., *Fanon: A Critical Reader* (Oxford: Blackwell, 1996), p. 81.

[12] Benedict Anderson, *Imagined Communities: Reflections on the Origin and Spread of Nationalism* (London: Verso, 1991).

[13] Children in a patrilineal society were, of course, considered to belong to the father's line. The idea that I am developing here relates to the conceptual political links between parents and progeny and in no way is meant to suggest that emotional links between African fathers and children were lacking.

BIBLIOGRAPHY

ARCHIVAL HOLDINGS

National Archives of Zimbabwe

A. Files of the British South Africa Company Administration, 1890–1923. These file references begin with the capital letters *A*, *C*, *H*, *N*, or *NSM*.

B. Files of the Government of Southern Rhodesia, post 1923.

1. File references begin with the capital letters *LG* and *S*. The S-series files are, in the main, correspondence and report files of the Chief Native Commissioner, the Prime Minister, and the Commissioner of the British South Africa Police.

2. Evidence to Committees and Commissions of Enquiry: ZNA, Native Affairs Commission (1930); ZBI, Committee of Inquiry into Economic, Social and Health Conditions of Employed Urban Africans (1943); ZBJ, Native Production and Trade Commission (1944); ZBZ, Commission of Inquiry into Recent Native Disturbances (1948).

3. Reports of Committees and Commissions of Enquiry: Report of Committee to Investigate the Economic, Social and Health Conditions of Africans Employed in Urban Areas (1944); Native Production and Trade Commission Report (1945); Report of the Commission Appointed to Investigate the Grievances Which Gave Rise to the Strike amongst the African Employees of the Rhodesia Railways (Tredgold Commission) (1946); Urban African Affairs Commission Report (1958); Report of the National Native Labour Board Enquiry into Conditions of Service for Native Women (1952); Native Education Enquiry Commission Report (1951).

4. Historical Manuscripts Collection: SO, Society of the Three Feathers, Rusape; WO, Federation of Women's Institutes of Southern Rhodesia; RH 27, Rhodesia Tobacco Association; RH 16, Federation of African Welfare Societies.

5. Miscellaneous Official Reports and Documents. The most important of these were government census reports; annual reports of the Commissioner of the British South Africa Police; Salisbury Mayor's Minutes; Salisbury Department of Native/African Administration annual reports; Ministry of Labour Annual Reports.

6. Uncatalogued documentary material from the Ministries of Internal Affairs and Native Affairs, mostly material relating to the mid-1950s. Location, box and file number given in notes.

7. Files of the Salisbury Municipality.

8. African Oral History interviews no. 56 and 63.

9. Newspapers and Magazines: *Rhodesia Herald,* 1930–1957; *Radio Post,* 1959; *African Daily News,* 1956; *Central African Daily News,* 1958; *African Weekly,* 1944–1958; *Bantu Mirror,* 1936–1945; *The African Businessman,* 1961; *The African Parade,* 1954–1960.

Killie Campbell Africana Library (KCAL) University of Natal, Durban, South Africa

Incomplete Set of "Security Branch Memoranda on Native Affairs" prepared by Criminal Investigation Department (CID) Headquarters, Bulawayo. These memoranda were widely circulated through organs of the state. Memorandum no. 2, 30 July 1947; no. 9, 1947; no. 18, 25 February 1948; no. 21, 11 June 1948; no. 44, 24 February 1950; no. 45 11 April 1950; no. 48, 29 June 1950; no. 49, 21 July 1950; no. 54, 22 May 1951; no. 55, 29 June 1951; no. 56, 26 July 1951; no. 57, 27 August 1951; no. 59, 31 October 1951; no. 63, 27 February 1952; no. 64, 31 March 1952; no. 65, 29 April 1952; no. 68, July 1952; no. 69, 28 August 1952; no. 70, 30 September 1952; no. 72, 29 November 1952; no. 73, 5 January 1953; no. 74, 31 January 1953; no. 75, 6 March 1953; no. 78, 8 June 1953; no. 88, 6 April 1954; no. 90, 22 June 1954; no. 98, 9 March 1955; no. 103, 4 August 1955.

CITED INTERVIEWS

Conducted by the Author with assistance mainly from Everjoice Win; Other assistants were Elisha Khumalo, Samson Manjolo, and Sitabile Ncube.

Mr. Laxon Gutsa, 5 November 1988.
Mr. Munamo Rubaba, Tafara, 21 November 1988.
Mrs. Shumirai Rubaba, Tafara, 23 November 1988.
Miss Sophie Mazoe, Mt. Pleasant, 16 February 1989.
Mr. Lawrence Vambe, Belgravia, Harare, 17 February 1989.
Miss Theresa Cele, Nyatsime College, Seke, 20 February 1989.
Mrs. Bertha Charlie, Mbare, 21 February 1989.
Mrs. Maria Chagaresango, Mbare, 21 February 1989.
Miss Caroline Renhas, Highfield, 27 February 1989.
Mrs. Mary Butao, Highfield, 28 February 1989.
Miss Ennia Gasa, Mbare, 1 March 1989.
Mrs. Elsie Magwenzi, St. Mary's, 6 March 1989.
Mrs. Loice Muchineripi, Mbare, 8 March 1989.
Mrs. Mary Ruswa, Highfield, 9 March 1989.
Mrs. Sarah Ndhlela, Highfield, 13 March 1989.
Mrs. Effie Maripakwenda, Mbare, 15 March 1989.
Mrs. Sarah Bakasa, Kambuzuma, 17 March 1989.
Mrs. Enniah Mutuma, Mbare, 20 March 1989.
Miss Keresiya Savanhu, Mbare, 21 March 1989.
Mrs. Katie Chitumba, Mbare, 29 March 1989.
Miss Matombi Savanhu, Mbare, 29 March 1989.

Mrs. Ruth Murhombe, Mbare, 5 April 1989.
Mrs. Makoni, Mbare, 5 April 1989.
Mrs. Esther Chideya, Mbare, 6 April 1989.
Mrs. Stella Mae Sondayi, Highfield, 11 April 1989.
Mrs. Sarah Tsiga, Mbare, 14 April 1989.
Mrs. Maggie Masamba, Epworth, 20 April 1989.
Mrs. Tabitha Munda, Epworth, 20 April 1989.
Mrs. Agnes Kanogoiwa, Waterfalls, 24 April 1989.
Mrs. Faina Guchu, St. Mary's, 24 April 1989.
Mrs. Selina Sitambuli, Mbare, 24 April 1989.
Mr. Beattie Ngarande, 25 April 1989.
Mrs. Cecilia Rusike, Mbare, 28 April 1989.
Mrs. Faina Chirisa, St. Mary's, 31 May 1989.
Mrs. Johanna Scott (Mwelase), Highfield, 31 May 1989.
Mrs. Jessie Marange, Mufakose, 26 June 1989.
Mr. Levi Gono, National Archives of Zimbabwe, 20 September 1989.
Mr. Reuben Jamela, Harare, 26 December 1990.
Mrs. Gertrude Shope, Johannesburg, 22 March 1996.

Conducted in 1995 under the Auspices of the Zimbabwe Congress of Trade Unions (ZCTU) for the ZCTU Labour History Project:

Mrs. Jane Ngwenya, Mrs. Katie Chitumba, Mrs. Helen Gamanya

BOOKS, ARTICLES, PAPERS, AND THESES CITED

Aidoo, Ama Ata. 1996. "Literature, Feminism and the African Woman Today." In Delia Jarett-Macauley, ed. *Reconstructing Womanhood, Reconstructing Feminism: Writings on Black Women.* London: Routledge.

Amadiume, Ifi. 1987. *Male Daughters, Female Husbands: Gender and Sex in an African Society.* London: Zed Press.

———. 1997. *Reinventing Africa: Matriarchy, Religion and Culture.* London: Verso.

Amory, Deborah P. 1997. "Homosexuality in Africa: Issues and Debates." *Issue: A Journal of Opinion* vol. 25 no. 1: 5–10.

Anderson, Benedict. 1991. *Imagined Communities: Reflections on the Origin and Spread of Nationalism.* London: Verso.

Arrighi, Giovanni. 1973. "Labor Supplies in Historical Perspective," and "The Political Economy of Rhodesia." In Giovanni Arrighi and John Saul. *Essays on the Political Economy of Africa*, 180–234, 336–377. New York: Monthly Review Press.

Banana, Canaan, ed. 1989. *Turmoil and Tenacity: Zimbabwe 1890–1990.* Harare: College Press.

Barnes, Teresa. 1987. *African Female Labour and the Urban Economy of Colonial Zimbabwe, with Special Reference to Harare, 1920–39.* M.A. thesis, University of Zimbabwe.

———. 1992. "The Fight to Control African Women's Mobility in Colonial Zimbabwe, 1900–1939." *Signs: Journal of Women in Culture and Society* vol. 17 no. 2: 586–608.

————. 1995. "'So That a Labourer Could Live with His Family': Overlooked Factors in Social and Economic Strife in Urban Colonial Zimbabwe, 1945–1952." *Journal of Southern African Studies* vol. 21 no. 1: 95–113.

————. 1995. "The Heroes' Struggle: Life after the Liberation War for Four Ex-Combatants in Zimbabwe." In Ngwabi Bhebe and Terence Ranger, eds. *Soldiers in Zimbabwe's Liberation War,* 118–138. London: James Currey.

————. 1997. "'Am I a Man?' Gender, Identity and the Pass Laws in Colonial Zimbabwe." *African Studies Review* vol. 40 no. 1:59–81.

————. 1997. "The Bark Has Been Stripped from the Tree: Theorizing African Fatherhood and Patriarchy in Southern Africa, circa 1850–1990s," paper presented to the South African and Contemporary History Seminar, University of the Western Cape.

Barnes, Terri and Everjoice Win. 1992. *To Live a Better Life: An Oral History of Women in Harare, 1930–1970.* Harare: Baobab Books.

Batezat, Elinor and Margaret Mwalo. 1989. *Women in Zimbabwe.* Harare: Sapes Books.

Batson, Edward. 1944. *The Poverty Line in Salisbury.* Cape Town: University of Cape Town.

Beach, David. 1980. *The Shona and Zimbabwe, 900–1850.* Gweru: Mambo Press.

————. 1984. *Zimbabwe before 1900.* Gweru: Mambo Press.

Berger, Iris. 1992. *Threads of Solidarity: Women in South African Industry, 1900–1980.* Bloomington: Indiana University Press.

————. 1994. "Interpretations of Women and Gender in Southern African Societies." In Robert W. Harms, Joseph Miller, David Newbury, and Michele Wagner, eds. *Paths towards the Past: Historical Essays in Honor of Jan Vansina,* 123–141. Atlanta: African Studies Association Press.

Bettison, David. 1960. "The Poverty Datum Line in Central Africa." *Rhodes-Livingstone Institute Journal: Human Problems in British Central Africa* no. 27: 1–40.

————. 1963. "Reply to Thomson and Kay." *Rhodes-Livingstone Institute Journal: Human Problems in British Central Africa* vol. 30.

Bhebe, Ngwabi. 1989. *Benjamin Burombo: African Politics in Colonial Zimbabwe, 1945–1958.* Harare: College Press.

Bond, Patrick. 1993. "Economic Origins of Black Townships in Zimbabwe: Contradictions of Industrial and Financial Capital in the 1950s and 1960s." *Economic Geography* vol. 69 no. 1.

————. 1996. *Uneven Zimbabwe: A Study of Finance, Development and Underdevelopment.* Trenton, New Jersey: Africa World Press.

Bonner, Philip. 1990. "Desirable or Undesirable Basotho Women? Liquor, Prostitution and the Migration of Basotho Women to the Rand, 1920–1945." In Cherryl Walker, ed. *Women and Gender in Southern Africa to 1945,* 221–250. Cape Town: David Philip.

————. 1992. "Division and Unity in the Struggle: African Politics on the Witwatersrand in the 1920s." Seminar Paper no. 307, African Studies Institute, University of the Witwatersrand.

Bozzoli, Belinda. 1983. "Feminism, Marxism and Southern African Studies." *Journal of Southern African Studies* vol. 9 no. 3: 139–171.

Bozzoli, Belinda with Mmantho Nkotsoe. 1991. *Women of Phokeng: Consciousness, Life Strategy and Migrancy in South Africa, 1900–1983.* Portsmouth: Heinemann.

Bradford, Helen. 1987. *A Taste of Freedom: The ICU in Rural South Africa, 1924–30.* New Haven: Yale University Press.

Brown, Wendy. 1995. *States of Injury: Power and Freedom in Late Modernity.* Princeton: Princeton University Press.

Buijs, Gina. 1996. "Women Alone: Migrants from Transkei Employed in Rural Natal." In Gina Buijs, ed. *Migrant Women: Crossing Boundaries and Changing Identities,* 179–194. Oxford: Berg.

Bujra, Janet. 1982. "Women Entrepreneurs of Early Nairobi." In C. Sumner, ed. *Crime, Justice and Underdevelopment.* London: Heinemann.

Burke, Timothy. 1996. *Lifebuoy Men, Lux Women: Commodification, Consumption and Cleanliness in Modern Zimbabwe.* Durham, North Carolina: Duke University Press.

Butler, Judith. 1990. *Gender Trouble: Feminism and the Subversion of Identity.* New York: Routledge.

———. 1993. *Bodies That Matter: On the Discursive Limits of "Sex."* New York: Routledge.

Central African Statistical Office. 1958. *First Report on Urban African Budget Survey in Salisbury, 1957–58.* Salisbury: mimeo.

Chauncey, George. 1981. "The Locus of Reproduction: Women's Labour in the Zambian Copperbelt, 1927–1953." *Journal of Southern African Studies* vol. 7 no. 2: 135–164.

Chavunduka, Gordon. 1979. *A Shona Urban Court.* Gwelo: Mambo Press.

Cheater, Angela. 1984. *Idioms of Accumulation: Rural Development and Class Formation among Freeholders in Zimbabwe.* Gweru: Mambo Press.

———. 1986. "The Role and Position of Women in Pre-Colonial and Colonial Zimbabwe." *Zambezia* vol. 13 no. 2: 65–79.

Chirwa, E. M. 1976. *The Role of Women in the Economy: Address to the Rhodesian Institute of Public Relations Seminar.* Salisbury: Rhodesian Institute of Public Relations.

Christopher, A. J. 1988. *The British Empire at Its Zenith.* London: Croom Helm.

Clarke, Duncan. 1975. "The Political Economy of Discrimination and Underdevelopment in Rhodesia with Special Reference to African Workers." Ph.D. thesis, University of St. Andrews.

Clements, F. and E. Harben. 1962. *Leaf of Gold.* London.

Cokorinos, Lee. 1984. "The Political Economy of State and Party Formation in Zimbabwe." In Michael Schatzberg, ed. *The Political Economy of Zimbabwe,* 8–54. New York: Praeger.

Comaroff, Jean. 1985. *Body of Power, Spirit of Resistance: The Culture and History of a South African People.* Chicago: University of Chicago Press.

Comaroff, Jean and John Comaroff. 1991. *Of Revelation and Revolution: Christianity, Colonialism and Consciousness in South Africa.* Chicago: University of Chicago Press.

Cooper, Frederick. 1983. "Urban Space, Industrial Time and Wage Labor." In F. Cooper, ed. *Struggle for the City,* 7–50. Beverly Hills: Sage.

———. 1987. *On the African Waterfront: Urban Disorder and the Transformation of Work in Colonial Mombasa.* New Haven: Yale University Press.

———. 1996. *Decolonization and African Society: The Labor Question in French and British Africa.* Cambridge: Cambridge University Press.

Cordell, E. 1939. "Some Economic and Social Aspects of African Family Life in the Salisbury Municipal Location," (Salisbury, unpublished paper).

Coquery-Vidrovitch, Catherine. 1997. *African Women: A Modern History.* Boulder, Colorado: Westview.

Cornwall, Andrea and Nancy Lindisfarne, eds., 1994. *Dislocating Masculinities: Comparative Ethnographies.* London: Routledge.

Cousins, Alan. 1991. "State, Ideology and Power in Rhodesia, 1958–1972." *International Journal of African Historical Studies* vol. 24 no. 1: 35–64.

Cripps, Arthur Shearly. 1941. "Africans' Pocket Money." *The Link* vol. 1 no. 6.

Cummings, Mary Lou. 1991. *Surviving without Romance: African Women Tell Their Stories.* Scottdale, Pennsylvania: Herald Press.

Curtin, Peter. 1968. "Field Techniques for Collecting and Processing Oral Data." *Journal of African History* vol. 9 no. 3: 367–385.

Davenport, T.R.H. 1972. "Rhodesian and South African Policies for Urban Africans: Some Historical Similarities and Contrasts." *Rhodesian History* vol. 3: 63–76.

Davies, D. Hywell. 1986. "Harare, Zimbabwe: Origins, Development and Post-Colonial Change." *African Urban Quarterly* vol. 1 no. 2: 131–138.

Davison, Jean. 1997. *Gender, Lineage and Ethnicity in Southern Africa.* Boulder, Colorado: Westview.

Day, J. 1975. "The Creation of Political Myths: African Nationalism in Southern Rhodesia." *Journal of Southern African Studies* vol. 2 no. 1: 52–65.

Dewar, Neil. 1987. "Salisbury to Harare: Citizen Participation in Public Decision-Making under Changing Ideological Circumstances in Zimbabwe." *African Urban Quarterly* vol. 2 no. 1: 37–48.

Drakakis-Smith, D. W. 1984. "The Changing Economic Role of Women in the Urbanization Process: A Preliminary Report for Zimbabwe." *International Migration Review* vol. 18 no. 4: 1278–1292.

———. 1987. "Urban and Regional Development in Zimbabwe." In Dean Forbes and Nigel Thrift, eds. *The Socialist Third World: Urban Development and Territorial Planning,* 194–213. Oxford: Basil Blackwell.

Eley, Geoff and Ronald Suny, eds. 1996. *Becoming National: A Reader.* New York: Oxford University Press.

English, Parker and Kibujjo Kalumba. 1996. *African Philosophy: A Classical Approach.* Upper Saddle River, New Jersey: Prentice-Hall.

Epprecht, Marc. 1995. "'Domestic' Violence and Capitalism in the History of Sub-Saharan Africa." Paper presented to South African Historical Society biennial conference, Grahamstown, South Africa.

———. 1996. "'Good God Almighty, What's This!': Homosexual 'Crime' in Early Colonial Zimbabwe." Paper presented to the African Studies Association annual meeting.

Etherington, Norman. 1996. "Recent Trends in the Historiography of Christianity in Southern Africa." *Journal of Southern African Studies* vol. 22 no. 2: 201–219.

Ferguson, James. 1990. "Mobile Workers, Modernist Narratives: A Critique of the Historiography of Transition on the Zambian Copperbelt [Parts One and Two]." *Journal of Southern African Studies* vol. 16 nos. 3 & 4: 385–412, 603–621.

Final Report of the April/May 1962 Census of Africans in Southern Rhodesia. 1964. Salisbury: Government Printer.

Folbre, Nancy. 1988. "Patriarchal Social Formations in Zimbabwe." In Sharon Stichter and Jane Parpart, eds. *Patriarchy and Class*, 61–80. Boulder, Colorado: Westview.

Frederickse, Julie. 1981. *None But Ourselves: Masses vs. Media in the Struggle for Zimbabwe*. Harare: Zimbabwe Publishing House.

Gaidzanwa, Rudo. 1985. *Images of Women in Zimbabwean Literature*. Harare: College Press.

Gann, L. H. 1964. *A History of Southern Rhodesia*. London: Chatto and Windus.

Gann, L. H. and Michael Gelfand. 1964. *Huggins of Rhodesia*. London: George Allen & Unwin.

Gargett, Eric. 1977. *The Administration of Transition: African Urban Settlement in Rhodesia*. Gweru: Mambo Press.

Garlake, P. S. 1973. *Great Zimbabwe*. London: Thames and Hudson.

Garrow, David. 1987. *The Montgomery Bus Boycott and the Women Who Started It: The Memoirs of Jo Ann Gibson Robinson*. Knoxville: University of Tennessee Press.

Garrow, David, ed. 1989. *The Walking City: The Montgomery Bus Boycott, 1955–1956*. New York: Carlson Publishing.

Geiger, Susan. 1990. "What's So Feminist about Women's Oral History?" *Journal of Women's History* vol. 2 no. 1: 169–182.

Gelfand, Michael. 1973. *The Genuine Shona: Survival Values of an African Culture*. Gweru: Mambo Press.

Godwin, Peter and Ian Hancock. 1993. *"Rhodesians Never Die": The Impact of War and Political Change on White Rhodesia, c1970–1980*. Oxford: Oxford University Press.

Gordon, Lewis. 1996. "The Black and the Body Politic: Fanon's Existential Phenomenological Critique of Psychoanalysis." In Lewis Gordon and T. D. Sharpley, eds. *Fanon: A Critical Reader*, 74–84. Oxford: Blackwell.

Gray, Richard. 1960. *The Two Nations: Aspects of Race Relations in the Rhodesias and Nyasaland*. London: Oxford University Press.

Green, Miriam. 1973. "The Salisbury Bus Boycott, 1956." *History of Zambia* no. 13: 1–16.

Gussman, Boris. 1962. *Out in the Midday Sun*. London: George Allen & Unwin.

Guyer, Jane. 1988. "Dynamic Approaches to Domestic Budgeting: Cases and Methods from Africa." In Daisy Dwyer and Judith Bruce, eds. *A Home Divided: Women and Income in the Third World*, 155–172. Stanford, California: Stanford University Press.

Hansen, Karen Tranberg. 1984. "Negotiating Sex and Gender in Urban Zambia." *Journal of Southern African Studies* vol. 10 no. 2: 219–238.

———. 1997. *Keeping House in Lusaka*. New York: Columbia University Press.

Hansen, Karen Tranberg, ed. 1992. *African Encounters with Domesticity*. New Brunswick, New Jersey: Rutgers University Press.

Harris, Peter. 1975. "Industrial Workers in Rhodesia: Working-Class Elites or Lumpenproletariat?" *Journal of Southern African Studies* vol. 1 no. 2: 139–161.

Hawkins, Anthony. 1976. "The Economy." In G. Leistner, ed. *Rhodesia: Economic Structure and Change*. Pretoria: Africa Institute.

Henige, David. 1982. *Oral Historiography*. London: Longman.

———. 1986. "African History and the Rule of Evidence: Is Declaring Victory Enough?" In Bogumil Jewsiewicki and David Newbury, eds. *African Historiographies: What History for Which Africa?* 91–104. Beverly Hills: Sage.

Herbert, Eugenia. 1993. *Iron, Gender and Power: Rituals of Transformation in African Societies*. Bloomington: Indiana University Press.

Herbst, Jeffrey. 1990. *State Politics in Zimbabwe*. Harare: University of Zimbabwe Publications.

Hodgson, Dorothy and Sheryl McCurdy. 1996. "Wayward Wives, Misfit Mothers and Disobedient Daughters: 'Wicked' Women and the Reconfiguration of Gender in Africa." *Canadian Journal of African Studies* vol. 30 no. 1: 1–9.

Holleman, J. F. 1952. *Shona Customary Law: With Reference to Kinship, Marriage, the Family and the Estate*. Manchester: Manchester University Press.

———. 1956. "The African Woman in Town and Tribe." *The Listener*, October 4.

Horn, Nancy. 1994. *Cultivating Customers: Market Women in Harare, Zimbabwe*. Boulder, Colorado: Lynne Rienner Publishers.

Howman, E. R. 1938. *The Urbanized Native in Southern Rhodesia*. Salisbury: Institute of Municipal Accounts.

Howman, R. 1945. "Report on Urban Conditions in Southern Rhodesia." (Howman Committee Report). *African Studies* vol. 4.

Hunt, Nancy Rose. 1989. "Placing African Women's History and Locating Gender." *Social History* vol. 14 no. 3: 359–379.

———. 1996. "Introduction" to special issue, "Gendered Colonialisms in African History." *Gender & History* vol. 8 no. 3.

Hyslop, Jonathan. 1986. "Trade Unionism in the Rise of African Nationalism: Bulawayo 1945–1963." *Africa Perspective* vol. 1 no. 1–2: 34–67.

Ibbotson, Percy. 1943. *Report on a Survey of Urban African Conditions in Southern Rhodesia*. Bulawayo: Federation of Native Welfare Societies.

Izzard, Wendy. 1985. "Migrants and Mothers: Case Studies from Botswana." *Journal of Southern African Studies* vol. 11 no. 2: 258–280.

Jackson, Lynette. 1987. *"Uncontrollable Women" in a Colonial African Town: Bulawayo Location, 1893–1953*. M.A. thesis, Columbia University.

Jackson, Peter. 1987. "The Idea of 'Race' and the Geography of Racism." In Peter Jackson, ed. *Race and Racism: Essays in Social Geography*, 3–21. London: Allen and Unwin.

Jacobs, Susan. 1989. "Zimbabwe: State, Class and Gendered Models of Land Resettlement." In Jane Parpart and Katherine Staudt, eds. *Women and the State in Africa*, 161–184. Boulder, Colorado: Lynne Rienner.

Jeater, Diana. 1993. *Marriage, Perversion and Power: The Construction of Moral Discourse in Southern Rhodesia, 1894–1930*. Oxford: Clarendon Press.

Jewsiewicki, Bogumil and David Newbury, eds. 1986. *African Historiographies: What History for Which Africa?* Beverly Hills: Sage.

Johnson, R.W.M. 1963. "An Economic Survey of Chiweshe Reserve." *Rhodes-Livingstone Institute Journal: Human Problems in Central Africa* vol. 36: 82–91.

Kadalie, Clements. 1970. *My Life and the ICU: The Autobiography of a Black Trade Unionist in South Africa*. London: Cass.

Kahari, George. 1986. *Aspects of the Shona Novel and Other Related Genres*. Gweru: Mambo Press.

Kay, George. 1970. *Rhodesia: A Human Geography*. New York: Africana Publishing Corporation.

Kay, George and Michael Smout, 1977. *Salisbury: A Geographical Survey of the Capital of Rhodesia*. Kent: Hodder & Stoughton.

Kennedy, Dane. 1987. *Islands of White: Settler Society and Culture in Kenya and Southern Rhodesia.* Durham, North Carolina: Duke University Press.

Kileff, Clive. 1975. "Black Suburbanites: An African Elite in Salisbury, Rhodesia." In Clive Kileff and William Pendleton, eds. *Urban Man in Southern Africa*, 81–97. Gwelo: Mambo Press.

King, Anthony. 1990. *Urbanism, Colonialism and the World Economy: Cultural and Spatial Foundations of the World Urban System.* London: Routledge.

Kinsman, Margaret. 1983. "'Beasts of Burden': The Subordination of Southern Tswana Women, ca 1800–1840." *Journal of Southern African Studies* vol. 10 no. 1: 39–54.

Kirkwood, Deborah. 1984. "The Suitable Wife: Preparation for Marriage in London and Rhodesia/Zimbabwe," and "Settler Wives in Southern Rhodesia: A Case Study." In Hilary Callan and Shirley Ardener, eds., *The Incorporated Wife*, 106–119, 143–164. London: Croom Helm.

Knox, Paul. 1995. *Urban Social Geography: An Introduction.* 3rd edition. London: Longman.

Krige, E. J. and J. L. Comaroff, eds. 1981. *Essays in African Marriage in Southern Africa.* Cape Town: Juta.

Kriger, Norma. 1988. "The Zimbabwean War of Liberation: Struggles within the Struggle." *Journal of Southern African Studies* vol. 14 no. 2: 302–322.

———. 1991. "Popular Struggles in Zimbabwe's War of National Liberation." In Preben Kaarsholm, ed. *Cultural Struggle and Development in Southern Africa*, 125–148. Harare: Baobab Books.

———. 1992. *Zimbabwe's Guerrilla War: Peasant Voices.* Cambridge: Cambridge University Press.

Kuimba, Giles. 1976. *Rurimi Inyoka.* Gwelo: Mambo Press in conjunction with the Rhodesia Literature Bureau.

Kuper, Adam. 1982. *Wives for Cattle: Bridewealth and Marriage in Southern Africa.* London: Routledge and Kegan Paul.

Küster, Sybille. 1994. *Neither Cultural Imperialism nor Precious Gift of Civilization: African Education in Colonial Zimbabwe, 1890–1962.* Hamburg: Lit.

La Hausse, Paul. 1988. *Brewers, Beerhalls and Boycotts: A History of Liquor in South Africa.* Johannesburg: Ravan Press.

Lan, David. 1985. *Guns and Rain: Guerrillas and Spirit Mediums in Zimbabwe.* Harare: Zimbabwe Publishing House.

Landau, Paul. 1995. *The Realm of the Word: Language, Gender and Christianity in a Southern African Kingdom.* Portsmouth: Heinemann.

Lanning, Greg with Marti Mueller. 1979. *Africa Undermined: A History of the Mining Companies and the Underdevelopment of Africa.* Harmondsworth: Penguin.

Lessing, Doris. 1965. *A Proper Marriage.* London: Hart-Davis MacGibbon.

Little, Kenneth. 1973. *African Women in Towns: An Aspect of Africa's Social Revolution.* New York: Cambridge University Press.

Lodge, Tom. 1983. *Black Politics in South Africa since 1945.* London: Longman.

Lovett, Margo. 1989. "Gender Relations, Class Formation and the Colonial State in Africa." In Parpart and Staudt, ed. *Women and the State in Africa*, 23–46. Boulder, Colorado: Lynne Rienner.

Lunn, J. R. 1986. *Capital and Labour on the Rhodesian Railway System, 1890–1939.* Ph.D. dissertation, St. Anthony's College, Oxford University.

Machingaidze, Victor. 1980. *The Development of Settler Capitalist Agriculture in Southern Rhodesia with Particular Reference to the Role of the State, 1908–1939.* Ph.D. thesis, University of London.

———. 1991. "Agrarian Change from Above: The Southern Rhodesia Native Land Husbandry Act and African Response." *The International Journal of African Historical Studies* vol. 24 no. 3: 557–588.

Manungo, Kenneth. 1991. "The Peasantry in Zimbabwe: A Vehicle for Change." In Preben Kaarsholm, ed. *Cultural Struggle and Development in Southern Africa*, 115–124. Harare: Baobab Books.

Martin, David and Phyllis Johnson. 1981. *The Struggle for Zimbabwe: The Chimurenga War.* Harare: Zimbabwe Publishing House.

May, Joan. 1979. *African Women in Urban Employment.* Gwelo: Mambo Press.

———. 1987. *Changing People, Changing Laws.* Gweru: Mambo Press.

Mayer, Philip. 1971. *Townsmen or Tribesmen? Conservatism and the Process of Urbanization in a South African City.* Cape Town: Oxford University Press.

McCrindle, Jean and Sheila Rowbotham, eds. 1979. *Dutiful Daughters: Women Talk about Their Lives.* Harmondsworth: Penguin.

Mhlaba, Sibongile. 1995. "South African Women in the Diaspora: The Case of Zimbabwe." Paper presented to Women's History Workshop, biennial conference of the South African Historical Society, Grahamstown, South Africa, July 1995.

Miller, Joseph. 1980. "Introduction: Listening for the African Past." In Joseph Miller, ed. *The African Past Speaks: Essays on Oral Tradition and History*, 1–59. Folkestone: Dawson.

Mittlebeeler, Emmet. 1976. *African Custom and Western Law: The Development of a Rhodesian Criminal Law for Africans.* New York: Africana.

Momsen, Janet and Janet Hutchinson, eds. 1987. *Geography of Gender in the Third World.* London: Hutchinson.

Moore, Henrietta and Megan Vaughan. 1994. *Cutting Down Trees: Gender, Nutrition and Agricultural Change in the Northern Province of Zambia, 1890–1990.* Portsmouth: Heinemann.

Morokvasic, Mirjana. 1984. "Birds of Passage Are Also Women." *International Migration Review* vol. 18 no. 4.

Mosley, Paul. 1989. "The Development of Food Supplies to Salisbury (Harare)." In Jane Guyer, ed. *Feeding African Cities*, 203–224. Bloomington: Indiana University Press.

Moyana, Henry V. 1984. *The Political Economy of Land in Zimbabwe.* Gweru: Mambo Press.

Muchena, Olivia. 1980. *Women in Town: A Socio-Economic Survey of African Women in Highfield Township, Salisbury.* Harare: Centre for Applied Social Studies, University of Zimbabwe.

———. 1980. *Women's Organisations in Zimbabwe: Assessment of Their Needs, Achievement and Potential.* Harare: Centre for Applied Social Studies, University of Zimbabwe.

Muzorewa, Farai David. 1975. "Through Prayer to Action: The Rukwadzano Women of Rhodesia." In Terence Ranger and J. Weller, eds. *Themes in the Christian History of Central Africa*, 256–268. London: Heinemann.

Nauright, John. 1996. "'I Am with You As Never Before': Women in Urban Protest Movements, Alexandra Township, South Africa, 1912–1945." In Kathleen Sheldon,

ed. *Courtyards, Markets, City Streets: Urban Women in Africa*, 259–283. Boulder: Westview.

Ncube, Welshman. 1987. "Released from Legal Minority: The Legal Age of Majority Act in Zimbabwe." In Alice Armstrong, ed. *Women and Law in Southern Africa*, 193–209. Harare: Zimbabwe Publishing House.

Nkomo, Joshua. 1984. *Nkomo: The Story of My Life*. London: Methuen.

Nyagumbo, Maurice. 1980. *With the People: An Autobiography from the Zimbabwean Struggle*. London: Allison & Busby.

Obbo, Christine. 1980. *African Women: Their Struggle for Economic Independence*. London: Zed Press.

O'Connor, Anthony. 1983. *The African City*. London: Hutchinson.

Oduyoye, Mercy Amba. 1995. *Daughters of Anowa: African Women and Patriarchy*. Maryknoll: Orbis Books.

Ogden, Jessica A. 1996. "'Producing' Respect: The 'Proper Woman' in Post-Colonial Kampala." In Richard Werbner and Terence Ranger, eds. *Postcolonial Identities in Africa*, 165–192. London: Zed Press.

Pape, C. W. (John). 1990. "The Perils of Sex in Colonial Zimbabwe." *Journal of Southern African Studies* vol 16 no. 4: 699–720.

———. 1991. "Domestic Workers and the Liberation Struggle." Unpublished paper presented to Conference on the Zimbabwean Liberation War, University of Zimbabwe.

———. 1993. "Still Serving the Tea: Domestic Workers in Zimbabwe, 1980–1990." *Journal of Southern African Studies* vol. 19 no. 3: 387–404.

———. 1995. *A Century of "Servants": Domestic Workers in Zimbabwe, 1890–1990*. Ph.D. dissertation, Deakin University.

Parpart, Jane. 1986. "Class and Gender on the Copperbelt." In Claire Robertson and Iris Berger, eds. *Women and Class in Africa*, 141–160. New York: Holmes & Meier.

Parpart, Jane and Kathleen Staudt, eds. 1989. *Women and the State in Africa*. Boulder, Colorado: Lynne Rienner.

Passerini, Luisa. 1980. "Italian Working Class Culture between the Wars: Consensus to Fascism and Work Ideology." *International Journal of Oral History* vol. 1 no. 1: 4–27.

———. 1987. *Fascism in Popular Memory: The Cultural Experience of the Turin Working Class*. Cambridge: Cambridge University Press.

———. 1989. "Women's Personal Narratives: Myths, Experiences and Emotions." In The Personal Narratives Group, ed. *Interpreting Women's Lives: Feminist Theory and Personal Narratives*. Bloomington: Indiana University Press.

Peil, Margaret with Pius O. Sada. 1984. *African Urban Society*. Chichester: John Wiley & Sons.

Phimister, Ian. 1986. "Discourse and the Discipline of Historical Context: Conservationism and Ideas about Development in Southern Rhodesia, 1930–1950." *Journal of Southern African Studies* vol. 12 no. 2: 263–275.

———. 1988. *An Economic and Social History of Zimbabwe: Capital Accumulation and Class Struggle, 1890–1948*. London: Longman.

———. 1994. *Wangi Kolia: Coal, Capital and Labour in Colonial Zimbabwe: 1894–1954*. Harare and Johannesburg: Baobab Books and Witwatersrand University Press.

Phimister, Ian and Charles van Onselen. 1978. *Studies in the History of African Mine Labour in Colonial Zimbabwe*. Gwelo: Mambo Press

Pollak, Oliver. 1973. "The Impact of the Second World War on African Labour Organization in Rhodesia." *Rhodesian Journal of Economics* vol. 7 no. 3.

Potts, Deborah and Chris Mutambirwa. 1990. "Rural-Urban Linkages in Contemporary Harare: Why Migrants Need Their Land." *Journal of Southern African Studies* vol. 16 no. 4: 677–698.

Radcliffe, Sarah A. 1991. "The Role of Gender in Peasant Migration: Conceptual Issues from the Peruvian Andes." *Review of Radical Political Economics* vol. 23 nos. 3 & 4: 129–147.

Radcliffe-Brown, A. R. and D. Forde, eds. 1950. *African Systems of Kinship and Marriage*. London: Oxford University Press.

Raftopoulos, Brian. 1995. "Nationalism and Labour in Salisbury, 1953–1965." *Journal of Southern African Studies* vol. 21 no. 1: 79–93.

———. 1997. "The Labour Movement in Zimbabwe: 1945–65." In Raftopoulos and Ian Phimister, eds. *Keep On Knocking: A History of the Labour Movement in Zimbabwe, 1900–1997*, 55–90. Harare: Baobab Books.

Rakodi, Carole. 1995. *Harare: Inheriting a Settler-Colonial City: Change or Continuity?* Chichester: John Wiley & Sons.

Ranchod-Nilsson, Sita. 1992. "'Educating Eve': The Women's Club Movement and Political Consciousness among Rural African Women in Southern Rhodesia, 1950–1980." In Karen Tranberg Hansen, ed. *African Encounters with Domesticity*, 195–217. New Brunswick, New Jersey: Rutgers University Press.

Ranger, Terence. 1967. *Revolt in Southern Rhodesia, 1896–97*. London: Heinemann.

———. 1970. *The African Voice in Southern Rhodesia*. London: Heinemann.

———. 1981. "Women in the Politics of Makoni District." Unpublished paper, University of Manchester.

———. 1983. "The Invention of Tradition in Zimbabwe." In T. O. Ranger and Eric Hobsbawm, eds. *The Invention of Tradition*, 211–262. Cambridge: Cambridge University Press.

———. 1985. *Peasant Consciousness and Guerrilla War in Zimbabwe*. Harare: Zimbabwe Publishing House.

———. 1995. *Are We Not Also Men? The Samkange Family and African Politics in Colonial Zimbabwe 1920–64*. Portsmouth: Heinemann.

Redding, Sean. 1996. "South African Women and Migration in Umtata, Transkei, 1880–1935." In Kathleen Sheldon, ed. *Courtyards, Markets, City Streets: Urban Women in Africa*, 31–46. Boulder, Colorado: Westview.

Riley, Denise. 1988. *Am I That Name? Feminism and the Category of Women in History*. Minneapolis: University of Minnesota Press.

Robertson, A. F. 1991. *Beyond the Family: The Social Organization of Reproduction*. Cambridge: Polity Press.

Robertson, Claire and Iris Berger, eds. 1986. *Women and Class in Africa*. New York: Holmes and Meier.

Rother, Andrea, ed. 1989. *Preliminary Discussions of Problems of Urbanization in Southern Africa*. East Lansing: Center for Urban Affairs, Michigan State University.

Rule, Peter. 1994. *Nokukhanya, Mother of Light*. Johannesburg: The Grail.

Russell-Robinson, Joyce. 1997. "African Female Circumcision and the Missionary Mentality." *Issue: A Journal of Opinion* vol. 25 no. 1: 54–57.

Salisbury: A City Comes of Age. 1956. Salisbury: Rhodesia Graphic.

Scarnecchia, Timothy. 1993. *The Politics of Gender and Class in the Creation of African Communities, Salisbury, Rhodesia, 1937–1957.* Ph.D. dissertation, University of Michigan.

———. 1996. "Poor Women and Nationalist Politics: Alliances and Fissures in the Formation of a Nationalist Political Movement in Salisbury, Rhodesia, 1950–6." *Journal of African History* vol. 37: 283–310.

Schmidt, Elizabeth. 1987. *Ideology, Economics and the Role of Shona Women in Southern Rhodesia, 1850–1939.* Ph.D. dissertation, University of Wisconsin-Madison.

———. 1988. "Farmers, Hunters and Gold-Washers: A Reevaluation of Women's Roles in Precolonial and Colonial Zimbabwe." *African Economic History* no. 17: 45–80.

———. 1990. "Negotiated Spaces and Contested Terrain: Men, Women and the Law in Colonial Zimbabwe, 1890–1939." *Journal of Southern African Studies* vol. 16 no. 4: 622–648.

———. 1991. "Patriarchy, Capitalism and the Colonial State in Colonial Zimbabwe." *Signs: Journal of Women in Culture and Society* vol. 16, no. 4: 732–756.

———. 1992. "Race, Sex and Domestic Labor: The Question of African Female Servants in Southern Rhodesia, 1900–1939." In Karen Tranberg Hansen, ed. *African Encounters with Domesticity,* 221–241. New Brunswick, New Jersey: Rutgers University Press.

———. 1992. *Peasants, Traders, and Wives: Shona Women in the History of Zimbabwe, 1870–1939.* Portsmouth: Heinemann.

Shamuyarira, Nathan. 1965. *Crisis in Rhodesia.* London: Andre Deutsch.

Sheldon, Kathleen, ed. 1996. *Courtyards, Markets, City Streets: Urban Women in Africa.* Boulder, Colorado: Westview.

Shire, Chenjerai. 1994. "Men Don't Go to the Moon: Language, Space and Masculinities in Zimbabwe." In Andrea Cornwall and Nancy Lindisfarne, eds. *Dislocating Masculinities: Comparative Ethnographies.* London: Routledge.

Sibanda, Mesheck. 1989. "Early Foundations of African Nationalism." In Canaan Banana, ed. *Turmoil and Tenacity: Zimbabwe, 1890–1990,* 25–49. Harare: College Press.

"Skokian King of African Alcoholic Beverages, a Typical Brickfields Sundowner [Cocktails] Scene," *African Weekly* 8 June 1949.

Smout, Michael. 1977. "The City Centre," and "The Suburban Shopping Centres." In George Kay and Michael Smout, eds. *Salisbury: A Geographical Survey of the Capital of Rhodesia,* 57–71, 72–87. Harare: College Press.

Stanley, Lady. 1941. "Hostels for African Girls: Home Life for Domestic Servants." *The Link* vol. 1 no. 2.

Staunton, Irene, ed. 1990. *Mothers of the Revolution.* Harare: Baobab Books.

Stichter, Sharon. 1985. *Migrant Labourers.* Cambridge: Cambridge University Press.

Stichter, Sharon and Jane Parpart, eds. 1988. *Patriarchy and Class: African Women in the Home and the Workforce.* Boulder, Colorado: Westview.

Stoneman, Colin, ed. 1988. *Zimbabwe's Prospects: Issues of Race, Class, State and Capital in Southern Africa.* London: Macmillan.

Stoneman, Colin and Lionel Cliffe. 1989. *Zimbabwe: Politics, Economics and Society.* London: Pinter Publishers.

Storrar, G. 1945. *City of Salisbury: Report on Sanitation Scheme at the Native Location and Investigations into the Organisation of the City Engineer's Department.* Pretoria: mimeo.

Stuart, Osmond Wesley. 1989. *"Good Boys," Footballers and Strikers: African Social Change in Bulawayo, 1933–1953*. Ph.D. dissertation, University of London.

Summers, Carol. 1994. *From Civilization to Segregation: Social Ideals and Social Control in Southern Rhodesia, 1890–1934*. Athens: Ohio University Press.

Sylvester, Christine. 1991. *Zimbabwe: Terrain of Contradictory Development*. Boulder, Colorado: Westview.

————. 1995. "'Women' in Rural Producer Groups and the Diverse Politics of Truth in Zimbabwe." In Marianne H. Marchand and Jane Parpart, eds. *Feminism/ Postmodernism/Development*, 182–203. London: Routledge.

Tanser, G. 1970. "The Birth and Growth of Salisbury, Rhodesia." In H. L. Watts, ed. *Focus on Cities*. Durban: University of Natal.

————. 1974. *A Sequence of Time: The Story of Salisbury, Rhodesia, 1900–1914*. Salisbury: Pioneer Head.

————. 1975. *A Scantling of Time*. Salisbury: Pioneer Head.

Thomson, B. and G. Kay. 1963. "The Poverty Datum Line in Central Africa (A Note on the P.D.L. in Northern Rhodesia)." *Rhodes-Livingstone Institute Journal: Human Problems in British Central Africa* vol. 30.

Thornton, J. Mills III. 1989. "First among Equals: The Montgomery Bus Boycott." In David J. Garrow, ed. *The Walking City: The Montgomery Bus Boycott, 1955– 1956*. New York: Carlson Publishing.

Thornton, Stephen. 1979. "Municipal Employment in Bulawayo, 1895–1935: An Assessment of Differing Forms of Proletarianisation." In *Southern African Research in Progress* vol. 4. Centre for Southern African Studies, University of York.

————. 1980. "The Struggle for Profit and Participation by an Emerging African Petty-Bourgeoisie in Bulawayo, 1893–1933." In *Societies of Southern Africa* vol. 9. London: University of London.

Tobaiwa, Donald. 1977. *The Impact of Urbanisation on Rhodesian African Prostitution*. B.S.W. honors dissertation, University of Zimbabwe.

Trinder, J. 1977. "The Industrial Areas." In George Kay and Michael Smout, eds. *Salisbury: A Geographical Survey of the Capital of Rhodesia*, 88–93. Kent: Hodder and Stoughton.

Uzoigwe, G. N. 1974. *Britain and the Conquest of Africa: The Age of Salisbury*. Ann Arbor: University of Michigan Press.

Vambe, Lawrence. 1972. *An Ill-Fated People: Zimbabwe before and after Rhodes*. London: Heinemann.

————. 1976. *From Rhodesia to Zimbabwe*. London: Heinemann.

Van Onselen, Charles. 1976. *Chibaro: African Mine Labour in Southern Rhodesia, 1900– 1933*. London: Pluto Press.

Vansina, Jan. 1985. *Oral Tradition as History*. London: James Currey.

Van Wyk, David. 1987. *The Political Economy of Urbanization in Colonial Zimbabwe, with Special Reference to Chitungwiza*. B.A. honors dissertation, University of Zimbabwe.

Vassilatos, E. 1974. *Race and Class: The Development of White Images of Blacks in Southern Rhodesia, 1890–1939*. Ph.D. dissertation, University of Rhodesia.

Vukani Makosikazi. 1984. Johannesburg: Ravan Press.

Walker, Cherryl. 1990. *Women and Gender in Southern Africa to 1945*. Cape Town: David Philip.

Weinrich, A.K.H. 1976. *Mucheke: Race, Status and Politics in a Rhodesian Community.* Paris: UNESCO.

———. 1979. *Women and Racial Discrimination in Rhodesia.* Paris: UNESCO.

———. 1982. *African Marriage in Rhodesia and the Impact of Christianity.* Gwelo: Mambo Press.

Weiss, Ruth. 1986. *The Women of Zimbabwe.* Harare: Nehanda Publishers.

———. 1994. *Zimbabwe and the New Elite.* London: British Academic Press.

Wells, Julia C. 1994. *We Now Demand! The History of Women's Resistance to Pass Laws in South Africa.* Johannesburg: Witwatersrand University Press.

Werbner, Richard. 1991. *Tears of the Dead: The Social Biography of an African Family.* Washington, D.C.: Smithsonian Institution Press.

West, Michael. 1990. *African Middle-Class Formation in Colonial Zimbabwe, 1890–1965.* Ph.D. dissertation, Harvard University.

———. 1992. "Ndabaningi Sithole, Garfield Todd and the Dadaya School Strike of 1947." *Journal of Southern African Studies* vol. 18 no. 2: 297–316.

———. 1997. "Liquor and Libido: 'Joint Drinking' and the Politics of Sexual Control in Colonial Zimbabwe, 1920s–1950s." *Journal of Social History* vol. 30 no. 3: 645–667.

White, Luise. 1983. "A Colonial State and an African Petty Bourgeoisie: Prostitution, Property, and Class Struggle in Nairobi, 1936–40." In F. Cooper, ed. *Struggle for the City,* 167–194. Beverly Hills: Sage.

———. 1990. "Bodily Fluids and Usufruct: Controlling Property in Nairobi, 1917–1939." *Canadian Journal of African Studies* vol. 24, no. 3: 418–438.

———. 1990. "Separating the Men from the Boys: Constructions of Gender, Sexuality, and Terrorism in Central Kenya, 1939–1959." *International Journal of African Historical Studies* vol. 23 no. 1:1–25.

———. 1991. *The Comforts of Home: Prostitution in Colonial Nairobi.* Chicago: University of Chicago Press.

Wikan, Unni. 1996. *Tomorrow, God Willing: Self-Made Destinies in Cairo.* Chicago: University of Chicago.

Wild, Volker. 1991. "Black Competition or White Resentment? African Retailers in Salisbury, 1935–1953." *Journal of Southern African Studies* vol. 17 no. 3: 179–190.

Wilkinson, Clive. 1987. "Women, Migration and Work in Lesotho." In Janet Momsen and Janet Hutchinson, eds. *Geography of Gender in the Third World,* 225–239. London: Hutchinson.

Willcox, R. R. 1949. *Report on a Venereal Diseases Survey of the African in Southern Rhodesia.* Salisbury: Government Printer.

Yoshikuni, Tsuneo. 1990. *Black Migrants in a White City: A History of African Harare, 1890–1925.* Ph.D. thesis, University of Zimbabwe.

Yudelman, Montague. 1964. *Africans on the Land.* Cambridge: Harvard University Press.

Zeleza, Paul Tiyambe. 1997. *Manufacturing African Studies and Crises.* Dakar: Codesria.

INDEX

Adultery, xxxiv, 113, 115, 132–33
Africa, xvii, xx, xxv, xxvii, 15, 21
African National Congress (ANC) of South Africa, 137
African National Congress of Southern Rhodesia, 152, 158
African Trades Union Club, 157
African Women's League, 151
Agriculture, 1–2, 4; role of women in, xxviii, xxix, xxxi, 6–9, 28, 36–38, 68–69, 71, 105, 110–17, 118
Alexandra township, 147
Algeria, 177
Amadiume, Ifi, 176
Anderson, Benedict, 177
Arrighi, Giovanni, xxviii, xxxiii

Bakasa, Sarah, 7, 112–13, 115, 117, 125
Bango, Grey, 149
Bango, Rolly, 154
Bantu Women's League, 29
Batson, Edward, 46
Beer, 28, 30, 34, 47, 50–51, 54, 99, 126
Berger, Iris, 176
Bettison, David, 46
Black peril, 80
Botswana, 111
Bozzoli, Belinda, xxv–xxvi, xxvii
Brewing, 28, 30, 34, 47, 50–54, 99, 126
British African National Voice Association, 142
British South Africa Company, xxxii, xxxiii–xxxv
Bubi, 68
Bulawayo, xxx, xxxiv, 2, 5, 27, 51–52, 80, 144, 152, 154; conditions for

women in, 8–9, 10, 11, 28–29, 49–50, 69–70, 75, 78–79, 82, 83, 85, 98–99; McIntyre Hostel in, 82, 83, 85; police in, 52, 77–78, 79; trade unions in, 109, 136, 142
Bulawayo Municipal Workers' Union, 109
Burke, Timothy, 33
Burombo, Benjamin, 142, 144, 149, 152
Bus boycott, Montgomery, Alabama, 146–47
Bus boycott of 1956, Salisbury, 135, 144–48, 158, 160
Butao, Mary, 93, 174
Butler, Judith, 175

Capitalism, xxvi, 22, 23, 24, 50, 72, 174
Carter House, 82, 83, 84–86, 145, 147–48, 160, 161
Causeway area, 2
Cele, Theresa, 29, 85
Central African Federation, 144
Central African Statistical Office, 46
Chagaresango, Maria, 115
Charlie, Bertha, 31, 102, 125
Chavunduka, Gordon, 101
Cheater, Angela, xxx, 101
Chibaro, xxi
Chideya, Esther, 113–15
Chigomah, Emmah, 151–52, 152
Children, xxii, xxv, xxix, 130, 138, 151, 172, 177–78
Chingattie, Victoria, 132
Chishawasha, 96, 98, 118
Chitumba, Katie, 9, 130, 157–58
Chiweshe reserve, 112
Choto, Abel, 142

ABOUT THE AUTHOR

TERESA A. BARNES teaches in the History Department at the University of the Western Cape. She is co-author, with Everjoice Win, of *To Live a Better Life: An Oral History of Women in Harare, 1930–1970* (1992). Her work has appeared in *Signs, African Studies Review,* and *The Journal of South African Studies* and in several edited collections on history and gender in southern Africa.

ISBN 0-325-00173-1

HARDCOVER BAR CODE